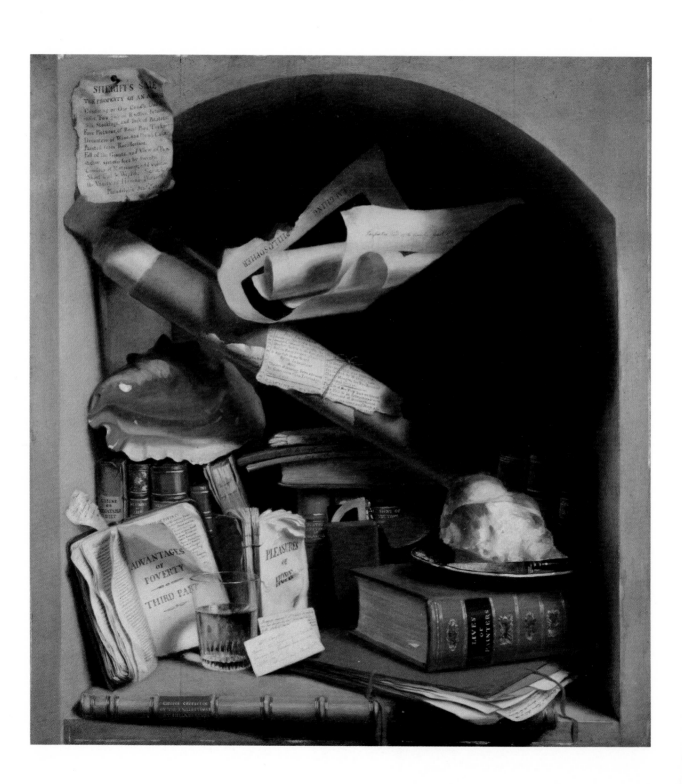

The Paintings of Charles Bird King
(1785-1862)

Andrew J. Cosentino

PUBLISHED FOR THE **NATIONAL COLLECTION OF FINE ARTS**

BY THE **SMITHSONIAN INSTITUTION PRESS**

CITY OF WASHINGTON, 1977

Published in conjunction with an exhibition at the
National Collection of Fine Arts
Smithsonian Institution
November 4, 1977-January 22, 1978

COVER: Detail from figure 102, *Landscape with Catalogue*
(*Environs of Milan, Italy*), 1828, catalog number 514.

FRONTISPIECE: *Poor Artist's Cupboard,* circa 1815, catalog number 497.

The author is a member of the faculty of the Department of Art,
Franklin and Marshall College, Lancaster, Pennsylvania.

Library of Congress Cataloging in Publication Data
Cosentino, Andrew J.
The Paintings of Charles Bird King (1785-1862)
Bibliography: p.
Supt. of Docs. no.: I 29.9/2:H19/2
1 King, Charles Bird, 1785-1862. 2 Painters—United States—Biography.
I. King, Charles Bird, 1785-1862
II. Smithsonian Institution. National Collection of Fine Arts.
III. Title
ND237.K53C67 759.13 (B) 77-608258
ISBN 0-87474-366-2

Contents

Foreword

Almost from the founding of Washington in 1793 there was talk of making it the cultural center of the United States. Once it became the political hub, artists made constant pilgrimages to the seat of power in hopes of lucrative commissions, and architects fought bitterly for the privilege of erecting its monumental structures. At some point just about everyone of importance passed through Washington – delegations from abroad, painters and sculptors bent on recording the likeness of a political notable, major writers and performers – but few stayed. Charles Bird King was a painter who settled in Washington and let the world come to him.

As an artistic personality, King is something of a puzzle since he is well known for certain outstanding specific achievements which seem to have little to do with each other. One can think of him in terms of his meticulous trompe l'oeil still lifes with their wry humor and sardonic assessment of the artist's life, or of his famous Indian portraits, painted for the most part in the 1820s in a straightforward manner with little sentiment or romantic flourish. It comes as no surprise, then, that he painted other, equally different, kinds of works. He had no commitment to a particular style or range of subjects, but quite evidently looked upon art as a serious profession that served the public and merited a just reward. As close to being the resident painter of Washington as anyone, he turned his hand to what was needed as the occasion arose, whether it meant painting the likenesses of visiting Indians for the War Department or recording the various members of the Adams family. He was a friend to visiting artists, regularly exhibiting their works in his studio, and was a respected land-owning citizen of the Capital City. Yet in spite of his associations with a wide range of people and his involvement in many projects, little is known about King as a person. This is regrettable since the key to this varied activity must reside in a very interesting man.

Many of King's works have been lost, most of the Indian portraits having been burned in a fire at the Smithsonian in 1865, and many paintings known from exhibition records cannot be traced. In looking at the surviving works, however, a few key qualities begin to emerge in spite of the varied range. Although at his best he showed himself to be an able professional painter who delighted in his medium, King seems to have been moved more by a sharp critical intellect than by a love of paint. Never carried away as was his close friend Thomas Sully by a fluent lyricism of form, he viewed his world with interest but dispassion. Sometimes, as in the empty spaces of his *Rip Van Winkle Returning from a Morning Lounge* or the *Interior of a Ropewalk,* the dispassion threatens to become a lonely burden of isolation. Like many American artists of his generation, he saw art in terms of the great tradition and clearly aspired to be a master, yet he was never accorded that role. One wonders, in fact, if because of some unadmitted personal doubt, he ever put himself to the test. His works adhere to modest goals and, although he announced himself as an historical painter, he seems not to have been a serious con-

tender for large commissions to record scenes of patriotic significance, showing remarkable reticence for a painter living in the nation's capital. When William Dunlap asked for biographical information so that he might place King properly in his *Rise and Progress of the Arts of Design in the United States,* it had finally to be supplied by King's friend Sully. Yet he sent versions of his works to the Redwood Library as a lasting record, choosing that place because it was there that he first expanded his intellectual interests. It is sadly consistent with the pattern of King's career that the library gradually disposed of most of his works.

King was readily available when an artist needed help or a patron needed advice, for he was conscious of art as a profession and gave it his loyal support. But he never lost his head over it. His mind was the constant monitor that directed the patiently contrived irony of the *Poor Artist's Cupboard* and *The Vanity of the Artist's Dream* as well as the candidly rendered detail of the over-adorned Mrs. Adams. Possibly the most emblematic painting respecting King's complex character is his view of a romantic landscape ostensibly copied from Salvator Rosa, which is brought harshly into the real world by an illusionistically painted replica of a rumpled catalog of his own paintings, seemingly glued to the surface at just the place to hide the antics of a pair of sporting lovers. Although he might wish to believe in high romance, King was a man always tagged by sober realities and, possibly to his own regret, looked without illusion on the actual world.

Possibly as serious research on the period continues, more works by King will emerge to add new facets to our knowledge of his accomplishments. His record as a distinctive character in the history of American art, however, is already established by some few paintings that will remain classics of their kind.

Joshua C. Taylor
Director, National Collection of Fine Arts

Acknowledgments

I am deeply indebted to many people for their assistance in making this study possible, and for the great pleasure of their associations. For their countless hours and efforts spent on my behalf, I am especially grateful to Joshua C. Taylor, Director, National Collection of Fine Arts, Washington, D.C., and William Truettner, Robin Bolton-Smith, Meryl Muller, Carroll S. Clark, and Kathleen Preciado, all of the National Collection; and to Donald T. Gibbs, Librarian, Richard L. Champlin, Assistant Librarian, and the staff of the Redwood Library and Athenaeum, Newport, R.I., who have continuously and unstintingly accommodated my every request over a period of six years; William I. Homer, Chairman, Department of Art History, Wayne A. Craven, advisor for my dissertation on Charles Bird King, and George B. Tatum, University of Delaware, Newark; Gladys E. Bolhouse and Samuel Ward, Newport Historical Society; Robert G. Stewart, Curator, and Mona Dearborn, Ellen G. Miles, and Monroe Fabian, National Portrait Gallery, Washington, D.C.; the late William Campbell, former Curator, American Paintings and Sculpture, National Gallery of Art, Washington, D.C.; Eugenia Calvert Holland, Maryland Historical Society, Baltimore; Mildred Steinbach and Helen Sanger, Frick Art Reference Library, New York; the staffs of the Archives of American Art, Washington, D.C., and of the manuscript collections of the Historical Society of Pennsylvania, Philadelphia, and The New-York Historical Society; Herman J. Viola, National Anthropological Archives, Smithsonian Institution, Washington, D.C., who afforded me much information, and photographs, as well; and Jack Warner, President, Gulf States Paper Corporation, Tuscaloosa, Ala. Others who helped me immeasurably are the late Gwendolen Rives, John S. H. Russell, Bayard LeRoy King, Gypsy R. Johnson, Albert M. Pitcher, Jr., and Alice D. Dibble – who graciously loaned me the journal of Elizabeth Hannah Newman – all collateral descendants of Charles Bird King's family; E. P. Richardson; Katherine McCook Knox, who did much pioneering research on King; Albert Bambino Johns; Linda Simmons; Mr. and Mrs. John R. Slidell; Anne Carter Greene; Rudolf Wunderlich, Kennedy Galleries, New York; Peter B. Rathbone, Sotheby Parke Bernet, Inc., New York; Vienna Ottobre, Jean Russo, Jeannette Yanucil, Barbara Napoleon and Frances Simla who toiled endlessly in typing for me; and, not least, my parents, Frank (deceased) and Carmela Cosentino, and John Perry Pritchett, whose help, guidance, and encouragement led me to this achievement and sustained me throughout.

A. J. C.

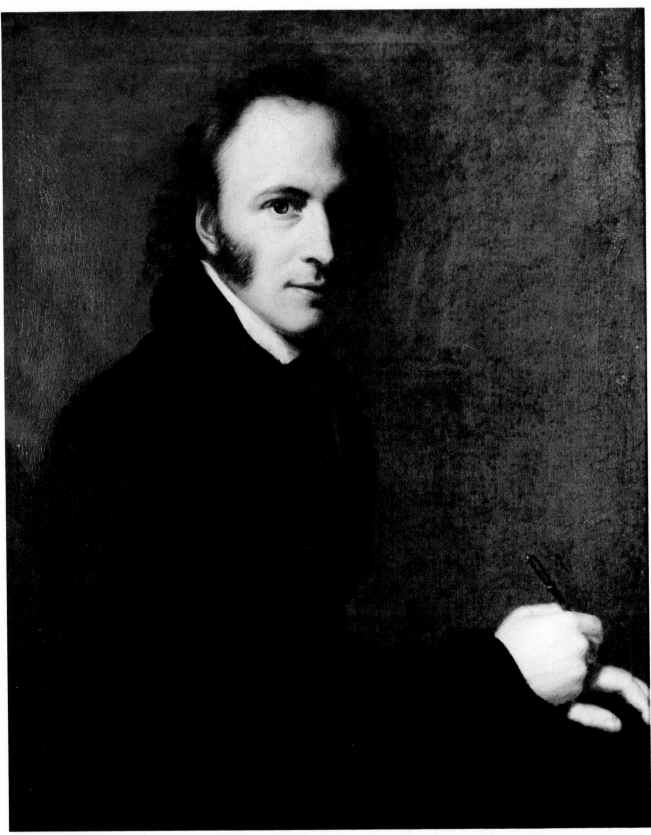

Figure 1. *Charles B. King, at the Age of 30,* 1815, catalog number 124.

Charles Bird King (1785-1862)

I Boyhood Years in Newport: 1785-1800

Charles Bird King was born September 26, 1785, in Newport, Rhode Island, the only child of Captain Zebulon and Deborah Bird King. In view of his later fame as a painter of Indian portraits, it is ironic that before King was four years old his father was killed by marauding Indians at Marietta, Ohio, where he was tilling lands awarded him for military service rendered during the revolution. Although King could hardly have known his father, the vivid description of his death must have remained with the boy throughout his life. According to an eyewitness, the captain had been shot in the chest, "once tomahawked, and then, scalped, and stripped of all his clothes except his shirt."[1]

On his father's death, King received a sizable inheritance, the first of several that later allowed him to study in London and helped to make him financially independent throughout his life – so much so as to dispel any notions of actual poverty that he conveyed in such paintings as the *Poor Artist's Cupboard*. Other legacies that he received – from his grandfather, Nathaniel Bird, and from his mother, in 1796 and 1819 – included a gun and powder flask, which the artist may have incorporated in his *Still-Life, Game,* and the attractive little house on Clarke Street in Newport that King later made into a studio-gallery.[2]

Most important in shaping the personality of the artist was the circumstance of his having been reared in the Moravian faith, the traditions of which – universal Christian brotherhood, honesty, austerity, and industry – so permeated King's being that the incursion of the more worldly views that he later absorbed served only to enhance the forthright nature and charitable goodness for which he was distinguished. George Gibbs Channing, King's childhood friend, who used to accompany him to Moravian church services and the "love-feasts" of chocolates and buns that followed, said of King, "He was, as a boy, faultless in temper and disposition. He evinced respect for the aged by graceful salutations; and to those of his own years he was endeared by joyousness and unselfishness." Thomas Sully, King's best friend of later years, said of him, "As a man, he is one of the purest in morals and principle. Steady in friendship, and tenderly affectionate . . . without professing to belong to any *particular* set of Christians, he is the best practical Christian I ever was acquainted with."[3]

Of King's formal education but little is known. Channing noted, for example, that he and King both attended one of those special schools in Newport, the renown

of which, together with the salubrity of the climate, attracted many a southern youth, including the South Carolinian Washington Allston, who was one of their classmates. A memorial piece that appeared in the local press on the occasion of King's death in 1862 suggested, in addition, that he may have studied at an academy in Pennsylvania, but there is no evidence to support this.[4]

Whatever his formal training may have been, King probably developed his love of reading and, consequently, the extensive fund of knowledge attested to frequently by his friends, through his visits to the Redwood Library and Athenaeum, a subscription library established by Abraham Redwood in 1747. The artist's lifelong benefactions to that institution give substance to the statement inscribed beneath his late self-portrait, which still hangs there: "Attributing much of his success in life to an early taste for Literature and Art, cultivated within the walls of this Library, he repaid the obligation by successive Donations to this Institution." Moreover, the library building itself, designed by Peter Harrison and built in 1748-1750, is an excellent example of Palladian classicism tastefully adapted to the colonial environment. It probably helped to inspire King's predilection for classical architecture, manifested years later in two buildings he is known to have designed.

Equally impressed upon the youthful King were the sights, sounds, and smells natural to a thriving seaport city such as Newport – as yet unspoiled by the popularity and ponderous residences which were to come after the Civil War. Time and again, recollections of these impressions appear in King's pictures: a lighthouse in the background of the self-portrait of 1858; the pungent odors of hemp and tar that one imagines filling the overwhelming cavernous space of the *Interior of a Rope-walk*; and the incredibly beautiful form and jewellike color of the conch shell in the *Poor Artist's Cupboard*.

More difficult to gauge, but surely as significant in molding King's character, was the liberal spirit that made Rhode Island, from its founding in 1636 by the religious dissident Roger Williams, a haven for religious refugees. That spirit was perhaps most brilliantly expounded by the "apostle of Unitarianism," William Ellery Channing, King's townsman and friend.

Rhode Island's liberal ethos was not, however, limited to religious tolerance. Cultural pursuits were also well supported, especially in Newport. No fewer than three outstanding examples of Peter Harrison's architectural designs and two of Richard Munday's are located there; the Redwood Library and Athenaeum was established in Newport in 1747; and, over the years, the city harbored a remarkable array of artists – John Smibert, Robert Feke, Joseph Blackburn, John Singleton Copley, and Gilbert Stuart, as well as Samuel King, Edward Greene Malbone, and Washington Allston, all three of whom encouraged King's desire to become a painter.

That King early developed a "love of art," as Channing recalled, is not surprising. In addition to the influence of the larger milieu, King was undoubtedly turned toward a career in art by his grandfather, Nathaniel Bird, with whom he and his mother probably lived from the time of Captain King's death in 1789 until Deborah's remarriage in 1796. Although Bird was a successful merchant, he was apparently also a painter of sea pieces and possibly of portraits.[5] Unfortunately, since none of his paintings has been located, the level of his skill and the influence he may have had on his grandson cannot be estimated.

In addition to the training he might have received from his grandfather, the

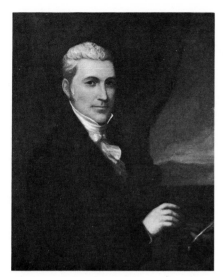

Figure 2. *Dr. David King I,* circa 1800-1805, catalog number 127.

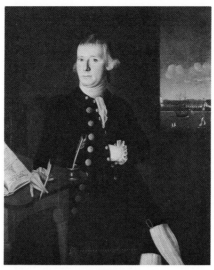

Figure 3. Samuel King, *David Moore,* 1772, oil on canvas, 47¼ x 37½ inches, (height by width). Albert Sherman, Middletown, R.I.

Figure 4. Samuel King, *Reverend Gardner Thurston,* circa 1802, oil on canvas, 27 x 23 inches (height by width). Newport Historical Society, Newport, R.I.

memorial article on King in the *Newport Daily News* of March 20, 1862, states that the artist received his "first lessons in drawing and painting . . . from Samuel King," a maker of quadrants and compasses who also painted portraits and miniatures in his spare time. Inasmuch as the two Kings (who were not related) were neighbors on Clarke Street from 1796 to 1800, there seems to be no reason to doubt this claim – especially since Samuel is known to have given some instruction to Allston also (though not to Stuart and Malbone, as tradition too generously has it).[6]

Indeed, a comparison of Charles King's earliest known picture, the portrait of his cousin, *Dr. David King I,* of about 1800-1805 (fig. 2), with Samuel King's *David Moore* of 1772 (fig. 3), reveals a similarity of conception, coloring, and pose that strongly suggests the influence of the older artist on the younger. Conversely, Samuel King's portrait of the Reverend Gardner Thurston (fig. 4) is so uncommonly powerful in its characterization that it suggests the influence or even the intervention of a more developed hand, perhaps that of Charles. By the time the *Thurston* was painted in 1802, Charles had had two years of instruction with Edward Savage in New York, and during that year he surely would have visited home because of the death of his stepfather, Nicholas Garrison.[7]

Other artists with whom King was acquainted in Newport and who may have affected his career were Washington Allston, his former classmate, and Edward Greene Malbone, a native of Newport who resided there intermittently until his premature death in 1807. Both were slightly older than King and both had begun their artistic careers earlier than he. Moreover, the two artists made a trip to England together in 1801, probably quickening King's desire to do likewise. In fact it may have been Malbone, considered America's foremost miniaturist, who initiated King's essays in that art, although Samuel King may have encouraged him as well. Because of his extensive travels to Providence, Boston, New York, and

Philadelphia, Malbone would also have been well qualified to advise his younger colleague to study elsewhere, possibly even with Edward Savage, whom Malbone may have met in Philadelphia in 1798-1799.[8] In any case, by 1800 King had begun his artistic training in earnest when he was apprenticed to Edward Savage, the well-known artist in New York City.

II *Student Years: New York (1800–1805), London (1806–1812)*

As is true of many important aspects of King's life, his years as an art student, which began when he was an adolescent of fifteen and ended when he was a man of twenty-seven, are largely obscure. Of these twelve important years, during which his philosophical and artistic ideals and his technical abilities matured, only a few biographical facts and two paintings survive.

According to Dunlap, King received his first formal instruction from Edward Savage, with whom he was apprenticed from 1800 to 1805, and whose studio in New York City the historian characterized as "half painting gallery, half museum." Although Dunlap considered Savage's art "wretched," contemporary opinion placed him on a level with Copley, West, and Trumbull.[9]

A study of Savage's art, best represented by his impressive painting, *The Washington Family* (1796), suggests that although the artist was at most a competent talent, he was a remarkably varied one. *The Washington Family* (fig. 5), one of the earliest American paintings in the English tradition of the conversation piece, reveals a sophisticated sense of composition, somewhat neoclassic in its severity, balance, and planometry; a keen eye for didactic detail, which enhances the "story"; and able characterization. All of these features are generally common to the works of Benjamin West, with whom Savage studied in London, and doubtless were conveyed by both artists to their student, Charles Bird King.

Although little else can be said of Savage's artistic influence on King, since none of the latter's work of this period is known, except, perhaps, the portrait of Dr. King, some note should be taken of the cultural milieu within which King lived and worked. To begin with, his instructor, Savage, was not only a portraitist, miniaturist, and engraver, but also a promoter of exhibitions. While in Philadelphia in the late 1790s, for example, Savage had exhibited the first panorama ever to be shown there, and in 1802, in New York, he opened the Columbian Gallery at the Pantheon, near the Battery, then the center of town. The gallery was described as a "genteel resort," where paintings and some "curiosities of nature," including a stuffed polar bear, could be enjoyed. Inasmuch as King was later to open a gallery with mixed curiosities in Washington, D.C., it is fair to assume that not a little of this entrepreneurial spirit affected him.[10]

Moreover, as fortune would have it, in early 1803 the American Academy of

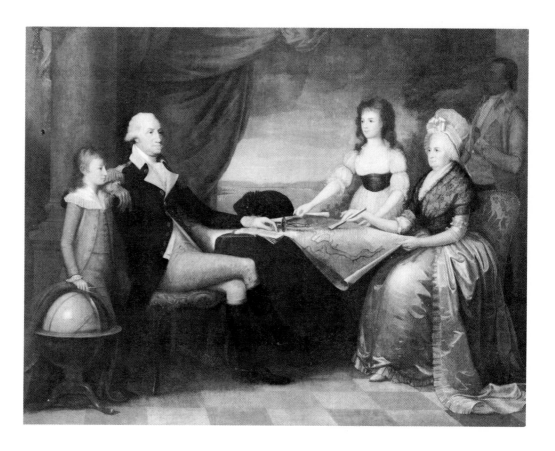

Figure 5. Edward Savage, *The Washington Family*, 1796, oil on canvas, 84 x 111¼ inches (height by width). National Gallery of Art, Washington, D.C.; Andrew W. Mellon Collection.

Fine Arts placed its newly acquired collection of casts in the rotunda of the Pantheon, next to Savage's gallery, and appointed Savage its keeper. Among the plaster casts were copies of some of the most venerated works of antiquity, then considered paradigms of beauty: the Dying Gladiator, the Capitoline Venus, the Laocoön, and the Apollo Belvedere, to name a few.[11] Since Savage's assistants probably were responsible for maintaining the collection, they would have had a rare opportunity to study the casts. These imposing works must have been a revelation to King, on whose memory their images were indelibly fixed. Years later, for example, in his haunting still life, *The Vanity of the Artist's Dream,* King painted the head of the Apollo Belvedere – a forlorn symbol of a lost ideal of beauty among a disarray of objects.

Of equal interest were the other assistants in Savage's studio while King was there. The engraver David Edwin was unquestionably the most artistically advanced, having been trained in England and Holland before coming to the United States. Through him the insights into Anglo-Dutch artistic tradition that King had gained from his grandfather Bird may have been further enlarged. John Wesley Jarvis was also employed as an engraver but soon devoted himself entirely to painting, perhaps following the example of King, whose abilities as a composer he admired. Jarvis quickly became noted as a portraitist and eccentric bon vivant, possibly influencing King to some degree in both respects. Of John Crawley, another Englishman, little can be said, except that he was the least noted of the group.[12]

Among other things that would have affected King during his five-year stay in New York City was the growing sense of cultural independence that pervaded the

young republic. Institutions such as the American Academy of Fine Arts and the New-York Historical Society were founded in 1802 and 1804, and the stately neoclassical City Hall, designed by Mangin and McComb, was begun in 1803. Wax museums, galleries, and theaters, including Dunlap's Park Theatre, abounded along Broadway, the handsome avenue just above the Battery. For 12½ cents one could see at Longworth's "Shakespeare Gallery" paintings and engravings after paintings by noted artists, including the British masters Reynolds, Opie, Northcote, and Fuseli, some of whom King was soon to meet personally.[13] Furthermore, New York was fast becoming the economic and artistic center of the country and was already attracting artists of note. In addition to Savage and his associates there were, among other artists, the Robertson brothers, Alexander and Archibald, whose Columbian Academy of painting was well known; Joseph Wood, the miniaturist; John Dixey, the sculptor; and John Vanderlyn and John Trumbull, whose long friendships with King probably began at this time.

Despite the many attractions of the city, King left New York for Newport in 1805 on the completion of his apprenticeship with Savage and, in the following year, sailed for London. Like many American artists before him, he probably felt a need for more advanced training than was available in the United States and realized from the experience of others that success as a professional artist at home often depended on study abroad. Moreover, as was related in the *Newport Daily News* memorial article of 1862, King received a "small patrimony" that allowed him to go abroad.

Although the exact date of King's departure for London is not known, he must have left, at the earliest, in June 1806 – the month during which Malbone entered into his account book that he had "Sent to London by Mr. Charles King for Ivory" – or, at the latest, in September, when he reached his majority and would have received his inheritance. On his arrival in London, according to Dunlap, King "took a room jointly in Titchfield Street" with Samuel L. Waldo, who had also just arrived. It cannot be said how long the two artists remained together, but by May 1807, King was living on Great Fitch Street, Cavendish Square, where he received a letter from Jarvis. Among other bits of news that Jarvis reported were the death of Malbone and his own exchange of King's letters with Savage, whom he described as "making money with his Musseums [*sic*] and Phantazmagorias." Jarvis also asked King to send some compositional sketches for female portraits, adding, "you have such a variety." This is the earliest recognition of King's skills as a composer, for which he became well known later.[14]

Of King's studies in London, Dunlap noted that he enjoyed the "benefit of the [Royal] Academy and the instruction of the benevolent West," who had succeeded to the presidency of the academy on the death of Reynolds in 1792.[15] That King should have been so much helped by West is not surprising, since, from the time of his arrival in England in the 1760s, West had become legendary for his liberal assistance to fellow Americans abroad. Further, it will be recalled that Savage had preceded King as West's student some twelve years earlier.

By the time that King began his studies at the Royal Academy in late 1806, the program had been extended from six to ten years. Candidates for admission were required to spend at least a year in preparation, during which they were allowed to draw in the "Plaister Academy" and from still-life models. On completing the trial period, candidates submitted a finished drawing of a plaster cast to a jury, which determined who would be accepted as students. Those so distinguished were

accorded various privileges: use of the model for drawing and painting; use of the library's books on arts and sciences, as well as its large collection of prints; criticism by the nine academicians who alternately supervised the academy's programs; admission to professorial lectures and to the annual discourse of the president of the academy; access to the academy's collection of old masters and paintings deposited by each academician on election; and, not least, the privilege of participating in the annual exhibition, an event of the realm usually opened by the patron of the academy, His Royal Highness, George III. In addition to these advantages, students were permitted to copy the old masters exhibited at the newly established British Institution. For all this students paid nothing and had only to abide by the regulations of the academy.[16]

King and Waldo must immediately have set forth on this course of study, for within little more than a year after their arrival in London both were accepted as students of the Royal Academy. According to the minutes of its Executive Council, read at a meeting held January 21, 1808, Henry Fuseli, the keeper, had "produced several Drawings from Plaisters, done in the Academy, for obtaining Tickets to become Students. And the following were admitted . . . C. B. King . . . Sam L. Waldo. . . ." and twenty-three others. Council members present at this review, in addition to Fuseli, were Benjamin West, Sir William Beechey, James Northcote, William Owen, and Henry Tresham.[17]

For some inexplicable reason, perhaps merely through an oversight, King's name does not appear in the official register of students admitted to the academy's schools on January 21, 1808, although those of the twenty-four others admitted with him are all inscribed. Equally strange is the fact that whereas Waldo participated in the academy's exhibition of 1808, King did not, nor did he contribute to subsequent exhibitions of the academy or of the British Institution, despite the fact that his compatriots, Allston, Leslie, Morse, Sully, and Trumbull, frequently exhibited.[18] Thus, except for the few lost pictures mentioned in the writings of Sully and John Neal, the works King may have produced while at the academy are not known. Something of their quality, however, may be surmised through a study of the only picture from his English period that is extant.

The *Still-Life, Game* (fig. 6), King's first known still life and his earliest signed painting, is inscribed "CB King 1806." Because of its date, one might argue that the picture was painted before King left home. Yet, from what is known of the artist's early training and to judge by the quality of the work, this seems unlikely. Indeed, although the background space is not integrated into the rest of the picture, the superbly rendered textures of the various fowl, the marble table, and the metal pieces, as well as the rich color and powerfully realized highlights, reflect a level of training hardly possible in the United States. Further, the distinctly Dutch character of the painting suggests the inspiration of authentic models, such as Willem van Aelst's *Dead Birds with Implements of the Chase* (fig. 7), which were plentiful in England because of the enduring popularity there of seventeenth-century Dutch art. As the *Still-Life, Game* and later pictures show, Dutch painting had an equally enduring and pervasive influence on King's art.

Several features seen in the *Still-Life, Game* were to become hallmarks of King's style. In addition to characteristics already noted – the fascination with textures, the use of strong highlights and handsome colors – there is visible the artist's tendency to crowd objects toward the picture plane in the manner of Dutch trompe l'oeil painting. This gives the objects, which are sharply defined against an ambig-

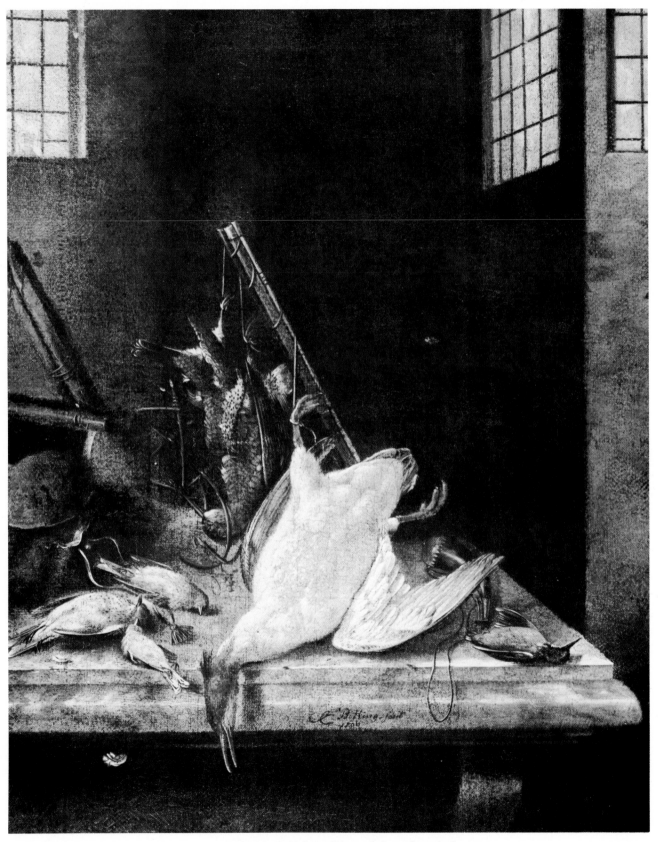

Figure 6. *Still-Life, Game,* 1806, catalog number 500.

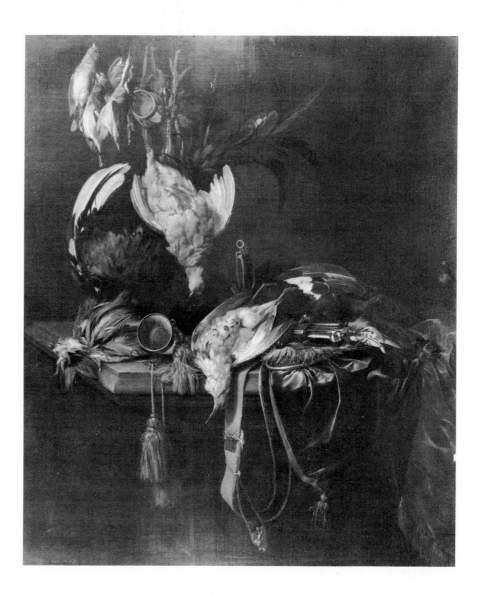

Figure 7. Willem van Aelst, *Dead Birds with Implements of the Chase,* 1657, oil on canvas, 41½ x 35½ inches (height by width). The Queen's Gallery, London.

uous background, an obsessive quality that strongly suggests they may have been selected and arranged, as in both Dutch and English traditions, with some symbolic intent in mind. The fowl, for example, may represent King's maternal family name, Bird. Moreover, it is possible that the gun and powder flask are emblematic of King's grandfather Bird, from whom he had inherited similar items. Thus, one could easily be led by the nature of the objects and their persuasive presence to speculate that the still life was conceived by King as an homage to the grandfather who had initiated his artistic career.

Late in 1808, Samuel Waldo left for home. He had married in April, and it was probably then that King moved to 8 Buckingham Place, Fitzroy Square, a boarding-house run by the "widow Bridgen" that was to become famous for the many noted American artists who lived there. Waldo's departure was balanced, as it were, by the return to England in 1808 of John Trumbull, who was to remain in London during the rest of King's residence there. Although only one instance of any contact

between King and Trumbull can be documented, their continuing friendship after they had returned to the United States suggests they may have communicated frequently while still in London.[19]

Insofar as King was concerned, the most significant event known to have occurred in 1809 was the arrival in London on July 18 of Thomas Sully, who immediately delivered a letter of introduction to King. Dunlap noted that the two artists developed "an immediate reciprocity of feeling," and related the following anecdote of their first exchange:

King had been some years studying in London, and could appreciate Sully's inexperience. "How long do you intend staying in England?" "Three years, if I can." "And how much money have you brought with you?" "Four hundred dollars." "Why my good sir, that is not enough for three months – I'll tell you what – I am not ready to go home – my funds are almost expended, and before I saw you I had been contriving a plan to spin them out, and give me more time. Can you live low?" "All I want is bread and water." "Oh, then you may live luxuriously, for we will add potatoes and milk to it. It will do! we will hire these rooms, they will serve us both – we will buy a stock of potatoes – take in bread and milk daily – keep our landlady in good humor, and (by the bye) conceal from her the motive for our mode of life by a little present now and then, and – work away like merry fellows."[20]

Neither artist could have known that this meeting marked the beginning of an intimate friendship that would continue throughout their lives.

During Sully's eight months in London, he and King shared not only a bedroom and painting room at Buckingham Place, but also their knowledge, skills, aspirations, and many invaluable experiences, which Sully, fortunately, often noted in his journal. Even a cursory review of their activities makes it clear that Sully was not exaggerating when he said of King years later: "I found him, as a fellow student, the most industrious person I ever met with. He limited his hours of sleep to four – was jealous of the least loss of time – his meals were dispatched in haste, even then . . . he read some instructive book." For example, in addition to painting regularly during the day and in the evening attending the academy's drawing school or an occasional lecture, such as those given by Fuseli on painting, the two artists managed to visit art collections, artists, and friends as well.[21]

Among the collections they saw, the most notable were those of the Royal Academy, which included paintings by Reynolds, Gainsborough, Fuseli, Stubbs, West, and Lawrence, among others, and those of J. J. Angerstein, whose series *Marriage à la Mode,* by Hogarth, most attracted Sully, despite the presence of many old masters. Artists whom they called upon included Sir Thomas Lawrence, Sir William Beechey, Sir Martin Archer Shee, and the gouty John Hoppner, who upon being asked by Sully what sort of yellow he used in flesh tones replied snappily, "There is no yellow in flesh, sir."[22]

Most significant to both Sully and King was the assistance given by Benjamin West, who on one occasion advised Sully to study osteology. Perhaps it was at West's suggestion, too, that King and Sully hired Sam, the porter of the academy, to model for them at their rooms. In addition to the guidance he offered them, West also allowed the two artists to borrow and copy his own paintings, including *Pylades and Orestes* and *Telemachus and Calypso* (fig. 8). Sully also copied two Holy Family groups by Correggio and Raphael that West owned, and a *Holy Family* by Reynolds, taken in oil from a print belonging to King. Of Reynolds's work, King copied two portraits, *John Hunter,* from the original, and *Lord Crue,*

Figure 8. Benjamin West, *Telemachus and Calypso,* oil on canvas, 41¼ x 58⅝ inches (height by width). Corcoran Gallery of Art, Washington, D.C.; gift of Bernice West Beyers, 1963.

probably from a print he owned. King's prints suggest that what was to become an extensive collection (now in the Redwood Library), was begun early in his career. That King could collect prints while in London and also send a gift of ten expensive volumes to the Redwood Library belies the role of poverty he adopted. Moreover, the titles of some of the books King sent home – Adams's *Roman Antiquities* and Volney's *Travels,* for example – indicate his growing interest in themes favored by the Romantics: the passage of time and distant and exotic cultures.[23]

Despite their busy schedule, King managed to introduce Sully to some of his English friends, among whom was the Mitchel family. On his return to England in 1837, Sully visited the Mitchels and they talked much of King, whom, Sully noted, they "sincerely love." As reminders of King, the Mitchels had his portraits of Mr. Mitchel, their son Stuart, and a self-portrait that he had given them. The latter they had placed in the bedroom of their daughter, Ann, whom King used to call his "little wife."[24]

Inasmuch as the two artists had lived and worked together for some eight months, Sully's departure for home in March 1810 must have been a sad occasion for King. Although they undoubtedly corresponded regularly, all that remains is a reference made in a letter of August 25, 1810, written to Sully by Trumbull, thanking the former for some documents that had been delivered to him by King.[25]

Two other letters from 1811 indicate that King had become increasingly well known in the London art community and that he often played (apparently with relish) the role of an intermediary on behalf of some of its members. On January 5, Sir William Beechey wrote to Sully, "I sometimes see your friend, who was very well the other day," and on July 11, Sir David Wilkie wrote to King, recalling their meeting at Lord Stafford's Gallery and King's offer to assist him in getting a letter to the United States.[26]

The Wilkie letter is of particular importance in that it establishes a direct link between the two artists, which may help to explain the profound influence of

Wilkie's art on King. In the light of King's penchant for Dutch art, it is significant that the inspiration for Wilkie's early pictures was also seventeeth-century Dutch and Flemish painting.[27]

Wilkie and King had other interests in common in addition to Dutch art. Both were born in 1785, and each had left his native land (Wilkie in 1805 and King in 1806) to study in London. Both were formal in their demeanor but modest, "determined," as Wilkie said of himself and as others said of King, "to be very industrious, for I knew I had no genius." Both were endowed with a generous if dry sense of humor, and finally, both were to remain bachelors. In two important ways, however, the careers and lives of these two artists differed markedly. Wilkie's style of painting changed radically after a trip he made in 1825 to Spain, where the somber, painterly works of Goya deeply impressed him. In contrast, King's style remained basically the same throughout his career. Moreover, Wilkie died an early – one might say romantic – death at sea in 1841 while returning from a journey to the Holy Land, whereas King lived placidly into his seventies.[28]

Despite the strained relations that existed between the United States and Great Britain, there arrived in London in 1811 three American artists, Washington Allston, Samuel F. B. Morse, and Charles Robert Leslie, who soon joined with King and some of his English artist friends in a convivial fraternity. Although King probably knew Allston from their Newport days, he did not know Morse, who accompanied Allston and his wife to England, or Leslie, who presented himself to King with a letter from Sully. Fortunately, Morse and Leslie wrote lengthy letters home, and only through these is anything known of King's activities after Sully left London.

Morse, for example, wrote to his parents of experiences undoubtedly shared by all the friends: of the "annoying cries of London," so well depicted in Hogarth's picture of the enraged musician; of an extraordinary balloon ascension witnessed at Hackney by hundreds of people, among whom a "gang of pickpockets" worked their skills; and of the "splendor" of evenings at Vauxhall Gardens with its Turkish and Scottish bands and "fireworks, sky-rockets, serpents, wheels, and fountains of fire in the greatest abundance." Leslie's comments, usually made in letters to his sister in Philadelphia, are especially personal and perceptive. Early on he referred to King and Allston as "our mentors," describing them as follows: "Allston, a most amiable and polished gentleman, and a painter of the purest taste; and King, warmhearted, sincere, sensible, prudent, and the strictest of economists." The distinction Leslie made between the two artists is instructive. References also abound in Leslie's letters to evenings spent at the theater and at frequent "evening parties composed of . . . two English gentlemen, Allston, King, Morse, and myself." Indeed, even the usually reticent King was moved to recall the pleasures of his London days. In a letter written in January 1813, some six months after he had left England, he mentioned the happy evenings with "novels, coffee, and *music by Morse,* with the conversation of that dear fellow Allston."[29]

It is also through Leslie's letters that one learns something of King's departure from England in late 1812, which probably resulted as much from the outbreak of hostilities between England and the United States in June as from the extended length of time the artist had spent abroad. Although the exact date of King's departure is not known, he must have left after May 12, the date on which Leslie wrote to his sister about the evening parties, and before August 6, the date on which Leslie wrote to his sister the following interesting remarks:

Bye the bye, we shall not now be able to hear of King's arrival very soon. If he delivers the letter I gave him to mother, I hope you will all show him a good deal of attention, as he was a very great friend to me here. I am sure you will like him, for he is very agreeable, has read a good deal, and, from the opportunities I have had of judging, I think he has an excellent heart as well as head. He will be able to give you a good account of me, of the manner in which I live & c. There is one quality that I found in King which pleased me much, because it is a scarce one, *he does not flatter*.[30]

On King's departure from England, Leslie and Morse, probably at King's suggestion, immediately occupied his rooms at Buckingham Place, where they were eventually joined by Allston. Morse remained at this location until 1815, at which time he returned home, but Leslie, the only one of the Americans to remain permanently in England, stayed until 1824, the year of his marriage. Other artists who later lived at Buckingham Place included the Americans Robert M. Sully (the nephew of Thomas Sully), James Bowman, Thomas J. Natt, and George Peter Alexander Healy, and the famous English animalier, Sir Charles Landseer. Thus, contrary to what has often been written, it was King who established the tradition of American artists lodging at the widow Bridgen's and it must also have been he who began the practice of leaving paintings with the landlady, perhaps those "little" presents he had suggested that he and Sully give occasionally to "keep our landlady in good humor."[31]

Because of the famous artists who had lived there and the paintings they had left behind, the house in Buckingham Place became something of a mecca in subsequent years for visiting Americans. John Neal, the novelist and often-times harsh critic of American art and literature, visited there in 1824 and recorded his experience in an article he wrote in 1829 for *The Yankee*. The ensuing dialogue from the article is part of a lengthy "chat" he had had with Mrs. Bridgen, who had housed painters for over twenty years because, as she declared, she was fond of them and found them so "innocent":

King live with her four years, nine months of which he slept on the floor. On the floor? said I, – Yes, and I'll tell you why, said she. . . . He had a good bed made up for him every day; but every night, instead of going into it like a Christian, he used to strip off the clothes, wrap himself up in them, and throw himself down with his whole length on the floor, that he might have it to say that he slept on a board, and lived on potatoes while pursuing his studies. . . . But, continued the old lady . . . at last we persuaded him, as the cold weather came on, to sleep in a bed like other folks.[32]

Whether or not this anecdote is apocryphal, it is nevertheless consistent with the artist's Spartan character and romantic, sometimes eccentric behavior. As Neal himself said, "It was so like my friend King."

Among the pictures Neal saw at Buckingham Place, mostly products of youthful fancy, were Morse's portrait of the eighteen-year-old Leslie in "fancy dress" and two of Leslie's pictures, which he considered the "oddest and queerest things" but in which he saw the "fine, quiet, peculiar nature" of the artist. One of these was a humorous scene of a boy seated in a chair and imitating "grandma" with her shawl and ostrich-feathered bonnet "à la Leslie." The latter picture, Neal asserted, was the source of inspiration for similar works by several European artists, as well as for King's *Grandfather's Hobby*. Other pictures there that he discussed with Mrs. Bridgen were by Sully and Allston.[33]

Of the two pictures by King at Buckingham Place, Neal made some penetrating observations:

There was one of Lear and Cordelia – judging by the old man's look, and the youthful beauty of the female. It was a very good picture, all things considered, strong and graceful, and better in idea than anything of his I have lately seen. There was another, a boy stealing fruit from his sister, whom he was amusing with a soap-bubble, which he was holding over the plate with one hand, while he drew away the fruit with the other. It was a good idea . . . and fortunately expressed. Were I to see such pictures now, by a youth, badly coloured and badly painted as they were, I should think that he promised more, much more than either West or Leslie.[34]

Although much of Neal's commentary on art was polemical, his insights were often valuable. In respect to King, his recognition of the artist's genius for composing and expressing the "idea" of a picture – in other words, his perception of King as an intellectual painter – was fundamentally sound.

The paintings that King is known to have completed while in London amply illustrate the depth and breadth of knowledge and skill he had attained. Assuming that he had gone to London with a limited experience in painting portraits, the deft touch and keen perception of textures exhibited in his *Still-Life, Game* are remarkable. Apparently it was these qualities, plus ingenious composition and an appropriate sense of sentiment, that Neal found so "fortunately expressed" in the picture of the boy stealing fruit and that engendered the "pleasure" Dunlap felt on seeing the picture of girls and a cat that King brought with him on his return from London. Moreover, to judge from their descriptions, these two works mark King as one of the earliest of American artists to be interested in genre painting, especially of the type that conveys a moral.

In his copies of West's classicizing *Telemachus* and *Pylades and Orestes,* King also tested his abilities as a history painter, the ultimate goal of most artists of the day, and in the *Lear and Cordelia,* he explored West's essays in Romantic expression, although he rarely used such furious moods in his own work. Through his copies after Reynolds, Van Dyck, and others, King not only enlarged his understanding of painting but rooted himself deeply in the traditions of Western art. In short, although King no doubt returned home "from one of the most dangerous cities in the world, with unsullied morals" – as Allston assured the Reverend Jedidiah Morse that his son Samuel had done[35] – he returned, nonetheless, a worldly artist, well suited to present himself as a "Historical and Portrait Painter."

III *The Wandering Limner: 1812–1819*

Of King's activities after returning to the United States, Dunlap noted that "Mr. King returned from England in 1812. . . . He set up his easel in Philadelphia, but did not succeed to his wish, and removed to Washington City in the year 1816."[36] While generally correct in his observations, Dunlap neglected to mention that after King left Philadelphia he went briefly to Richmond, spent several years in Baltimore, and often visited Washington, where he settled permanently only in 1819. Thus, for some seven years King was an itinerant artist.

King's first stop on arriving home was Newport, where he presented twenty-

seven volumes of books, presumably purchased in London, to the Redwood Library. Accompanying the gift was a letter dated October 13, 1812, in which King addressed the directors of the library with an obvious touch of British noblesse oblige: "Had my Fortune been equal to my wishes for your success, it [the gift] should not have been so small." Leslie's observation that King "had read a good deal" is given substance by the diversity of titles included in this gift, that of 1810, and the many books he was subsequently to give to the library.[37]

Despite the presence in Newport of his mother, grandmother, and many cousins, it is not surprising that King soon left for Philadelphia. After his experiences in London, Newport must have seemed pitifully provincial, while Philadelphia, by contrast, was the leading city of the United States and, equally important, the home of Thomas Sully.

The first indication that King had moved to Philadelphia occurs in a letter he wrote from that city on January 3, 1813, to Leslie and Morse in London. The letter affords a rare glimpse into King's Romantic sensibility, which had been nurtured abroad, but which the practical realities of life at home generally repressed. In recalling their "delightful time" together in London, King added, rather melodramatically, "The reflection that it will not again take place, comes across my mind accompanied with the same painful sensation as the thought that I must die." Leslie's correspondence also confirms King's presence in the Quaker City. Writing to his sister there, on February 25, 1813, he said, "I rejoice to hear you like King so well, and I sincerely hope he will get business in Philadelphia." He went on to make a reasonably fair – and the earliest known – evaluation of King's manner of painting:

I think his close intimacy with Sully will be of very great advantage to him. You will perceive that King's greatest excellence is his colouring of flesh. His drawing is very correct, and his heads are generally very like; but they have not always a happiness of expression, and his attitudes generally want ease. Now in these two points Sully is very excellent, and as they are not to be imparted by rules, King will be more likely to acquire a feeling for them by having pictures that possess them constantly before him than he would by any other means. He is also deficient in the management of draperies which Sully paints very beautifully.[38]

Among the artists then in Philadelphia, and with whom King no doubt became acquainted since they all had been made academicians of the Pennsylvania Academy of the Fine Arts, were Charles, James, Raphaelle, and Rembrandt Peale; Thomas Birch; and Benjamin Trott.[39] King probably also met Bass Otis, and certainly reestablished the acquaintance he had made in New York with David Edwin, the engraver, and Joseph Wood, the former partner of Jarvis's. From Wood he may have learned of the enviable commission Jarvis received in 1813 to paint for New York's elegant new City Hall several large, full-length portraits of heroes of the ongoing War of 1812.

Unfortunately, King seems not to have been so lucky, as only two portraits can be attributed to this period. This apparent lack of commissions is underscored by the nature of his entries in the Pennsylvania Academy's exhibition of 1813, held annually in July. All four works he submitted were painted in England and included copies after West's *Telemachus,* Reynolds's *Lord Crue in the Character of Henry VIII,* and Van Dyck's *Earl of Warwick*; the only original work was a genre piece entitled *Children and Bubble,* which carried the witty couplet: "Philosophers like children sometimes choose/to chase the bubble and the substance lose."[40]

The unnamed art critic who reviewed the show for the *Port Folio* magazine described the *Telemachus* as possessing "much merit" and the *Lord Crue* as a "charming little picture." His most extensive comments were reserved, however, for King's *Children and Bubble*.

This picture is entitled to much praise. The subject is fanciful and executed with considerable judgment; there are some parts, especially the cat on the table looking up at the bubble, that attracted our attention; we are, however, inclined to believe that the artist has laboured more on this picture than was necessary, particularly the colouring.[41]

On the whole, the critic's remarks seem balanced enough, and accord well with what is known of the artist's abilities at the time. Nonetheless, King must have taken exception to even such generally favorable comments, perhaps feeling they were as meager as the few commissions he had received. His dissatisfaction with Philadelphia critics and patrons was later to be vented in the powerful *Poor Artist's Cupboard*, probably painted in 1815. In the center of the picture he depicted a newspaper on which he meticulously printed the following notices:

Just Published Proofs that Philadelphia is the most Beautiful, the most Hospitable, the Greatest Patron of the Fine Arts, And in Every Respect Superior to any City in the World. By an Inhabitant. Also The Art of Painting better advanced by Criticism than Patronage./ The Beautiful Estate Prospect Hill was yesterday purchased by Mr. Penny, late Cheese Monger, for Two Hundred Thousand Dollars./ The City of New York has ordered their Hall to be Ornamented with the Portraits of Distinguished [o]fficers of the Army and Navy. Also – .

Notwithstanding the wry wit evident in the inscriptions, King was clearly piqued by the lack of patronage accorded by Americans to artists and all forms of painting except portraiture, and by their crass materialism, which he felt retarded the country's cultural development. Although Philadelphia bore the brunt of the criticism, the city and its "Athenians," as John Neal sarcastically called them,[42] serve as symbols of the larger problem in America. King's displeasure with Philadelphia had some basis in fact and was not merely a case of personal indignation. For lack of patronage, Sully often considered leaving the city and Rembrandt Peale did leave for many years.

Sometime between the Pennsylvania Academy's exhibitions of July 1813 and July 1814, King left Philadelphia. The catalog for the 1814 show listed a single entry by him, the copy after West's *Pylades and Orestes,* and gave his address as Richmond, Virginia. King's presence in the latter city may possibly be corroborated by two bits of evidence: a small portrait of the wealthy Richmond merchant Mann Valentine may have been painted by King in 1814; and it was possibly in 1814 that the Richmond painter James Warrell acquired the painting by King that he later raffled off, along with one by Sully, to go abroad.[43] King could not, however, have remained in Richmond very long, for by year's end he was in Washington, D.C.

King's first visit to the capital is recorded in a letter written on December 24, 1814, by William Hunter, the senator from Rhode Island, to his wife. "I went last Wednesday night . . . to the [White House] Drawing Room for the purpose of introducing Charles King the Painter [to President and Mrs. Madison]." Hunter also noted that King was currently painting the portrait of a fellow Rhode Islander named Reed.[44] It was probably at that time that King painted Hunter's portrait, as well as the probing character study of Joseph Anderson, the first comptroller of the United States Treasury.

Undoubtedly the termination of the congressional session in early spring of 1815,

and possibly the uncertainty of the capital's future after its devastation by the British in August 1814, influenced King's departure from Washington for Philadelphia, which he perhaps visited enroute to Newport, where he often spent his summers. In Philadelphia he must have visited Sully, but his primary business seems to have been with Joseph Delaplaine, a publisher-bookseller turned art dealer, whom he probably knew from his earlier years in the city.[45]

Possibly as early as 1812, Delaplaine had established a portrait gallery of "distinguished" Americans, for which he had commissioned paintings by artists in Philadelphia, New York, Boston, Baltimore, and Washington. He had also begun a serial publication entitled *Delaplaine's Repository of the Portraits and Lives of the Heroes, Philosophers, and Statesmen of America,* of which only three parts were published between 1814 and 1816. Each part consisted of six brief biographies accompanied by engravings of the subjects, "correct and striking likenesses," most of which were based on the portraits he had commissioned. It must have been to discuss some arrangement for participation in this project that King met with Delaplaine in the summer of 1815; by December of that year, King was already settled in Baltimore, where he painted the first of a sizable number of portraits for Delaplaine. He was to remain in Baltimore for three years, until late 1818.[46]

In addition to the likelihood of his receiving portrait commissions from Delaplaine, King may also have been attracted to Baltimore by the presence nearby of some of his Newport cousins, Mrs. Elizabeth Hannah Newman in particular.[47] Then, too, Baltimore's size and situation was similar to Newport's, and not to be overlooked was the fact that the citizens of the city had embarked on an ambitious program to commemorate in monumental art their experiences in the Revolutionary War and in the War of 1812. Moreover, while each of the major cities of the eastern coast had several outstanding resident artists – Sully and the Peales in Philadelphia; Jarvis and Waldo in New York; and Stuart, Savage, and Morse in Boston – Baltimore had only Rembrandt Peale, who was often occupied by the museum he had opened there in 1814.

During his several years in Baltimore, interrupted occasionally by trips to Newport and Washington, King painted some of his finest pictures, of which four are especially noteworthy. His self-portrait (see fig. 1), although clearly in the manner of West's *Self-Portrait* of about 1771 (fig. 9), is singularly direct and simple in design, yet forceful in conveying, through the heightened contrasts, the Romantic mood of the subject: a keen and kindly observer of human nature, not without a a touch of mischief in his glance. Since the picture depicts the artist at the age of thirty, it must have been painted during or after September 1815, probably soon after King arrived in Baltimore. Perhaps because of the dearth of earlier works by King, the strength of his self-portrait, with its subtle brushwork and powerful chiaroscuro, comes as something of a surprise, despite the fact that this quality is foreshadowed in his *Still-Life, Game* of 1806. Nor does either of these works, despite their high quality, fully prepare one for the extraordinary achievement of King's *Poor Artist's Cupboard.*

The *Poor Artist's Cupboard* (fig. 10) is one of King's most imaginative and skillfully executed works, as well as being unusually explicit in its message. Although criticism of America's cultural immaturity abounded in parlors and in the press, never, it appears, had an American artist utilized a painting as a literal and symbolic manifesto to denounce philistinism in American society. Apparently the theme

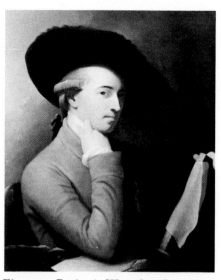

Figure 9. Benjamin West, *Self-Portrait,* circa 1771, oil on canvas, 30¼ x 25⅝ inches (height by width). National Gallery of Art, Washington, D.C.; Andrew W. Mellon Collection.

of the *Poor Artist's Cupboard* so intrigued King that he returned to it again in 1830 in his *The Vanity of the Artist's Dream*.

In the *Poor Artist's Cupboard*, King's penchant for illusion, for the didactic, and for the witty and sardonic, only intimated in earlier works, reached its maturity. Drawing once again on the seventeenth-century Dutch tradition, specifically on that of the university town of Leiden where the *niche* painting and the *vanitas* were most fully exploited for moralizing purposes, as in Cornelis Gysbrechts's *Vanitas* (fig. 11), King created a picture at once intellectual in content and effectively artistic in technique and design. Indeed, as in the Dutch tradition, the objects in the painting operate on several levels simultaneously, conveying their message with equal force throughout.

For example, apart from the explicit rebukes in the *Poor Artist's Cupboard*, the images of poverty that overburden the picture – the torn books, the stale morsel of bread, and the sheriff's sale sign – reflect on the deplorable condition of the artist. However, contrary to what is generally supposed, King was not poor, so he must not have been commenting on his own financial condition, but rather on the state of poverty among artists generally, and their neglect by the American public.

On quite a different symbolic level the objects may represent the five senses, as was often the practice in Dutch and French painting of the seventeenth through the nineteenth centuries, about which King was certainly knowledgeable. The books, for instance, may represent the power of sight, the conch shell of hearing, the water and bread of taste and of smell, and the beaver hat of touch. On a more abstract allegorical level, the picture dramatizes the eternal struggle of the creator and the creative life in a world of material concerns, an idea effectively conveyed by the tattered books, which traditionally represent the destruction of culture,[48] and their ironic titles: the *Advantages of Poverty* and the *Pleasures of Hope*. Thus, rather than a depiction of the material poverty of an artist, the *Poor Artist's Cupboard* should be read as a brilliant metaphor of cultural poverty.

Regarding the date of the work, the rolled drawing at the top center of the picture, entitled "Perspective View of the County Gaol of Philadelphia 1814," indicates that the *Poor Artist's Cupboard* was painted no earlier than 1814. That it was painted in late 1815 or early 1816, while King was in Baltimore, seems to be a justifiable assumption. This is most convincingly supported by the style of the painting: its powerful chiaroscuro and its exquisitely sensuous color and texture, as in the conch shell, the books, and the glass of water, correspond well with King's self-portrait of 1815. Moreover, the very nature of the subject suggests a settled condition wherein objects could be carefully arranged and painted over an extended period of time. Since King is known to have been on the move after he left Philadelphia in late 1813 or early 1814, it seems logical to assume that he painted the *Poor Artist's Cupboard* after he established himself in Baltimore in late 1815.

Of the four major canvases that King painted in Baltimore, his *William Pinkney* (fig. 12) may have been of particular importance to the artist's reputation, since Pinkney was a man of national stature, an outstanding lawyer whom Chief Justice Marshall called "the greatest man I ever saw in a Court of Justice." The portrait was undoubtedly painted before April 1816, when Pinkney was appointed Minister to Russia. That it was an excellent likeness and a good psychological study is suggested by a description of Pinkney that bears some remarkable parallels to the painting:

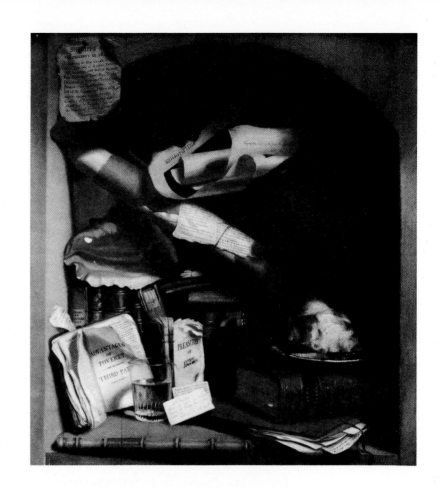

Figure 10. *Poor Artist's Cupboard,* circa 1815, catalog number 497.

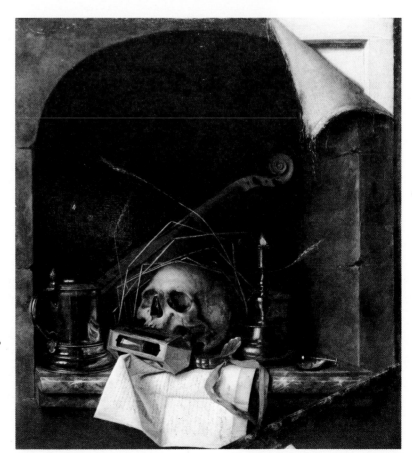

Figure 11. Cornelis Gysbrechts, *Vanitas,* circa 1666, oil on canvas, 33½ x 31 inches (height by width). Museum of Fine Arts, Boston, Mass.; Abbott Lawrence Fund, 1958.

Figure 12. *William Pinkney,* 1815-1816, catalog number 194.

Conspicuous in Pinkney's physical appearance were his square shoulders, erect carriage, and intense blue eyes, but most conspicuous were the deep furrows in his face and the heavy circles under his eyes, and to conceal them he used cosmetics. He wore corsets to diminish his bulk. Despite apparent robust health, he was a hypochondriac. In society he was haughty and reserved. He had little sense of humor.[49]

In the supple line of the pose and in the soft modeling of the contours, achieved through small, vigorous brushstrokes somewhat in the manner of Gainsborough, there is an echo of the rococo style still lingering in England while King was there – at which time (1806-1811) it might be added, Pinkney was also in London, serving the United States in a ministerial capacity. King must have found the pose congenial as he used it several times later, as in the 1825 portrait of the Indian boy *Mistipee* (fig. 13).

The last of the four major pictures that King painted before leaving Baltimore briefly in late 1816 is the portrait of General John Stricker (fig. 14), commander of the city's forces at North Point during the War of 1812. According to an inscription on the back of the original canvas, King painted the picture in 1816. Perhaps he painted it in late April or early May, the period during which Rembrandt Peale must have begun his own portrait of General Stricker (fig. 15), which, with several other portraits of the city's heroes, was commissioned by the city council in February 1816.[50]

King and Peale may have worked together on their portraits, most logically in Peale's commodious painting rooms in his museum, inasmuch as the attire of General Stricker is almost identical in the two pictures, the poses are complementary, and the form of the portraits is similar. Such vigorous solidity as they display was natural for Peale, nurtured as he was in the school of David, but not for King, who was steeped in the English tradition of softer, more harmonious modeling. The extent of Peale's influence on King, in this instance, becomes clear when one compares King's portrait of General Stricker with his earlier portrait of William Pinkney and his later of Henry Clay (see fig. 29). To be sure, both of the Stricker portraits conform to the ideals of the period, as does the Jarvis portrait of General Brown (fig. 16),[51] all of which envisioned military personalities as vigorous leaders – unlike persons engaged in elegant pursuits such as law, whose gentlemanly aspects are well exemplified by the Pinkney portrait.

There are other features in King's portrait of General Stricker that have been characterized as hallmarks of his style. Most notable are the constriction of the pictorial space toward the foreground plane and the intensely realistic details of the picture, which combine to create those illusionistic effects toward which King seemed to be instinctively inclined. The use of emblems, too – in the uniform and epaulets signifying rank, in the Order of the Cincinnati on the chest of the citizen-defender, and in the sword of the defender – although inherited from sixteenth-century theorists such as Lomazzo,[52] is typically carried to its logical didactic conclusion by King, who posed the general pointing to a map of the area of the battle of North Point.

On November 22, 1816, Hannah Bird, King's aged grandmother, died in Newport. A painting given by the artist to the Redwood Library and acknowledged by its directors in January 1817[53] indicates that he was in Newport at the time of his grandmother's death, or at least for her burial. King could not have remained in Newport long, however, since by late 1816 or early 1817 he was in Washington

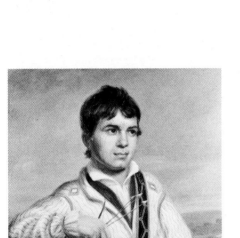

Figure 13. *Mistipee,* 1825, catalog number 372.

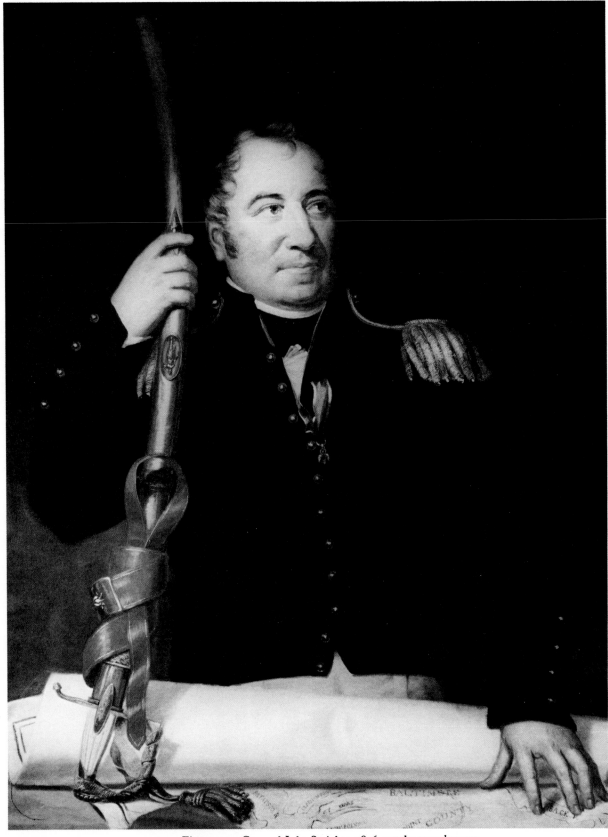

Figure 14. *General John Stricker,* 1816, catalog number 249.

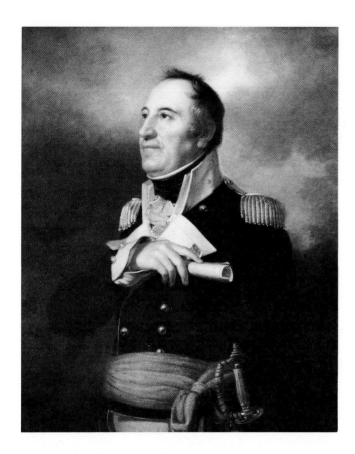

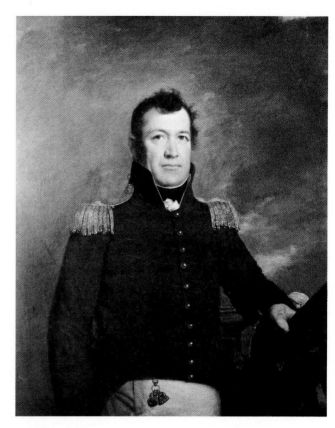

Figure 15. Rembrandt Peale, *General John Stricker*, 1816, oil on canvas, 36 x 31 inches (height by width). The Peale Museum, Baltimore, Md.

Figure 16. John Wesley Jarvis, *General Jacob Jennings Brown*, 1815, oil on canvas, 42½ x 35 inches (height by width). Corcoran Gallery of Art, Washington, D.C.; purchase and gift of Orme Wilson, 1958.

painting the portraits of two nationally famous men: Daniel Webster (fig. 17) and President James Monroe (fig. 18).

Both the Webster and Monroe portraits are estimable artistic achievements. Of the two, the *Daniel Webster* is a simpler, more direct design, one in which the artist's primary concern was to capture the force of the sitter's personality. This he did well, as may be verified by comparing his portrait with the many other likenesses of Webster rendered by some of the outstanding artists of the time, including Stuart, Powers, and Harding. Although Webster had not yet fully attained his great fame as orator and eloquent spokesman for New England's interests, he is represented by King with remarkable insight as a man of unusual determination. His firm jaw and deep-set, intense eyes befit the man whom legend describes as talking down the Devil himself. Even Charles Francis Adams, the haughty son of John Quincy Adams, was led to remark that the portrait "is one of his best likenesses. . . . The eyebrows and expression of the eyes is very admirably copied."[54]

In contrast to the Webster portrait, that of President Monroe required that the artist work within a more complex tradition of state or official portraiture in which the dignity of office and its representation through visual emblems had to be balanced against character reading. The task was complicated by the fact that Monroe was the head of a democratic state in which the trappings of public office, even the highest in the country, were hardly distinguishable from those of ordinary citizens. Nevertheless, King's picture of Monroe is eminently successful. In addition to conveying something of Monroe's soft-spoken, sincere, and rather deliberate

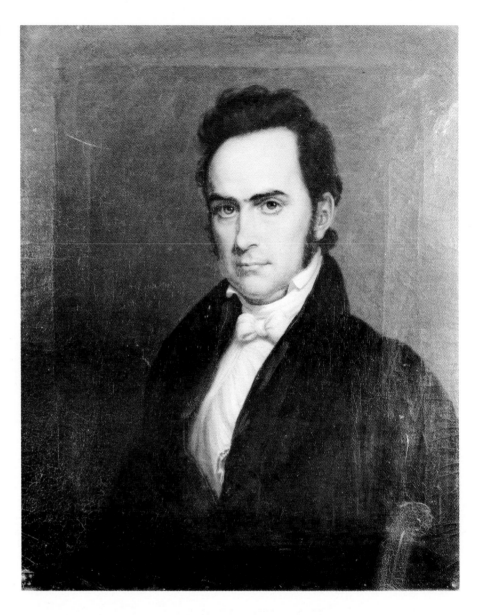

Figure 17. *Daniel Webster,* 1817, catalog number 279.

character, King had him appear to be naturally and comfortably disposed in his official surroundings in the East Room of the White House, which had only recently been renovated and refurbished after having been burned by the British in late 1814. To the left is a deep vista along the yet untamed Mall of L'Enfant's plan, at the end of which is seen the Capitol Building framed against a luminous sky. The impressive structure is depicted from the west side, not as it appeared at the time – without the dome and with only two wings completed and connected by an enclosed wooden passage – but rather according to a concept of the building delineated by the current Architect of the Capitol, King's friend and fellow Moravian, Benjamin Latrobe.[55]

The Monroe portrait reflects well King's genius for portraying character and for composing a picture, as well as his adherence to the best in the English portrait

Figure 18. *President James Monroe,*
1816-1817, catalog number 169.

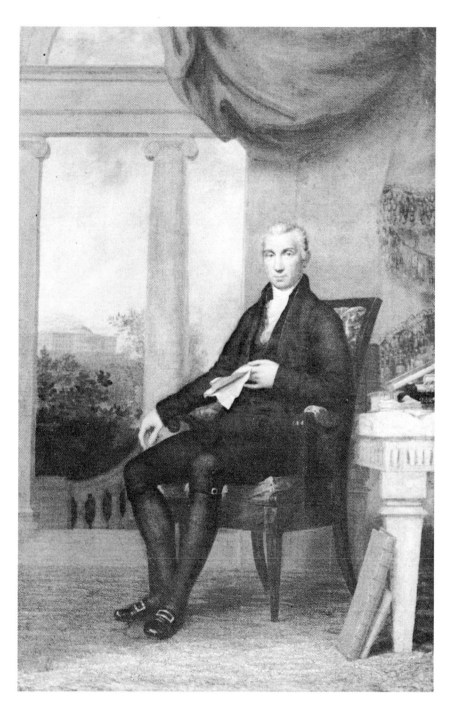

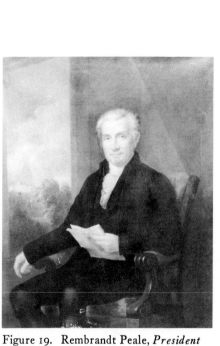

Figure 19. Rembrandt Peale, *President
James Monroe,* circa 1817, oil on canvas,
54 x 44 inches (height by width). Mrs.
Westesson Hoes, Washington, D.C.

tradition. Representing as it does the pictorial manifestation of the shift of political
dominance in the West from the aristocracy to the bourgeoisie, King's portrait can
hardly be conceived of without the precedents of Hogarth's incomparable likeness
(1739) of Captain Coram, and of Reynolds's portrait (1786) of Joshua Sharpe and
Copley's (1782) of Henri Laurens, of which King owned engravings.

Perhaps it was because of King's stay in Washington during this period that

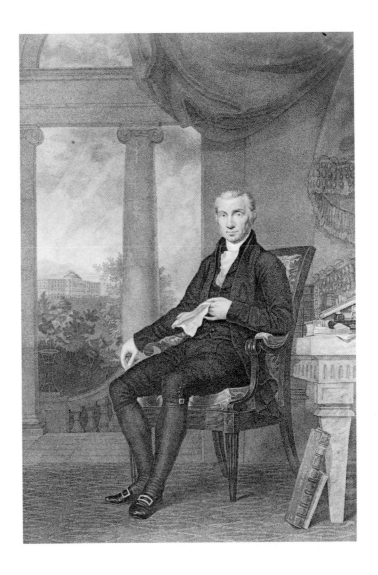

Figure 20. *President James Monroe,*
1817, engraved after King by Goodman &
Piggot, and published December 15, by
W. H. Morgan, Philadelphia.

Dunlap was led to say, quite correctly, that the artist "removed to Washington City in the year 1816," and to imply, quite incorrectly, that he remained there for the rest of his life. Actually, King must have returned to Baltimore early in 1817, as the city directory, published about May, listed him as living on Monument Square.[56] It may have been at this time, when King no doubt was completing the Monroe portrait and had his studies at hand, that Rembrandt Peale painted his own portrait of Monroe (fig. 19), which seems to depend heavily on King's. Or perhaps King and Peale painted their portraits of Monroe together in Washington, as they seem to have done in Baltimore with their respective portraits of General Stricker.

Whatever the case, for the first time since 1814 King again participated in the Pennsylvania Academy's annual exhibitions in 1817 and 1818. Although he doggedly billed himself as "Historical and Portrait Painter," he submitted only three portraits in 1817, those of General Robert Goodloe Harper, President Monroe, and an unidentified "gentleman," perhaps William Pinkney, and but one in 1818,

of Charles Carroll of Carrollton. The Harper and Carroll portraits were painted for Joseph Delaplaine and were intended for reproduction in the *Repository,* but since that publication had been discontinued, they never appeared in it. In contrast to these works, the portrait of Monroe, described in the catalog of the exhibition as "to be engraved by Goodman & Piggot, for the publisher, H. Morgan," was reproduced as intended. According to the inscription the engraving was issued on December 15, 1817. A handsome work, and one quite true to the original oil, the print (fig. 20) was a distinction for the young artist, to whom it brought a measure of fame and possibly some additional income.[57]

That King continued to paint in Baltimore in late 1817 and well into 1818 is indicated by the Carroll portrait and by a letter from Delaplaine to Bishop Kemp, spiritual leader of the Episcopal Church in Baltimore. Writing from Philadelphia on October 27, 1817, the art dealer noted that he had waited a "long time very anxiously, to receive your portrait by Mr. King," and implored the bishop to "afford to Mr. King an opportunity . . . to complete the portrait. . . ." Before long, however, the call of the itinerant again led King to Washington, this time at the behest of Delaplaine, who in November 1818 had written to John Quincy Adams, then secretary of state, as follows:

I am extremely desirous to obtain your portrait for my National Gallery. Mr. King, a very respectable man, and an excellent portrait painter, of Baltimore, has arrived in Washington where he has gone to paint the portraits of several distinguished characters for me. . . . My wish is that you will have the goodness to sit to him.[58]

Adams did sit to King, and eventually so did many other members of his family.

IV *Artist-in-Residence at the Capital: 1819–1862*

Judging from Delaplaine's letter to Adams, King probably arrived in Washington about the middle of October 1818, when the city was reawakening in preparation for the opening of the congressional session in December. According to Delaplaine, the artist took rooms at "the corner of 12th & F Sts.,"[59] in which location, due to unforeseen circumstances, he was to reside for more than forty years.

The immediate factor that kept King in Washington was the unusually large number of portrait commissions he received. From the time of his arrival at the capital until March 24, 1819, when John Quincy Adams visited his rooms and noted the pictures he saw there, King painted at least sixteen portraits – an average of three to four a month – of which eight were commissioned by Delaplaine for his "National Gallery." Were such rapidity of execution not accomplished with a high degree of quality it is unlikely that the artist would have received the stream of distinguished sitters that he did. As Adams observed, the portraits are "almost without exception very strong likenesses; and good Pictures."[60]

Despite his success, of which he had written to his friend Samuel Waldo in New

York City, King clearly had no intention of remaining in Washington. He even took pains so to inform John Quincy Adams, who had agreed to sit for a portrait and who recorded in his diary on March 3, 1819, "King . . . spoke to me some weeks since, and told me that he expected very soon to leave the City. I called this morning at his rooms, but he told me he should be obliged to remain here two or three months longer."[61]

If the more than sufficient patronage he received were not enough to induce King to remain in Washington, two unhappy events that occurred in 1819 no doubt were: the Panic and the ensuing economic depression that struck the country early in the year, and the death of King's mother in October.

The impact of the depression of 1819 was broad and deep; thousands lost their jobs and property and real estate values plummeted to record lows. Artists, of course, were not immune to its effects, and many, among them Dunlap, Sully, Jarvis, and Morse, took to the road seeking commissions at reduced prices. Only in the capital were the acute effects of the depression somewhat ameliorated by the presence of governmental offices. The higher echelon of dignitaries, native and foreign, whose portraits King continued to paint, were probably not at all affected by contemporary conditions. Thus, Washington proved to be a relatively secure place for an artist, a lesson which undoubtedly impressed itself deeply upon King.

Upon the death of his mother on October 16, 1819, King inherited about $5,000, which he received in July 1820.[62] Such a windfall could not have come at a more propitious time. With real estate selling (for some time to come) at a fraction of its former value, and with the prospect of a reasonably steady income from portrait commissions, King was in an excellent position to take advantage of the many bargins available. This he did, as is well documented, but exactly when he began purchasing property in Washington must be inferred.

While tax and land records indicate that King did not begin his purchases until 1824 or 1825, accounts by Sully and Dunlap of their visits to Washington during the winter of 1824-1825 suggest otherwise. During his visit in December 1824, Sully recorded in his journal that he was King's guest at the artist's new house on Twelfth Street, just around the corner from F Street: "King's building cost about $5,000. Exhibition room 39 x 28 feet, skylight of which is 22 x 11 feet – 4 panes of glass each one foot – wall 16 feet – Painting room 28 x 19½, a second 20 x 19½. Basement story has 5 rooms." Add to this Dunlap's observation that King "built a house at Washington, and a good picture gallery," and it becomes clear that King must have begun buying land probably as early as 1822 and certainly no later than 1823.[63]

A reasonably good idea of King's residence at 486 Twelfth Street may be had from an old photograph and from a contemporary written description. The photograph (fig. 21) shows King's house, on the right, as it appeared in 1881, probably shortly before it was demolished. The description was written in 1847 by George Watterston, the first Librarian of Congress, in his Washington guidebook: "This neat and beautiful gallery is situated on Twelvth street west, near F street. The edifice is of wood, twenty-seven feet front by thirty-eight feet deep, with a room in the rear, and a neat portico in front." The "gallery or upper room," he added, contained about 160 paintings, while the "lower room" held about 100. Clearly the former was the exhibition room mentioned by Sully as occupying the entire second floor and the latter was probably the ground-floor room, facing on Twelfth Street

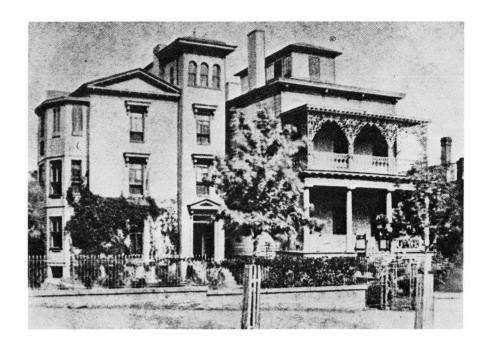

Figure 21. King's home, 486 Twelfth Street, Washington, D.C., in 1881, from *Star Magazine* (Washington, D.C.), December 31, 1961.

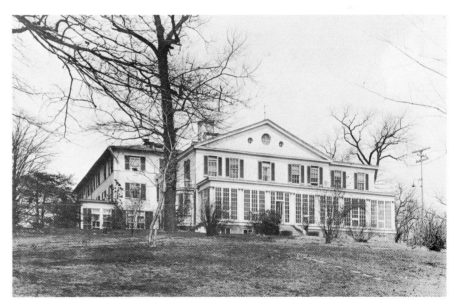

Figure 22. "Eckington," home of Joseph Gales, Jr., Washington, D.C., in 1921.

and backed by a larger room facing the deep garden in the rear, in which King is said to have enjoyed painting.[64]

The austerity of the original fabric with the Tuscan Doric columns of the portico (the "New Orleans" ironwork above was probably added in the 1850s, by which date the artist could well afford to indulge his Romantic proclivities) neatly reflects the Greek Revival of the 1820s. The same style is seen in "Eckington" (fig. 22), the home King designed in 1830 for Joseph Gales, Jr., which suggests that the artist designed his own house also. In addition to being products of that "good taste, in architecture" that Sully observed in King,[65] both houses may owe something

Square 321 Square 453

Figure 23. Central Washington, D.C., showing King's properties in relation to the White House and the Capitol.

Figure 24. Square 321, Washington, D.C. Schematic drawing showing lots King bought from 1825 to 1854.

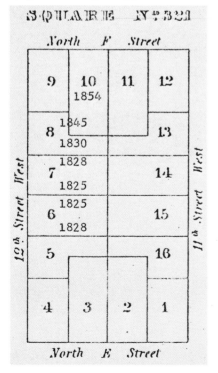

of their straightforward quality to the example of the reductive or "primitive" classical style of Benjamin Latrobe.

The location of King's house (fig. 23), just north of Pennsylvania Avenue and between the White House and the Capitol, was ideal for a studio-gallery. Along this axis was the city's greatest concentration of business establishments and population, including the most prestigious of government officials and local citizenry, among whom King quickly became a well-known figure.

While it would serve no useful purpose to examine King's other properties in detail, it should be pointed out that over the years, largely from 1825 to 1854, he acquired extensive real estate holdings (fig. 24), amounting to one-fourth of the block on which he lived (Square 321), plus a large lot on H Street in what is presently called "Chinatown" (Square 453). Moreover, from 1840 on the artist was deeply involved in the development of his properties, from which he received sizable rentals if one can judge by the receipts recorded after his death by his cousin and executor, George Gordon King. This income was incidental to the return King received on stocks, which at his death were valued at $9,144, and to the considerable income he received from the hundreds of portraits he painted while resident at the capital.[66]

Thus, Sully's remark that King "began the world at Washington with little other materials than his palette, pencils and books"[67] and the generally held belief that King was an impoverished artist must, on the one hand, be counted as nothing more than sympathetic romanticizing. On the other hand, the successful execution of so many ventures required the artist to be unflagging in his industry, a trait frequently confirmed by the testimony of his friends. It is evident from an examination of the paintings of King's late period, however, that his increasing concern with property matters clearly had a deleterious effect on the quality of his artistic production.

Having established himself as artist-in-residence at the capital, King remained there until his death in 1862, leaving only in the summer months to visit his friends

and relatives in and along the way to Newport. During his many years in Washington, he was eminently successful both as an artist and as a social figure. As Dunlap noted while in Washington in 1824, King was "full of business and a great favorite, assiduously employed in his painting room through the day, and in the evening attending the soirees, parties, and balls of ambassadors, secretaries of the cabinet, president or other representatives and servants of the people, and justly esteemed everywhere."[68]

Of the many incidents that can be related about King's life in Washington, and of the development of the city itself, only a few need be mentioned to establish the context within which the artist worked. Perhaps the most striking feature about the capital was the dichotomy that clearly existed (and still exists) between monumental Washington and its residential and commercial areas. Under the supervision of a series of talented designers and architects, from William Thornton and Benjamin Latrobe to James Mills and Thomas U. Walter, the basically classical character of official Washington was fixed: the White House and the Capitol, and the imposing Treasury and Patent Office buildings were completed; the Washington Monument was begun; numerous elegant town and country houses were built; and, adding a touch of Romantic medievalism, James Renwick's exotically picturesque Smithsonian Institution was erected.[69]

In contrast to these imposing edifices, most of the residences, boardinghouses, and commercial establishments that lined the main thoroughfares were shabby structures, often erected by speculating developers. Further, most streets, including the broad, handsome Pennsylvania Avenue, were not macadamized or lighted until late in the 1830s, and pigs, cows, and geese roamed freely about their muddy, garbage-strewn ruts. Even L'Enfant's magnificently conceived mall was used for raising crops and for pasture, and, near the White House, as an outlet for sewage. In 1841 a reporter for the *National Intelligencer* described the area about the Capitol as a "Sahara of solitude and waste."[70]

More tragic in terms of human suffering were the city's social ills: inadequate hospital and sanitation facilities; the closing of the public or "pauper" schools; the alarming increase of destitute children; and, most deplorable, the slave trade. In addition, the city lacked decent boarding facilities and hostelries for temporary residents, including congressmen, and entertainments and artistic and intellectual pursuits were practically nonexistent, except for public dinners at which whiskey and rum flowed freely—perhaps as an antidote to ennui – and gambling, for which the city became notorious. It is often said that most of the city's ills could be traced to the neglect of Congress, on which the city was wholly dependent for subsistence. As Samuel Southard reported to Congress in 1835, "The city [has] pecuniary obligations . . . *utterly impossible* [to satisfy] . . . unaided by Congressional legislation."[71]

Most of the less desirable conditions that prevailed in the city did not much affect the resident upper-middle-class population, which dominated the city's social and cultural life, and of which King was a part. As a matter of fact, in the opinion of Mrs. Samuel Harrison Smith, a close friend of King's and an author, social leader, and the city's most avid chronicler, Washington possessed a "peculiar interest and to an active, reflective, and ambitious mind, has more attractions than any other place in America."[72]

The attractions to which Mrs. Smith referred included the endless round of

social calls, teas, soirees, parties, and balls that enlivened the capital during the congressional session from December to March. Among these were the glittering Friday evening parties at the Gales' house, "Eckington," which King (a frequent guest) had designed for Joseph Gales, Jr., the editor of Washington's most powerful newspaper, the *National Intelligencer*. Also popular were the annual fancy dress balls at which King's "picturesque figure" was seen at least on two ocassions, in the respective guises of Rembrandt and Rubens, appropriately enough. Great excitement was stirred, too, by the visits of such famous people as Lafayette, whose portrait King painted, and the English visionaries Robert Owen and Harriet Martineau, the latter of whom King met at Mrs. Smith's. Perhaps the most colorful of the guests at the capital were the delegations of American Indians, whose costumes, painted bodies, and fierce dances enthralled the multitudes and many of whose portraits were painted by King.[73]

Beside lending his colorful character and engaging wit to many an important social event, King enriched the life of the city in other ways, as well. For example, with John Quincy Adams, Benjamin Latrobe, Samuel Harrison Smith, and others, he was a member of the Washington Botanical Institute, which developed several acres of ground near the Capitol into a botanical garden that was to long remain one of the favorite places of Washingtonians. In 1825, he was appointed by President Adams to a three-man committee, the first governmental art commission, to judge the competition for a sculptural design for the central pediment of the east facade of the Capitol. Lastly, there was King's love of children, summed up by a Miss Dorsey's recollection of him in later years as a "courtly old gentleman, extremely fond of inviting parties of children to his sylvan studio, where he regaled them with tops and other remembrances," which manifested itself substantially in his support of and bequests to the Protestant and Catholic orphan "asylums" in Washington, and to one of the public schools of Newport.[74]

Not the least important of King's activities was his significant contribution to the cultural life and heritage of the capital. In addition to the Indian Gallery begun in 1821, the first government-sponsored collection of art, King's own studio-gallery immediately became a mecca for artists and lovers of art. There King lived and worked for almost forty years, and there he played host to easily a score of artists and hundreds of visitors who came to see his remarkable gallery of paintings, of which Watterston wrote in 1847, "It is the only collection of paintings in this city, and though not very extensive, is equal, if not superior to any in this country in beauty of coloring and skillfulness of execution."[75]

V Artist Friends and Associations

Undoubtedly as a result of his growing reputation as a painter and as proprietor of a spacious studio and gallery, King's professional associations increased noticeably after he moved to Washington. Of the many artists who called on him, some came as old friends and exhibitors, others as students for instruction, and still others merely to use his facilities or to employ his good offices as an intermediary in various transactions. All, it seems, were received with that generosity of spirit that was

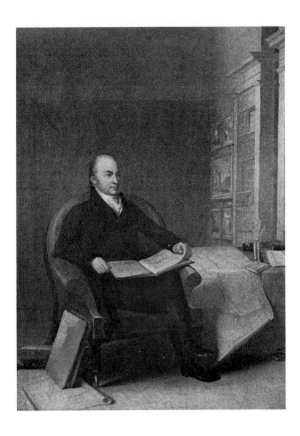

Figure 25. Thomas Sully, *John Quincy Adams,* 1825, oil on canvas, 33 x 25 inches (height by width). The Cochran Collection, Philipse Manor State Historic Site, Taconic State Park and Recreation Region, New York State Office of Parks and Recreation.

characteristic of King. Yet, even a cursory examination of these associations reveals that King was a personality of multiple dimensions. In addition to being an industrious painter, a witty conversationalist, and a shrewd businessman, King emerges as a stubborn individualist, a friend to aspiring young artists, and an imaginative inventor. Together with his literary, architectural, and horticultural interests, these qualities point to a man deeply involved with the challenges of his own age and with life in general.

The oldest and most devoted of King's friends was Thomas Sully, whose faithful records preserve much of what is known about King, and whose estimate of him as "steady in friendship, and tenderly affectionate" is perhaps the best testament to their enduring relationship. In matters personal and professional the two artists were unstinting in their assistance to each other. On one occasion, for example, Sully arranged for King to purchase a collection of plaster casts for his studio and gallery, and on another sought King's assistance in procuring a position for his stepson, Chester. When Sully's daughter Ellen was married, King spent a week in Philadelphia. Also, King included Sully's name in two of his paintings, *The Vanity of the Artist's Dream* and the self-portrait of 1858; and bequeathed to him $300, his large manikin, and sundry other items.[76]

Perhaps the best measure of their friendship is seen in their many artistic exchanges, of which Sully's copies of King's *Grandfather's Hobby* and the portrait entitled *O. Brown,* and his own painting of *The Adieu,* the subject of which was suggested by King, are good examples. Moreover, Sully's *John Quincy Adams* of 1825 (fig. 25) bears a striking resemblance in its composition, although in reverse,

to King's *President James Monroe,* which Sully knew quite well, having exhibited it at his own gallery in Philadelphia.[77] Much of the restrained quality of the *Monroe* uncharacteristically permeates the *Adams,* which Sully painted between two more vigorous portraits, *Samuel Coates* (1812) and *Thomas Handasyd Perkins* (ca. 1832).

Of course, Sully also influenced King, although the latter is known to have copied only two of his pictures: his *Mrs. Mason and Child* and *Thomas Jefferson.* Nonetheless, in a number of his paintings King seems to have depended heavily on Sully for inspiration. King's *Mrs. John Quincy Adams,* for example, was surely painted with Sully's *Eliza Ridgely* in mind (see figs. 27 and 28). Further, King's paintings of the late 1820s and especially of the 1830s, such as his *Miss Satterlee* (fig. 26) and *Costume, Time of Charlemagne* (see fig. 97) often suggest Sully's more liquid brushwork and his elegant, transparently Romantic style.

During his many trips to the capital, where he often went to paint portrait commissions, Sully usually roomed at King's and frequently joined him in painting. Arising to their work one Saturday late in December 1824, Sully noted with some amazement and not a little humor the activities of the day: "Painted without fire in the room and windows open. King took four sittings – breakfasts at daylight – luncheon at 12 – dines at candlelight – but no exercise!!" Apparently Sully's recollection of King's legendary habits of industry and frugality, which he had observed while they were in London, had been dimmed by time and perhaps by success. Not so with King. It was during that visit, also, that both artists painted (probably together in King's studio) portraits of Lafayette, of which Adams said, "I think King's the best."[78]

In addition to these mutual endeavors, Sully also arranged to exhibit his copy of François Granet's *Capuchin Chapel* at the opening of King's new gallery in late 1824-early 1825. In what is the first known and one of the few public notices indulged in by King, he advertised the opening in the *National Intelligencer* of January 4, 1825: "Capuchin Chapel copied from the Original Painting of Granet, by Mr. Sully, is now opened for Exhibition, at Mr. King's Painting Rooms, in Twelfth, near F street. Admittance 25 cents." Several days later the *Capuchin Chapel* was joined by Dunlap's large *Bearing of the Cross.* Obviously, King's friends kept abreast of his activities and as soon as he opened his gallery it became part of the circuit for traveling works of art.[79]

King's spacious gallery undoubtedly afforded ample space not only for large exhibition pieces but also for his growing collection, which must at that time have included plaster casts; portraits (including his *Adams, Calhoun, Clay,* and *Webster*); Indian subjects (including his *Young Omaha . . . , Petalesharro,* and *Hayne Hudjihini*); numerous history, still-life, and genre pictures; prints; books; and, consistent with Newport tradition, probably a collection of shells.

Although it would appear that not a little of Savage's showmanship had rubbed off on King, the significant role of his gallery as an agency for cultural development and for encouraging the artistic revolution that occurred in early-nineteenth-century America can hardly be overestimated. Until the opening of commercial establishments in the 1840s, artists' galleries were among the few places in which one could see and study works of art of a reasonably high quality, even though the galleries were occasionally augmented by displays of natural wonders. Something of the excitement felt in visting such places is conveyed by Charles Francis Adams's

Figure 26. *Miss Satterlee,* circa 1838, catalog number 227.

refusal to be daunted by delays in visiting King's studio. "This was so good an opportunity," he wrote, "that I did not wish it lost...."[80]

Another of King's close friends was Rembrandt Peale, whom King probably first met in Philadelphia in 1812-1813 and with whom he developed an intimate association during their joint residency in Baltimore from 1815 to 1818. The warmth of their friendship is evident in a letter written by Peale to Sully on July 4, 1820, in which Peale related an amusing incident that had occurred during King's recent visit to Baltimore: "King staid but a short time with us, but did me the favor to point out many faults in my Picture. As far as he went it did me good – but perhaps if he had staid longer he would have made me too discontented with it." The picture to which Peale referred was probably his huge *Court of Death*, which he completed in July and then sent on a successful tour.[81]

That Peale kept in touch with and visited King is suggested by his request, probably one of many, to copy one of King's portraits. King responded that he would have to borrow the picture from its owner, but assured Peale that he would find his friend a room in which to paint a copy after his arrival in Washington. Peale's complimentary remarks about King's mechanical ingenuity, made in a series of "Reminiscences" he wrote for *The Crayon* in 1856, are also indicative of their mutual respect. Discussing his efforts since 1809 to improve on containers for pigments by using glass tubes, Peale noted that King proposed the use of "tubes of tin, with a cork piston; which we readily adopted." Peale again addressed this subject in a very popular talk he gave in 1858 before the Washington Art Association.[82]

Were it not for the essay that appears in Dunlap's *History,* scarcely anything would be known about King. Although Dunlap depended heavily on Sully's intimate knowledge of the artist, the historian's own long and close association with King allowed him to make some penetrating observations, the value of which are not in the least impaired by his obvious ambivalence toward his subject.

For example, Dunlap lauded King's generosity in exhibiting several of his pictures, stating that "his conduct has not only been honorable but friendly." Yet, his estimation of King's abilities was such that even the humble artist at the capital must have felt some chagrin:

... it is his industry in painting that has served him instead of genius, in which nature has stinted him. It appears that all he has acquired has been by very hard study; and Mr. King is an example of a man of very moderate genius who has acquired much in his profession, and commanded that employment which has made him independent in his circumstances, and an object of attention in society.

Dunlap's ambivalence is felt even in small matters. While acknowledging that King "contrived several mechanical machines for facilitating the labor of artists," he described only a "slender rod of wire" the artist devised for measuring proportions, adding, "But all mechanical aids are mischievous. The artist should depend alone on his eye."[83]

Although one might well divine a measure of jealousy in Dunlap's essay on King, on the whole its tone is complimentary and warm, as indeed the friendship of the two men remained. Perhaps what most piqued the writer was the difficulty he (and Sully) had in establishing the chronology of King's life, about which Dunlap remonstrated, "I am obliged to guess, as he refuses to satisfy my curiosity by giving me any information."[84] Since King seems to have systematically avoided keeping personal records and press notices or joining organizations, his reluctance to give

Dunlap information cannot be ascribed to enmity, nor merely to his eccentricity. Deeper motivation must have compelled such behavior.

The obvious explanation for King's apparent indifference to temporal fame is his upbringing within the austere framework of the Moravian creed. Perhaps, too, his economic independence precluded his having to pursue such fame. Yet, neither of these factors suffices to explain that sophisticated philosophical point of view that King seems to have developed, which is implicit in Dunlap's description of him:

In person and manners Mr. King is prepossessing. He has not the polish of a court, neither has he the duplicity of a courtier. A frankness and naïveté have attended him through life, seldom found in men who have mingled so much in society.[85]

One fascinating possibility is that King may have fancied himself what his age called a "melancholic," a term used in antiquity and revived in Jacobean England, where Robert Burton's book *The Anatomy of Melancholy* (1621) had fired the imagination.[86] During the first decade of the nineteenth century in England, when King and Allston and Morse were there, the concept of melancholy was again revived and became a central concern of the early Romantics. No doubt King was affected by this current of thought, at least to some degree, as is evident in those periodic emotional eruptions in his art, writing, and behavior. Indeed, some importance should be attached to the fact that in two of his most successful paintings, the *Poor Artist's Cupboard* and *The Vanity of the Artist's Dream* (see figs. 10 and 79), he gave a central place to Burton's *Anatomy*. Moreover, it is tempting to compare what is known about King to Burton's delineation of the melancholic as solitary, taciturn, a wanderer who prefers to dwell in shadows, one possessed of unusual intellectual and artistic abilities, and, above all, one who is "of all others . . . most witty."[87]

As noted previously, King exhibited in early 1825, along with Sully's *Capuchin Chapel,* Dunlap's *Bearing of the Cross,* which a notice in the *National Intelligencer* described as a "great Evangelical subject . . . 18 feet by 15, and containing 120 figures." Later that year he exhibited Dunlap's *Christ Rejected* and *Death on the Pale Horse,* both after West, and in 1829, *The Graces Adorning Venus,* after Guido Reni. Apparently King had to repair the *Christ,* which had been damaged enroute to Washington, and in respect to the *Graces,* was told by Dunlap that "if you can sell it for me, your part of the proceeds shall be liberal." What King may have received for his services in this instance and in others is unknown, although when Dunlap had shortly before exhibited the *Bearing of the Cross* at Sully's and Earle's gallery in Philadelphia, he offered them either ten dollars a week or one-third of the receipts – if they agreed to incur one-third of the expenses.[88]

Because of his knowledge of art, King apparently was often called upon for assistance. On one occasion, for example, he was asked to appraise four paintings by Gilbert Stuart in the estate of King's long-time friend Dolly Madison. Most interesting are his dealings with the well-known Baltimore collector Robert Gilmor, to whom King wrote in 1827 to inquire if he wished to purchase a leaden bust of Sir Walter Raleigh in the possession of a Mrs. David Mead Randolph. In 1830 he again wrote to Gilmor in response to the latter's inquiry about the date of sale of a Mr. Coxe's picture collection. It most likely was during King's residence in Baltimore that he met Gilmor. Given their mutual regard for Dutch art – Gilmor was educated in Holland and was the foremost collector of Dutch art in America –

it is unlikely that their meeting was fortuitous, and it may even be that King advised Gilmor in respect to his collection.[89]

Of the many young artists with whom King became associated in Washington, three may be counted as his students: George Cooke, John Gadsby Chapman, and John Cranch. Although the works of these artists show no influence of King's style, probably because each of them subsequently studied with other artists and then worked abroad for several years, their enduring friendships with King indicate that they must have appreciated his instruction. As Dunlap noted, King was "ever ready to impart instruction," and, he might have added, probably without remuneration.[90]

Despite his ceaseless wandering, George Cooke usually kept in touch with King. It was probably on his return from Italy in 1831 that he gave King a print of Adrian van Ostade's *The Painter's Studio,* and in 1837 he assisted King in painting portraits of the flood of Indian delegates into the capital. Earlier, in 1835, he had also shown a large exhibition piece at King's, his copy of Gericault's *The Raft of the Medusa,* whose figures were the "size of life" according to notices in the *National Intelligencer.* In an entertaining letter written from Raleigh, Cooke urged King to be generous in advertising the picture, which he described as 400 feet square (larger than the original!), adding cynically, "In N York we send free tickets to the Editors of the paper, & to the Clergy. The Adam & Eve, was three weeks unnoticed until a clergyman pronounced it a good *moral* painting, and then it was crowded to overflowing."[91]

Perhaps the most successful and closest of King's charges was John Gadsby Chapman, whose greatest achievement was his series of more than 1,400 drawings for Harper's *Illuminated Bible,* a copy of which he probably presented to King personally. Prior to moving to Italy in 1848, Chapman frequently communicated with King, sending him color samples or seeking his good offices for a friend. In the 1830s he exhibited at the National Academy of Design two of King's Indian paintings, which he had perhaps acquired in exchange for two of his own paintings, *The Ruins of Adrian's Villa, near Tivoli* and *View of Washington* (which King later gave to the Redwood Library). As he did with Sully, King included Chapman in his will, leaving him $300 and two small manikins.[92]

Little is known of the relationship between King and John Cranch, a native Washingtonian and cousin of John Quincy Adams's. Nonetheless, Cranch was another of the several artists to whom King made a bequest of sundry items. Moreover, Cranch somehow acquired King's striking portrait of Henry Clay, which he ultimately sold to William Wilson Corcoran in 1881.[93]

Some of the younger artists whom King assisted were among the leaders of that generation in which a native character in the arts began to flower. One of the better known of these was the sculptor Horatio Greenough, who used King's facilities in early 1828 to do a bust of President Adams (who seemed ever to be sitting to someone in King's studio). Evidently pleased with his situation, Greenough wrote to his brother Henry in February, "Through the politeness of Mr. King I have a noble studio in his house." That he could also remark that "my lodgings cost three dollars per week, and my board about two and a half, so that I spend less money than I had anticipated" suggests that King let him have the studio gratis. Moreover, Greenough must have felt quite secure in the good nature of his host, as he wrote to Henry that "[Chester] Harding is here, and . . . I offered to allow him to paint [Adams's portrait] while I was modeling."[94]

Although there is no known evidence of any exchange between them during his four years at the capital from 1840 to 1844, George Caleb Bingham must surely have had some contact with King. So too must Eastman Johnson who, because his father had a position with the Department of the Navy, was frequently in Washington. In fact, it was in Washington, at his father's house on F Street, just around the corner from King's, that he was inspired in 1859 to paint his best known – if not his finest work – the *Old Kentucky Home*.[95]

Other artists whom King knew included Thomas Doughty, Henry Inman, and Andrew J. H. Way. King probably came to know Doughty through the portraits he painted of Doughty's brother and sister-in-law, Colonel William Doughty and his wife. Inman was responsible for making the copies of King's Indian portraits that served as the basis for the lithographs in McKenney and Hall's *Indian Tribes of North America*. King also painted portraits of Way's relatives: his father, Andrew Way, his mother, and his older brother, George Brievitt Way. Legend has it that in 1859 Leutze advised Way to specialize in still-life painting, in which he was adept. Inasmuch as Way's fruit pieces harken back to King's much earlier efforts in that field, it may have been King instead of Leutze who offered the advice. In any case, Way owned a portrait by King that he exhibited at the Maryland Historical Society in 1856.[96]

Surely none of King's associates could match the international fame of George Peter Alexander Healy, sometime student of the brilliant French painter Baron Gros, and portraitist to the royal houses of France and England. It apparently was in the spring of 1842, at John Quincy Adams's house in Washington, that King met Healy, whom he guided about the city and showed, among other things, the picturesque black quarter of the capital. King also wrote, for the *National Intelligencer,* a remarkable critical analysis of Healy's striking portrait of Louis Philippe's scholarly minister, François Guizot, which Healy had sent home from France. Cast in a manner reminiscent of the effusive letter he had written to Morse in 1813, King's notice nevertheless seems genuinely to reflect his response to the picture, as well as his current ideals vis-à-vis painting:

I have seldom had the pleasure of seeing so beautifully perfect a masterpiece as the splendid, full-length likeness of M. Guizot by the distinguished young artist, Mr. Healy. So noble, calm, simple and characteristic is the posture of the Minister, so chaste and correct the drawing, so natural and harmonious the coloring, so rounded and full of bold relief is the whole figure without either harshness or rigidity, and so tasteful the disposition of all its parts, that it is impossible to view with an artist's eye this noble production of the pencil without feelings of exquisite delight and unqualified admiration. Certainly, nothing equal to this have I yet seen from any native artist; and one knows not whether most to applaud the skill of the painter or the magnanimous liberality of his Royal Patron. Louis-Philippe's generous attentions to Mr. Healy have set an example, patronizing merit, regardless of the accident of birthplace.[97]

In 1845 Healy was again in Paris, where King wrote him a letter introducing a friend. In closing he asked Healy to convey his love to John Vanderlyn, then in Paris to execute his mural for the Rotunda of the Capitol Building in Washington.[98]

King's friendship with the embattled Vanderlyn probably dated from their days in New York in the early 1800s. The apparent lack of communication between the two is belied by Vanderlyn's trusting words about King, written in 1850 to Colonel Payne Todd, son of Dolly Madison and a notorious spendthrift. Referring to his

portrait of the deceased Dolly, Vanderlyn petitioned for the "balance due" on the picture, to which, he added, "I trust King has given the finishing...." He requested that the money be paid "into the hands of friend C. B. King ... whom I know is stationery."[99] Dependable, sympathetic old King.

Fate also dealt harshly with John Mix Stanley, whose many Indian paintings were destroyed along with King's in the Smithsonian's fire of 1865. Here, too, a steadfast friendship is suggested by the fact that King bequeathed to Stanley a share in sundry items to be divided with Sully and Cranch.[100]

The range of King's associations is indicated by the assistance he gave to foreign artists. For example, the Frenchman Jean Baptiste Adolphe Gibert was commended by Mrs. Adams to the "kind patronage" of her "long and friendly acquaintance," King. In another instance, King exhibited in his gallery a large historical painting entitled *The Landing of Lafayette at Cincinnati,* the work of the French artist Auguste Hervieu, who had been part of Frances Trollope's party on its arrival in Washington in 1830. Although the critic for the *Daily National Journal* considered the picture "spirited and admirable," apparently not many people came to see it, nor was Congress convinced to buy it. Perhaps out of sympathy for the financially beleaguered troupe, King acquired Hervieu's strangely imposing portrait of Andrew Jackson, which he later gave to the Redwood Library.[101]

Of the many organizations concerned with art that flourished from the early 1800s on, King belonged to only a few, and joined even these reluctantly. No doubt as a result of Sully's efforts, in 1812 King had been made an academician of the Pennsylvania Academy of the Fine Arts, where he exhibited more than at any other place, perhaps to satisfy Sully and Delaplaine. In 1827 he was elected an Honorary Member of the National Academy of Design, whose first president was Samuel F. B. Morse. Although King never exhibited at the National Academy himself, Chapman, as noted, had shown two of King's Indian paintings there, in 1837 and 1838, respectively. When the Washington Art Association was formed in 1856, King became a paying member, but was inactive, exhibiting only a single portrait in 1859.

Perhaps the most interesting of King's connections was with the Apollo Gallery in New York City, whose founder was James Herring.[102] Herring probably came to know King while he and Longacre were working on their series *The National Portrait Gallery of Distinguished Americans,* published from 1834 to 1839, which included engravings of two of King's portraits. By 1835, Herring and King must have been on good terms, for in a letter to King, Herring referred to their meeting in Newport and to King's recent visit to the Herring home in New York. He also requested that King make arrangements for him, his wife, and his daughter Emily (King's "little pupil") to lodge during a visit to the capital, trusting to King's ability to "judge pretty well what [accommodations] will suit me."[103]

Later events proved that King could be stubborn as well as helpful and kind. When the Apollo Association purchased two paintings – *Property of a Poor Artist* and *Grandfather's Hobby* – that he had been exhibiting there in 1828-1839, the prices paid him apparently were unsatisfactory, for King never again exhibited with the association or with its successor, the American Art Union. Nor did he subscribe to the latter organization, though Herring seems to have kept after him to do so. In fact, King and others unhesitatingly criticized the inequities within the

art union, as Herring noted in a letter he wrote from Washington in 1840 to one of its officers: "The advantages still secured to the members of our Association resident in N. York, which others cannot partake of, I hear is still harped on by King and Chapman." Writing again to the same person, Herring seemed exasperated by his difficulties in the capital, especially by King's humorous willfulness: "It will be absolutely necessary for me to have 20 of your circulars to Artists, sent here immediately by private hands, by some means, to Gadsby's [tavern]. King would not take his from the Post Office knowing what it was. (The mean old Bachelor.)."[104]

VI *Portraits and Indian Paintings*

Of the hundreds of pictures King painted during his years in the capital, the best known are his portraits of Indians and of prominent local citizens and national leaders. As might be expected, these portraits vary in quality from the merely perfunctory to the excellent and even the superb. Among the most artistically satisfying, exclusive of the Indian portraits, which are treated later, are the portraits of Mrs. John Quincy Adams, Henry Clay, and John C. Calhoun, all painted in the early 1820s when King's ability to manipulate paint tellingly and his powers as a colorist were at their fullest.

As is evident in examining these works, King's portraits of women seem more self-conscious than those of men, generally being more embellished and imbued with an artificial sentiment. These qualities may have been due, in part, to King's avowed bachelorhood, but they may also be ascribed to the aesthetic law articulated in the sixteenth century and still broadly operative in the nineteenth, which required that portraits of women should emphasize gracefulness as opposed to the forcefulness of character demanded in representations of men. While these conventions prevail in the portrait of Mrs. Adams (fig. 27), some of the uneasiness of her pose may also be attributed to King's frequent difficulty in handling anatomy and probably to the magisterial presence of the subject herself, who, while in his studio, once upbraided King for "treating religious topics with so much levity and disrespect that I took the liberty of telling him he had better confine himself to subjects which he understood."[105]

Despite the stiffness of the picture, of which one is hardly aware in the presence of its handsome coloring and intricate detail, King succeeded in conveying (even if somewhat rhetorically) the image of the woman refined: cultivated in music; fresh as the unsullied glimpse of nature in the background; and obviously as faithful as the song she holds before her, "Oh! Say Not Woman's Love Is Bought."

In comparison with the relaxed and graceful subject of Sully's *Eliza Ridgely* of 1818 (fig. 28), the subject of King's *Mrs. John Quincy Adams* seems rigid, yet the deeply gouged and excessively active folds of its apparel make it seem agitated. Whereas Sully created a deep space within which his figure could calmly and naturally exist, King characteristically occupied himself with the specificity of things, instinctively compressing them toward the picture plane. Yet, because he multiplied his images (like a good poet) and delineated them strongly, King's likeness of Mrs. Adams has an insistence and force that Sully's langorous Miss Ridgely lacks.

Figure 27. *Mrs. John Quincy Adams*, 1821-1825, catalog number 9.

Figure 28. Thomas Sully, *Lady with a Harp: Eliza Ridgely,* 1818, oil on canvas, 84⅜ x 56⅛ inches (height by width). National Gallery of Art, Washington, D.C.; gift of Maude Monell Vetlesen, 1945.

Much that has been said of the portrait of Mrs. Adams applies to that of Henry Clay (fig. 29), as well. Here, too, the spatial compression gives a sense of immediacy and monumentality to the portrait, and here, too, the subject's role is clearly explicated by the inclusion of the inkwell (still in use) of the Speaker of the House, an office Clay held several times, and of Clay's famous resolution of February 10, 1821, advocating American support of the Latin states' struggle for "Liberty and Independence." Also, both portraits are enlivened with bold scintillating highlights, as in the *Poor Artist's Cupboard,* and dashes of vermillion, blue, green, and gold in the flesh tones and elsewhere reflect King's continuing association with Sully, his superior as a colorist. Like his portrait of President Monroe, King's *Henry Clay* was engraved in 1822 (fig. 30) and was widely distributed.[106]

Figure 29. *Henry Clay,* 1821, catalog
number 47.

Figure 30. *Henry Clay,* 1822, engraved
after King by Peter Maverick, and
published by Benjamin O. Tyler,
Washington, D.C.

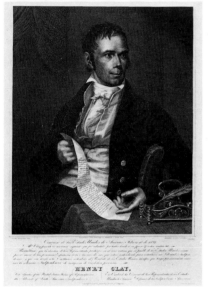

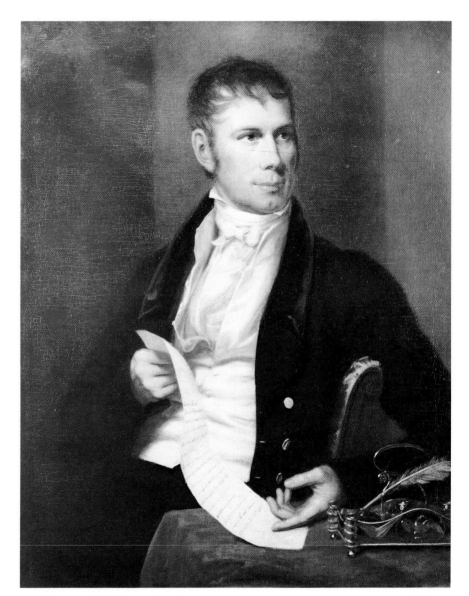

When John Quincy Adams visited King's studio in March 1819, he was quite
specific in mentioning that the artist had painted John C. Calhoun "twice." He was
probably referring to the two versions of the portrait showing the secretary of war
(fig. 32) seated before a map of the Upper Missouri Territory, an allusion to
Calhoun's plan to secure the Northwest with military posts in order, as he so stir-
ringly put it, "to extend and protect our trade with the Indians" and to show the
world "the mighty growth of our republic . . . now . . . ready to push its civilization
and laws to the western confines of the continent."[107]

While both versions of this portrait are straightforward and impressive, they are
surpassed by a later likeness of Calhoun that King painted when Calhoun became
vice-president in 1825 (fig. 33). In terms of depth of character expressed and

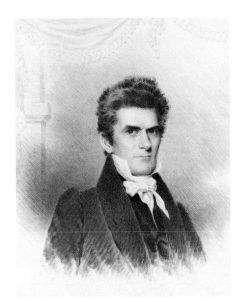

Figure 31. James Barton Longacre, *John Caldwell Calhoun,* circa 1834, sepia drawing from life, 10¾ x 8⅞ inches (height by width). Andrew Longacre, Dorset, Vt.

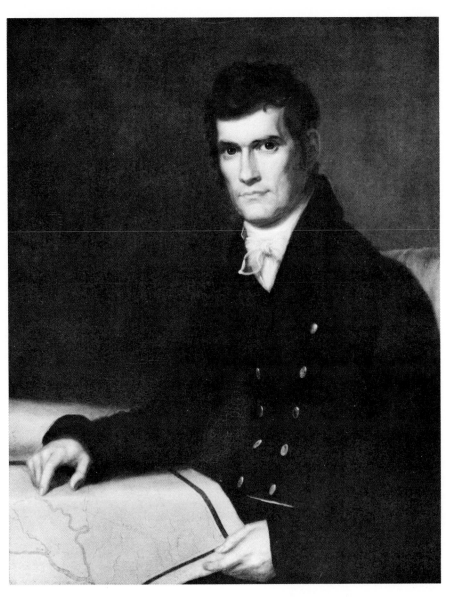

Figure 32. *John C. Calhoun,* 1818-1820, catalog number 26.

fluidity of technique, only in several of his Indian portraits did King approach the quality of the later *Calhoun,* which probes much more deeply than either the *Mrs. John Quincy Adams* or the *Henry Clay.* There is an attractively pensive mood about the handsome Calhoun, evoked by delicate brushwork and modeling, which captures that transient quality of existence characteristic of most good portraiture.

As Calhoun would have been forty-three in 1825, and as we are accustomed to visualizing him according to Healy's wild image of the great "Nullifier," the question naturally arises (as it does in respect to some of King's Indian portraits) of whether Calhoun is accurately or flatteringly portrayed. A comparison of the portrait with James Longacre's rather sober drawing of Calhoun done in the 1830s

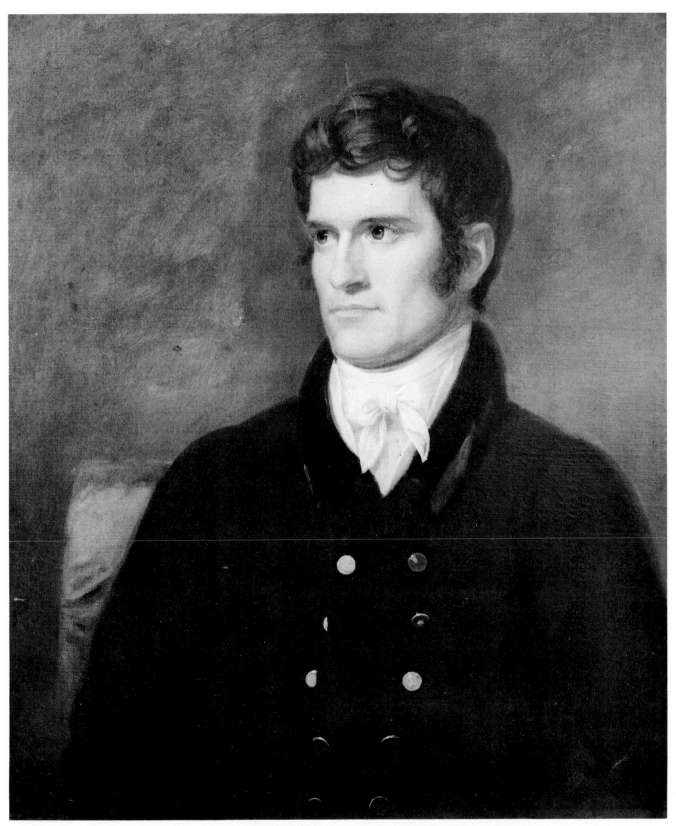

Figure 33. *John C. Calhoun,* circa 1825, catalog number 27.

(fig. 31), when Calhoun was nearly fifty, gives assurance that King's likeness is quite trustworthy.[108]

In contrast to the formal, rather decorative portrait of Mrs. Adams, several informal portraits of women that King painted in the 1830s are remarkable for their expression of a direct – one is inclined to say American – yet sensitive response to youthful beauty. In two of these, *Mrs. Robert Chew* and *Mrs. James Johnson* (figs. 34 and 35), King again effectively employed the intense chiaroscuro that he used in his powerful self-portrait of 1815, combining it here with a simplicity and delicacy of brushwork and color that make these among the finest of King's female portraits. Less dramatic but more exotic is the portrait of Mrs. Benjamin Larned (fig. 36), the provocative pose and restrained but sensuous color of which is unusual in King's work. The tenderness apparent in the *Mrs. James Johnson* and *Mrs. Benjamin Larned* may have been the result of the affection King felt for these two daughters of his cousin, Mrs. Elizabeth Hannah Newman, with whose family in Washington he maintained a close relationship for many years.

Among the better portraits of King's late period – that is, after 1840 – is his self-portrait completed in 1858 (fig. 37), painted when the artist was seventy-three years old. In its stately pose the picture reflects the deeply rooted influence of the English portrait tradition, which King had absorbed as a student in London, as well as that of Healy's portrait of Guizot. Moreover, a comparison of the portrait with a photograph of the artist taken at about the same time (fig. 38) indicates that King could still set down a good likeness and that encroaching time could not

Figure 34. *Mrs. Robert Chew,* circa 1835, catalog number 43.

Figure 35. *Mrs. James Johnson,* circa 1835, catalog number 105.

Figure 36. *Mrs. Benjamin Larned,* circa 1838, catalog number 132.

diminish his quaint sense of humor, exhibited in the message printed on the piece of paper on the table, ". . . when you have nothing to do, paint your own portrait. Yours Sincerely T. Sully. . . ."

Important as these and other portraits were in establishing King's reputation at the capital, ultimately it was the many Indian pictures he painted that brought him a just and lasting fame. Of course King was not the first artist in America to paint Indian portraits. In Philadelphia in 1735, the immigrant Swedish artist Gustavus Hesselius painted two remarkably incisive portraits of the Delaware chiefs Tishcohan and Lapowinsa. Also in that city, in 1804, the French émigré Charles Févret de Saint-Mémin made crayon portraits of several Indians who were part of one of the first delegations to visit Washington. Unlike King, however, these artists depicted Indians only occasionally, and neither was regularly commissioned to do so by an agency of the federal government.

Commissioned by the Department of War, then administered by Secretary Calhoun, King began his Indian portraits in the winter of 1821-1822 with the arrival of a delegation of Indian chiefs (whom Calhoun sought to befriend in order to realize the goals of his "Missouri Expedition") from the Great Plains tribes of

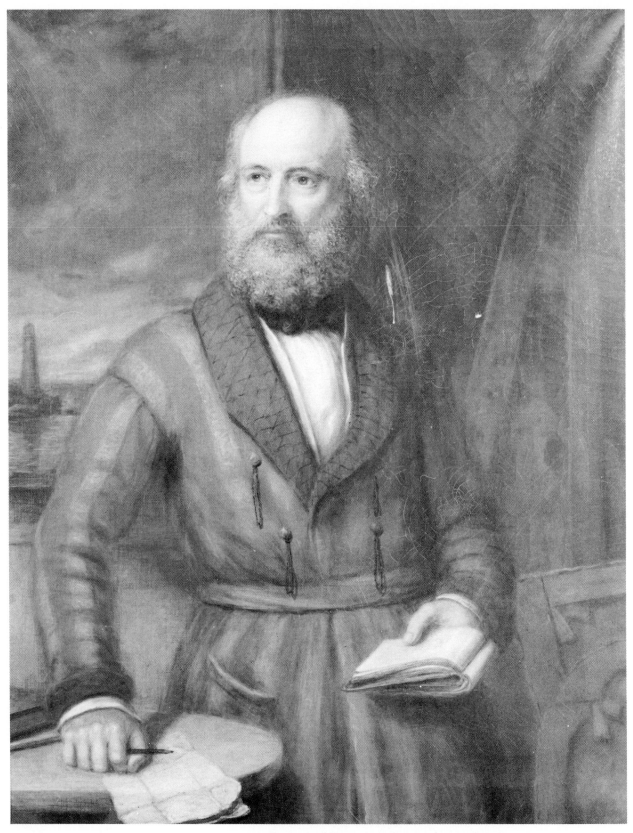

Figure 37. *Charles Bird King,* 1856-1858, catalog number 125.

Figure 38. Charles Bird King, circa 1858. Mrs. Walter Harvey.

the Upper Missouri River. Except for commissions given to artists in the field and to several assistants called upon when the number of delegates was too numerous for him to handle, King continued to receive, almost exclusively, orders to paint portraits of important Indian delegates at the capital until 1842, when financial problems, prejudicial political opposition, and the development of the camera effectively denied the need for such paintings. During these twenty years, King painted about 143 portraits, most of which were completed by 1830, for which he received some $3,500.[109]

All of the Indian portraits were destined for the "Indian Gallery," a collection of Indian memorabilia originated as early as 1816 by Thomas L. McKenney, chief of the Bureau of Indian Affairs, although the idea of including portraits in the gallery may have originated with King, who was long experienced with art collections. Referred to as the "Kickapoo Ambassador," McKenney had a profound understanding of and sympathy for Indians and their rapidly disappearing culture. His interest was perhaps best expressed by his adoption of two Indian boys and by the policy he established for government trade with the Indians, which, as he put it, was engaged in not for profit but for the sake of "pure humanity . . . to sustain . . . refresh, and bless the Indians." Of course this policy was vehemently opposed by the powerful fur companies that sought to dominate trade with the Indians, and by President Jackson, who dismissed McKenney in 1830.[110]

By that year, King had already completed 130 Indian portraits, which, except for

five full-length examples probably painted on canvas, were usually three-quarter-view busts (with no hands) painted on panels about eighteen inches high by fourteen inches wide. However, the replicas given to the Indians themselves were probably smaller, to facilitate transportation. For many years the portraits were housed in McKenney's office on the second floor of the old War Department Building (fig. 39), a Federal-style structure just west of the White House and only a few blocks from King's home. The collection was immensely popular with foreign visitors and natives alike, as is evident in the reaction of that intrepid British traveler Frances Trollope, who visited the capital in 1830 and found the gallery of "great interest," noting that the "original portraits of all the chiefs . . . are by Mr. King and, it cannot be doubted, are excellent likenesses, as are all the portraits I have seen from the hands of that gentleman." Equally praiseworthy were the words of Jonathan Elliot, a resident of the capital who wrote in his Washington guidebook of 1830: "But for this gallery, our posterity would ask in vain – 'what sort of a looking being was the red man of this country?' In vain would the inquirers be told to *read* descriptions of him – These could never satisfy. He must be *seen* to be known. Here then is a gift to posterity."[111]

Unfortunately, Elliot's references to "posterity" turned out to be only partially prophetic. In 1858 the Indian portraits were removed to Renwick's recently completed building for the Smithsonian Institution, where, with an equally remarkable collection of almost 200 Indian portraits and scenes painted by John Mix Stanley, they were hung in a specially designed Gallery of Art (figs. 40 and 41) located at the western end of the building, on the second floor. There, in a fire that raged through the gallery on January 24, 1865 (fig. 42), several years after King's death, this unique and irreplaceable record of the Indians of North America was almost entirely destroyed. Notwithstanding the conclusion of a report made to the Senate in February 1865 that "it is a consolation that by far the greater part of the valuable contents of the building have escaped without injury," the loss to the impoverished Stanley, who had not been paid for his pictures, was irreparable. King had at least been paid for his work and, more important, would have had the satisfaction of knowing that most of his portraits had been preserved in copies he had made and in lithographic reproductions.[112]

Between 1837 and 1844, Thomas L. McKenney, the former chief of the Bureau of Indian Affairs, and James Hall published their monumental three-volume work, *The Indian Tribes of North America with Biographical Sketches and Anecdotes of the Principal Chiefs,* which contained magnificent lithographic portraits of the 120 Indians portrayed therein. Although these colorful reproductions were about the same size as King's paintings, eighteen by fourteen inches, they were not based directly upon the portraits in the Indian Gallery but upon oil copies made by the well-known portrait and genre painter of New York, Henry Inman. Inman painted his copies in Philadelphia, where McKenney, who no longer had direct access to the Indian Gallery, was able to have the originals shipped, several at a time, by former associates.[113]

Judging by King's existing Indian portraits, Inman's copies (entirely preserved at Harvard's Peabody Museum) are remarkably true to the originals except for some minor changes, mostly in the backgrounds. Moreover, since the lithographs are extraordinarily faithful reproductions of Inman's copies, they reflect the originals almost equally well, as can be seen in comparing examples of each of these (figs. 43, 44, and 45).

39.

OLD WAR DEPARTMENT.

40.

THE SMITHSONIAN INSTITUTION.

THE PICTURE GALLERY.

The Gallery of Art.

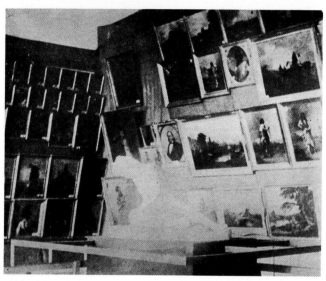

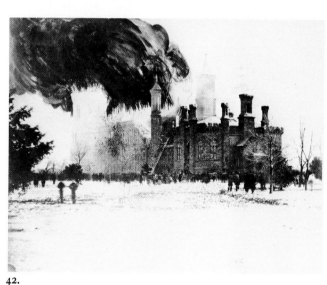

41.

42.

Figure 39. War Department Building in the 1820s, from Benjamin Perley Poore, *Reminiscences of Sixty Years in the National Metropolis,* 2 vols. (Philadelphia: Hubbard brothers, 1886), 1 : 91.

Figure 40. *The Gallery of Art in the Smithsonian Institution Building,* wood engraving, from William J. Rhees, *An Account of the Smithsonian Institution* ... (Washington, D.C.: Thomas McGill, 1859).

Figure 41. The Gallery of Art in the Smithsonian Institution Building, before the fire of 1865.

Figure 42. Smithsonian Institution fire, January 24, 1865.

Indeed, from concept to execution the *Indian Tribes of North America* was superbly wrought. With its handsome illustrations and informative and engaging biographies, all tinged with an underlying Romantic sense of wonder and presentiment about the nature and fate of the hapless Red Man, the history has remained one of the outstanding works on the American Indian. Although King could hardly have wished for a more desirable means by which to be ushered into posterity, it is ironic to recall that his father had been killed by Indians. Moreover, though he might justly have been bitter over such a recollection, King, as is evident in the profound sympathy with which he portrayed his Indian subjects, harbored no animosity toward them. Perhaps he was endeavoring, in the zealous, evangelical Moravian way, to capture the soul of the "savage" nations that his widowed mother had charitably pitied and forgiven.

Despite the many Indian portraits he painted, King's fascination with his subjects seems never to have diminished. Unlike the portraits of some of his "civilized" sitters, who not infrequently reflect the ennui of a tiresome social conformity, the aborigines' images almost always reveal their subjects' restrained but intense indi-

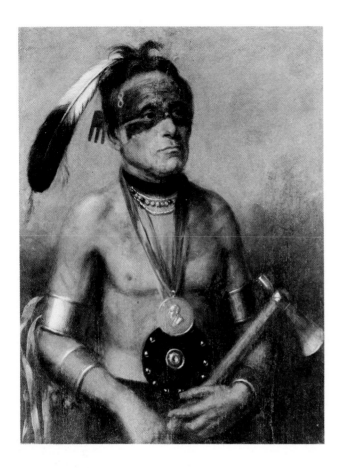 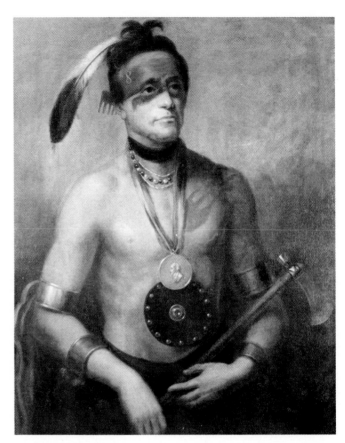

Figure 43. *Hoowaunneka,* 1828, catalog number 339.

Figure 44. Henry Inman, after King, *Hoowaunneka,* circa 1834, oil on canvas, 30½ x 25½ inches (height by width). Peabody Museum, Harvard University, Cambridge, Mass.

viduality and primeval naïveté – characteristics that must have appealed to the repressed Romantic aspect of King's being.

Not surprisingly, many of King's best Indian likenesses were painted in the 1820s, those fruitful years during which he painted the Adams, Clay, and Calhoun portraits. Of the Indian paintings, his portrayals of several of the chiefs from the Upper Missouri who arrived at the capital in late December 1821 are among his most powerful, perhaps because they were his first.

Especially popular among that remarkable group of delegates was the young and handsome chief of the Pawnee Loups, Petalesharro (fig. 46), who had gained fame by rescuing a Comanche maiden from the sacrificial stake of his own tribesmen. In honor of his heroism, the young women of Miss White's Seminary presented Petalesharro with a silver medal engraved with depictions of his rescue and with the words "To the Bravest of the Braves."[114] The story and the strong yet sensitive image of the young warrior proved to be so appealing that reproductions of King's portrait were used even on china plates (fig. 47).

Equally attractive is the portrait of the ruggedly handsome and regal Peskelechaco (fig. 48), chief of the Republican Pawnees. Gazing somberly and pensively outward, the warrior is shown with bared chest and wearing a ceremonial buffalo robe upon which a horse, one of the symbols of the Pawnees, is beautifully represented. Bound snugly about his throat is a wampum band and from his neck hangs a silver "peace" medal bearing the image of President Monroe. The chief's partly shaven

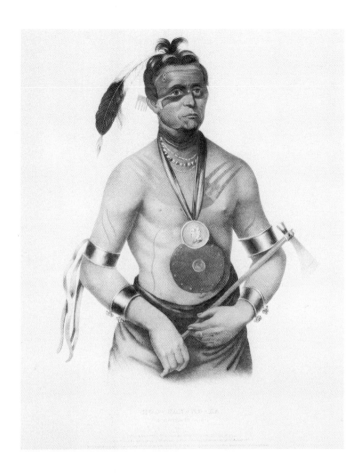

Figure 45. *Hoowaunneka,* 1828, litho-
graph from Inman's copy after King,
from McKenney and Hall's *The Indian
Tribes of North America . . . ,* ed.
Frederick Webb Hodge, 3 vols. (Edin-
burgh: John Grant, 1933-34), 2: 306.

head is capped with a deerhair crest, while circular strands of wampum hang from
his pierced ear. The great dignity of bearing and the unflinching gaze of the warrior
are recorded with unusual sensitivity.

It may have been the commanding appearances and characters of Petalesharro
and Peskelechaco that inspired King to paint his finest picture of the 1822 series and
one of the most impressive works of his entire oeuvre, the group portrait of five
warriors entitled (from left to right), *Young Omaha, War Eagle, Little Missouri,
and Pawnees* (fig. 49). Whatever is best in King as a technician, colorist, and image
maker is fully represented here. Although the subjects comprise a newly discovered
and exotic race, their magnificent image immediately recalls the tradition of the old
masters in which King was so completely steeped: Rubens's study of negro heads;
Philippe de Champagne's multiple portrait of Richelieu; or, getting closer to King's
actual sources of inspiration, Van Dyck's triple portrait of Charles I (fig. 50), or
Hogarth's study of his servants.

Despite the differentiation implied by the title of King's group portrait, the
similarity in the warriors' faces suggests that they were based on the portraits of
Petalesharro and Peskelechaco. The two heads on the right, for example, are surely
after *Peskelechaco,* while that on the left is no doubt based on *Petalesharro,* as are
the two central portraits, though these are modified with features denoting age,
possibly taken from another of King's portraits, *Sharitarish* (see fig. 71), the subject
of which was also a member of the 1821 delegation. In terms of composition, the

Figure 46. *Petalesharro,* circa 1822, catalog number 414.

Figure 47. Petalesharro, circa 1895.
Transfer print on china plate, Krautheim,
Selb Bavaria, Germany. Based on the
lithograph in McKenney and Hall, *The
Indian Tribes of North America...,*
ed. Frederick Webb Hodge, 3 vols.
(Edinburgh: John Grant, 1933-34), 1 : 202.

Figure 48. *Peskelechaco,* circa 1822,
catalog number 411.

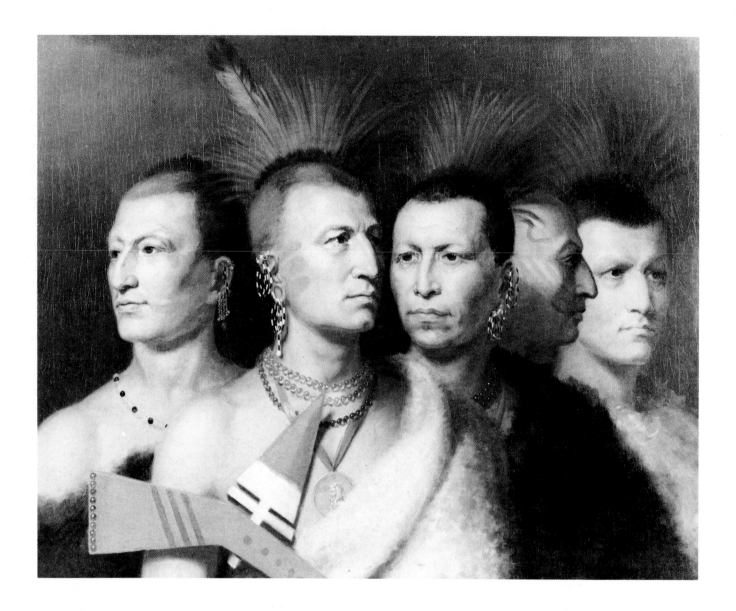

Figure 49. *Young Omaha, War Eagle, Little Missouri, and Pawnees*, 1822, catalog number 484.

disposition of the heads creates a pleasing undulating movement from left to right that is effectively reinforced by the pattern of light and dark, the harmonizing use of reds, and the linear rhythms of the design. Altogether, then, in addition to being a profound study of Indian character, *Young Omaha, War Eagle, Little Missouri, and Pawnees* is a felicitous amalgam of the real and the ideal, qualities seemingly inherent in the subjects themselves to judge from the observations about the 1821 delegation made by the English farmer William Faux, who wrote, "All of them were men of large stature, very muscular, having fine open countenances, with the real noble Roman nose, dignified in their manners, and peaceful and quiet in their habits."[115]

Apparently, the *Young Omaha, War Eagle, Little Missouri, and Pawnees* was painted not for the Indian Gallery but for display in King's own studio and later in his gallery, where he also exhibited his many replicas of the Indian portraits he painted for the government. Chapman undoubtedly saw and admired these likenesses

Figure 50. Sir Anthony Van Dyck, *Charles I,* circa 1635, oil on canvas, 33¼ x 39¼ inches (height by width). The Queen's Gallery, London.

while he was studying with King and eventually acquired the portrait of an Indian maiden, *Hayne Hudjihini,* and the group portrait, *Young Omaha . . . and Pawnees* (or another version of it), which he exhibited under King's name at the National Academy of Design in New York in 1837 and 1838, respectively.[116]

That Chapman should have owned these two paintings was no coincidence. After years of maneuvering, he was awarded a commission in 1837 to paint one of the four remaining panels for the Rotunda of the Capitol. Since Chapman's subject was to be "the baptism of Pocahontas," and since he had no experience in painting Indians from life, he naturally turned for authentic examples to King, either importuning his friend to sell the two portraits or to exchange them for two of his own.[117]

A close study of Chapman's mural (fig. 51) shows that he made good use of King's pictures. The figure of Pocahontas, for example, draws from King's *Hayne Hudjihini* (fig. 52) for its smooth, rounded countenance, slanted eyes, and high forehead, while the features of her brother, Nantequaus (standing right of center and, oddly enough, looking right as War Eagle does), are remarkably similar to those of War Eagle, the foremost figure in the *Young Omaha . . . and Pawnees* group portrait. The half-clothed seated and standing Indians in the lower right corner of the mural are likewise based on King's Little Missouri and the Pawnee in profile to the right in the group portrait. Finally, the scene in the right foreground of the mural, depicting Pocahontas's sister and her child seated on the floor, is no doubt adapted from another of King's portraits, *Mohongo and Child* (see fig. 58). As a matter of fact, inasmuch as the mural was completed, according to tradition,

Figure 51. John Gadsby Chapman, *The Baptism of Pocahontas,* 1837-1840, oil on canvas (mural), 12 x 18 feet (height by width). United States Capitol Building, Washington, D.C.

Figure 52. *Hayne Hudjihini,* circa 1822, catalog number 335.

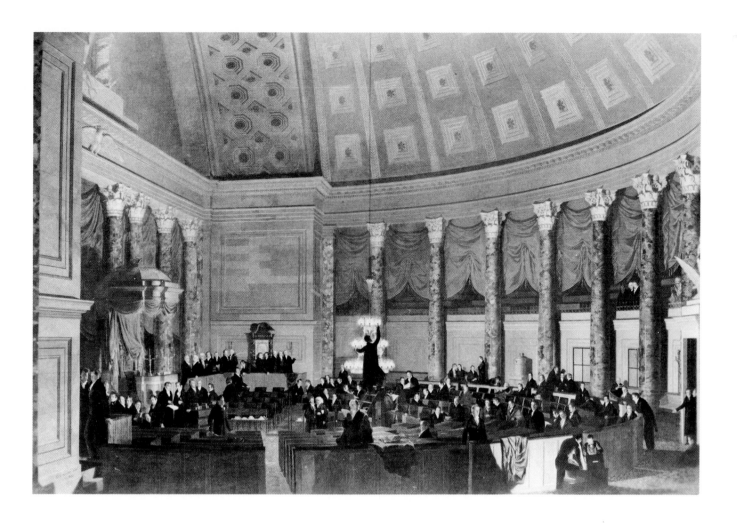

Figure 53. Samuel F. B. Morse, *The Old House of Representatives,* 1822, oil on canvas, 86½ x 130¾ inches (height by width). Corcoran Gallery of Art, Washington, D.C.

in James Clephane's barn in Washington (where Sully saw it in 1840) and inasmuch as the barn was only two blocks from King's studio, it is likely that King offered Chapman an abundance of criticism on the project.[118]

Other artists also adapted King's Indian paintings to their own uses. In his *The Old House of Representatives* (fig. 53), which he began in Washington in the fall of 1821, Samuel F. B. Morse included among the four observers in the balcony (the figure to the left is unidentifiable) his father, the Reverend Jedidiah Morse, second on left; Benjamin Silliman, scientist and professor at Yale, to the right of Morse; and, on the far right, none other than Petalesharro, whose image is a literal if sketchy translation of King's. An engraving of King's *Petalesharro* was also used by the elder Morse as the frontispiece for his *Report to the Secretary of War* (published in 1822) on "the moral and material condition of the Northwest Indians." Even Stanley utilized some of King's images in at least one work, his *Indian Council at Tahlequah* of 1843.[119]

Despite the diminutive size of most of King's Indian portraits, many are monumental in effect, as are the *Wakechai* (fig. 54) and *Pushmataha* (fig. 55). Lush in color, these and other examples have a painterly quality comparable, in their way, to some of Delacroix's studies of heads of the 1820s, with which they are contemporary. In addition, many of the portraits are telling character studies. The

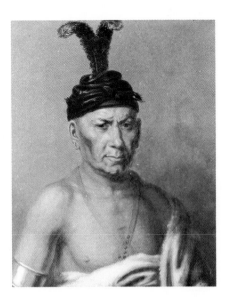 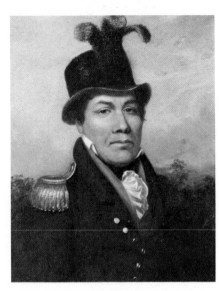

Figure 54. *Wakechai*, circa 1824, catalog
number 472.

Figure 55. *Pushmataha*, 1824, catalog
number 423.

Pushmataha, painted in the year (1824) of the great Choctaw leader's death,
captures the red man's childlike fascination with the white man's colorful regalia
and at the same time conveys something of the chief's strength of character. Push-
mataha's wisdom had led him to seek an accommodation with the more powerful
settlers, and on his deathbed he asked that "the big guns be fired over me."[120]

Equally interesting was Sagoyewatha, a Seneca chief portrayed in figure 56.
While he, too, sought peace with the white man, he insisted on preserving Indian
customs. In fiery oratory he denounced the Indians' growing dependence on foreign
implements and their acceptance of foreign beliefs, especially those of the mission-
aries sent among them, of whom he said:

They do us no good. . . . If they are useful to the white people . . . why do they not keep
them at home? They tell us different stories about what . . . [the Bible] contains. . . .
If we had no . . . land . . . to be cheated out of, these black coats would not trouble . . .
about our good hereafter.[121]

Sagoyewatha's deep sense of humanity and his ability to dispense a withering
sarcasm somehow coalesce in King's simple but powerful portrait of him.

Since Indian women seldom were part of the delegations coming to Washington,
King painted them infrequently. When he did, the portraits were attractive but
lacking in character, as is evident in his *Hayne Hudjihini,* even though the subjects
themselves included such intriguing personalities as the wiley Tshusick and the
tragic Mohongo. Tshusick (fig. 57) arrived at the capital in tatters and left with
gifts that had been showered upon her by Washington society, which later found
she had left a similar trail of contrived tears in other cities. It was otherwise with
Mohongo, who, with her husband, had been taken to Europe, exploited as a primi-
tive showpiece, abandoned, then widowed during the voyage home. In Washington
she and her child were aided in returning to Missouri. Before they left in 1830,
McKenney importuned King to paint their portraits (fig. 58): "There is an Osage
woman & her child at William's [Hotel]. The Secretary agrees if you will paint
her, & introduce the head of her child for 20$ to have her painted. *Better do it* – I

Figure 56. *Sagoyewatha*, 1828, catalog number 432.

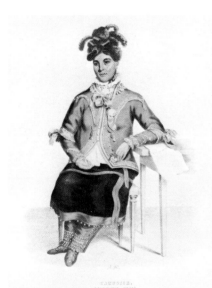

Figure 57. *Tshusick*, 1827, lithograph from Inman's copy after King, from McKenney and Hall, *The Indian Tribes of North America* . . . , ed. Frederick Webb Hodge, 3 vols. (Edinburgh: John Grant, 1933-34), 1 : 353.

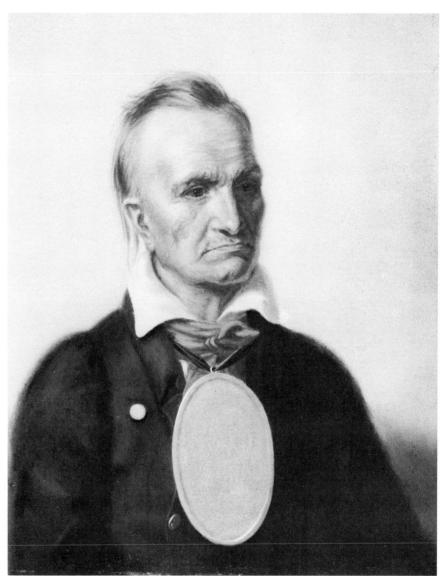

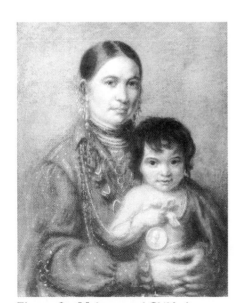

Figure 58. *Mohongo and Child*, circa 1830, catalog number 377.

think it may open the door, again, for more work. The gallery is growing daily, in popularity."[122]

One Indian painting, the *Indian Girl at Her Toilet* (fig. 59), is unique in King's oeuvre. In what may be the single instance in which he gave relatively free rein to his Romantic inclinations, King attempted to paint a vision of loveliness. Seated in a glade in the woods, vibrant with light and atmosphere, the maiden gazes dreamily at herself in a mirror, her mood of reverie strangely reminiscent of the *Indian Widow* painted by Joseph Wright of Derby in 1785 (fig. 60). The theme of King's painting, the aborigine happy in the state of nature, was popular and was also played upon by Alfred Jacob Miller in his *Indian Girl Swinging* of about 1859 (fig. 61).

Not all of the Indian portraits executed by King were painted from life. At times, when the number of delegates to the capital abated, he was asked to paint oil

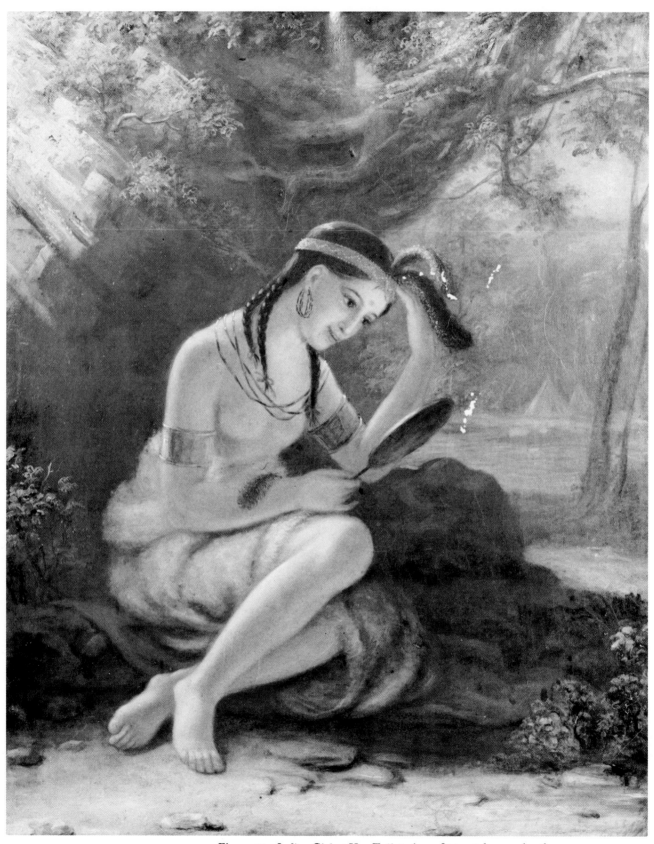

Figure 59. *Indian Girl at Her Toilet*, circa 1835, catalog number 620.

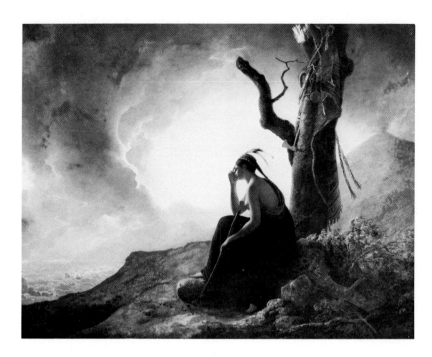

Figure 60. Joseph Wright, *The Indian Widow*, 1785, oil on canvas, 40 x 50 inches (height by width). Derby Art Museum and Art Gallery, Derbyshire, England.

Figure 61. Alfred Jacob Miller, *Indian Girl Swinging*, circa 1859, watercolor on paper, 10¹⁵⁄₁₆ x 9½ inches (height by width). Walters Art Gallery, Baltimore, Md.

versions of portrait sketches made by others in the field. In 1826-1827, for example, he copied over thirty portraits made for the War Department by James Otto Lewis while the latter was among the Indians of the western Great Lakes. Though crude and awkward, Lewis's images have an appealing raw power that King was able to preserve in his copies. This is evident in comparing King's copy of Lewis's *Wanata* (fig. 62) with a lithograph (fig. 63) made from Lewis's original portrait for his *Aboriginal Port-Folio*, a collection of seventy-two Indian portraits published in 1835 in anticipation of McKenney and Hall's *Indian Tribes of North America*.[123]

Several recently discovered charcoal studies by King of the heads of Indian subjects are of great interest because they reveal his traditional techniques and his facility as a draftsman. As can be seen in a comparison of King's charcoal study of Moanahonga to an extant oil replica of the portrait and to the lithograph that appeared in the *Indian Tribes of North America* (figs. 64, 65, and 66), both of which were based on the original version destroyed in the fire of 1865, King followed the pattern of the classically trained artist in making an original drawing from life and replicating it as many times as he wished by blackening the back and tracing the drawing onto a prepared surface. There are, as examples, five versions of King's *Hayne Hudjihini* and three of his *General John Stricker*. No doubt these studies, taken immediately from life to insure their fidelity as likenesses, were complemented by other studies designed to resolve problems of costume, background, and chiaroscuro, although none of the latter have been located. Perhaps they were among the six portfolios of sketches in pencil, wash, and oil that were sold (for $14.30!) on King's death.[124]

These studies by King rank well among American works of the time, revealing a competent and incisive hand capable of recording quickly and simply the essence of various personalities. Yet, in the generally ovoid heads, heavy eyelids, and rounded

Figure 62. *Wanata,* after James Otto Lewis, 1826, catalog number 475. Figure 64. *Moanahonga,* circa 1824, catalog number 636.

lips, something still remains of the mannerisms evident in West's studies, such as his *Portrait Head of a Lady* of about 1779 (fig. 67). This is not to say that because King generalized his forms to some degree his likenesses are not faithful. Indeed, as has been discussed previously in respect to other portraits by King, he treated his non-Indian subjects with candor and there is every indication that he treated his Indian subjects in the same manner. Nonetheless, it is true that because he never lived and painted among the Indians in their own environment, King's portraits, painted entirely in his studio in Washington, lack the sense of natural vitality evident in the works of such an artist as George Catlin.

Even the untrained eye can see, for example, that many of King's Indian portraits have features that are markedly caucasoid. This may largely be explained by the

Figure 63. James Otto Lewis, *Wanata,* lithograph from Lewis's *Aboriginal Port-Folio* (Philadelphia: J. O. Lewis, 1835-36).

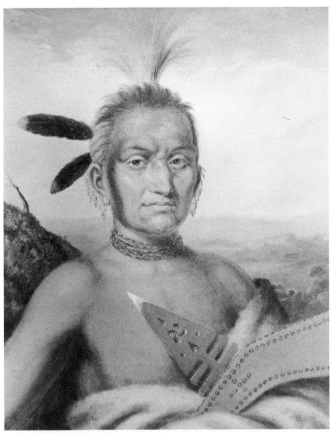

Figure 65. *Moanahonga,* circa 1824, catalog number 375.

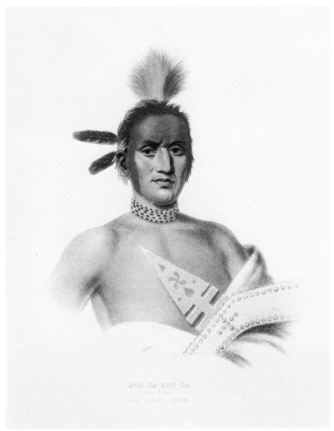

Figure 66. *Moanahonga,* 1824, lithograph from Inman's copy after King, from McKenney and Hall, *The Indian Tribes of North America...,* ed. Frederick Webb Hodge, 3 vols. (Edinburgh: John Grant, 1933-34), 1 : 318.

Figure 67. Benjamin West, *Portrait Head of a Lady,* circa 1779, black chalk on paper, 14⅜ x 10½ inches (height by width). Pierpont Morgan Library, New York, N.Y.

fact that many of the delegates he painted were of mixed blood,[125] as well as by the artist's tendency to soften and round his forms. As an example of his occasional lapse of verity, King's portrait of the Assinaboin chief, Wijunjon, is often compared to Catlin's (figs. 68 and 69, both painted about 1831-1832). Although there is an obvious discrepancy between the likenesses in the two works, it should be pointed out that it is not certain that King's portrait is of Wijunjon; it may, in fact, depict another delegate who accompanied the Assinaboin delegation to the capital.[126]

A comparison of several of King's Indian portraits to those of members of the 1821 delegation painted by John Neagle, and to extant photographs of some of King's subjects, allows a fair estimation of the exactness of King's likenesses. The subject of Sharitarish in Neagle's double portrait, *Choncape and Sharitarish* (fig. 70), for example, shows a remarkable similarity to the same subject as portrayed by King (fig. 71). Neagle's Choncape, however, bears less resemblance to King's Choncape (fig. 72) than to King's Ongpatonga (fig. 73), a member of the same delegation. The question is thus raised as to whether Neagle may have made an error in identifying his subject. How likely this possibility is may be judged by

Figure 68. *Assinaboin Indian (Wijun-jon? The Light),* circa 1832, catalog number 308.

Figure 69. George Catlin, *Wijunjon,* 1832, oil on canvas, 29 x 24 inches (height by width). Smithsonian Institution, Washington, D.C.

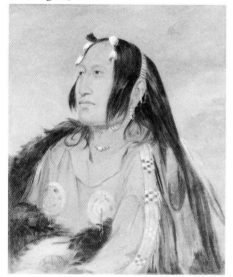

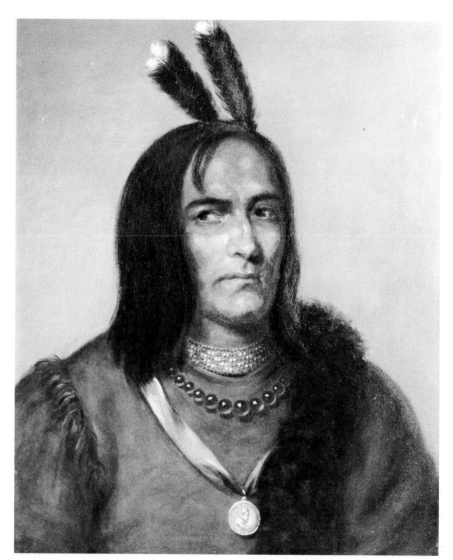

comparing Neagle's Petalesharro (fig. 74) to King's (see fig. 46). The similarity of the two subjects is unquestionable, although King's is the more appealing. Equally striking is the resemblance between King's Notchimine and Keokuk (figs. 75 and 77) and the photographs of these men, which were made years after the portraits were painted (figs. 76 and 78). Perhaps, then, one may take at face value the words of Secretary of War James Barbour, who also encouraged McKenney's development of the Indian Gallery:

Believing as I did, that this race was about to become extinct, and that a faithful resemblance of the most remarkable of them would be full of interest in after times . . . this duty was assigned to Mr. King of Washington, an artist of acknowledged reputation; he executed it with fidelity and success, by producing the most *exact* resemblances. . . .[127]

In addition to the several portraits singled out here for special attention, King painted hundreds more, both of Indians and of whites. His subjects were the great

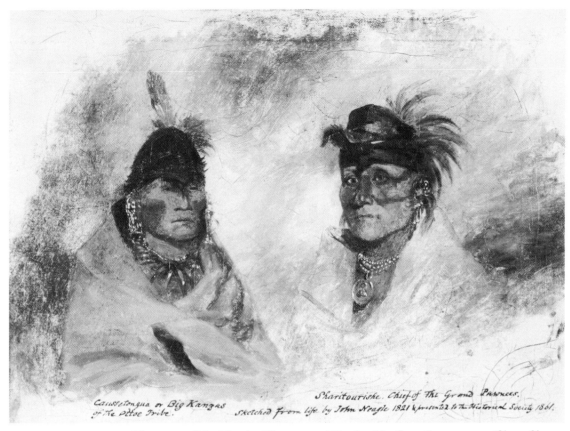

Figure 70. John Neagle, *Choncape and Sharitarish*, 1821, oil on canvas, 16⅜ x 22¾ inches (height by width). Historical Society of Pennsylvania, Philadelphia.

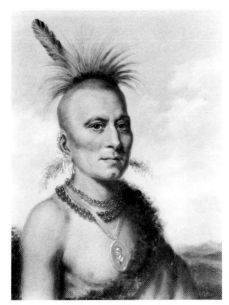

Figure 71. *Sharitarish*, circa 1822, catalog number 440.

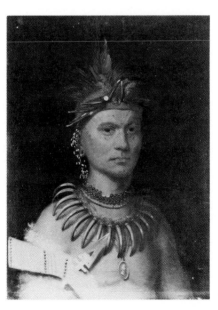

Figure 72. *Choncape*, circa 1822, catalog number 321.

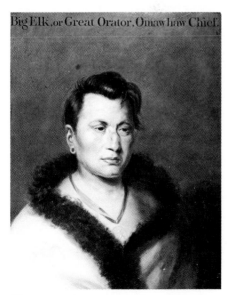

Figure 73. *Ongpatonga*, circa 1822, catalog number 398.

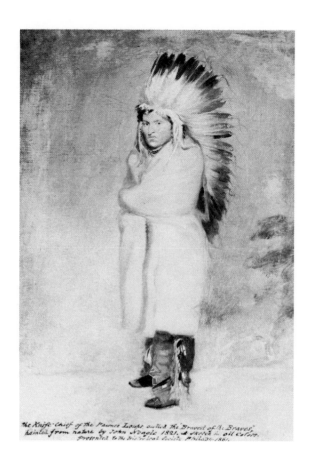

Figure 74. John Neagle, *Petalesharro,* 1821, oil on canvas, 16⅜ x 22¾ inches (height by width). Historical Society of Pennsylvania, Philadelphia.

and the humble alike, and included not only the living, but occasionally even the dead. Upon calling at her cousin's studio in April 1839, for example, Mrs. Newman found that he was at "the Late Mr. Bowie's who died last night. The family wish to have a likeness of him."[128]

King also often painted replicas or copies of his portraits, no doubt to enhance his gallery. His practice of retaining many of his original portraits, however, suggests other motives, as well. Although a number of these originals were of nationally known figures, others were of subjects less renowned, such as Smith Thompson (former secretary of the navy, then associate justice of the Supreme Court) and George McDuffie (previously a congressman, but then governor of South Carolina), each of whom wrote to King requesting copies of their portraits.[129] This range of subjects seems to suggest that, like many others – Charles Willson Peale, Delaplaine, Herring and Longacre, and the sculptors John I. H. Browere and Edward A. Brackett – King hoped that Congress would eventually acquire his collection to form a national portrait gallery. If so, like the others, King pursued the elusive dream in vain, with the exception that he alone was partially successful in the portraits he painted for the Indian Gallery. Perhaps sensing the futility of waiting on Congress, and motivated by increasing age and by the considerable expansion of the Redwood Library during the late 1850s, King gradually deposited all of his portraits, and many other pictures as well, in the library that had been his boyhood refuge. Thus were transferred to Newport representative works of one of the city's most famous native sons and Washington's artist-in-residence.

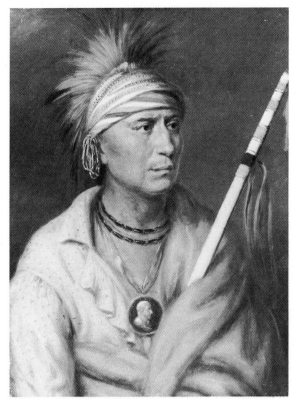

Figure 75. *Notchimine (No Heart)*, 1837, catalog number 390.

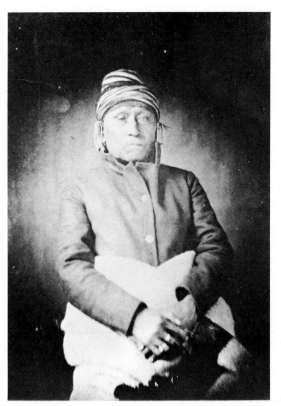

Figure 76. Photograph of Notchimine, before 1862.

Figure 77. *Keokuk,* 1827, catalog number 349.

Figure 78. Keokuk, 1847, daguerreotype.

VII *Subject Paintings*

Contrary to the generally accepted view that King was nothing more than an industrious "phiz monger," the few of his nonportrait works still extant, as well as the many titles of those which are lost, indicate that his choice of subject matter was extremely varied. As early as 1824, during his visit to King's studio in Washington, Charles Willson Peale noted seeing "still life, landscapes, and 'emblematical' pieces."[130] To these may be added the many history, genre, "fancy" pieces, seascapes, religious pictures, and even copies from plaster casts that the artist painted. Among these, King's best and most original works are his still lifes, genre, fancy pieces, and landscapes.

Like his *Still-Life, Game* of 1806 and *Poor Artist's Cupboard* of 1815, King's *The Vanity of the Artist's Dream* of 1830 (fig. 79) is in the tradition of seventeenth-century Dutch art. However, in its restrained brushstroke, limited palette, and harmonizing chiaroscuro, the *Vanity* is not as daring as the *Cupboard,* of which it seems to be a sequel. Yet, it goes well beyond that work in its symbolism, and represents King at the height of his powers, technically and intellectually.

Like its companion piece, *The Vanity of the Artist's Dream* depicts the accumulated debris of an artist's studio, and several of the books used in the *Poor Artist's Cupboard* appear again, showing a properly advanced state of wear. Conspicuously absent are the beaver hat and the conch shell, which have been replaced by a fragmented plaster head of the Apollo Belvedere, possibly part of the collection of casts King bought in 1824-1825. The *Vanity* also contains explicit statements of rebuke. Just over the bread, for example, King noted, with no little hyperbole, that at an exhibition in Philadelphia a catskin brought in $1,200, whereas Lawrence's portrait of West could not produce enough to pay expenses. The writing here is continued out to the edges of the painted frame, creating a unique double trompe l'oeil effect, and includes humorous and didactic aphorisms, such as "Women after all are certainly a little wayward, just made to fatigue or please us. . . ."[131]

The Vanity of the Artist's Dream not only exploits the same images as the *Poor Artist's Cupboard* but likewise symbolizes the senses – hearing is suggested by the sound of coins being spilled by the figure of Plenty in the background – and the struggle between the artist and society. But whereas the *Cupboard* focuses on the plight of the artist, The *Vanity* concerns itself with the rejection by society of art itself, personified in the head of the Apollo. So critical is the condition of the arts that Plenty empties her cornucopia of its dwindling riches.

Thus, like the *vanitas*, King's painting moralizes on the injustice of the temporal world toward the "spiritual" world of the arts. Unlike the *vanitas*, however, the concern of King's *The Vanity of the Artist's Dream* is not metaphysical, but with what he perceived to be the sad condition of the arts in America at the time (although one cannot be certain even of this; King's *Itinerant Artist,* painted about the same time, is much more optimistic in mood). In urging the cultivation of the arts in *The Vanity of the Artist's Dream,* King inverted the traditional message of the *vanitas,* which reflects on the futility of all human endeavors.

The more mundane theme of King's *The Vanity of the Artist's Dream* relates it more closely to the "attributes" painting of the eighteenth century. In Pierre Subleyras's *Attributes of the Arts* of the 1730s (fig. 80), for example, Saint Susanna

81

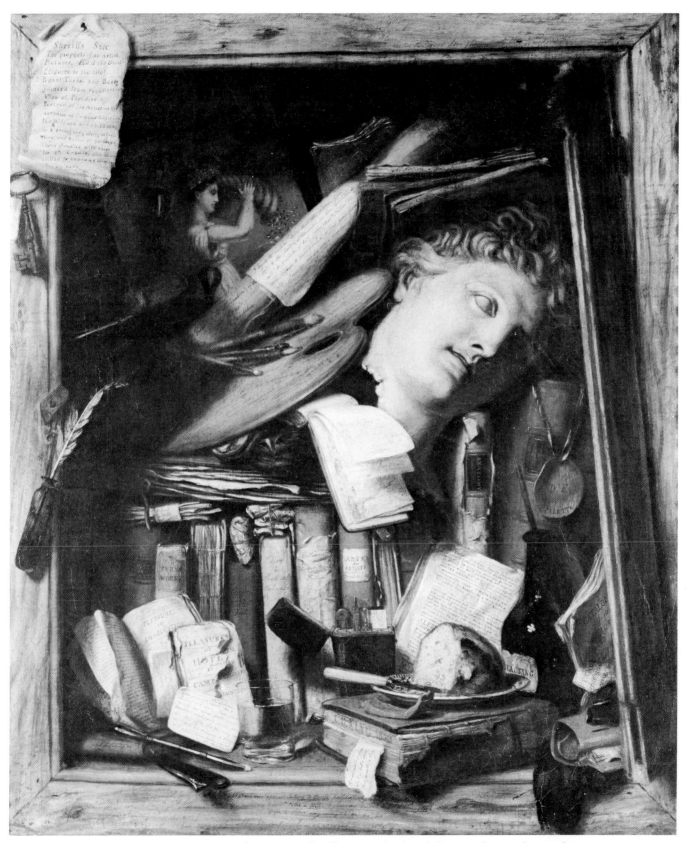

Figure 79. *The Vanity of the Artist's Dream,* 1830, catalog number 501.

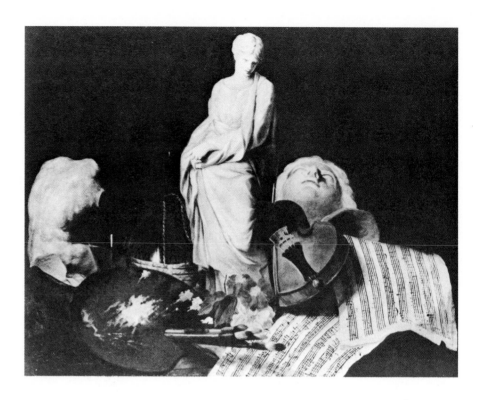

rejects the symbols of the sensual life – the torso Belvedere and the flask and glass of wine – in favor of the arts, symbolized by a head of Apollo remarkably similar to King's.[132] Similarly, in Johann Schenau's *Der Weise* of 1773 (fig. 81), an allegory on the vanity of wisdom, one also finds an Apollo's head much like King's, perhaps not coincidentally, considering that King owned a print of the painting and had made a copy of it.[133] That such themes should have appealed to King is not surprising: by requiring the expression of philosophical notions through an accumulation of objects, they provided exactly the combination required to stimulate King's wit and skill as an illusionist to their most creative pitch.

The Vanity of the Artist's Dream is also unusual among King's patintings in that it is clearly signed and dated on the front and includes a humorous reference, on the right side of the role of paper above Apollo's head, to its probable owner: "I regret to inform you that the Picture you *lent* to the Boston Athenaeum for their Exhibition is sold (*by mistake at half price*) to Mr. Fullerton who refuses to relinquish it or pay your price. The Directors say it is none of their business. . . ."

The purchaser referred to was undoubtedly J. Fullerton, a Bostonian who probably first encountered King's work in 1828 at an exhibition held by the Boston Athenaeum. King was represented by three portraits and a still life entitled *The Poor Artist's Closet,* possibly the picture now known as the *Poor Artist's Cupboard.* In the same year Fullerton apparently visited Philadelphia, and while there may have met King through Sully, who recorded in his journal that he "called on Mr. & Mrs. Fullerton of Boston." In any case, Fullerton is listed in the athenaeum's catalog of 1832 as the owner of King's *Poor Artist's Study,* as well as of a host of other works that suggest that he had a discriminating taste for American paintings. In addition to the painting by King, Fullerton owned four other still lifes, three of which were by James Peale; five seapieces, two by Thomas Birch and three

Figure 81. Johann E. Schenau, *Der Weise,* 1773, engraved by C. F. Stoelzel, 1774. Redwood Library and Athenaeum, Newport, R.I.

by Robert Salmon; four landscapes, two of them by Thomas Doughty; and a painting by Alvan Fisher. He also owned Sully's copy of King's *Grandfather's Hobby,* discussed below.[134]

The otherwise simple conclusion that the *Poor Artist's Cupboard* and *The Vanity of the Artist's Dream* were the pictures that King exhibited at the Boston Athenaeum in 1828 and 1832, respectively, is complicated by two facts. The first is that at the Apollo Association's annual lottery in December 1839, a painting by King entitled *The Property of a Poor Artist* was raffled off to an Albert Christie of New York. The second is that upon his death in 1862 the artist bequeathed to the Redwood Library a still life entitled *Poor Artist's Closet; or Sale of Artist's Effects,* which the library disposed of after 1885. These transactions require that at least a third still life was painted by King, either an original conceived along the lines of the *Poor Artist's Cupboard* and *The Vanity of the Artist's Dream,* or a replica of one of them.[135]

Quite distinct from King's vertical cupboard-type still lifes are his horizontal "tabletop" pictures, in which are depicted, in the Dutch manner, various foods and exotic items. These included a still life, *Shells and Coral,* a game piece called *Basket with Beef and Poultry; Fish Nearby,* a vegetable piece, and at least six fruit pieces, all of which are now unlocated, except for two of the latter.

King's *Grapes, Peaches, Pears, with Decanter,* and the *Pomegranate, Grapes, Pineapples* (figs. 82 and 83) are among the more appealing of his pictures. Accord-

Figure 82. *Grapes, Peaches, Pears, with Decanter*, circa 1815-1825, catalog number 493.

Figure 83. *Pomegranate, Grapes, Pineapples,* circa 1835-1840, catalog number 495.

Figure 84. Villa of Edward King, 1849, Newport, R.I., designed by Richard Upjohn.

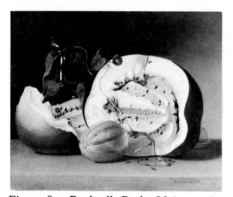

Figure. 85. Raphaelle Peale, *Melons and Morning Glories,* 1813, oil on canvas, 20¾ x 25¾ inches (height by width). National Collection of Fine Arts, Smithsonian Institution, Washington, D.C.

ing to family tradition, they were given by King to his first cousin, Edward King, to grace the dining room of the latter's lovely new Italianate villa (fig. 84), which was designed in 1849 by Richard Upjohn and from which the artist was buried in 1862. In its insistence on contour, color, and highlights, the *Grapes, Peaches, Pears, with Decanter* is similar to King's *Poor Artist's Cupboard* and *Rip Van Winkle Returning from a Morning Lounge* (see fig. 86), and thus was probably painted between 1815 and 1825. The muted tones of the *Pomegranate, Grapes, Pineapples* are comparable to *The Vanity of the Artist's Dream,* a similarity suggesting that the former was painted between 1830 and 1840. The frontal composition and controlled lighting of both pictures suggest the influence of the Peales, especially of James and Raphaelle (fig. 85), whose works King undoubtedly knew well as a result of his early residence in Philadelphia, his later frequent visits there, and his long friendship with Rembrandt Peale. Yet, King's paintings seem less insistent than those of the Peales, although the objects are as well observed. Moreover, there is a similarity between King's *Grapes, Peaches, Pears, with Decanter* and contemporary still lifes by Thomas Badger and Eliab Metcalf that requires exploration.[136]

Of the many genre subjects King is known to have painted, only four are extant. On the basis of these and the titles of lost works, it is evident that the artist ranged widely in this field. His enduring taste for genre had been developed abroad where, it will be recalled, he painted the *Children and Bubble,* one of the first pictures he exhibited after returning home in 1812. What is known of the picture indicates that it depicted one of those charmingly sentimental scenes that had become increasingly popular in Europe throughout the eighteenth century and during the early nineteenth century, especially in England[137] at the very time that King was there.

Among the many English painters of genre, Sir David Wilkie seems to have had the greatest impact on American artists of the early nineteenth century, including King. Why this was so may be explained by the reaction of the critic for the *Port Folio* to John Krimmel's copy of Wilkie's *The Blind Fiddler,* which was exhibited at the Pennsylvania Academy of the Fine Arts in 1813.

Mr. Wilkie may be considered the founder of a new school of painting – he appears to have copied nature very closely, without her deformities: he has given all the character and finish of *Teniers* without his vulgarities. His pictures are equally interesting to the learned and ignorant. . . . We have thus been particular relative to this artist, because we believe his school of painting is well fitted for our republican manners and habits. . . .

The reference to Teniers was fitting, for Wilkie, whose principal source of inspiration was seventeenth-century Dutch and Flemish art, was known as the "Teniers of Scotland." As for the appropriateness of his style of art for a democratic society, time would prove otherwise.[138]

Wilkie's influence is evident in King's *Rip Van Winkle Returning from a Morning Lounge* (fig. 86) and the *Itinerant Artist* (fig. 87). Their homey quality, still-life detail, and spatial contrivances clearly echo Wilkie's two most popular pictures, *The Blind Fiddler* of 1806 (fig. 88) and the *Blind Man's Buff* of 1812 (fig. 89), the dates of which exactly span the time King was in England. Also inspired by Wilkie is the sense of artificiality in King's paintings, as seen in their peasantlike interiors and in the rather theatrical poses of their subjects.

The *Rip Van Winkle* is one of the few literary subjects that King attempted, unlike his friend Leslie, whose fame was wholly based on literary works. The painting's precise linearity, strong lighting, and handsome coloring suggest a date of about 1825, which, if even nearly correct, would place it among the earliest illustrations of Washington Irving's *Sketch-Book,* published in 1819-1820.

Notwithstanding its lack of spatial cohesion, the *Rip Van Winkle* is attractively colored and has a strangely appealing quality engendered by the eerie light from the window, the mysterious staircase, and the intensely introspective children in the middle of the picture. Perhaps King centered on the boy blowing bubbles purposely, to signify (as in the Dutch tradition) the transience of life or the futility of worldly pursuits – an appropriate reflection on Rip's shrewish wife, no doubt. It is instructive to contrast King's oblique and intellectualized interpretation of Irving with John Quidor's more robust and raucous *The Return of Rip Van Winkle* of 1829 (fig. 90), which seems almost a visual counterpart of the written passage.

Altogether different in spirit is King's *Itinerant Artist,* which may be a biographical statement on the artist's years as a peripatetic limner. Given the passage of some fifteen years, the appearance of the artist in the picture is remarkably similar to King as he depicted himself in his portrait of 1815. Even the style of the *Itinerant Artist,* with its cohesive composition and color scheme and soft but dramatic chiaroscuro, accords well with a date of about 1830.

Working in the tradition of Adrian van Ostade's *The Painter's Studio* of about 1640, a print of which he owned (fig. 91), King created in the *Itinerant Artist* an imaginery setting and situation that nevertheless effectively convey the story of the itinerant artist triumphing under the most adverse conditions. The sense of pleasure that pervades the picture is diametrically opposed to the mood of *The Vanity of the Artist's Dream,* painted in the same year, yet both reflect King's witty manipulation of themes.

It is evident from the foregoing discussion that the impact on King of the Dutch or Dutch-inspired art he had experienced in England did not abate after his return home in 1812. Several copies he made of Dutch paintings further attest to that interest: *Smoker and Card Player,* from Adrian van Ostade; *The Chemist in*

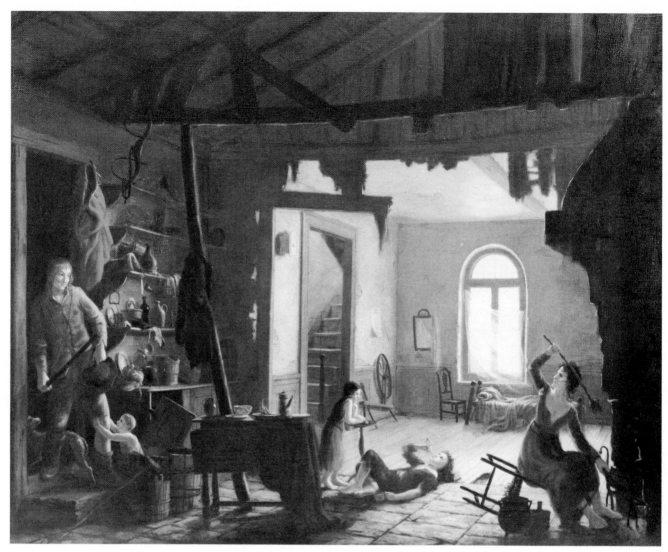

Figure 86. *Rip Van Winkle Returning from a Morning Lounge,* circa 1825, catalog number 598.

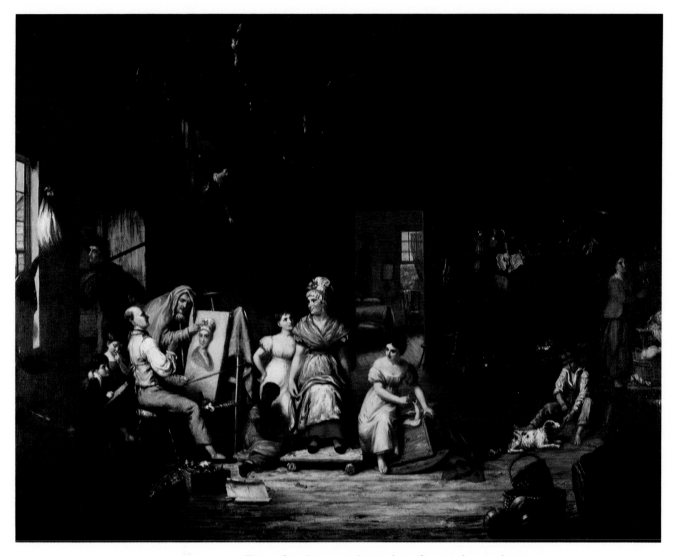

Figure 87. *Itinerant Artist,* circa 1830, catalog number 545.

88.

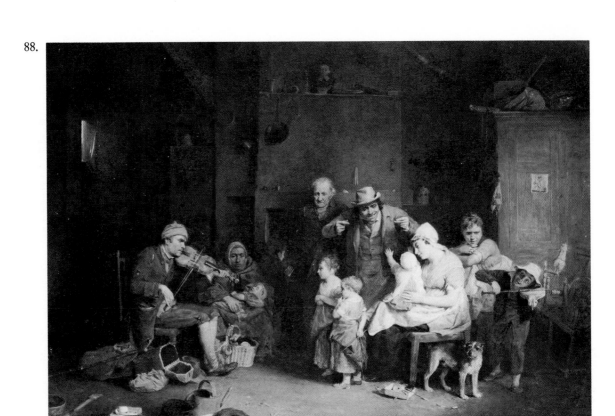

89.

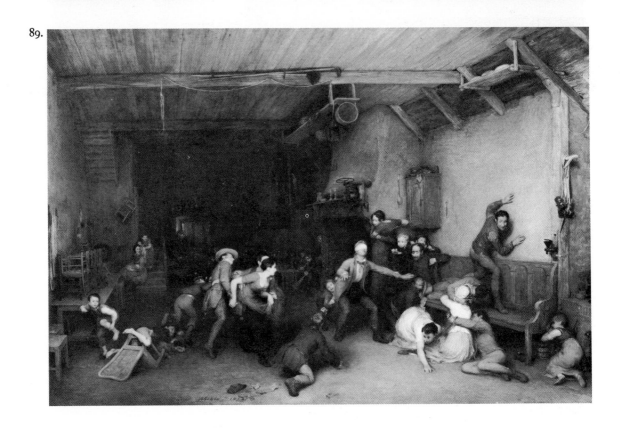

Figure 88. Sir David Wilkie, *The Blind Fiddler*, 1806, oil on panel, 23 x 31 inches (height by width). Tate Gallery, London.

Figure 89. Sir David Wilkie, *Blind Man's Buff*, 1812, oil on panel, 24¾ x 37¼ inches (height by width). The Queen's Gallery, London.

Figure 90. John Quidor, *The Return of Rip Van Winkle*, 1829, oil on canvas, 30¾ x 49¾ inches (height by width). National Gallery of Art, Washington, D.C.; Andrew W. Mellon Collection.

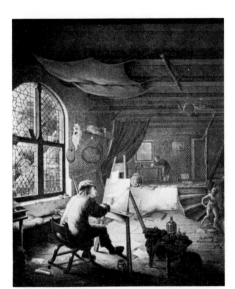

Figure 91. Adrian van Ostade, *The Painter's Studio*, circa 1640, lithograph by E. Ekeman-Alleson. Redwood Library and Athenaeum, Newport, R.I.

Meditation, from Gabriel Metsu; and *Rustic Scene*, from Nicholas Berchem. Indeed, King's too-heavy reliance on European sources as inspiration for his genre pieces seems to have prevented their achieving the widespread recognition of his Indian portraits. The few of his genre works still extant have a contrived air that is alien to the very effective and popular genre scenes painted by Bingham, Mount, and Woodville, all of whom were no less influenced than King by Dutch art.

The bulk of King's genre paintings seem to have been of the kind represented by his *Children and Bubble,* subjects that appealed to the popular taste for sentimental representations of children. Such paintings would appear to be entirely at odds with the intellectual subtlety of his *The Vanity of the Artist's Dream* and the powerful realism of his Indian portraits. Yet, sentimental subjects such as his *Grandfather's Hobby,* which depicts a little boy playing the role of an adult, obviously commanded a wide public and often occupied the talents of the best artists of the age.

King painted at least three versions of the *Grandfather's Hobby,* of which two are extant (figs. 92 and 93). According to Neal, the idea for the subject originated with Leslie and was appropriated by English and French artists as well as by King, an assertion that may be true at least in part. It is a fact, however, that King's original was faithfully copied by Sully (fig. 94), who may have listed it in 1824, in his scrupulously kept register of paintings, as *Juvenile Ambition.* Possibly both artists changed the titles of their pictures to *Grandfather's Hobby* in order to suit a patron or the literary needs of *The Token,* an attractive gift annual. In the 1830 issue of *The Token* there appeared an engraving (fig. 95) after Sully's copy of the *Grandfather's Hobby,* which was owned by the Bostonian J. Fullerton. The

Figure 92. *Grandfather's Hobby*, circa 1824-1830, catalog number 537.

Figure 93. *Grandfather's Hobby,* 1852, catalog number 539.

engraving is accompanied by a poem describing the magical effect of a grandfather's tales on his grandson:

How on the morrow will that boy
With swelling thought resign his toy,
Steal the cocked hat, and on his nose,
The reverend spectacles impose,
Mount to the vacant chair, and place
The wise gazette before his face,
And there half sly, half serious pore
The last night's legend o'er and o'er,
And deem himself in boyish glory,
Like the old man that told the story![139]

Figure 94. Thomas Sully, *Grandfather's Hobby*, 1824-1825, oil on canvas, 35 x 28 inches (height by width). Hunter Museum of Art, Chattanooga, Tenn.; gift of Mrs. Henry Hayes, 1967.

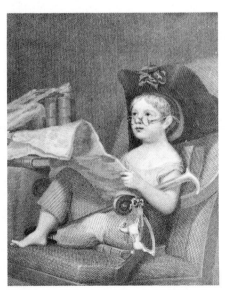

Figure 95. Thomas Sully, *Grandfather's Hobby*, 1824-1825, engraved by E. Gallaudet for S. G. Goodrich, ed., *The Token: a Christmas and New Year's Present* (Boston, 1830), p. 233.

In 1831 King's *Riding My Grandfather's Hobby,* probably the original painting, was exhibited at the Boston Athenaeum, and was listed as being owned by a W. H. Eliot, another Bostonian who had an interesting art collection. Both King and Sully painted second versions of the subject, both of which were exhibited by the two artists at the Apollo Gallery in New York in 1838-1839. Amazingly enough, although Sully's version was listed as "From the original by C. B. King," it was priced at $500, and King's "Original" at only $200. King's version was purchased by the Apollo Association and was distributed at the annual lottery of December 1839, to a Joseph J. West of New York.[140]

In a review of the exhibition at the Apollo Gallery, the critic for the *New York Mirror* made some interesting remarks about King's entries, particularly his *Grandfather's Hobby*: "Charles B. King has also several works that give us a better opinion of his talents than we before entertained. His 'Grandfather's Hobby' is pleasingly designed, well drawn and coloured with great beauty."[141]

Just how handsomely colored the *Grandfather's Hobby* was is evident from a surviving version, which may be the original and so, was painted sometime prior to 1825; if a replica, the work cannot have been painted later than 1838. The same cannot be said of the version of 1852, which is marred by patches of raw pigment throughout and brownish glazes in the flesh tones. Yet, in terms of conception, the later version is more complex than the other, and more interesting. Among other changes, King labeled the newspaper "UNION" and turned it upside down, perhaps

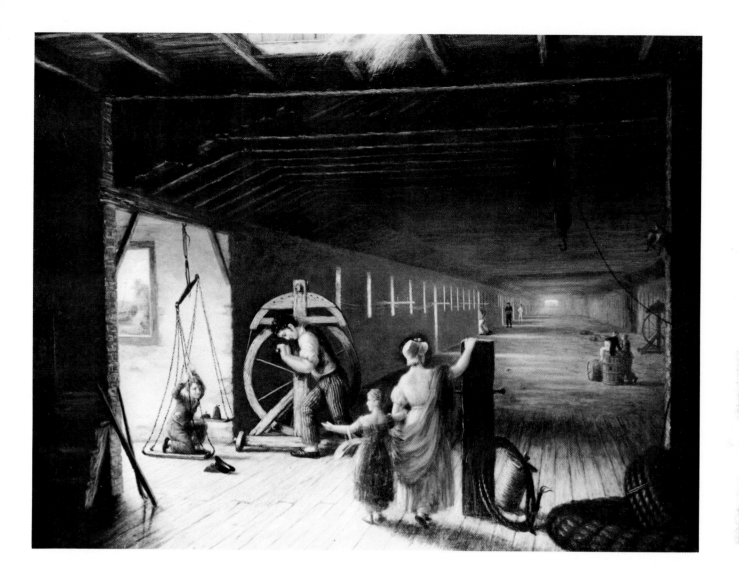

Figure 96. *Interior of a Ropewalk*, circa 1845, catalog number 544.

alluding to the state of the union and the tenuous truce imposed on North and South by the Missouri Compromise of 1850. What this allusion may signify in respect to King's sympathies vis-à-vis the sectional dispute is unclear, except that it suggests a skepticism about both points of view.

The last of King's extant genre paintings is documentary rather than imaginative. *Interior of a Ropewalk* (fig. 96) is a tour de force of perspective drawing and, with Bass Otis's *Interior of a Smithy,* is one of the earliest representations of an industrial scene. The rather raw coloring and summary technique of *Interior of a Ropewalk* suggest a late date, in the 1840s or early 1850s. At that time King established a studio in Newport where the scene may have been painted, or it may have been painted in Baltimore, where ropewalks also abounded. The extraordinary depth of the scene is not exaggerated; ropewalks in Newport, for example, ranged in length from 250 to 700 feet.

Several titles of lost genre works by King, such as the *Bust of Dead Mother. Two Young Ladies and Little Boy Contemplating It,* suggest an almost morbid

fascination with death and with the poignant suffering of children who confront it. Another, the *Slave on Sale. Girl with a Chain on Her Wrist*, invites speculation about whether it was merely a variant on Hiram Powers's popular *Greek Slave*, or a commentary on the issue of slavery, in which case it would have been unusual for its time. It also leads one to wonder about King's views on slavery. Given his stereotyped treatment of the black girl in his *Itinerant Artist* (one of two blacks to appear in his known work), his practice of showing friends through the picturesque black quarter of the capital, and the apparent ownership of slaves by his cousin Mrs. Newman and his friends the Smiths and the Thorntons, one might well conclude that King at least tacitly accepted the institution of slavery. Yet, from what is known of his upbringing and character and of his generosity toward blacks, it seems likely that he would have found the very idea of slavery repugnant.[142]

Many of King's genre pieces have moral overtones, but some apparently were meant to be specifically didactic, though not without humor. As examples, the titles of his unlocated *Industry and Idleness* and *Neglected Wife* suggest the hortatory purpose often found in the works of Hogarth and Greuze. It would be particularly interesting to know the circumstances under which King painted a series of four "temperance lectures" moralizing on the evils of excessive indulgence: *First Step to Ruin; The Loafer; The Fast Man;* and *Meditating on Departing Spirits.* Clearly in the spirit of Hogarth's *A Rake's Progress*, these may have been painted in the 1830s during the heyday of the temperance movement, when every means was employed to encourage abstention.[143]

Among the more varied and Romantic of King's paintings were his fancy pieces. These are imaginative pictures, usually of single figures whose character, dress, or situation is exotic or fanciful enough to distinguish them from portraiture. About twenty of King's paintings can be designated as fancy pieces; almost all of these were given to the Redwood Library, but only a few have survived. Nothing is known of the circumstances under which they were painted, but it may be that as with Gainsborough and Sully, they were among King's most financially successful work.[144] Among the fascinating subjects treated, some, such as *The Gambler, with His Cards, Pistol Case and Goblet* and *The Mexican Girl*, were probably popular character pieces, while others, such as *Female Lashed to a Wreck* and *Old Witch by Firelight*, were undoubtedly melodramatic. With regard to the *Female Lashed to a Wreck*, it may be recalled that a painting with a similar theme, Cooke's copy of Gericault's *Raft of the Medusa*, was exhibited in King's gallery in 1835.

Of the existing fancy pieces by King, three are especially appealing. The *Indian Girl at Her Toilet* (see fig. 59) has already been considered. Clearly a product of the imagination, it nicely distinguishes the fancy picture from the literal Indian portraits. The same imaginative quality characterizes the *Costume, Time of Charlemagne* (fig. 97), one of a series of costume pieces done by King, whose collection of costume books was bequeathed to the Redwood Library. A picture of considerable charm, this costume piece was probably painted in the late 1830s, when King seems to have been much taken by the fluid, painterly style of Sully.

Perhaps the most complex of this group is *The Castle Builder* of 1829 (fig. 98), which may be the same picture that the artist called *Blind Girl Reading*, an appropriately paradoxical title. This is suggested by the fact that the eyes of the girl are half-closed, the book is turned toward the viewer, and a packet of letters on the table is clearly marked "Letters from an Unknown Friend." The chapter heading to which the book is opened, "Castle Builder," suggests the girl's state of reverie, in

Figure 97. *Costume, Time of Charlemagne. Female Head and Beautiful Vase of Flowers.* Circa 1838, catalog number 609.

Figure 98. *The Castle Builder*, 1829, catalog number 605.

Figure 99. *Harper's Ferry, Government Work Lock on the Potomac,* circa 1815-1820, catalog number 508.

Figure 100. *Harper's Ferry, Looking Upstream,* circa 1815-1820, catalog number 509.

which she is reading the book only in a metaphorical sense, the contents of her mind and of the book being in accord. The "unknown friend" also suggests the remoteness and isolation of a mind that can find its reality only through speculation and dream. The poetic quality in *The Castle Builder* well exemplifies the nature of the fancy piece, which depends on the inner eye of the viewer to grasp its meaning. How right, then, to call the fancy piece a visual conceit.

Of all of his works, King's landscapes are the least appreciated. Yet, even a cursory review of them compels respect for the breadth and depth of the artist's efforts. Among them were many copies, including works after Flemish masters, Claude Lorrain, Salvator Rosa, and an unknown Spanish master. In addition, King copied the *House of Torquato Tasso, at Sorrento, near Naples,* possibly from one or another of his friends who had studied in Italy: Chapman, Cooke, or Morse. If one can judge by the titles of these copies, a wide range of styles probably also characterized King's original landscapes. Several of the titles, such as *Hadley's Falls, New York* and *View on the Wissahicon Creek,* indicate, for example, that King shared the interest of his contemporaries in depicting picturesque locations.

Although they are not landscapes per se, the glimpses of nature included in many of King's figural works offer the best evidence of his abilities in this field. Some of the finest of these are found in the portrait of Mrs. John Quincy Adams and, appropriately enough, in a number of the Indian pictures, such as the *Indian Girl at Her Toilet, Moanahonga* (see figs. 59 and 65), *Keokuk,* and *Nesouaquoit.* The mood of these background views is remarkably varied, ranging from the lyrical to the Romantic, the latter including the shattered tree motif and misty transcendentalism often found in the works of contemporary artists.

It is unfortunate that only two of King's original landscapes are extant and that their present whereabouts are unknown. The *Harper's Ferry, Government Work Lock on the Potomac* and the *Harper's Ferry, Looking Upstream* (figs. 99 and 100) were undoubtedly painted during the years 1815-1825, for they combine all of the features salient in King's pictures of that period: powerful yet sensitive tonal harmonies, crisp highlights and daring brushwork, nicely modulated atmospheric backgrounds, and carefully controlled compositions. The estimate of dating is supported by the absence in either picture of any references to the Chesapeake and Ohio Canal or the Baltimore and Ohio Railroad, both of which had been extended to Harpers Ferry by 1833, and neither of which the artist would have excluded. Overall, the scenes have much in common with those that Rembrandt Peale painted of the Potomac as early as 1812 (fig. 101). Perhaps the two artists painted together on outdoor trips taken while they both lived in Baltimore, from 1815 to 1818.

One of King's most tantalizing paintings, *Landscape with Catalogue* (or *Environs of Milan, Italy*), of 1828 (fig. 102), is an ingenious blend of nature and trompe l'oeil, as seen in the catalog, which may have been inspired by Raphaelle Peale's *Catalogue . . . A Deception,* of 1812. In addition to being technically satisfying, the picture is richly poetic, and may be taken as a metaphor of human life: the landscape with its ruins and setting sun, in the manner of Salvator Rosa, suggests the haunting sublimity of our temporal existence; the male and female figures hidden behind the catalog may represent our secret desires, obscured by the book of our lives written by ourselves for public display. That King was capable of such philosophical ruminations has been shown time and again, and is supported by John Quincy Adams's observation that King was "an ingenious thinking man, with a facility of conversing upon almost any topic."[145]

Figure 101. Rembrandt Peale, *Harper's Ferry,* 1812, watercolor on paper, 8¼ x 13 inches (height by width). The Peale Museum, Baltimore, Md.

100

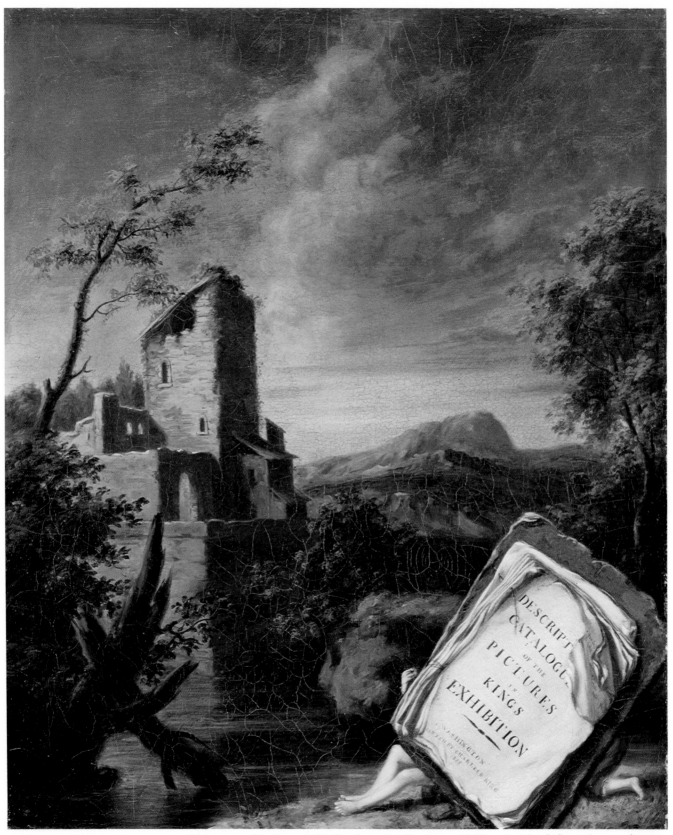

Figure 102. *Landscape with Catalogue* (or *Environs of Milan, Italy*), 1828, catalog number 514.

Epilogue

When he died on March 18, 1862, King bequeathed one-quarter of his estate – which totaled some $38,000 – to each of two institutions in Newport: the Public School for Girls on Clarke Street and the Redwood Library. To the latter he also bequeathed seventy-five paintings which, when added to those he had previously given to the library, brought the total to about 215 pictures.[146] The artist's generosity was no doubt motivated by the love he felt for his native city, a love which, in his view, was not sufficiently reciprocated.

Writing to one of the directors of the Redwood Library about the pictures he was sending there in May 1859, King lamented:

> I sometimes think it strange that I should have so great an attachment to Newport and its people by whom I have been so much neglected. When I commenced painting, the extent of my patronage was $200. Since then I have only had a forty dollar head except from my relations – Once in my life I was invited out to dinner, and in my last visit I was not asked into any house but those of two New York cottagers –[147]

The artist's tone might justifiably have been bitter rather than sad, since these were not the only rebuffs he had experienced in Newport. Probably about 1850, about seven years after he had inherited the Clarke Street house from his Aunt Vinson, King added a gallery to the building (figs. 103, 104). According to a biographical sketch of the artist that appeared in the *Newport Mercury* of January 7, 1854, his idea was to hold free exhibitions of his own works as well as those of others. Having adorned the gallery with "flowers and even with the temptation of fruit," King opened the doors, but the public's indifference forced him to close the exhibition and to give up the idea.[148]

King fared little better with posterity. Over the years, for example, some 175 of his paintings, many of them genre and Indian portraits, have been disposed of by the Redwood Library, and 100 large engravings he gave to the Smithsonian Institution in 1861 have been lost. Moreover, by 1867, only five years after the artist's death, Dunlap's remark that it was his "industry . . . that served him instead of genius in which nature has stinted him," was codified and expanded in the influential *Book of the Artists,* written by the critic Henry T. Tuckerman. The latter's appraisal of King's artistic abilities was lukewarm at best:

> During a period of forty years his studio at the Capital was filled with the portraits of the political and other celebrities of the day, – not remarkable for artistic superiority, but often curious and valuable as likenesses, especially the Indian portraits. His industry and simple habits enabled him to acquire a handsome competence, and his amiable and exemplary character won him many friends.[149]

Generally, in the marginal references to King that have appeared since the above was written, Tuckerman's estimate of the artist has prevailed. This is unfortunate since the critic's evaluation seems to have been based on King's portraits alone and contains no reference to his still life, genre, or literary paintings, those very works in which the artist most forcibly expressed his genius. Indeed, even with respect to King's portraits, which often enough are "not remarkable for artistic superiority" and even mediocre, there are many that are noteworthy: the *John C. Calhoun* of circa 1825 (see fig. 32) and the *Peskelechaco* and *Young Omaha, War Eagle, Little Missouri, and Pawnees* (see figs. 48 and 49) are examples.

Figure 103. House of Charles Bird King at 32 Clarke Street, Newport, R.I., before restoration in 1970. King's studio was located on the third floor, rear, where the rounded window is seen.

Figure 104. King's house at 32 Clarke Street, Newport, R.I., after restoration in 1970 by the Newport Restoration Foundation.

A more balanced view of King's artistic abilities is to be found in the notations made by Charles Francis Adams in his *Diary* after he had visited King's studio in 1824:

The pictures, some of them are excellent, others only moderate and others bad. That of Cyr. King . . . is . . . good, Mr. Wirt's is good, General Brown's and . . . others are remarkably fine. I think my father's a good one, but by no means so good as I think one could be made. . . . He has some very sweet fruit pieces, which would adorn a summer house or even a dinner parlour very much. Some voluptuous pieces also which it would not do to notice before ladies. One in particular which appeared to be Joseph and the wife of Potiphar although we could not see for a veil which John and myself attempted to raise, when we discovered the deception. It was very accurate.[150]

Adams's remarks emphasize several characteristics of King's, which, along with his industry, must be recognized in any appraisal of his work: his technical competence and his versatility as a painter; his originality, coupled with a creative adherence to tradition; and his forceful wit.

Despite the relatively few works by King other than portraits that are still extant, some tentative conclusions may be drawn about his place in early nineteenth-century American art. King's importance as the first artist to paint the Indian systematically is well established. That he was also among the vanguard of artists who dramatically enlarged the scope of American art is substantiated by his early essays in still life, genre, and landscape. Further, in his concern for the symbolic, even iconic, power of ordinary objects, King seems to have foreshadowed similar concerns seen in the works of late nineteenth-century artists, such as William Harnett and John LaFarge.

Significant as these contributions are, King's reputation as an artist falls short of those of his friends Allston, Morse, and Sully. Perhaps this is due to the sense of moderation that is evident in King's life and his art. Never, for example, did he achieve the dramatic power of Allston's *The Dead Man Restored to Life by Touching the Bones of the Prophet Elisha* (1811-1813); the sweeping grandeur of Morse's *The Old House of Representatives* (1822); or the lyrical sentiment and technical virtuosity of Sully's *Mother and Son* (1840).

Despite the rational, sometimes enervating, balance in King's art, he painted some of the most fascinating works of his age, among which the *Poor Artist's Cupboard* and *The Vanity of the Artist's Dream* must be counted, and possibly his self-portrait of 1815 and the *Young Omaha, War Eagle, Little Missouri, and Pawnees*. In comparing these paintings to others by King, one senses that his potential for producing a more significant body of art was arrested – possibly by his conservative upbringing, his relative isolation in Washington from the artistic centers of the country, and the increasing demands of his business enterprises. From this perspective, the sense of disappointment implicit in John Neal's remark about the pictures by King he saw in 1824 in London, at the widow Bridgen's, was prophetic: "Were I to see such pictures now, by a youth, badly coloured and badly painted as they were, I should think that he promised more, much more than either West or Leslie."[151]

Notes

1. "Reminiscences of Zebulon King," manuscript of journal, unpaged, in the King Family Papers, Newport Historical Society, Rhode Island. The circumstances of the captain's death on April 30, 1789, were related to his widow by a Benjamin Slocum in a letter that was copied and kept in the journal.

2. Probate Records, Probate Court, City Hall, Newport, R.I., 2:263, 316-17; 3:19; 6:26-28 (hereafter cited as Probate Records). Captain King's estate amounted to $5,000, apparently exclusive of the Ohio lands. His son's share was held in trust, no doubt, until he reached his majority in 1806. The Clarke Street house came into the possession of Deborah King through her second marriage, probably in 1796, to Nicholas Garrison, who died in 1802. See Antoinette F. Downing and Vincent J. Scully, Jr., *The Architectural Heritage of Newport, Rhode Island, 1640-1915* (New York: Bramhall House, 1967), pp. 461ff.; Osmund Overby, "32 Clarke Street, an Historical Report to the Newport Restoration Foundation," unpublished research paper, [1970] (typewritten).

3. George G. Channing, *Early Recollections of Newport, R.I., from the Year 1793 to 1811* (Newport: A. J. Ward, C. E. Hammett, Jr., 1868), p. 223; King's mother, stepfather, and probably his father were Moravians; William Dunlap, *History of the Rise and Progress of the Arts of Design in the United States,* ed. Alexander Wyckoff (1834; reprint ed., New York: Benjamin Blom, 1965), 3:29.

4. Channing, *Early Recollections of Newport,* pp. 59-61; E. P. Richardson, *Washington Allston, A Study of the Romantic Artist in America* (1948; reprint ed., New York: 1967), p. 29, specifies that Allston attended Robert Rogers's school; *Newport Daily News,* March 20, 1862. Since the latter article contains some mistakes, the suggestion that King studied in Pennsylvania is open to question. If he did, however, the possibility exists that he began his apprenticeship with Edward Savage in Philadelphia, or that he attended Nazareth Hall, a Moravian boarding school for boys, in Nazareth, Pennsylvania.

5. Channing, *Early Recollections of Newport,* p. 223. In the "Last Will and Testament of Charles Bird King," p. 3, estate number 4525 O.S., Federal Records Center, Suitland, Maryland (hereafter cited as King, "Will"), there is a codicil dated October 23, 1861, wherein King assigned to a cousin several items, including "the portraits of our Grandmother & of my mother, and the sea piece hanging in my room painted by my Grandfather Bird." The ambiguity of the language makes it difficult to determine whether Bird painted the portraits and the sea piece, or only the latter.

6. Richardson, *Washington Allston,* pp. 28 (and n. 5), and 187 (entry 22); Dunlap, *History,* 2:298-99. According to Maude Howe Elliott ("Some Recollections of Newport Artists: A Paper Read Before the Society, Monday, November 15th, 1920," *Bulletin of the Newport Historical Society* 35 [January 1921]:7), Samuel King lived on Clarke Street, probably in the house of Samuel Vernon. In 1770 King married Vernon's daughter (see William B. Stevens, "Samuel King of Newport," *Antiques,* November 1969, p. 729). The Vernon house is next door to 32 Clarke Street where

Charles King lived from 1796, when his mother married Nicholas Garrison, who owned the house, to 1800 when he left for New York.

7. Stevens, "Samuel King of Newport," p. 733; Probate Records, 4: 15, 28.

8. Ruel Pardee Tolman, *The Life and Works of Edward Greene Malbone, 1777-1807* (New York: New-York Historical Society, 1958), pp. 277ff.

9. Dunlap, *History*, 1: 381; 3: 28; Louisa Dresser, "Edward Savage, 1761-1817," *Art in America* 40 (Autumn 1952): 159. Ronald Vern Jackson, ed., *Rhode Island 1800 Census* (Salt Lake City: Accelerated Indexing System, 1972); the source confirms King's absence from Newport in 1800. That King was apprenticed to Savage is inferred from the fact that Jarvis was contracted to him also for five years, according to Harold E. Dickson, *John Wesley Jarvis, American Painter, 1780-1804* (New York: New-York Historical Society, 1949), p. 337.

10. Dickson, *John Wesley Jarvis*, pp. 37, 53-54; Rita S. Gottesman, *The Arts and Crafts in New York: Advertisements and News Items from New York City Newspapers*, vol. 3, *1800-1804* (New York: New-York Historical Society, 1965), pp. 25-26.

11. Mary Bartlett Cowdrey, *American Academy of Fine Arts and American Art-Union. Introduction, 1816-1852* (New York: New-York Historical Society, 1953); hereafter cited as *AAU. Introduction*.

12. Dunlap, *History*, 1: 381-82; 2: 217ff., and 391; Dickson, *John Wesley Jarvis*, pp. 22, 55, 63ff.

13. *A Catalogue of the Pictures &c. in the Shakespeare Gallery, No. 11 Park, New York: 1802*, bound in front of Longworth's *New York City Directory for 1802*, on file in The New-York Historical Society, New York.

14. Tolman, *Life and Works of Malbone*, p. 112; Dunlap, *History*, 3: 28, 2: 357. Dunlap is contradictory on this point and has King arriving in London both in 1805 and in 1806. Jarvis to King, May 2, 1807, Letters of Charles Bird King, in the Historical Society of Pennsylvania, Philadelphia (hereafter cited as HSP), Dreer Collection.

15. Dunlap, *History*, 3: 28.

16. Sidney C. Hutchison, "The Royal Academy Schools, 1768-1830," *Walpole Society* 38 (1962): 126-30, and Sidney C. Hutchison, *The History of the Royal Academy, 1768–1968* (London: Chapman & Hall, 1968), pp. 57ff., 85.

17. Royal Academy of Arts, London, England, "Royal Academy Council Minutes, 1768 to date," 4:34-35. [For this information, I am indebted to Miss Constance-Anne Parker, assistant librarian of the Royal Academy.]

18. Hutchison, "Royal Academy Schools," pp. 163-64; Algernon Graves, *The Royal Academy of Arts. A Complete Dictionary of Contributors and Their Works from Its Foundation in 1769 to 1904*, 8 vols. (London: H. Graves & Co., Ltd., 1905-06), vol. 8, and Algernon Graves, *Dictionary of Artists Who Have Exhibited Works in the Principal London Exhibitions from 1760 to 1893* (1901; reprint ed., Bath, England: Kingsmead Reprints, 1969).

19. Dunlap, *History*, 2: 357-58; "Observations on American Art. Selections from the Writings of John Neal," ed. Harold E. Dickson, *Pennsylvania State College Bulletin* 37 (February 5, 1943): 53-54 (hereafter cited as Neal, "Observations").

20. Dunlap, *History*, 2 : 255. See also Thomas Sully, "Journal of Activities, 1792-1846," p. 11; a typewritten copy of the original is in the New York Public Library and a copy on microfilm is on file in the Archives of American Art, Smithsonian Institution, Washington, D.C.

21. Dunlap, *History*, 3 : 28; Sully, "Journal," pp. 11-12.

22. Dunlap, *History*, 2 : 256-58, 261-62.

23. Ibid.; Sully, "Journal," pp. 11-12; Edward Biddle and Mantle Fielding, *The Life and Works of Thomas Sully (1783-1872)* (Philadelphia: Wickersham Press, 1921), pp. 198, 360. See also "Register of Donations to the Redwood Library, 1810-1858," p. 2, Redwood Library and Athenaeum, Newport, R.I. (the register is hereafter cited as "Donations 1810-58").

24. Sully, "Journal," p. 120ff., 130-31.

25. Trumbull's letter is in the *Port Folio*, July 1812, p. 28.

26. HSP, Dreer Collection and Gratz Collection, respectively.

27. John Woodward, *Paintings and Drawings by Sir David Wilkie R.A., 1785-1841*, catalog of an exhibition held at the Royal Academy of Arts (London, 1958), p. vi, pt. 1; pt. 2 contains reproductions.

28. Ibid., pp. iv-viii; Charles Robert Leslie, *Autobiographical Recollections*, ed. Tom Taylor (Boston: Ticknor and Field's, 1860), pp. 105, 115-16; Dunlap, *History*, 3 : 28-29.

29. Samuel F. B. Morse, *Samuel F. B. Morse: His Letters and Journals*, ed. Edward Lind Morse (Boston: Houghton Mifflin Company, 1914), 1 : 46-52; also included herein, p. 60, is King's letter. See also Leslie, *Autobiographical Recollections*, pp. 19-21, 172-73, 177.

30. Leslie, *Autobiographical Recollections*, pp. 178-80.

31. Ibid.; *Samuel F. B. Morse: Letters and Journals*, 1 : 85; Graves, *Royal Academy. Contributors*, 1 : 28, and 5 : 38, 305; Neal, "Observations," p. 53; Sully, "Journal," p. 127.

32. Neal, "Observations," p. 54.

33. Ibid., pp. 53-58.

34. Ibid., p. 55.

35. Allston to Morse, August 4, 1815, HSP, Gratz Collection.

36. Dunlap, *History*, 3 :29.

37. King to directors, October 13, 1812, Redwood Library; "Donations 1810-58," p. 6; Leslie, *Autobiographical Recollections*, p. 180.

38. *Samuel F. B. Morse: Letters and Journals*, 1 : 60-61; Leslie, *Autobiographical Recollections*, pp. 187-88.

39. "Pennsylvania Academicians, 1812," vertical file, Pennsylvania Academy of the Fine Arts, Philadelphia (hereafter cited as PAFA).

40. Anna Wells Rutledge, ed., *Cumulative Record of Exhibition Catalogues; the Pennsylvania Academy of the Fine Arts . . .*, Memoirs of the American Philosophical Society, vol. 38 (Philadelphia, 1955), p. 114. Rutledge omits the couplet; thus, these and subsequent entries are taken from the original catalogs (hereafter cited, respectively, as *PAFA 18___*. The couplet is quoted from *PAFA 1813*, pp. 13-16.

41. *Port Folio*, August 1813, pp. 122ff.

42. Neal, "Observations," p. xxv.

43. *PAFA 1814*, p. 25, and address list; Warrell advertised his raffle in the *Richmond Patriot*, January 27, 1816, according to *Richmond Portraits in an Exhibition of Makers of Richmond, 1737-1860,* catalog of an exhibition held at the Valentine Museum, Richmond, Va. (Richmond: Valentine Museum, 1949), p. 237.

44. "Letters of Hon. Wm. Hunter to Wife, 1813-1816," Newport Historical Society, R.I.

45. In a letter of January 12, 1816, in the Charles Bird King file, Archives of American Art, Washington, D.C., Leslie wrote to King, then in Baltimore, "By Mr. Delaplaine's last letter I find you were in Philadelphia. . . ."

46. For Joseph Delaplaine, see James Grant Wilson and John Fiske, eds., *Appleton's Cyclopaedia of American Biography*, 7 vols. (New York: D. Appleton and Company, 1887-1900), 2: 134. For Delaplaine's gallery, see his letter of November 13, 1819, to Mayor James A. Barker in the HSP, Gratz Collection, wherein he wrote that over a period of seven years he had spent some $23,000 on the gallery. For the *Repository*, see the *Port Folio*, May 1814, p. 482, and July 1814, pp. 112-17; Delaplaine's letter of May 13, 1820, to Chief Justice Tilghman, in the HSP, Gratz Collection; and Delaplaine's *Repository of the Lives and Portraits of Distinguished American Characters* (Philadelphia, 1815). For King's presence in Baltimore, see Samuel F. B. Morse's letter of December 30, 1815, addressed to King at 79 High Street, inserted in Dr. John W. Francis, *Old New York. Reminiscences* (New York, 1865), on file in The New-York Historical Society, New York.

47. The Newmans lived at "La Grange" in Charles County, Maryland, from 1798 to 1817, at which time they moved to Washington, according to information provided by Mrs. Parley Johnson, a descendant of the family, in a letter to the author dated September 2, 1976. Probate Records, 5: 375, also cites the Newmans as residents of Charles County in 1817.

48. Charles Sterling, *Still Life Painting from Antiquity to the Present Time,* trans. James Emmons (New York: Universe Books, 1959), passim.

49. *Dictionary of American Biography,* 14: 627-28.

50. Wilbur Harvey Hunter, *The Peale Family and Peale's Baltimore Museum, 1814-1830* (Baltimore: The Peale Museum, 1965); Eleanor McSherry Fowble, "Rembrandt Peale in Baltimore" (Master's thesis, University of Delaware, 1965). That Peale did not begin the Stricker portrait before mid-April 1816 is indicated by a letter General Stricker wrote to the council on April 18, stating he would make himself available for sittings when required. The letter is included in a "Stricker Memoir" [1837] written by the general's son, John Stricker, on file in the Maryland Historical Society, Baltimore, Manuscript 794.

51. Possibly during one of his many trips to New York City, King may have seen this.

52. See the book on "History" in Giovanni Paolo Lomazzo, *Trattato dell' arte pittura, scultura et archittetura* (Milan, 1584).

53. George Champlin Mason, *Annals of the Redwood Library and Athenaeum, Newport, R.I.* (Newport: Redwood Library, 1891), p. 121.

54. Charles Francis Adams, *Diary of Charles Francis Adams,* ed. Aïda DiPace Donald and David Donald, 4 vols., series 1 (*Diaries*) of The Adams

Papers, ed. L. H. Butterfield (Cambridge, Mass.: Belknap Press of Harvard University Press, 1964), 1: 48.

55. Glenn Brown, *History of the United States Capitol,* 2 vols. (Washington, D.C.: Government Printing Office, 1900-1903), 1: 38ff., and plates 44-46. Latrobe made his drawing of the west elevation in 1811. In 1816 a perspective view of the Capitol, based on Latrobe's drawing, was published in a travel book by D. B. Warden.

56. *The Baltimore Directory for 1817-18 . . . Corrected Up to the First of April . . .* (Baltimore: James Kennedy, 1817).

57. Rutledge, *Cumulative Record of Exhibition Catalogues* (PAFA), p. 114; *PAFA 1817,* p. 104, and *PAFA 1818,* p. 7.

58. Delaplaine to Kemp, October 27, 1817, HSP, Gratz Collection; Delaplaine to Adams, November 2, 1818, quoted in Andrew Oliver, *Portraits of John Quincy Adams and His Wife,* Series 4 (*Portraits*) of The Adams Papers, ed. L. H. Butterfield (Cambridge, Mass.: Belknap Press of Harvard University Press, 1970), p. 91 (hereafter cited as Oliver, *J. Q. Adams*).

59. Delaplaine to General Thomas M. Nelson, January 3, 1819, HSP, Society Collection. According to *The Washington Directory* for 1822, p. 50, King had his rooms on the south side of F, just east of Twelfth; thereafter his permanent home was on the east side of Twelfth, just south of F.

60. Oliver, *J. Q. Adams,* p. 92; Rutledge, *Cumulative Record of Exhibition Catalogues* (PAFA), p. 114.

61. Oliver, *J. Q. Adams,* p. 92; Waldo to King, February 11, 1819, HSP, Gratz Collection.

62. Probate Records, 9: 97; 12: 186ff.; 13: 20ff.; Land Evidence, City Hall, Newport, R.I., 13: 540. While in Newport in July 1820, King transferred his Clarke Street house to his Aunt Susanna Bird Vinson for the sum of $1,000, quaintly referring to himself in the deed as "Limner." After several years of legal disputes over the will of his Aunt Vinson, who had died in 1839, King reinherited the house in 1843 and retained it until his death in 1862, when it was sold.

63. Sully, "Journal," p. 33; Dunlap, *History,* 3: 29; Office of the Recorder of Deeds, Washington, W. B. 12: 323-25 (hereafter cited as Deeds, with specific volumes indicated). Information on King's tax records was provided by Miss Dorothy S. Provine of the National Archives, Washington, D.C., in a letter to the author dated December 14, 1973.

64. The photograph appeared in an article entitled "The Changing Scene," *Star Magazine* (Washington, D.C.), December 31, 1961, p. 2, and was called to the author's attention by Robert A. Truax, curator of the Columbia Historical Society, Washington, D.C. See also George Watterston, *New Guide to Washington . . .* (Washington, D.C.: Robert Farnham, 1847-48), p. 102. For King's painting in his garden, see Thomas L. McKenney and James Hall, *The Indian Tribes of North America with Biographical Sketches and Anecdotes of the Principal Chiefs,* ed. Frederick Webb Hodge, 3 vols. (Edinburgh: John Grant, 1933-34), 1: xxxiii, n. 1.

65. Dunlap, *History,* 3: 29.

66. Deeds, W. B. 12: 323-25; 23: 53-54; 30: 108-11; 32: 302-4; 42; 261-62. See also Provine to author, December 14, 1973, and King, "Will," Schedule C of Inventory taken May 1862, and "Abstract of rents collected by

George G. King . . . ," which shows that from about September 1862 to April 1863, King's properties brought in $1,385.49 in rentals.

67. Dunlap, *History*, 3 : 29.

68. Ibid.

69. Daniel D. Reiff, *Washington Architecture, 1791-1861: Problems in Development* (Washington, D.C.: U.S. Commission of Fine Arts, 1971), passim.

70. Ibid.; Constance McLaughlin Green, *Washington, Village and Capital, 1800-1878* (Princeton: Princeton University Press, 1962), pp. 127, 164.

71. Reiff, *Washington Architecture*, p. 31; Green, *Washington, Village and Capital*, pp. 42-103, 135-36, 143-44.

72. Mrs. Samuel Harrison Smith, *The First Forty Years of Washington Society*, ed. Gaillard Hunt (New York: Charles Scribner's Sons, 1906), p. 94.

73. Ibid., pp. 196ff., 218ff., 247, 354ff.; Anne Hollingsworth Wharton, *Social Life in the Early Republic* (Philadelphia: J. B. Lippincott Company, 1902), p. 231; John von Sonntag De Havilland, *A Metrical Description of a Fancy Ball Given at Washington, 9th April, 1858. Dedicated to Mrs. Senator Gwin* (Washington, D.C.: F. Philp, 1858).

74. Green, *Washington, Village and Capital*, pp. 69-103; John Quincy Adams, *Memoirs of John Quincy Adams Comprising Portions of His Diary from 1795 to 1848*, ed. Charles Francis Adams, 12 vols. (Philadelphia: J. B. Lippincott & Co., 1875), 7 : 4-7. See also McKenney and Hall, *Indian Tribes of North America*, 1 : xxxiii, n. 1; and King, "Will," Schedule A, pp. 4-5, which indicates the artist bequeathed $500 to the Girls School in Newport and $1,000 to the Protestant Orphan Asylum. According to an entry dated May 16, 1839, in the journal of Elizabeth Newman, King's cousin, the artist also supported St. Vincent's Catholic orphanage, on the board of directors of which Mrs. Newman served ("Journal of Elizabeth Hannah Newman, 1838-1846," now in the possession of Mrs. T. R. Dibble, Peru, Vermont).

75. Watterston, *New Guide to Washington*, pp. 102-3.

76. Dunlap, *History*, 3 : 29. In his "Journal" (pp. 33, 39), Sully mentions that the casts were at the academy and were the property of "Nielson and Hastings." See also Newman, "Journal of Elizabeth Hannah Newman," entries of November 6 and 15, 1838; and King, "Will," pp. 1, 4.

77. Biddle and Fielding, *Life and Works of Thomas Sully*, pp. 108, 335. In his "Journal" (p. 57, entry of March 16, 1828), Sully records that he "sent home Morgan's whole length of Munroe [*sic*] by King."

78. Sully, "Journal," p. 33; Oliver, *J. Q. Adams*, pp. 109-10.

79. Sully, "Journal," p. 34; Dunlap, *History*, 1 : 346-48, 2 : 274; *National Intelligencer* (Washington, D.C.), January 4, 1825, p. 3; Harold Dickson, "Artists as Showmen," *The American Art Journal* 5 (May 1973): 4-17.

80. Adams, *Diary of C. F. Adams*, 1 : 47-48.

81. Peale to Sully, July 4, 1820, HSP, Dreer Collection.

82. King to Peale, July 21, 1857, HSP, Gratz Collection; Rembrandt Peale, "Reminiscences," *The Crayon* 3 (March 1856): 102; Josephine Cobb, "The Washington Art Association: An Exhibition Record, 1856-1860,"

Records of the Columbia Historical Society of Washington, D.C. 63-65 (1963-65): 130, 133-34.

83. Dunlap, *History,* 3: 27ff.

84. Ibid.; William Dunlap, *Diary of William Dunlap (1766-1839), The Memoirs of a Dramatist, Theatrical Manager, Painter, Critic, Novelist, and Historian,* 3 vols. (New York: New-York Historical Society, 1931), 3: 668.

85. Dunlap, *History,* 3: 30.

86. Lawrence Babb, *Sanity in Bedlam: A Study of Robert Burton's Anatomy of Melancholy* (Michigan State University Press, 1959); Babb mentions on p. xi that the *Anatomy* went through forty-one editions in the nineteenth century. See also Roy Strong, *The English Icon: Elizabethan & Jacobean Portraiture* (London: Paul Mellon Foundation for British Art, in association with Rutledge & K. Paul, 1969).

87. Strong, *The English Icon,* p. 35.

88. *National Intelligencer,* January 29, 1825, p. 3; Dunlap to King, January 14, 1826, and October 1, 1829, on file in the Charles Roberts Autograph Collection of American Artists, Archives of American Art; Sully, "Journal," p. 32, entry of December 1, 1824.

89. Allen C. Clark, *Life and Letters of Dolly Madison* (Washington, D.C.: Press of W. F. Roberts Company, 1914), p. 454; King to Gilmor, October 23, 1827, and November 20, 1830, HSP, Dreer Collection and Gratz Collection respectively; "Robert Gilmor," *The National Cyclopaedia of American Biography* (New York, 1901), 9: 402.

90. Dunlap, *History,* 3: 30.

91. "A Collection of Engravings, Made by Charles B. King, and by Him Presented to the Redwood Library and Athenaeum," vol. 4, number 24, inscribed in pencil "Geo. Cooke to C. B. King," on file in the Redwood Library and Athenaeum, Newport, R.I.; McKenney and Hall, *Indian Tribes of North America,* 1: xli, xxxvi, and n. 1; *National Intelligencer,* January 30, 1835, p. 3; Cooke to King, February 1, 1835, HSP, American Painters & Sculptors.

92. William P. Campbell, *John Gadsby Chapman: Painter and Illustrator,* catalog of an exhibition held at the National Gallery of Art (Washington, D.C., 1962-63), pp. 9-11; "Donations 1810-58," p. 29; Chapman to King, October 6, 1836, and August 9, 1837, HSP, Gratz Collection, and Maryland Historical Society, Baltimore, Manuscript 7, respectively; Mary Bartlett Cowdrey, *National Academy of Design Exhibition Record, 1826-1860,* 2 vols. (New York: New-York Historical Society, 1943), 1: 278 (hereafter cited as Cowdrey, *NAD*); *Catalogue of Pictures and Busts Belonging to the Redwood Library, Newport, R.I., July 1st, 1859. With the Names of the Donors, &c.,* Redwood Library and Athenaeum, Newport, R.I. (hereafter cited as RL 1859); King, "Will," pp. 1, 4, 6.

93. Oliver, *J. Q. Adams,* p. 239; King, "Will," p. 4; Henry Clay File, curator's office, Corcoran Gallery of Art, Washington, D.C.

94. Nathalia Wright, *Horatio Greenough: The First American Sculptor* (Philadelphia: University of Pennsylvania Press, 1963), pp. 50-51; Horatio Greenough, *Letters of Horatio Greenough to His Brother, Henry Green-*

ough, ed. Francis Boott Greenough (Boston: Ticknor and Company, 1887), pp. 25-26; Oliver, *J. Q. Adams,* p. 139 and n. 4.

95. E. Maurice Bloch, *George Caleb Bingham,* vol. 1, *The Evolution of an Artist* (Berkeley: University of California Press, 1967); John I. H. Baur, *An American Genre Painter, Eastman Johnson, 1824-1906* (Brooklyn: Brooklyn Museum, 1940), pp. 5-18.

96. Howard N. Doughty, "Life and Works of Thomas Doughty," p. 14, manuscript in The New-York Historical Society. See also William E. Ames, *A History of the National Intelligencer* (Chapel Hill: University of North Carolina Press, 1972), p. 160; Ames mentions that Way's father was a government printer and an associate of King's close friend, Joseph Gales, Jr. See also William H. Gerdts and Russell Burke, *American Still-Life Painting* (New York: Praeger, 1971), p. 72; on the portrait Way owned, see catalog number 276, *Andrew Way.*

97. Oliver, *J. Q. Adams,* p. 251, entry of May 18, 1842; Marie De Mare, *G. P. A. Healy, American Artist: An Intimate Chronicle of the Nineteenth Century* (New York: David McKay Co., Inc., 1954), pp. 107-8.

98. King to Healy, May 5, 1845, HSP, Gratz Collection.

99. Vanderlyn to Todd, June 11, and August 7, 1850, Madison Collection, Greensboro Historical Museum, N.C.

100. King, "Will," p. 4.

101. Adams to King, March 29, 1845, quoted in Oliver, *J. Q. Adams,* pp. 237-39; Frances Trollope, *Domestic Manners of the Americans,* ed. Donald Smalley (New York: Alfred A. Knopf, 1949), pp. lii-liii; RL 1859.

102. Cowdrey, *NAD,* 1:278; Cobb, "Washington Art Association," pp. 133-34; Cowdrey, *AAU. Introduction.*

103. James Herring and James B. Longacre, *The National Portrait Gallery of Distinguished Americans,* 4 vols. (New York: Monson Bancroft; Philadelphia: Henry Perkins; London: O. Rich, 1834-39), see vols. 1 and 3 for Josiah Johnston and William Pinkney, respectively; Herring to King, November 17, 1835, HSP, Gratz Collection.

104. Mary Bartlett Cowdrey, *American Academy of Fine Arts and American Art-Union. Exhibition Record, 1816-1852* (New York: New-York Historical Society, 1953), pp. 215-16 (hereafter cited as *AAU. Record*); "Minutes of the Committee of the Apollo Association to Promote the Fine Arts &c., 1839-1846," The New-York Historical Society, New York, meetings of March 12 and December 17, 1839; Herring to John P. Ridner, July 18 and August 1, 1840, "Letters Received by American Art Union, April, 1838, to March, 1842," The New-York Historical Society, New York (hereafter cited as "Letters, AAU"). *AAU. Record* and the "Minutes" show that King's *Grandfather's Hobby,* for which King asked $200, was purchased in March 1839 for $150, and the *Property,* for which he asked $75, was purchased in December 1839 for $85. Perhaps the $10 increase for the latter was to assuage King's feelings, possibly also ruffled by Herring's imperious tone evident in a letter he wrote to King about the *Grandfather's Hobby,* asking whether the picture "is the *original* . . . by yourself, and, if so, what is the *lowest* price which I may sell it for." (See Herring to King, March 2, 1839, HSP, Gratz Collection.)

105. Lomazzo, *Trattato,* and Roger de Piles, *The Principles of Painting,* trans.

[Richard Haydocke] (London, 1743); Adams to King, HSP, Gratz Collection; Stephanie Belt, "The Portrait of Mrs. John Quincy Adams in the National Collection of Fine Arts," an unpublished paper in the National Collection of Fine Arts, January 15, 1969, p. 20. In the "Journal of Elizabeth Hannah Newman," entry for December 21, 1838, Mrs. Newman suggests a family connection between King and Mrs. Adams by recording a visit by King and her son-in-law, Dr. Johnson, to the latter's "Cousin Mrs. Adams."

106. *Dictionary of American Biography*, 2: 173-80; Henry Clay, *The Papers of Henry Clay*, ed. James F. Hopkins (Lexington: University of Kentucky, 1963), vol. 3, pp. 29-31, 241-42, 413-15, and vol. 4, pp. 495-96. See also Henry Clay File, Corcoran Gallery of Art.

107. John C. Calhoun, *The Papers of John C. Calhoun*, ed. W. Edwin Hemphill (Columbia, S.C.: University of South Carolina Press for the South Carolina Society, 1963, 1967), 2: 194-95; 3: xviii, xxix-xxxi, 633-34; 4: 381, 388, 538-39, 645-47.

108. Robert G. Stewart, *A Nineteenth Century Gallery of Distinguished Americans*, catalog of an exhibition held at the National Portrait Gallery (Washington, D.C., 1969), p. 50, plate 1.

109. William Faux, "Memorable Days in America," vols. 11 and 12 of *Early Western Travels, 1748-1846*, ed. Reuben Gold Thwaites, 32 vols. (Cleveland: Arthur H. Clark Co., 1904-7), 12: 51; *National Intelligencer*, November 30, 1821; John C. Ewers, "Charles Bird King, Painter of Indian Visitors to the Nation's Capital," *Smithsonian Report for 1953* (Washington, D.C., 1954), p. 464; Herman J. Viola, "Portraits, Presents, and Peace Medals . . . ," *American Scene* 9 (1970): unpaged.

110. Herman J. Viola, "Washington's First Museum: The Indian Office Collection of Thomas L. McKenney," *The Smithsonian Journal of History* 3 (Fall 1968): 5-7; Thomas L. McKenney, *Memoirs, Official and Personal, with Sketches of Travels among the Northern and Southern Indians*, vol. 1 (New York, 1846), 1: passim; McKenney and Hall, *Indian Tribes of North America*, 1: ixff.; Ewers, "Charles Bird King, Painter of Indian Visitors," p. 464.

111. Jonathan Elliot, *Historical Sketches of the Ten Miles Square Forming the District of Columbia* . . . (Washington, D.C.: J. Elliot, Jr., 1830), pp. 165-66; Viola, "Washington Museum," p. 10; Trollope, *Domestic Manners of the Americans*, pp. 220-21.

112. William J. Rhees, comp. and ed., *The Smithsonian Institution: Documents Relative to Its Origin and History, 1835-1899*, 2 vols. (Washington, D.C.: Government Printing Office, 1901), 1: 435-36, 643; 2: 1011-13, 1228, 1315, 1320; Thomas Donaldson, "Miscellaneous Collections . . . ," *Annual Report . . . of the Smithsonian Institution . . . to July, 1885* (Washington, D.C., 1886), pp. 794-97.

113. Herman J. Viola, *The Indian Legacy of Charles Bird King* (Washington, D.C.: Smithsonian Institution Press and Doubleday & Company, Inc., 1976); McKenney and Hall, *Indian Tribes of North America*, 1: xxivff.; James D. Horan, *The McKenney-Hall Portrait Gallery of American Indians* (New York: Crown Publishers, 1972).

114. McKenney and Hall, *Indian Tribes of North America*, 1: 204ff. The medal is in the Buffalo Historical Society, New York.

115. Faux, "Memorable Days," 12 : 49.

116. Dunlap, *History*, 3 :244; Cowdrey, *NAD*, 1 :278; Campbell, *John Gadsby Chapman.*

117. Campbell, *John Gadsby Chapman*, p. 12; *RL 1859*.

118. Georgia S. Chamberlain, in her "The Baptism of Pocahontas . . . ," *The Iron Worker* 23 (Summer 1959) : 18-19, made most of these observations; Sully, "Journal," p. 218, entry of May 9, 1840.

119. Oliver W. Larkin, *Samuel F. B. Morse and American Democratic Art* (Boston: Little, Brown, 1954), pp. 56-57, 64ff.; Herman J. Viola, "Invitation to Washington—A Bid for Peace," *The American West* 9 (January 1972) : 2-3; Viola was the first to recognize Petalesharro in Morse's painting. McKenney and Hall, *Indian Tribes of North America*, 1 : 212, n. 5.

120. McKenney and Hall, *Indian Tribes of North America*, 1 : 64ff.

121. Ibid., 6, 16-17.

122. Ibid., 44ff., 351ff.; Viola, "Washington's First Museum," p. 16.

123. Viola, "Washington's First Museum," pp. 10-13; McKenney and Hall, *Indian Tribes of North America*, 1 : xxxivff.

124. King, "Will," Inventory Schedule A, p. 3, and Account number 3, sale of November 6, 1862; the drawings are owned by Mr. and Mrs. Bayard LeRoy King of Saunderstown, Rhode Island. A collateral descendant of the artist, Mr. King discovered them in 1974 among family papers he had inherited.

125. Ewers, "Charles Bird King, Painter of Indian Visitors," p. 467.

126. Ibid., pp. 467-68; see also, Viola, *Indian Legacy of Charles Bird King*, pp. 89-90. The inscription on the back of the painting – "Assinaboin Indian from the most remote tribe that had ever visited Washington up to 1838 – C. B. King" – uncharacteristically does not give the name of the subject and was written by the artist in 1838 or as late as 1859, by which time he had given the portrait to the Redwood Library.

127. McKenney and Hall, *Indian Tribes of North America*, 1 : xxxiii-iv.

128. Newman, "Journal of Elizabeth Hannah Newman," entry for April 25, 1839.

129. Thompson to King, August 4, 1834, and McDuffie to King, June 10, 1836, HSP, Dreer Collection.

130. Charles Coleman Sellers, *Charles Willson Peale*, 2 vols. Memoirs of the American Philosophical Society, vol. 23, pts. 1-2 (Philadelphia, 1947), 2 : 367.

131. The inscriptions on *The Vanity* were collated by Professor Daniel D. Reiff of the State University of New York at Fredonia, who made a copy available at the Fogg Art Museum, where it was called to my attention by Mrs. Phoebe Peebles, archivist.

132. Sterling, *Still Life Painting*, p. 59.

133. Clarence Hornung, *Treasury of American Design: A Pictorial Survey of Popular Folk Art Based upon Watercolor Renderings of the Index of American Design, at the National Gallery of Art*, 2 vols. (New York: H. N. Abrams, 1972), 1 : 54-57; the source proves that even the lowly American tobacco store Indian often reflects the influence of the Apollo's pose.

134. [Boston Athenaeum], *A Catalogue of the Second Exhibition of Paintings*,

in the Athenaeum . . . (Boston, 1828), pp. 5-8; Sully, "Journal," p. 61; [Boston Athenaeum], *Catalogue of the Sixth Exhibition of Paintings in the Athenaeum Gallery* (Boston, 1832), p. 1.

135. Cowdrey, *AAU. Record,* pp. 215-16; Redwood Library and Athenaeum, *The Annual Report of the Directors of the Redwood Library . . . , 1862,* pp. 25, 59, items 26 and 214.

136. Gerdts and Burke, *American Still-Life Painting,* pp. 22-40, 49.

137. Ellis [K.] Waterhouse, *Painting in Britain 1530 to 1790* (Baltimore: Penguin Books, 1953), pp. 121ff., 204ff.

138. *Port Folio,* August 1813, pp. 138-40; Woodward, *Wilkie,* 1: vi.

139. Neal, "Observations," p. 56 and note. Neal's claim that the idea for King's *Grandfather's Hobby* was Leslie's may be supported by a letter written to the Apollo Association by John H. Gray, a friend of G. P. A. Healy, in which Gray referred to several paintings that Healy had sent to Boston from Paris in 1841. Among them was "an early study by King supposed from C. R. Lillie," no doubt Charles Robert Leslie. How, then, or why Healy acquired this early King study, very likely of the *Grandfather's Hobby* theme, is unknown (see Gray to John P. Ridner, February 1, 1842, "Letters, AAU"). See also Biddle and Fielding, *Life and Works of Thomas Sully;* Sully, "Journal," p. 33; [Boston Athenaeum], *Catalog of the Second Exhibition* (1828), p. 3, lists J. Fullerton as owner of Sully's "Riding my Grandfather's Hobby"; S. G. Goodrich, ed., *The Token; A Christmas and New Year's Present* (Boston, 1830), pp. iii-iv, ix, 233-34.

140. [Boston Athenaeum], *Catalogue of the Fifth Exhibition of Paintings in the Athenaeum Gallery* (Boston, 1831), p. 1; Cowdrey, *AAU. Record,* p. 216.

141. *New York Mirror,* October 27, 1838, p. 142.

142. De Mare, *Healy,* pp. 107-8; Newman, "Journal of Elizabeth Hannah Newman," entry of January 12, 1839; Smith, *Forty Years of Washington Society,* passim. See also Deeds, W. B. 68: 298-99, 78: 332-34; and King, "Will," pp. 2, 4, which indicate, respectively, that King assisted one Charles Dyson, a "free man of color" in his indebtedness and that he left a trust fund for his two servants – free blacks, no doubt – Philip Allen and Rosanna Day.

143. Russel Crouse, *Mr. Currier and Mr. Ives* (Garden City, N.J.: Garden City Publishing Company, Inc., 1936), pp. 21-25.

144. Waterhouse, *Painting in Britain,* pp. 168-69, and "Gainsborough's 'Fancy Pictures,'" *The Burlington Magazine* 88 (June 1946): 134ff.; Biddle and Fielding, *Life and Works of Thomas Sully* (see the "Register").

145. Oliver, *J. Q. Adams,* p. 92, diary entry for June 29, 1819.

146. King, "Will," passim. The total of pictures is derived from the *Catalogue of Pictures, Statuary, &c., Belonging to the Redwood Library, September 1, 1885,* on file at the Redwood Library and Athenaeum, Newport, R.I.

147. King to "Dear Gould," May 24, 1859, Redwood Library and Athenaeum, Newport, R.I.

148. Overby, "32 Clarke Street," p. 9; *Newport Mercury,* January 7, 1854.

149. *Annual Report of the Board of Regents of the Smithsonian Institution . . . for the Year 1861* (Washington, D.C., 1862); Henry T. Tuckerman, *Book of the Artists . . .* (New York: G. P. Putnam & Son, 1867), pp. 67-68.

150. *Diary of C. F. Adams,* 1: 47-48.

151. Neal, "Observations," p. 55.

Chronology

1785 Is born in Newport, R.I., September 26, the only child of Deborah Bird and Captain Zebulon King.

1789 Father is killed April 30, by Indians at Marietta, Ohio. Probably lives at the home of his grandparents and undoubtedly receives lessons in art from his grandfather, Nathaniel Bird.

1796-1800 Probably lives at 32 Clarke Street, in the house of his stepfather, Nicholas Garrison, whom his mother no doubt had married by 1796. Receives informal art instruction from his neighbor, Samuel King. Friends with Washington Allston and Edward Greene Malbone.

1800-1805 Serves apprenticeship with Edward Savage in New York City and becomes acquainted with fellow apprentices John Wesley Jarvis, David Edwin, and John Crawley. Probably meets John Trumbull and John Vanderlyn.

1802 Nicholas Garrison dies, and King's mother inherits the Clarke Street house.

1806-1812 Departs for London, England, sometime between June and September 1806. Studies with West at the Royal Academy, and rooms for a time with Samuel Waldo. From 1808 to 1812, lives at the widow Bridgen's at No. 8 Buckingham Place. Shares his rooms with Thomas Sully from July 1809 to March 1810. Sends home, probably by way of Sully, ten volumes for the Redwood Library and Athenaeum in Newport. Assists Samuel F. B. Morse and Charles Robert Leslie, who arrive in England in 1811. Meets many English artists, including Sir David Wilkie and Sir William Beechey. Elected an academician of the Pennsylvania Academy of the Fine Arts in March 1812. Returns home by August 1812.

1812 Presents twenty-seven volumes to the Redwood Library in October. Moves to Philadelphia shortly thereafter.

1813 Writes from Philadelphia on January 3 to Leslie in London. In July, exhibits four paintings at the Pennsylvania Academy of the Fine Arts. These are reviewed in the August issue of the *Port Folio*.

1814 Exhibits one painting at the Pennsylvania Academy and is listed in the catalog of the exhibition as residing in Richmond, Va. Is in Washington, D.C., by December.

1815 Leaves Washington before summer. Visits Philadelphia. Moves to Baltimore by December.

1816 Visits Newport on the death of his grandmother Bird in November. Gives a painting to the Redwood Library. Returns to Baltimore by December, then proceeds to Washington, D.C.

1817 Returns to Baltimore from Washington before May. In July exhibits three paintings at the Pennsylvania Academy.

1818 In July exhibits one painting at the Pennsylvania Academy. Visits Waldo in New York enroute to or on his return from Newport during his annual summer visit there. In Washington, D.C., by December; has painting rooms at Twelfth and F streets.

1819 In February, mentions to John Quincy Adams his plans to return to Baltimore, but circumstances keep him in Washington and cause him to settle there until his death in 1862. Visits Newport on the death of his mother in October.

1820 Visits Newport in July to settle his mother's estate. Sells the Clarke Street house, which he inherited from his mother, to his aunt, Susanna Vinson, for $1,000. Visits Rembrandt Peale in Baltimore and criticizes his *Court of Death.*

1822 Still rooming at Twelfth and F streets in Washington, D.C., but probably begins to buy land. Begins painting Indian portraits for the War Department, and continues to do so regularly until 1830 and intermittently until 1842.

1823 Exhibits five paintings at the Pennsylvania Academy. Joins the Washington Botanical Society.

1824 Exhibits one painting at the Pennsylvania Academy. Visited in December by Sully and William Dunlap in his newly built house and gallery at 486 Twelfth Street, on the east side, between E and F streets, Washington, D.C. Gives instruction to George Cooke and John Gadsby Chapman.

1825 Purchases two half-lots on the east side of Twelfth Street, between E and F streets. Exhibits in his gallery Sully's *Capuchin Chapel* and Dunlap's *Bearing of the Cross* and *Christ Rejected.* Appointed by President John Quincy Adams to a three-man commission to judge a competition for a sculptural design for the Capitol. Visits Sully in Philadelphia. Exhibits four paintings at the Pennsylvania Academy.

1826 Exhibits in his gallery Dunlap's *Death on a Pale Horse.*

1827 Elected honorary member, professional, in the National Academy of Design.

1828 Purchases two more half-lots on the east side of Twelfth Street, between E and F streets. Exhibits four paintings at the Boston Athenaeum. From February through April allows Horatio Greenough to model a bust of John Quincy Adams in one of his studios. Chester Harding paints Adams's portrait there also.

1829 Exhibits in his gallery Dunlap's *The Graces Adorning Venus.* Gives to the Redwood Library five volumes and two Indian portraits, *Hayne Hudjihini* and *Shaumonekusse.*

1830 Purchases one half-lot on the east side of Twelfth Street, between E and F streets. Designs "Eckington," the home of Joseph Gales, Jr. Exhibits August Hervieu's *The Landing of Lafayette at Cincinnati.* Exhibits one painting at the Pennsylvania Academy.

1831 Exhibits one painting at the Boston Athenaeum. Exhibits at the Pennsylvania Academy the portrait of John Quincy Adams, which is shown again in 1832, 1834, 1836-1838, 1840, and 1843.

1832 Exhibits one painting at the Boston Athenaeum, and one at the Pennsylvania Academy. Inman begins copying the portraits in the Indian Gallery as the basis for the lithographs to appear in Thomas L. McKenney and James Hall's *History of the Indian Tribes of North America*.

1833 Purchases one lot on H Street, between Fifth and Sixth streets, Washington, D.C. Gives the Redwood Library one volume.

1835 Exhibits in his gallery Cooke's copy of Gericault's *Raft of the Medusa*. Visits Norfolk, Va. Gives the Redwood Library nine volumes.

1836 Gives the Redwood Library one volume.

1837 Paints many Indian portraits with the assistance of Cooke, S. M. Charles, A. Ford, and Shaw. Gives the Redwood Library a portrait of Columbus. Chapman exhibits King's portrait *Hayne Hudjihini*, which he owned, at the National Academy of Design in New York City. Volume 1 of the *Indian Tribes of North America* is published.

1838 Chapman exhibits King's painting, *Young Omaha, War Eagle, Little Missouri, and Pawnees*, at the National Academy. Volume 2 of the *Indian Tribes of North America* is published. Visits Sully for a week, on the marriage of Sully's daughter, Ellen. Exhibits five paintings at the Apollo Gallery in New York; reviewed in the *New York Mirror*, October 27.

1839 Exhibits at the Apollo Association three paintings in January, two in May, and seven in October. The association purchases and raffles off his *Grandfather's Hobby* and a still life.

1841 The Indian Gallery is transferred from the Department of War to the National Institution and is housed in the new Patent Office building.

1842 Writes an extensive review in the *National Intelligencer*, June 15, about G. P. A. Healy's portrait, *Guizot*. Ceases to paint Indian portraits. Gives two volumes to the Redwood Library. Volume 3 of the *Indian Tribes of North America* is published.

1843 Reinherits the house at 32 Clarke Street, Newport, on the death of his aunt, Susanna Vinson. Gives the Redwood Library one volume, a copy of the portrait of Governor William Coddington of Rhode Island, and $100, to be matched by the library's board of directors for the purchase of books.

1844 Gives the Redwood Library nineteen volumes and money to purchase two ladders for fire protection.

1845 Purchases one half-lot on the east side of Twelfth Street, between E and F streets, Washington, D.C. Gives the Redwood Library one volume.

1846 Gives the Redwood Library eight or nine volumes, and possibly some Indian portraits.

1847 Gives the Redwood Library thirty-nine volumes.

1850	Establishes a public gallery of art at his Clarke Street home, but lack of interest causes him to discontinue it.
1854	Purchases one lot on F Street, between Eleventh and Twelfth streets and abutting on his Twelfth Street properties. Danish National Museum acquires nine of King's Indian portraits from the estate of Peter von Scholten. Biographical article appears in the *Newport Mercury,* January 7. Exhibits one painting at the Pennsylvania Academy.
1856	Joins the Washington Art Association but is an inactive member. Andrew Way exhibits a portrait by King at the Maryland Historical Society.
1857	Visits Newport and Philadelphia.
1858	Appears dressed as Rubens at an annual fancy dress ball in Washington, D.C. The Indian Gallery is transferred to the new Smithsonian Institution Building and is exhibited, along with John Mix Stanley's paintings, in the Gallery of Art on the second floor. Rembrandt Peale addresses the Washington Art Association and notes King's invention, years before, of a flexible paint tube. Possibly exhibits one painting at the Maryland Historical Society.
1859	Gives several volumes to the Redwood Library and about seventy-eight paintings, to be hung in the newly added reading room. Exhibits one painting at the Washington Art Association.
1860	His cousin, Mrs. Elizabeth Hannah Newman of Washington, dies. Gives the Redwood Library seven volumes.
1861	Gives 100 large engravings to the Smithsonian Institution. Gives forty-six volumes, many maps and pamphlets, and forty-two paintings to the Redwood Library. Becomes gravely ill later in the year.
1862	Dies in Washington, March 18. Buried in the Newport Island Cemetery. Bequest to the Redwood Library includes 75 paintings, 395 volumes, 14 volumes of engravings, and about $10,000.
1863	Clarke Street and Washington properties sold for about $30,000 by the executor, his cousin George Gordon King.
1865	Fire in the Smithsonian Institution destroys almost all of King's and Stanley's paintings in the Gallery of Art.
1882	Inman's copies of the portraits in the Indian Gallery given to the Peabody Museum of Harvard University.
1885-1970	About 175 of King's paintings disposed of by the Redwood Library.
1970	Twenty-one Indian portraits sold at Parke Bernet auction May 21, by the Redwood Library.
1973	Exhibition of twenty-one Indian portraits by King (mostly from the collection of the Gulf States Paper Corporation, Tuscaloosa, Ala.) at the Corcoran Gallery of Art, January 12 to February 18.
1977	*Perfect Likenesses,* an exhibition of portraits (oils and lithographs) used in the *Indian Tribes of North America* at the National Museum of History and Technology, Smithsonian Institution, Washington, D.C., April to September.

Catalog of Known Works

The entries describing the known works of Charles Bird King are listed by type of subject matter under the major categories of portraits, subject pictures, and studies. Those under portraits are arranged alphabetically by last name of subject, and the remainder are arranged alphabetically by title of work.

The titles of the works were taken verbatim from contemporary sources whenever possible and were selected as the most fully descriptive of known variants. In respect to Indian names, those used in McKenney and Hall's *The Indian Tribes of North America* are usually followed. Many of the extant works have been seen at firsthand by the author, but some only in photographs and several not at all. The latter are denoted by the annotation "Not seen by author."

Unless otherwise indicated, all works given or bequeathed to the Redwood Library and Athenaeum, Newport, Rhode Island, were the gifts of Charles Bird King or came from his estate. All inscriptions are by King and, unless otherwise indicated, all works described are oil on canvas. Their dimensions are given in inches, with height preceding width. References not fully cited are included in the bibliography. The abbreviations used in the entries are as follows:

Annals	George Champlin Mason, *Annals of the Redwood Library and Athenaeum,* Newport, R.I.
BA 18__	Boston Athenaeum. Date denotes a specific catalog for an annual exhibition held at the athenaeum in 1828, 1831, 1832, or 1854. On file at the BA.
B-S	Kaj Birket-Smith, *Charles B. King's Indian Portraits in the National Museum* [Copenhagen].
CAP	Catalog of American Portraits, National Portrait Gallery, Smithsonian Institution, Washington, D.C.
CBK	Charles Bird King.
CBK, "Will"	Charles Bird King, "Last Will and Testament," estate number 4525 O.S., Federal Records Center, Suitland, Md.
Cowdrey, *AAU. Record*	Mary Bartlett Cowdrey, *American Academy of Fine Arts and American Art-Union. Exhibition Record, 1816-1852.*
Diary of C. F. Adams	Adams, *Diary of Charles Francis Adams,* 4 volumes.
Donations 1810-1858	"Register of Donations to the Redwood Library, 1810-1858." On file in the Redwood Library and Athenaeum, Newport, R.I.

Donations 1859-1863	"Primary Record Book of Donations since June 1859 to May 1, 1863." On file in the Redwood Library and Athenaeum, Newport, R.I.
Ewers	John C. Ewers, "Charles Bird King, Painter of Indian Visitors to the Nation's Capital," *Smithsonian Report for 1953*.
FARL	Mounted and annotated photographs, Frick Art Reference Library, New York.
GGK	George Gordon King, the artist's second cousin and executor of his estate, whose several letters sent from Washington, D.C., to the Redwood Library and Athenaeum refer to Charles Bird King's paintings. The letter of March 21, 1862, is especially important as it contains a numbered list of the seventy-five paintings selected for the library by George Champlin Mason to satisfy the artist's bequest. This letter is referred to simply as GGK, # ; for other letters, dates are given. The letters are on file in the Charles Bird King File, Redwood Library and Athenaeum, Newport, R.I.
HSP	The Historical Society of Pennsylvania, Philadelphia.
Index	Index of Portraits, Redwood Library and Athenaeum, Newport, R.I.
JHP	J. Hall Pleasants's collection of mounted and annotated photographs, Maryland Historical Society, Baltimore.
Lewis	James Otto Lewis, many of whose sketches of Indians made in the field were copied by King for McKenney and Hall's *The Indian Tribes of North America*.
MH	Thomas L. McKenney and James Hall, *The Indian Tribes of North America . . .*, edited by Frederick Webb Hodge, 3 volumes, 1933-1934. This is the definitive edition.
NCFA	National Collection of Fine Arts, Smithsonian Institution, Washington, D.C.
NPG	National Portrait Gallery, Smithsonian Institution, Washington, D.C.
Oliver, *J. Q. Adams*	Andrew Oliver, *Portraits of John Quincy Adams and His Wife*.
PAFA	Pennsylvania Academy of the Fine Arts, Philadelphia.
PAFA 18__	Date denotes a specific catalog for an annual exhibition held at the Pennsylvania Academy of the Fine Arts in 1813, 1814, 1817, 1818, 1822-25, 1830-32, 1834, 1836-38, 1840, or 1843. On file at the PAFA.
PB	Parke Bernet sale catalog, May 21,1970, *The Important Collection of Twenty-One Portraits of North American*

Indians by Charles Bird King (1785-1862). Property of the Redwood Library....

PM Peabody Museum, Harvard University, collection of Henry Inman's copies of the portraits by Charles Bird King formerly in the Indian Gallery of the Smithsonian Institution.

Redwood Library or RL Redwood Library and Athenaeum, Newport, R.I.

Rhees, #___ William Jones Rhees, *An Account of the Smithsonian Institution . . .*, 1859, which contains the only known list of the portraits formerly in the Indian Gallery. Number (#) denotes a specific title on Rhees's list.

RL 1859 *Catalogue of Pictures and Busts Belonging to the Redwood Library, Newport, R.I., July 1st, 1859...* on file at the Redwood Library and Athenaeum.

RL 1862 *Annual Report of the Directors of the Redwood Library and Athenaeum, Newport, R.I., ... Sept. 24, 1862,* on file at the Redwood Library and Athenaeum.

RL 1885 *Catalogue of Pictures, Statuary, &c., Belonging to the Redwood Library, September 1, 1885,* on file at the Redwood Library and Athenaeum.

SI Smithsonian Institution, Washington, D.C.

Stauffer David McNeely Stauffer, *American Engravers Upon Copper and Steel,* vol. 2.

Sully, "Journal" Thomas Sully, "Journal of Activities, 1792-1846," filed on microfilm in the Archives of American Art, Smithsonian Institution, Washington, D.C.

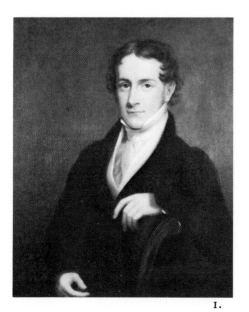

1.

Portraits
Arranged alphabetically by last names of subjects.

Subjects Other Than Indians

1. *Charles Francis Adams* (1807-1886) 1827
 Owner: Adams National Historic Site, Quincy, Mass.
 Reference: *Diary of C. F. Adams,* 2: 116-35, 145.

2. *Fanny Adams, Granddaughter of John Quincy Adams* 1835
 Unlocated. Bequeathed to RL on August 2, 1862; deaccessioned after 1885.
 References: GGK, #12. RL 1862 and 1885, #139. Oliver, *J. Q. Adams,* p. 221.

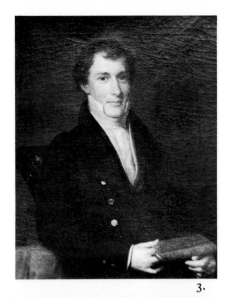

3.

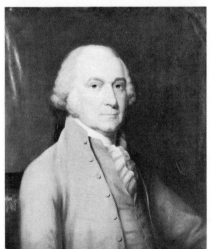

4.

5.

3. *George Washington Adams* 1823

30 x 25½.

Owner: Mrs. Waldo C. M. Johnston, Old Lyme, Conn., subject's great-great-grandniece.

Reference: *Diary of C. F. Adams,* 3: xv-xvii, 315.

4. *John Adams* (1735-1826) after Robert Field

30 x 25.

Signed on back: John Adams President of the U.S. Copy from the original by Field by C. B. King Washington.

Owner: Redwood Library. Given before 1859.

References: RL 1859, #89. RL 1862 and 1885, #109; listed as "Copied from Stuart." Oliver, *J. Q. Adams,* pp. 221-25; no prototype for this portrait is known to Oliver except, perhaps, the "Doggett replica." He also mentions a tinted drawing after CBK by "Gerard," and an engraving by François Louis Couché, circa 1820-1825.

§ The inscription is probably correct.

5. *John Adams* after Gilbert Stuart 1827

30 x 25.

Owner: Redwood Library. Bequeathed on August 2, 1862.

References: GGK #29. RL 1862 and 1885, #106. Index, #67. Oliver, *J. Q. Adams,* pp. 192, 194-95; notes that portrait was copied for J. Q. Adams from Stuart's 1826 replica of his original of 1823.

6. *John Adams II* 1823-1827

30 x 25½.

Owner: Mrs. Waldo C. M. Johnston, Old Lyme, Conn., subject's great-great-granddaughter.

Reference: *Diary of C. F. Adams,* 3: xv-xvii, 315.

7. *John Quincy Adams* (1767-1848) 1819-1821

36 x 28.

Signed on back: John Quincy Adams Sct. of State at the time this original picture was painted by C. B. King Newport Washington.

Owner: Redwood Library. Given before 1859. Possibly exhibited at the PAFA in 1831, 1834, 1836-1838, 1840, and 1843.

References: RL 1859, #90. RL 1862 and 1885, #110; incorrectly list portrait as "Copied from Stuart." Index, #93. Rutledge, *Cumulative Record of Exhibition Catalogues* (PAFA), p. 114. Oliver, *J. Q. Adams,* pp. xxii, xxxiii 1, 3, 19, 91-102, this version is dated 1819 by Oliver, who believes it is the original. Mantle Fielding, *American Engravers upon Copper and Steel . . . A Supplement to . . . Stauffer* (Philadelphia, 1917), pp. 154, 211. Stauffer, #1565, #2275.

§ This portrait is probably the first of two versions that CBK painted for Joseph Delaplaine's "National Gallery," the other probably being that at Lafayette College (see cat. no. 8). Oliver notes that this version was commissioned by Delaplaine in March 1819 but was found unsatisfactory; a second version was begun in July 1819. In May 1820, when more sittings were held, Mrs. John Quincy Adams wrote to her father-in-law, John Adams, that although a good likeness, the portrait was "disagreeable." About September 1821 or shortly thereafter CBK finished the portrait, for Delaplaine wrote to John Adams on February 9, 1822, that he had received the picture "within

6.

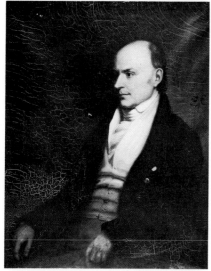

7.

10.

the last five months." However, on January 1, 1824, Charles F. Adams saw a finished version of the painting at CBK's gallery and remarked, "I think my father's a good one, but by no means so good as I think one could be made. His eyes are placed in such a way that one appears directly over his nose." The description aptly fits this version, the first attempt, no doubt, which CBK completed and retained for himself until giving it to the Redwood Library. According to Andrew Oliver, Gerard made a tinted drawing and Couché an engraving of this version. Another engraving by an unknown artist was made probably after 1825.

8. *John Quincy Adams* 1819-1821
23 x 19.
Owner: Lafayette College, Easton, Pa.
§ Although labeled on the frame as by James Frothingham, this portrait is correctly ascribed to CBK by Andrew Oliver, who believes it is the first version begun by CBK. It is, however, probably the second version painted for Delaplaine, and perhaps was later cut down. Oliver notes that the Delaplaine version was engraved by Francis Kearney and published April 27, 1824, by B. O. Tyler; by I. W. Moore for the 1828 *Souvenir* of P. Price, Jr.; and by M. M. Peabody.

9. *Mrs. John Quincy Adams* (Louisa Catherine Johnson) 1821-1825
Illustrated in figure 27.
51½ x 39¾.
Owner: National Collection of Fine Arts, Washington, D.C., given with the harp and music book used in the painting to SI in 1950 by Maria Louisa Adams Clement, subject's great-great-granddaughter.
References: Belt, "Portrait of Mrs. John Qincy Adams," unpublished research paper, passim. Knox, "Adventuring in Early American Art," *The Daughters of the American Revolution Magazine,* passim. CBK file, NCFA. Oliver, *J. Q. Adams,* pp. xxiii, 102-4. Mrs. Adams to CBK, July 14, 1836, HSP, Gratz Collection.
§ According to Belt, Mrs. Adams wrote in her diary for January 3, 1821: "Mr. King, the painter sent me a small painting for a present which will cost me a sitting for a portrait. T'is a heavy tax but is [important]"; and Mr. Adams's account book shows that on June 30 and October 16, 1821, respectively, he paid King $50 for a portrait of Mrs. Adams, and Isaac Cooper $25 for a frame. In July 1836, Mrs. Adams wrote to King expressing her wish for him to put off some seven years and to have the picture "new dressed." X-rays of the portrait show no signs of overpainting, however, and only minor changes in the left sleeve.

10. *Reverend Walter Dulany Addison* (1769-1848) circa 1846
30¼ x 25¼.
Owner: Maryland Historical Society, Baltimore. Given in January 1950 by Miss Adele Maria Batre, subject's great-granddaughter.
Reference: JHP, #3335; notes that Addison was seventy-seven years of age and blind when the portrait was taken.

11.

14.

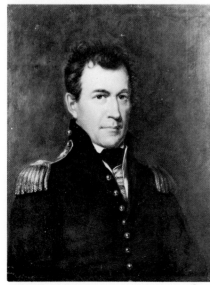

18.

11. *Joseph Anderson* (1757-1837) circa 1815-1817
29¾ x 24½ (sight).
Owner: Deputy Comptroller General's Office, Washington, D.C.
Reference: FARL.
§ Anderson was appointed the first comptroller of the Treasury by President
Madison in 1815.

12. *Sir Charles Bagot* (1781-1843) 1819
Unlocated. Exhibited at the PAFA in 1822.
References: PAFA 1822, pp. 13-14; lists this portrait as having been painted
for Delaplaine. Oliver, *J. Q. Adams*, p. 92; mentions that Adams saw it at CBK's
on March 24, 1819.

13. *Dr. Samuel Baker* (1785-1835) circa 1825
36 x 30.
Unlocated. Presented in 1926 to the Medical and Chirurgical Faculty of
Maryland, Baltimore, by Eloise Baker, subject's daughter.
Reference: FARL.

14. *William T. Barry* (1785-1835)
Unlocated.
Reference: Stauffer, #1930; lists an engraving (shown here) by Longacre
and labeled "William T. Barry of Kentucky Post Master General."

15. *Barnabas Bates* circa 1845
Unlocated. With Purnell Galleries, Baltimore, in 1933.
Reference: FARL.

16. *Mrs. George Bender and Child* circa 1825
44 x 34.
Unlocated.
Reference: FARL.

17. *Mrs. Robert Bolling* (1780-1846)
30 x 25.
Owner: Department of State, Washington, D.C. Given in 1976.
References: FARL. Virginia Historical Society, Richmond.

18. *General Jacob Brown* (1775-1828) circa 1821
Oil on wood, 28 x 23.
Signed on back: Gen'l Jacob Brown Commander in Chief U. S. Army
Painted by C. B. King Washington 18__ being the last portrait he ever sat for.
Owner: Redwood Library. Given before 1859.
References: RL 1859, #81. RL 1862 and 1885, #124. Index, #38. *Diary of
C. F. Adams*, 1: 47; mentions that Adams saw this portrait at CBK's on January
17, 1824.

19. *O. Brown* circa 1848
Unlocated.
Reference: Biddle and Fielding, *Life and Works of Thomas Sully*, p. 108,
#212; records a bust-length portrait that Sully painted of Brown "from a portrait
by King." Sully valued it at $150.

21.

25.

20. *Colonel Elijah Brush* circa 1812
36 x 33.
Owner: Detroit Historical Museum, Detroit, Mich.
Reference: Inventory of American Paintings Executed before 1914, NCFA.
§ Not seen by author.

21. *Tristam Burges* (1770-1853) circa 1825
29 x 25.
Owner: Brown University, Providence, R.I. Given in 1857 by John R.
Bartlett.

22. *Tristam Burges*
17½ x 13½ (sight).
Owner: State Capitol, Providence, R.I.; located in Supreme Court.
Reference: Lee, *Portrait Register,* p. 550.
§ Not seen by author.

23. *Nathaniel Burwell* (1750-1814)
42 x 32.
In private collection.
Reference: FARL; possibly a copy of a lost miniature.
§ Attribution doubtful.

24. *Colonel Butler*
Unlocated.
Reference: Oliver, *J. Q. Adams,* p. 92; mentions that Adams saw this portrait
at CBK's on March 24, 1819.

25. *John C. Calhoun* (1782-1850) 1818-1820
36 x 28.
Owner: Redwood Library. Given before 1859.
References: RL 1859, #93; lists portrait as "John C. Calhoun, Secretary of
War, 1818." RL 1862 and 1885, #117. Index, #50. Oliver, *J. Q. Adams,* p. 92;
mentions that at CBK's on March 24, 1819, Adams saw, among other portraits,
"Calhoun twice" – probably a reference to this and the Norfolk version (see cat.
no. 26). PAFA 1822, 1823, 1824, pp. 14, 14, and 4, respectively. Calhoun, *Papers
of John C. Calhoun,* 2: 194-95; 3: xvii, xxix-xxi, 633-34; 4: 381, 388, 538-39,
645-47.
 § Although the two versions of this portrait may have been begun in 1818,
 they could not have been completed before January 1820, when the road to
 Chariton, depicted on the map, was surveyed.

26. *John C. Calhoun* 1818-1820
Illustrated in figure 32.
36 x 28¼.
Owner: Chrysler Museum of Art, Norfolk, Va. Given by the family of
Charles Wiley Grandy. Possibly the version exhibited at the PAFA in 1822, 1823,
and 1824.
 Reference: PAFA 1822, 1823, 1824, pp. 14, 14, and 4, respectively; variously
list portrait as *Calhoun, Secretary of War,* painted for Delaplaine's gallery.

28.

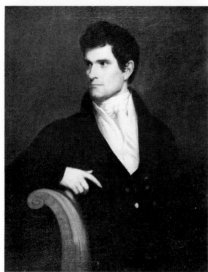

29.

30.

27. *John C. Calhoun* circa 1825
Illustrated in figure 33.
30½ x 25⅜.
Owner: Corcoran Gallery of Art, Washington, D.C. Purchased on January 18, 1879, by W. W. Corcoran from Mrs. G. W. Hughes, daughter of Virgil Maxcy, for whom it is said the portrait was painted in 1822.
References: PAFA 1825, p. 7, #160. Stauffer, #1949-50; records an engraving by Longacre, and the Corcoran Gallery's files note one by Atkinson and Alexander for P. Price's *Casket*. Davira Spiro, Corcoran Gallery, to the author, May 21, 1975; notes that on January 11, 1888, W. W. Corcoran wrote to Robert N. Gourdin about the gallery's "portrait of Mr. Calhoun, painted in early life, by King, of this city which I consider the best likeness of him I ever saw save that by Delblocks, which was destroyed by fire."
§ Calhoun is probably represented here as vice-president, to which office he acceded in 1825, the year King exhibited at the PAFA a portrait of Calhoun entitled *J. C. Calhoun, Vice President*.

28. *John C. Calhoun*
30 x 25.
Owner: National Portrait Gallery, Washington, D.C. Bought from R. McClellan Brady by August F. DeForest; sold in 1922 by Keeler Galleries, New York; bought by Kraushaar; sold to Knoedler's; acquired in 1936 by the Mellon Charitable and Educational Trust Co.; given in 1942 to the National Gallery of Art, Smithsonian Institution, for the NPG, which received it in 1965.
§ A copy of the Corcoran's *Calhoun*, this version may be by Rembrandt Peale.

29. *John C. Calhoun*
26 x 28.
Owner: South Carolina Museum Commission, Columbia. Purchased in 1976 from Mrs. William McClure of Oklahoma City, whose family acquired the painting and other furnishings in the 1930s when they bought a Calhoun family home in Abbeville, S.C.
§ Possibly a copy after CBK's portrait at the Corcoran.

30. *Calmady Children* after Sir Thomas Lawrence circa 1835
33 x 30.
Owner: Redwood Library. Bequeathed on August 2, 1862.
References: GGK, #66. RL 1862 and 1885, #10. Index, #21.

31. *Eleanor Calvert* (1753-1811)
Unlocated. Formerly hung at "Mount Airy"; sold to John Milton Hay in 1903 at Sloan's Gallery, Washington, D.C.
References: JHP. FARL; lists portrait as after an original by an unknown artist.

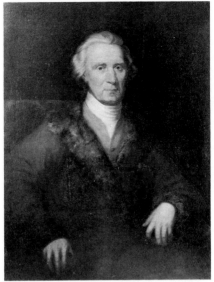

32.

32. *Charles Carroll of Carrollton* (1737-1832)
30 x 28.
Owner: The Carroll family.
References: FARL. JHP, #130. CAP. Kate Mason Rowland, *The Life of Charles Carroll of Carrollton 1737-1832* . . . , 2 vols. (New York and London: G. P. Putnam's Sons, 1898), pp. 311-12. PAFA 1818, p. 7, #27; lists portrait as "to be engraved for Delaplaine's Repository. *C. B. King.* Mr. Carroll signed the Declaration of Independence, and is now living, in the 82nd year of his age." Carroll to Delaplaine, August 21, 1816 (on file in the Historic American Building Survey, National Park Service, Department of the Interior, Washington, D.C.): "I received this day your letter of the 28th. past. . . . My letter of the 6th. instant in answer to Mr. King's of the 29th. of July, informed him I should be in Baltimore about 20th. December and remain there during the winter where I will sit to him for my portrait at any place in that city he may appoint."

§ The painting, which CBK probably did not begin to paint until late 1817, was never engraved, nor did it appear in Joseph Delaplaine's *Repository of the Lives and Portraits of Distinguished American Characters* (Philadelphia, 1815).

33. *Robert Wormeley Carter* (1792-1861) 1840
29½ x 24½.
Owner: T. Dabney Wellford, Warsaw, Va.
Reference: Carter account book, University of Virginia (according to owner): "1840. Paid C. B. King $60 for picture of self."

34. *Mrs. Robert W. Carter* (Elizabeth Mary Tayloe; ?-1832)
29½ x 24½.
Owner: T. Dabney Wellford, Warsaw, Va.

35. *Mrs. Robert W. Carter*
Oil on wood, 16½ x 12¾.
Owner: Rensselaer County Historical Society, Troy, N.Y.
§ Undoubtedly a copy of catalog number 34.

33.

34.

35.

39.

40.

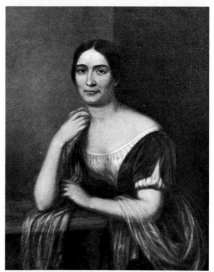

41.

36. *Manuel Carvallo* (1808-1867) 1834
Owner: Ben E. Merino Carvallo, Viña del Mar, Chile.
References: Jordi Fuentes y Lia, *Diccionario Histórico de Chile,* 2d ed. (Santiago: Editorial Del Pacifico, S.A., 1965), p. 93. Ben E. Merino Carvallo to the National Gallery of Art, February 15, 1937, filed in the NPG library; states that the portraits of Mr. and Mrs. Carvallo were commissioned on the couple's wedding in 1834 by the bride's father, James H. Causten. In 1839 the paintings were sent to Santiago, Chile, to which Carvallo, formerly Chile's chargé d'affaires in Washington, and his wife had returned.

37. *Manuel Carvallo* 1834
Unlocated. Given to RL before 1859; deaccessioned after 1885.
References: RL 1859, #32; lists portrait as "Miguel Carvallo, Minister from Chili." RL 1862 and 1885, #84.
§ Probably a replica of catalog number 36.

38. *Mrs. Manuel Carvallo* (Mary Elizabeth Causten; ?-1851) 1834
Owner: Ben E. Merino Carvallo, Viña del Mar, Chile.
Reference: Same as for catalog number 36.

39. *Mrs. Manuel Carvallo* 1834
Oil on wood, 17½ x 12½.
In private collection.

40. *Dr. James H. Causten, Jr.* (?-1856) 1852-1853
36 x 30¼.
Owner: Greensboro Historical Museum, Greensboro, N.C. Acquired from John Baker Kunkel, subject's grandson, by the Dolly Madison Memorial Association, which presented it to the Greensboro museum in 1963.
References: James H. Causten's account book, on file in The Dolly Madison Collection, Greensboro Historical Museum, Greensboro, N.C.; lists two entries, dated February 22 and March 31, 1853, for payments to CBK of forty and sixty dollars, respectively, "for portraits of Annie & me." The administrative account of CBK's estate (Schedule A, July 26, 1862), also on file in The Dolly Madison Collection, lists the two portraits as valued at $50 each.

41. *Mrs. James H. Causten, Jr.* (Anna Payne; ?-1852) 1852-1853
36 x 29½
Owner: Greensboro Historical Museum, Greensboro, N.C.
Reference: Same as for catalog number 40.
§ Possibly painted from a photograph illustrated in Ethel Arnett Stephens, *Mrs. James Madison: The Incomparable Dolley* (Greensboro, N.C.: Piedmont Press, 1972), p. 316.

42. *Helen Mary Chapman* (Mrs. Thomas W. Swann; 1825-1895) 1846
30 x 25.
Signed on back: Helen Mary Chapman, May 1846, by King, Washington, D.C.
Owner: Miss Helen Chapman Calvert, Alexandria, Va., the subject's granddaughter.
Reference: FARL.

43. *Mrs. Robert Chew* (Elizabeth Ringgold Smith; 1816-1899) circa 1835
Illustrated in figure 34.
Oil on wood, 24 x 20.
Owner: Mr. and Mrs. John R. Slidell, Washington, D.C.; Mrs. Slidell is
the subject's great-granddaughter.

44. *Child of Clement C. Clay, Jr., Huntsville, Ala.*
Unlocated. Given to RL before 1859; deaccessioned after 1885.
References: RL 1859, #31. RL 1862 and 1885, #14. Donations 1859-1863,
November 2, 1860; lists an "Oval Gilt Frame" CBK gave to the Redwood Library
for the picture.

45. *Thomas Childs* (1796-1853) circa 1833
35½ x 28½.
Owner: Mrs. T. C. Woodbury, Washington, D.C., widow of subject's
grandson.
Reference: FARL.

46. *Mrs. Thomas Childs* (Ann Eliza Coryton; 1800-1875)
35½ x 28½.
Owner: Mrs. T. C. Woodbury, Washington, D.C.

47. *Henry Clay* (1777-1852) 1821
Illustrated in figure 29.
36⅛ x 28⅛.
Owner: Corcoran Gallery of Art, Washington, D.C. Purchased through the
Gallery Fund on May 9, 1881, from John Cranch by W. W. Corcoran, who
overruled the Committee on Works of Art to make the purchase.
References: CBK file, Corcoran Gallery, and Davira Spiro, Corcoran Gallery,
to author, May 21, 1975. Clay, *Papers of Henry Clay,* 3: 29-31, 241-42, 413-15;
4: 495-96. Russell J. Quandt, "Reclamation of Two Paintings," *Corcoran Gallery
of Art Bulletin* 6 (October 1953): 10-15.
 § Engraved by Peter Maverick and published by Benjamin O. Tyler, June
 1822 (see fig. 30).

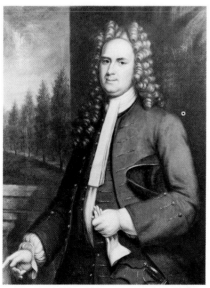
48.

48. *William Coddington* (1600-1678) 1843
44 x 34½.
Signed on back: Portrait of William Coddington, Governor of Rhode Island,
painted by Charles Bird King of Washington from an original portrait and pre-
sented to the Redwood Library Society, A.D. 1843.
Owner: Redwood Library. Given in 1843.
References: RL 1859, #95. RL 1862 and 1885, #134. Index, #55. Mason,
Annals, p. 165; records that on December 12, 1843, the board of directors, Redwood
Library, voted their thanks to CBK for the portrait, copied from the original owned
by the city of Newport and hung in its city hall.

49. *Mrs. Isaac A. Coles* (1796-1876) circa 1830
29 x 24½.
Owner: Walter Lippincott Coles, Keene, Va.
Reference: FARL.
 § Attribution doubtful.

51.

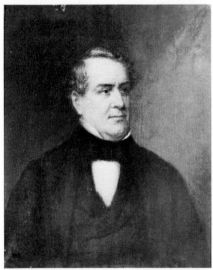

54.

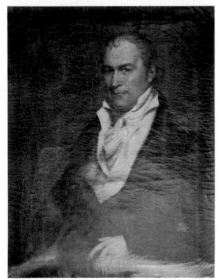

58.

50. *Columbus*
Unlocated. Bequeathed to RL on August 2, 1862; deaccessioned after 1885.
References: GGK, #58. RL 1862 and 1885, #220.

51. *Christopher Columbus, from an Old Spanish Painting* circa 1838
Oil on wood, 17½ x 13¾.
Owner: Barridoff Galleries. Purchased in 1976 from Ross Levett; gift to
RL in 1838; deaccessioned after 1885.
References: RL 1859, #79. RL 1862 and 1885, #131. Mason, *Annals*, p. 157;
records that on January 4, 1838, the library board thanked CBK for the painting.
§ Although this could be the portrait described in catalog number 50, the
style of the picture accords well with a date of 1838.

52. *Mr. Conner, a Revolutionary Soldier, at 94 Years of Age*
Unlocated. Given to RL before 1859; deaccessioned after 1885.
References: RL 1859, #57. RL 1862 and 1885, #136.

53. *Hon. G. Seymour Conway* after Sir Joshua Reynolds
Unlocated. Given to RL before 1859; deaccessioned after 1885.
References: RL 1859, #16. RL 1862 and 1885, #197.

54. *William Corcoran, of Washington* (1798-1888) circa 1850
30 x 25.
Owner: Redwood Library. Bequeathed on August 2, 1862.
References: GGK, #34. RL 1862 and 1885, #63. Index, #45.

55. *Abbe Correa* 1819
Unlocated.
References: Oliver, *J. Q. Adams*, p. 92; notes that Adams saw this portrait
at CBK's on March 24, 1819. Green, *Washington, Village and Capitol*, p. 69;
mentions that Correa, the Portuguese minister to the United States, returned home
in 1820, and that he was an expert botanist and founder-member (1817) of the
the Washington Botanical Society, of which CBK became a member.

56. *Hernando Cortez, Conqueror of Mexico*
Unlocated. Bequeathed to RL on August 2, 1862; deaccessioned after 1885.
References: GGK, #60. RL 1862 and 1885, #56.

57. *Hernando Cortez* [?]. *Head.* after Giorgione
Unlocated. Given to RL before 1859; deaccessioned after 1885.
References: RL 1859, #58. RL 1862 and 1885, #5.

58. *William H. Crawford, Secretary of Treasury* (1772-1824) 1817-1824
37 x 28.
Owner: Redwood Library. Given between 1848 and 1859.
References: Watterston, *New Guide to Washington*, p. 102; in 1847 this
portrait was seen at CBK's by Watterston, who described it as "inimitable." RL
1859, #92. RL 1862 and 1885, #115.

60.

61.

59. *Richard Cutts*
Owner: George B. Cutts, Brookline, Mass.
Reference: Virginia Historical Society, Richmond, *Portraiture in the Virginia Historical Society* (privately published, 1945); lists this portrait as after Stuart.
§ Not seen by author.

60. *Mrs. Richard Cutts* (Anna Payne; 1779-1832) after Gilbert Stuart
30 x 25.
Owner: Virginia Historical Society, Richmond. Bequeathed by Mrs. Walter Farwell in 1944.

61. *Daingerfield Children* circa 1853
29½ x 24½ (oval).
Owner: Admiral John Lesslie Hall, Jr., Alexandria, Va., son-in-law of William Bathhurst.
References: FARL. Lee, *Portrait Register,* p. 550.
§ The Daingerfield children are, from left to right, William Bathhurst (1845-1917), Mary Helen (1842-1875), and Edward Lonsdale (1847-1925).

62. *Commodore Stephen Decatur* (1779-1820) 1820
Oil on wood, 30 x 24.
Inscribed on back: Painted from a mask [?] after his death. Coloring from Stuart[?].
Owner: Redwood Library. Given before 1859.
References: RL 1859, #84. RL 1862 and 1885, #126. Index, #43. Charles Lee Lewis, "Decatur in Portraiture," *Maryland Historical Magazine* 35 (December 1949): 365-73.

63. *Commodore Stephen Decatur* after Gilbert Stuart
30 x 25.
Owner: National Collection of Fine Arts, Washington, D.C.
Reference: William H. Truettner, "Portraits of Stephen Decatur by or after Gilbert Stuart," *The Connoisseur* 171 (August 1969): 264-73.

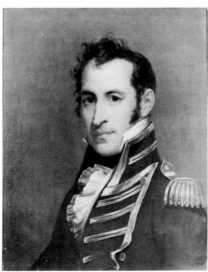

62.

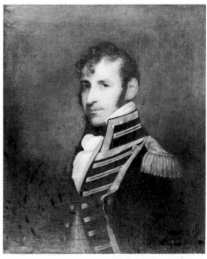

63.

64.

65.

73.

64. *Ann Caroline Fowle Dennis* (1823-?)
Oil on wood, 17½ x 13¾.
Owner: Anne Carter Greene, Washington, D.C.

65. *Jane Amelia Dickins* (1815-?) circa 1835
30 x 25.
Signed on back of original canvas: Charles Bird King.
Owner: Mrs. Hilliard E. Miller, Colorado Springs, Colo., subject's great-grandniece.
References: FARL. Mrs. Hilliard E. Miller to author, May 5, 1973.

66. *Emily Donelson*
Unlocated.
References: Amy La Follette Jensen, *The White House and Its Thirty-Five Families* (New York: McGraw-Hill Book Company, 1970), p. 51; illustrates portrait, unattributed. Sully, "Journal," p. 99D, June 30, 1834; records that Sully and CBK were guests at a family dinner at the White House, at which "Mrs. Donaldson [*sic*]," the wife of President Jackson's nephew, was present.

67. *William Doughty*
Unlocated.
Reference: Howard N. Doughty, "Life and Works of Thomas Doughty," unpublished manuscript on file in The New-York Historical Society; mentions that Thomas Doughty's older brother, William, commissioned CBK to paint portraits of his wife and himself, the latter showing "the Colonel with his drafting compass in hand and a set of Naval specifications on his desk."

68. *Mrs. William Doughty*
Unlocated.
Reference: Same as for catalog number 67.

69. *Mr. Duffy*
Unlocated.
Reference: Sully, "Journal," p. 114, October 31, 1836: "Shipped to King ... his port of Mr. Duffy, for the use of wh Tappan pd me $10."

70. *Earl of Pembroke* after Sir Anthony Van Dyck
Unlocated. Bequeathed to RL on August 2, 1862; deaccessioned after 1885.
References: GGK, #42. RL 1862 and 1885, #33.

71. *Earl of Warwick* after Sir Anthony Van Dyck
Unlocated. Exhibited at PAFA in 1813; given to RL in December 1861; deaccessioned after 1885.
References: PAFA 1813, p. 16, #73. GGK, December 14, 20, 1861. Donations 1859-1863, December 12, 1861. RL 1862 and 1885, #104. Mason, *Annals*, p. 226.

72. *Christopher Ellery*
Unlocated.
Reference: John O. Austin, *Ancestry of Thirty-Three Rhode Islanders ...* (Albany: John Munsell's Sons, 1889); lists portrait as by CBK.
§ Possibly the husband of CBK's aunt, Clarissa Bird Ellery.

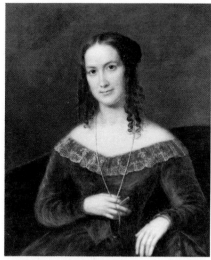

74.

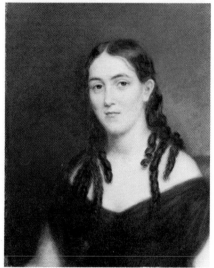

79.

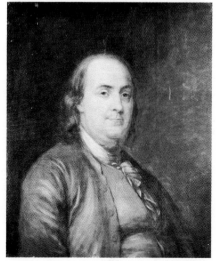

80.

73. *Dr. Orlando Fairfax* (1806-1882) circa 1846
30 x 25.
Owner: Mrs. Colin MacRae, Alexandria, Va.
References: FARL. Lee, *Portrait Register*, p. 550.

74. *Mrs. Orlando Fairfax* (Mary Randolph Cary; 1811-1887) circa 1846
30 x 25.
Owner: Mrs. Colin MacRae, Alexandria, Va.

75. *Senator James Fenner* (1771-1846)
35½ x 28½.
Owner: State Capitol, Providence, R.I.
Reference: Lee, *Portrait Register*, p. 551.
§ Not seen by author.

76. *Anna Forsyth*
30 x 25.
Owner: Leonard Marbury, Chevy Chase, Md.
§ According to family tradition, CBK painted Anna's portrait for her parents, Senator and Mrs. J. G. Forsyth, after the child's death at the age of two years.

77. *John Graham Forsyth* (1780-1841) 1818-1819
Unlocated.
Reference: Oliver, *J. Q. Adams*, p. 92; notes that John Quincy Adams saw this portrait at CBK's on March 24, 1819.
§ Probably painted when Forsyth was elected senator from Georgia in 1818, after having served for six years in the House of Representatives.

78. *Mrs. John G. Forsyth* (Clara Meigs)
30 x 25.
Owner: Leonard Marbury, Chevy Chase, Md., subject's great-great-grandson.
§ Possibly by John Vanderlyn.

79. *Harriet Boardman Fowle* (Mrs. Charles Sinclair Tayloe; 1825-1873) circa 1843
Oil on wood, 17½ x 13¾.
Owner: Anne Carter Greene, Washington, D.C.

80. *Benjamin Franklin* (1706-1790) after Joseph S. Duplessis
30 x 25.
Owner: Redwood Library. Given before 1859.
References: RL 1859, #87: "B. Franklin, said, by President Monroe to be the best likeness of him that he had ever seen." RL 1862 and 1885, #111. Index, #63. Clarence Winthrop Bowen, *The History of the Centennial Celebration of the Inauguration of George Washington as the First President of the United States* (New York: D. Appleton and Company, 1892), p. 450; mentions that the portrait was copied from an original by Duplessis, which had been acquired by Monroe while he was minister to France and which is now in the possession of Mrs. Douglas Robinson of New York.

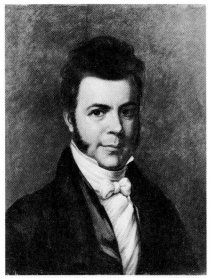

84.

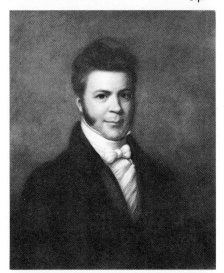

85.

86.

81. *French Consul*
Unlocated.
Reference: Sully, "Journal," pp. 194-96, January 12, 29, and February 5, 1839; mention that Sully had received a box from CBK for the French consul, and that the consul paid him $40, which Sully sent to CBK "for a port."

82. *Mrs. Nathaniel Frye* (nee Johnson) 1822-1823
Unlocated.
Reference: Belt, "Portrait of Mrs. John Quincy Adams," unpublished research paper, pp. 19, 20; notes that from December 12, 1822, to January 11, 1823, Mrs. Adams recorded in her diary several visits to CBK's studio with her sister, Mrs. Frye, whose portrait CBK was painting. Mrs. Adams wrote that the portrait "will be an excellent likeness."

83. *Joseph Gales*
Unlocated.
References: Clark, "Joseph Gales, Junior, Editor and Mayor," *Records of the Columbia Historical Society*, p. 133; Clark places this portrait with the pictures that hung in the hall of "Eckington," the home of Joseph Gales, Jr., and relates that because Gales insisted on being shown with a copy of his son's newspaper, the *National Intelligencer*, CBK included the words "Dry Goods" in the only visible advertisement column. This anecdote was first related by Mary Caroline Crawford in her *Romantic Days in the Early Republic* (Boston: Little, Brown, and Company, 1912), p. 224.

84. *Joseph Gales, Jr.* (1786-1860) circa 1818
Oil on wood, 24 x 20.
Signed on back: Washington Joseph Gales, National Intelligencer C. B. King.
Owner: Redwood Library. Given before 1859.
References: RL 1859, #52. RL 1862 and 1885, #42. Index, #51. William E. Ames, *A History of the National Intelligencer* (Chapel Hill: University of North Carolina Press, 1972). Clark, "Joseph Gales, Junior, Editor and Mayor," *Records of the Columbia Historical Society*.

85. *Joseph Gales, Jr.* circa 1818
30 x 25.
In private collection.

86. *Mrs. Joseph Gales, Jr.* (Sarah Julianna Maria Lee) circa 1821
52 x 40 (sight).
In private collection.
§ The picture is similar in style and pose of subject to that of *Mrs. John Quincy Adams* (cat. no. 9) and the subject likewise holds a music score, "The Queen of Prussia Waltz" by Gelineck.

87.

89.

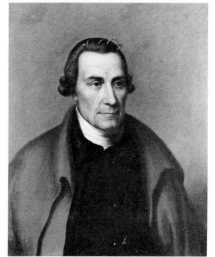

92.

87. *Mrs. Joseph Gales, Jr.* circa 1840
29 x 24.
Owner: North Carolina Museum of Art, Raleigh. Given by Mrs. Mary Wilson Walker in 1970.

88. *Mrs. William Branch Giles* (Frances Anne Gwynn; 1793-1815)
Owner: Mrs. J. W. Sharp, Richmond, Va.
References: Lee, *Portrait Register,* p. 551. CAP.
§ Not seen by author.

89. *Ezra Carter Gross* 1820
30 x 25.
Owner: University of Vermont, Burlington. Bequeathed by Emily McKibbin in 1973.
Reference: Isabel Bradshaw to author, September 11, 1974; records a letter written by CBK on September 28, 1841, to Gross's son-in-law, Ransom E. Wood, which states, "I painted Mr. Gross's portrait in 1820 for Mr. Delaplaine's Gallery of Distinguished Men."

90. *Charles Carroll Harper* (1802-1837) circa 1825
28½ x 24½.
In private collection.

91. *General Robert Goodloe Harper* (1765-1825) 1817
Unlocated. Exhibited at the PAFA in 1817.
Reference: PAFA 1817, p. 12, #88.

92. *Patrick Henry* (1736-1799) 1825
Oil on wood, 28 x 24.
Signed on back: Patrick Henry of Virginia Painted by C. B. King from an original miniture [*sic*] and under the direction of the family Washington 1825.
Owner: Redwood Library. Given before 1859.
References: RL 1859, #88. RL 1862 and 1885, #112. Index, #48.

93. *Homer, from a Bust*
Unlocated. Given to RL before 1859; deaccessioned after 1885.
References: RL 1859, #66. RL 1862 and 1885, #68.

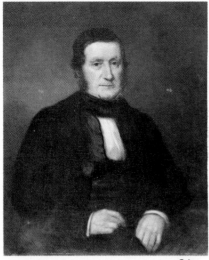

94.

95.

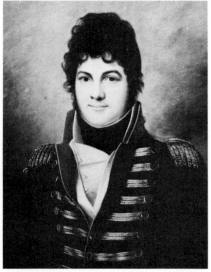

98.

94. *John Hooff* (1783-1859) circa 1843
36¼ x 30.
Owner: Charles R. Hooff, Sr., Alexandria, Va.
Reference: FARL.

95. *Martha Hooff* (Mrs. Aquila Brook Beale; circa 1830-1907) circa 1847
36 x 30.
Owner: Charles R. Hooff, Sr., Alexandria, Va.

96. *John Hunter* after Sir Joshua Reynolds
Unlocated.
References: *Daily News* (Newport), March 20, 1862, describes this as "one of the best copies among the students of West . . . it is admirable in every respect." Leslie, *Autobiographical Recollections,* p. 51, relates that Royal Academy students used to copy, among other works, Reynolds's *Hunter* at the British Institution.

97. *Hon. William Hunter* (1774-1849) circa 1814
30 x 25.
Unlocated. Formerly owned by Mrs. Hugh Birckhead, Newport, R.I., wife of subject's great-grandson.
References: FARL. JHP, #46.
§ Hunter was the senator from Rhode Island who in 1814 introduced CBK to the Madisons in the White House.

98. *General George Izard* (1776-1828) 1813
Oil on wood, 29⅝ x 23⅝.
Signed on back: Coll. George Izard/ Painted by C. B. King/ Phila; 1813.
Owner: The Arkansas Arts Center Foundation. Given by Mr. and Mrs. F. W. Allsopp, Little Rock, Ark., in 1938; acquired by Hewitt Erskine from H. Burlingame in 1934; sold to A. Zarine in 1938.
References: CAP. FARL.

99. *General Andrew Jackson* 1818-1819
Unlocated. Exhibited at the PAFA in 1823.
References: Oliver, *J. Q. Adams,* p. 92; mentions that Adams saw this portrait at CBK's on March 24, 1819. PAFA 1823, p. 13, #250; lists portrait as "painted for Delaplaine's Gallery."

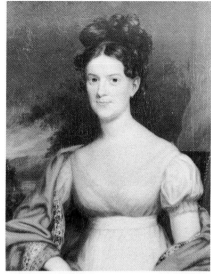

100.

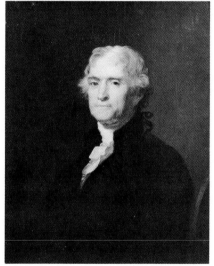

101.

100. *Mrs. Samuel Jaudon* (Marguerite Peyton Alricks; 1799-1880) circa 1840
30¼ x 25.
Owner: The New-York Historical Society, New York. Given by Mrs.
Cortlandt Van Rensselaer in 1921.
References: Lee, *Portrait Register*, p. 551. The New-York Historical
Society, *Catalogue of American Portraits*, 2 vols. (New Haven: Yale University
Press, 1974), 1 : 393.

101. *Thomas Jefferson* (1743-1826)
Unlocated. Formerly in the collection of Gordon Trist Burke.
Reference: CAP; lists portrait as a copy from Stuart's "medallion portrait."

102. *Thomas Jefferson* after Thomas Sully
30 x 25.
Owner: Redwood Library. Bequeathed on August 2, 1862.
References: GGK, #22. RL 1862 and 1885, #107. Index, #35.

103. *Thomas Jefferson. Profile.* after Gilbert Stuart
Oil on wood, 21 x 17.
Inscribed on back: Thomas Jefferson Copy from G. Stuart by C. B. K.
Owner: Redwood Library. Given before 1859.
References: RL 1859, #26. RL 1862 and 1885, #40. Index, #119. Lawrence
Park, *Gilbert Stuart. An Illustrated Descriptive List of His Works, Compiled by
Lawrence Park, with an Account of his Life by John Hill Morgan, and an Appre-
ciation by Royal Cortissoz,* 4 vols. (New York: William Edwin Rudge, 1926),
1 : 440; mentions that Stuart's original is at Monticello.

104. *General Thomas Sidney Jesup* (1788-1860) circa 1818-1819
44¼ x 33⅞.
Inscribed on back of original canvas: Genl T. S. Jesup.
Owner: Washington Cathedral, Washington, D.C. Bequeathed by Mary
Jesup Sitgreaves, 1941.
§ Probably painted when Jesup was appointed quartermaster general by
President Monroe in 1818.

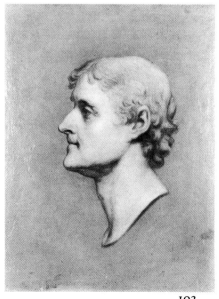

103.

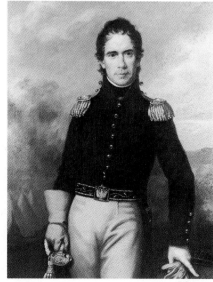

104.

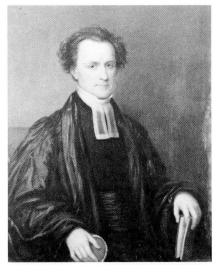

109.

110.

111.

105. *Mrs. James Johnson* (Emily Newman) circa 1835
Illustrated in figures 35.
Oil on wood, 17½ x 13¾.
Owner: Mr. and Mrs. T. R. Dibble, Peru, Vt.
References: FARL. Newman, "Journal of Elizabeth Hannah Newman,"
passim; identifies Emily Newman as the daughter of Colonel and Mrs. Francis
Newman (see cat. nos. 174 and 175). Mrs. Newman was CBK's first cousin.

106. *Colonel Richard M. Johnson* 1818-1819
Unlocated. Exhibited at the PAFA in 1822.
References: Oliver, *J. Q. Adams,* p. 92; mentions that Adams saw this por-
trait at CBK's on March 24, 1819. PAFA 1822, p. 14, #333; lists it as "Col.
Richard M. Johnson, Senate, U.S. Painted for Delaplaine's National Gallery."

107. *W. Cost Johnson*
Unlocated.
Reference: Davira Spiro, Corcoran Gallery, to author, May 21, 1975; quotes
from a letter written on May 30, 1853, by W. W. Corcoran to Johnson: "I acci-
dentally heard last night that your picture was in the hands of Mr. Charles B. King
of this city. On application to him I learnt that it never was in my possession but
was brought to my house by himself and after showing it to me, it was taken away
by him and has been in his possession ever since."

108. *Prof. W. U. Johnson*
Unlocated. Exhibited at the Washington Art Association in 1859.
Reference: Cobb, "Washington Art Association," *Records of the Columbia
Historical Society,* p. 169, #12; lists the owner in 1859 as Mrs. N. Johnson.

109. *Reverend James T. Johnston* (1798-1877) circa 1833
36 x 30.
Owner: Mrs. John Marshall, Washington, D.C.
Reference: FARL; lists this version as a copy after F. R. Spencer's portrait
in Saint Paul's Church, Alexandria, Va.
§ Probably an original by CBK.

110. *Mrs. James T. Johnston* (Jane Sanford; 1799-1884) circa 1833
36 x 30.
Owner: Mrs. John Marshall, Washington, D.C.
§ Possibly a replica of catalog number 111.

111. *Mrs. James T. Johnston* circa 1833
36¼ x 29.
Owner: Saint Paul's Church, Alexandria, Va.
Reference: FARL.

112. *Josiah S. Johnston* (1784-1833. U.S. Senator from Louisiana.) circa 1825
Oil on wood, 17¾ x 14.
Signed on back: Original C. B. King Josiah Johnston of Louisiana Blown
up in the [steamboat] Lioness.
Owner: Redwood Library. Given before 1859.
References: RL 1859, #12. RL 1862 and 1885, #69. Index, #11. Herring
and Longacre, *National Portrait Gallery of Distinguished Americans,* vol. 1, 1834;
includes an engraving by Longacre.

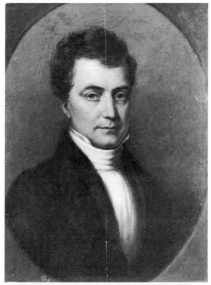

112.

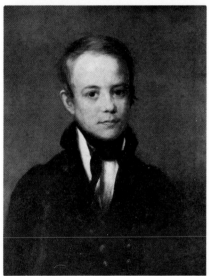

113.

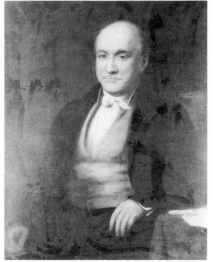

119.

113. *Commander Catesby ap. Roger Jones* (1821-?) 1837
Oil on wood, 23 x 19.
Owner: Mrs. Gertrude M. Bailey, Selma, Ala., subject's granddaughter.
References: Thomas A. C. Jones (subject's uncle) to CBK, October 7, 1834, HSP, Gratz Collection; refers to Jones's "delinquency" in an obligation to CBK and adds that Jones will soon "call & square all matters between us" – possibly a reference to payment for this portrait or for one of himself. Page Melvin (owner's sister) to author, April 1, 1977; records that Miss Page's grandfather recorded in his diary that at the age of sixteen he had had his "portrait taken by King" for the "gratification" of his father. Inventory of American Paintings Executed before 1914, NCFA.

114. *Commodore Thomas A. C. Jones* circa 1834
Unlocated.
Reference: Same as for catalog number 113.

115. *Mrs. Jones* (Mary Tyler)
27 x 22.
Owner: James S. Wilson, Charlottesville, Va.
Reference: FARL.
§ Attribution doubtful. Possibly the same as catalog number 116.

116. *Mrs. Henry L. Jones*
Owner: William and Mary College, Williamsburg, Va.
Reference: CBK file, Valentine Museum, Richmond, Va.; file contains a letter of December 3, 1902, from Letitia Tyler Semple (see cat. no. 233), daughter of President Tyler, to the Richmond sculptor Edward Valentine: "The portrait of my sister, Mrs. Henry L. Jones was also painted by Mr. King, and is now in the College of William and Mary...."
§ Not seen by author.

117. *Mrs. John A. Kearney* (Mary Forrest)
Oil on wood, 23½ x 19½.
Owner: Mrs. Joseph P. Crockett, Alexandria, Va.
Reference: FARL.

118. *Bishop Kemp of Baltimore*
Unlocated.
Reference: Delaplaine to Kemp, October 27, 1817, HSP, Gratz Collection: "I have been waiting for a long time very anxiously to receive your portrait by Mr. King. I hope Dr Sir, you will afford to Mr. King an opportunity to enable him to complete the portrait...."

119. *Governor Joseph Kent* (1779-1837) circa 1837
36½ x 30.
Owner: State House, Annapolis, Md. Gift of Elizabeth Kent.
References: CAP; FARL; JHP, #1052.

120.

120. *Anna Maria King* (1810-1843) circa 1835
30 x 25.
Owner: "Kingscote," property of The Preservation Society of Newport County, Newport, R.I. Bequeathed in 1972 by Mrs. Anthony Rives, subject's great-grandniece.
 § Anna Maria was the daughter of Dr. David King (see cat. no. 127).

121. *Mrs. Benjamin King* (Sarah Virginia Price; 1811-1855) circa 1835
29 x 26.
Owner: Thomson King, Baltimore, Md.
References: FARL. JHP, #3668.

122. *Charles Bird King* (1785-1862) 1806-1812
Unlocated.
Reference: Sully, "Journal," pp. 125-26, November 26, 1837; records Sully's having seen, at the Mitchel home near Dulwich, England, "an excell. port of him [King] (by himself) in their bedroom of his little wife – as he used to call Ann [the Mitchels' daughter]. . . ."

123. *Charles Bird King* before 1820
Unlocated.
Reference: Will, August 12, 1803, of Deborah Bird King Garrison, Probate Records, Probate Court, City Hall, Newport, R.I., 6:26, 40; the will states, "I wish my Dear Mother to accept of Minature [*sic*] Picture, and one of my Sons. . . ." Inventory, January 31, 1820, estate of Deborah Bird King, same depository; lists "a miniature of her Son set in Gold."
 § The statement in the will is ambiguous and may refer to a painting either by or of CBK. If the latter, it may have been a miniature self-portrait, or a portrait by Samuel King or Malbone.

124. *Charles B. King, at the Age of 30* 1815
Illustrated in figure 1.
30 x 25.
Owner: Redwood Library. Bequeathed on August 2, 1862; possibly exhibited at the Apollo Association, New York, in 1838.
References: GGK, #4. RL 1862 and 1885, #62. Index, #44. Cowdrey, *AAU. Record,* p. 215.

125. *Charles Bird King* 1856-1858
Illustrated in figure 37.
44½ x 34.
Inscribed on pad lower left: I saw W. [?] Sully and [illegible] a note and send [illegible] to you/[illegible] Mr. Duncan [?]/[illegible] When you have nothing to do paint your own Portrait/Yours Sincerely/T. Sully/Washington May 22, 1858 [?].
Owner: Redwood Library. Given in December 1861.
References: GGK, December 14, 1861. GGK, December 20, 1861; refers to a "Portrait of C. B. King abt 1858." Donations 1859-1863, December 12, 1861; records portrait as "about 1856." Index, #47. Mason, *Annals,* pp. 226, 253, 291; this is probably the portrait for which, according to the *Annals,* the library board on August 14, 1865, ordered a "handsomer frame" and is probably also the portrait

128.

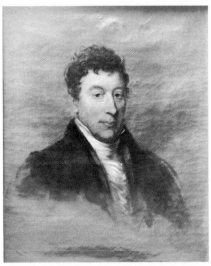

129.

130.

that the senior class of the high school asked to have hung in their room "at their Annual King Festival."

§ The date on the pad lying on the table may be read as May 22, 1856 or 1858.

126. *Cyrus King* (1772-1817)
Unlocated.
Reference: *Diary of C. F. Adams,* 1 : 47, January 17, 1824; Adams saw this portrait at CBK's and noted, "That of Cyr. King of Maine is said to be good."

127. *Dr. David King I* (1774-1836) circa 1800-1805
Illustrated in figure 2.
30 x 25.
Owner: Redwood Library. Bequeathed in 1972 by Mrs. Anthony Rives, subject's great-great-granddaughter.
§ David King was the artist's first cousin.

128. *George Gordon King* (1807-1870) circa 1816
Oil on wood, 14 x 11.
Owner: George Gordon King, Washington, D.C., the subject's great-great-great-grandnephew.
§ The back has an oil sketch of two pieces of fruit.

129. *Lafayette* (1757-1834) 1825
30 x 25.
Signed on back: Lafayette Original from life Washington, 1825 by C. B. King.
Owner: Redwood Library. Given in December 1861.
References: Oliver, *J. Q. Adams,* p. 110; records a diary entry by Adams for December 31, 1824, at the time Adams was sitting at CBK's for his portrait by Sully: "Third and last sitting to Sully. He and King have both taken likenesses of La Fayette, of which I think King's the best." GGK, November 25, 1861.
§ See catalog number 651 for an illustration of the original drawing.

130. *Lafayette*
28½ x 23.
Owner: The Cochran Collection, Philipse Manor State Historic Site, Taconic State Park and Recreation Region, New York State Office of Parks and Recreation.
References: CAP. FARL.
§ Attribution doubtful, but this portrait may be a copy by King after Ary Sheffer's portrait of Lafayette, which has been in the Capitol Building since 1824.

131. *Mrs. Lancaster*
Unlocated. Exhibited at the Apollo Association, New York, in October 1839.
Reference: Cowdrey, *AAU. Record,* p. 216, #207.

133.

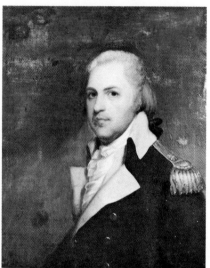

135.

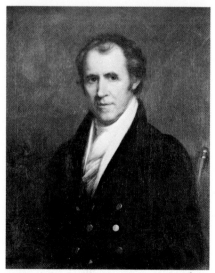

136.

132. *Mrs. Benjamin Larned* (Elizabeth Rachel Newman) circa 1838
Illustrated in figure 36.
Oil on wood, 35 x 27.
Owner: Mr. and Mrs. T. R. Dibble, Peru, Vt. Mrs. Dibble is the subject's great-great-grandniece.
Reference: Newman, "Journal of Elizabeth Hannah Newman," passim; identifies Mrs. Larned as the sister of Mrs. James Johnson (see cat. no. 105) and CBK's second cousin.

133. *Mrs. Benjamin Larned* circa 1850
Watercolor on ivory, 1 15/16 x 1 1/2 (oval).
Owner: Mrs. Parley Johnson, Downey, Calif., subject's great-grandniece.

134. *R. Lawrence*
Unlocated.
Reference: Watterston, *New Guide to Washington*, p. 102; in 1847 this portrait was seen at CBK's by Watterston, who described it as "inimitable."

135. *General Henry Lee* (1756-1818) after Gilbert Stuart 1830
30 x 25.
Owner: Redwood Library. Given before 1859.
References: RL 1859, #80. RL 1862 and 1885, #123. Index, #42.

136. *Theodoric Lee* (1766-1849)
30 x 25 (sight).
In private collection.
Reference: Lee, *Portrait Register*, p. 551.

137. *Helen Mecklin LeGrand and Son, John Carroll*
35 1/2 x 28 1/16.
Owner: Mrs. E. A. Prichard, Fairfax, Va.

138. *Peter Lenox*
35 3/4 x 27 1/2.
In private collection.
Reference: CAP.
§ Not seen by author.

139. *Mrs. Emelyn Cony Webster Lindsly* (1808-1892) circa 1830
Oil on wood, 30 x 24 7/8.
Owner: Mrs. Joseph W. Hazell, Chevy Chase, Md.
Reference: King, "Will"; includes bequests of $200 to Mrs. Lindsly, and $100 to her sister Mrs. C. G. Page (see cat. nos. 185 and 186). The subject's husband, Dr. Harvey Lindsly, received from CBK's estate $340 in payment for "medical attendance," probably rendered during artist's terminal illness in late 1861-early 1862. Lindsly paid into the estate $10.03 on a "note" he apparently owed to CBK.

139.

140.

141.

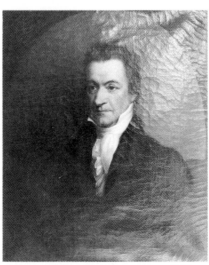

142.

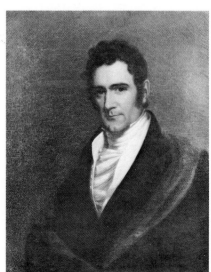

144.

140. *Frances Lindsly* (Mrs. Edward Washburn) 1846
Oil on wood, 17½ x 13½.
Signed on back: Painted and Presented by C. B. King to his Friend Mrs. Lindsly Washington 1846.
 Owner: Mrs. Joseph W. Hazell, Chevy Chase, Md.
 § Subject was the daughter of Mrs. E. C. W. Lindsly (see cat. no. 139).

141. *Webster Lindsly* (1835-1866) circa 1858
Oil on wood, 21 x 16¾.
 Owner: Mrs. Joseph W. Hazell, Chevy Chase, Md.
 § Subject was the son of Mrs. E. C. W. Lindsly (see cat. no. 139).

142. *Edward Livingston. Secretary of State.* (1764-1836) circa 1831-1833
30 x 25.
 Owner: Redwood Library. Given before 1859.
 References. RL 1859, #18. RL 1862 and 1885, #122. Index, #61.

143. *Lord Crewe in the Character of Henry VIII* after Sir Joshua Reynolds
1806-1812
 Unlocated. Exhibited at the PAFA in 1813. Bequeathed to RL on August 2, 1862; exhibited at the Newport (R.I.) High School in January 1865; deaccessioned after 1885.
 References: GGK, #24. RL 1862 and 1885, #78. PAFA 1813, p. 15, #48. *Port Folio,* August 1813, p. 130; contains a description of this painting in a review of the PAFA's exhibition: "This is a charming little picture, and gives an excellent idea of the general manner of the celebrated artist from whom it is taken." Mason, *Annals,* pp. 234, 247.

144. *Dr. Joseph Lovel, Surgeon General, U.S.* (1788-1836) circa 1823
30 x 25.
 Owner: Redwood Library. Bequeathed on August 2, 1862.
 References: GGK, #28. RL 1862 and 1885, #6. Index, #58. Lee, *Portrait Register,* p. 551.

145.

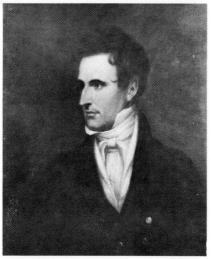

147.

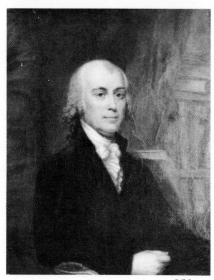

153.

145. *Mrs. Joseph Lovel*
24 x 20.
Owner: Redwood Library. Bequeathed on August 2, 1862.
References: GGK, #63. RL 1862 and 1885, #141. Index, #54.

146. *General Lyman*
Unlocated.
References: Sully, "Journal," pp. 41, 62; Sully refers to this portrait in the journal entry for May 16, 1826: "Mr. Robinson sent me a portrait of J. Neal, painted by Harding, which I have stretched over a portrait of Gen. Lyman painted by King...." and in the entry for August 24, 1828: "22nd: Received the portrait of Gen. Lyman from the Gallery."

147. *George McDuffie* (1788-1851) circa 1828
Oil on wood, 28 x 23.
Signed on back: George McDuffie Original C. B. King.
Owner: Redwood Library. Given before 1859.
References: McDuffie to CBK, June 1836, HSP, Dreer Collection; written by McDuffie to introduce Major Wyatt Stanke, who wanted to have a plate made "for exacting miniature prints [from the] likeness in your possession." RL 1859, #53. RL 1862 and 1885, #28. Index, #49.
 § Probably painted between 1821-1834, the period during which McDuffie represented South Carolina in the House of Representatives.

148. *William McKendree* 1814
Unlocated.
Reference: Stauffer, #815; notes that this portrait was engraved by Edwin and inscribed "The Rev'd William McKendree, Bishop of the Methodist Episcopal Church in the United States." The engraving was published May 24, 1814, in Philadelphia, by S. Kennedy.

149. *Mrs. Anna E. R. McKinney*
In private collection.
Reference: Inventory of American Paintings Executed before 1914, NCFA.
 § Not seen by author.

150. *Mr. McLane*
Unlocated.
Reference: Davira Spiro, Corcoran Gallery, to author, May 21, 1975; records a letter of January 10, 1888, from W. W. Corcoran to R. M. McLane, to which a Mr. Hyde added a note suggesting that Corcoran inform McLane that the portrait of McLane's father by CBK was "the best likeness he [Hyde] ever saw."

151. *John MacTavish* (circa 1787-1852) circa 1827
40½ x 30½.
Unlocated.
Reference: FARL.

152. *Dolly Madison* (1768-1849) after Gilbert Stuart
Unlocated. Given to RL before 1859; deaccessioned after 1885.
References: RL 1859, #15. RL 1862 and 1885, #74.

154.

155.

153. *President James Madison* (1751-1836) after Gilbert Stuart
30 x 25.
Owner: Redwood Library. Bequeathed on August 2, 1862.
References: GGK, #21. RL 1862 and 1885, #108. Index, #52.

154. *John Mason* (1767-1849) 1824
35½ x 27½.
Owner: Mr. and Mrs. John D. Smucker, Alexandria, Va.
References: FARL. *Diary of C. F. Adams,* 1:48, January 17, 1824; writing after a visit to CBK's, Adams mentions "a portrait of John Mason, not finished but nearly so, which was a remarkable likeness. One of Mrs. Mason also."

155. *John Mason*
35¼ x 29¼ (sight).
Owner: Miss Elizabeth J. Hodges, Cambridge, Mass.

156. *John Mason*
35¼ x 29¼.
Owner: Gunston Hall Plantation, Lorton, Va.

157. *John Mason*
Owner: Lippitt family.
§ Not seen by author.

158. *Mrs. John Mason* (1776-1857) 1824
36 x 28.
Owner: Mr. and Mrs. John D. Smucker, Alexandria, Va.
References: Same as for catalog number 154.

159. *Mrs. John Mason* circa 1857
35¼ x 29⅜ (sight).
Owner: Mrs. Charles S. Denny, Chevy Chase, Md.

160. *Mrs. John Mason*
Owner: Lippitt family.
§ Not seen by author.

156.

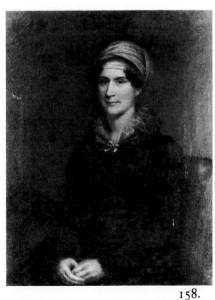

158.

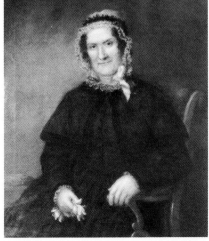

159.

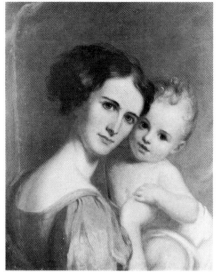

161.

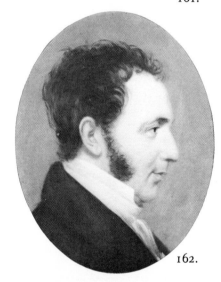

162.

163.

161. *Mrs. John Mason and Child* after Thomas Sully circa 1829
Oil on wood, 24 x 20.
Owner: Redwood Library. Bequeathed on August 2, 1862.
References: Sully, "Journal," p. 68; June 28, 1829: "June 1st. . . . Began Mrs. Mason & Child [while at CBK's in Washington]." GGK, #37. RL 1862 and 1885, #67. Mason, *Annals,* p. 234. H. P. Beck to the Redwood Library, October 1, 1862; states that Sully told Beck that he "took the portrait of Mrs. Mason" at Washington. A. J. Macomb to the Redwood Library, November 21, 1862; confirms that the picture was copied from Sully.
§ The back has a preliminary oil sketch of the subject.

162. *Dr. George Washington May* (?-1845)
Oil on wood, 17¼ x 14¼.
Owner: Mrs. F. Murray Hastings, Cincinnati, Ohio.
Reference: Lee, *Portrait Register,* p. 551.

163. *Mrs. George Washington May* (Catharine Lee; ?-1874)
Owner: Mrs. F. Murray Hastings, Cincinnati, Ohio.
Reference: Same as for catalog number 162.

164. *Richard Worsam Meade* (1778-1828)
31 x 25 (sight).
Owner: Philip V. R. Van Wyck, Tuscon, Ariz., subject's great-great-grandnephew.
Reference: Philip Van Wyck, Sr., to author, February 27, 1977.

165. *Richard Worsam Meade* circa 1822
20 x 17¼.
Owner: John Paulding Meade, Rye, N.Y.
Reference: FARL; notes that this portrait was painted in Washington, D.C., and had been cut down in size.

166. *Josiah Miegs*
Unlocated. Exhibited at the PAFA in 1823.
Reference: PAFA 1823, p. 15, #316: "late Commissioner of the Land Office of the U. States, painted for Delaplaine's Gallery."

167. *Mr. Mitchel* circa 1806-1812
Unlocated.
Reference: Sully, "Journal," pp. 125-26, November 26, 1837; records Sully's having seen, at the Mitchel home near Dulwich, England, a portrait of "Mr. Mitchel and one of Stuart who lately died," painted by CBK.

168. *Stuart Mitchel* circa 1806-1812
Unlocated.
Reference: Same as for catalog number 167.

164.

171.

174.

169. *President James Monroe* (1758-1831) 1816-1817
Illustrated in figure 18.
42½ x 27½.
Owner: County of Loudoun, Leesburg, Va. Given by Huntington Harris, 1951; purchased in the 1940s from the Bland Gallery, New York; exhibited at the PAFA in 1817.
References: PAFA 1817, p. 13, #104: "James Monroe, President of the United States. To be engraved by Goodman & Piggot, for the publisher H. Morgan." Print Collection, Library of Congress, Washington, D.C.; contains a copy of the engraving dated December 15, 1817, and published by W. H. Morgan, Philadelphia (see fig. 20). Sully, "Journal," p. 57, March 16, 1828; this portrait was apparently exhibited at Sully's gallery: "11th. . . . Sent home Morgan's whole length of Munroe [*sic*] by King. . . ."CAP. FARL.

170. *Senator Morell* 1818-1819
Unlocated.
Reference: Oliver, *J. Q. Adams,* p. 92; mentions that Adams saw this portrait at CBK's on March 24, 1819.

171. *Sally Scott Murray and Her Sister, Anna Maria* (Mrs. John Mason)
after Bouché circa 1838
43½ x 33⅜ (sight).
Owner: Mrs. Elizabeth J. Hodges, Cambridge, Mass.
References: Elizabeth J. Hodges to author, April 7, June 22, 1977. Carolyn J. Weekly, "Portrait Painting in Eighteenth-century Annapolis," *Antiques,* February 1977, pp. 351-53; Weekly notes that the bust before which the girls are placing flowers is of "Dr. Upton Scott, a well-known Annapolis physician."
§ Anna Maria Murray became the wife of John Mason (see cat. nos. 154-157).

172. *General Thomas M. Nelson*
Unlocated.
Reference: Delaplaine to Nelson, January 3, 1819, HSP, Society Collection; Delaplaine requests that Nelson sit to CBK in Washington for a portrait.

173. *Hyde de Neuville*
Unlocated. Exhibited at the PAFA in 1822.
Reference: PAFA 1822, p. 14, #322: "Late Ambassador from France. Painted for Delaplaine's National Gallery."

174. *Colonel Francis Newman* (?-1818) circa 1816
43 x 33.
Owner: Mrs. Parley Johnson, Downey, Calif., subject's great-great-granddaughter.

175.

175. *Mrs. Francis Newman* (Elizabeth Hannah Fryers) circa 1840
Oil on wood.
Owner: Mrs. Parley Johnson, Downey, Calif., subject's great-great-grand-
daughter.

 § Mrs. Newman was the daughter of CBK's mother's sister, Elizabeth
 Hannah Bird Fryers, who had died in Newport by 1817. Mrs. Newman
 lived in Washington from about 1818 until her death in 1860. Her journal
 reveals that CBK had a close relationship with the Newman family and
 visited the Newman home several times daily.

176. [Newman family member?] *Girl with Fan* circa 1830
Oil on wood, 24 x 20.
Owner: Mrs. Philo Pitcher, Pittsburgh, Pa.

177. [Newman family member?] *Girl with Map* circa 1838
Oil on wood, 18 x 14½.
Owner: Albert Merritt Pitcher, Washington, D.C.

178. *Mrs. William Nicholls and Roberta* circa 1834
39¾ x 30.
Owner: Mr. and Mrs. Walter A. Williams, Jr., Richmond, Va.
References: CAP. FARL.

179. *Mary Owen Nixon* circa 1854
29½ x 24¾.
Owner: Mrs. Raynor M. Gardiner, Colorado Springs, Colo., subject's
great-granddaughter.

180. *Mrs. Benjamin Ogle* (Anna Maria Cooke; 1777-1856)
42 x 36 (sight).
Owner: Mr. and Mrs. H. Gwynne Tayloe II, Warsaw. Va.
References: FARL. Mrs. Tayloe to author, March 24, 1977; states that the
paint on the subject's face is now entirely flaked off.

176.

177.

178.

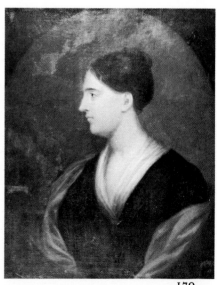

179.

180.

181.

181. *Mrs. Benjamin Ogle*
 30 x 25.
 Owner: Reading Public Museum and Art Gallery, Reading, Pa. Purchased from the American Art Association, 1925.
 Reference: FARL.

182. *Catherine Ogle* (Mrs. Charles Goodrich) 1834
 Oil on wood, 17½ x 14.
 Inscribed on back: Miss Catherine Ogle/ of Bellair/ Maryland/ 1834/ Married to the Rev. Charles Goodrich.
 Owner: Mr. and Mrs. H. Gwynne Tayloe II, Warsaw, Va.

183. *Kathleen O'More* 1843
 21 x 16¼.
 Owner: E. Haight. Sold by Adam A. Weschler & Son, Washington, D.C., October 1972.
 Reference: Inventory of American Paintings Executed before 1914, NCFA.
 § Not seen by author.

184. *Onis* 1818-1819
 Unlocated.
 Reference: Oliver, *J. Q. Adams*, p. 92; mentions that Adams saw this portrait at CBK's on March 24, 1819.

185. *Mrs. Charles Grafton Page* (Priscilla Sewall Webster; 1823-1899) circa 1835.
 30 x 25.
 Owner: Joseph Hazell, Los Angeles, Calif.
 Reference: King, "Will"; includes bequests of $100 to "Mrs. Dr. Page" and $200 to her sister, Mrs. E. C. W. Lindsly (see cat. no. 139).

186. *Mrs. Charles Grafton Page* circa 1835
 Oil on wood.
 Owner: Mrs. John Poinier, Gladstone, N.J.

182.

185.

186.

187.

188.

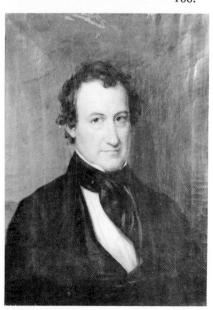

190.

187. *Jere Lee Page* (1797-1866) circa 1835
30 x 25.
Owner: Mrs. Joseph W. Hazell, Chevy Chase, Md.

188. *Mrs. Jere Lee Page* (Lucy Darby Lang) circa 1835
30 x 25.
Owner: Mrs. Joseph W. Hazell, Chevy Chase, Md.

189. *General Parker*
Unlocated.
Reference: Oliver, *J. Q. Adams,* p. 92; mentions that Adams saw this portrait at CBK's on March 24, 1819.

190. *John Howard Payne* (1792-1852. Author of "Home, Sweet Home.")
circa 1837
27 x 21.
Owner: Redwood Library. Bequeathed on August 2, 1862.
References: GGK, #15. RL 1862 and 1885, #60. Index, #91.

191. *Lt. Nathaniel Hazard Perry* (1803-1832) circa 1825
Oil on wood, 30 x 25.
Owner: A. Perry Osborn, New York.
Reference: FARL.
§ Attribution doubtful.

192. *Mr. Peter*
Unlocated. Exhibited at the PAFA in 1822 and 1825.
References: PAFA 1823, p. 13, #251: "Hon. Mr. Peter of Maryland, of H of Rep. of the U.S., painted for Delaplaine's Gallery." PAFA 1825, p. 7, #157.

193. *General Benjamin Pierce* (1758-1839)
30 x 25.
Owner: Redwood Library. Given before 1859.
References: RL 1859, #85. RL 1862 and 1885, #113. Index, #37.

194. *William Pinkney* (1764-1822) 1815-1816
Illustrated in figure 12.
44½ x 34½.
Owner: Maryland Historical Society, Baltimore. Given by Mrs. Laurence R. Carton, 1956, subject's great-great-granddaughter.
References: FARL. JHP, #1243. Herring and Longacre, *National Portrait Gallery of Distinguised Americans,* vol. 3, 1836; includes an engraving of this portrait by E. Wellmore.

195. *Joel R. Poinsett* (1779-1851) circa 1837
Oil on wood, 27 x 23.
Signed on back: Joel Poinsett Original C. B. K. Sec. of War Washington.
Owner: Mrs. John Kane, Newport, R.I. Given to RL before 1859; acquired by Mrs. Kane, descendant of subject, in 1970.

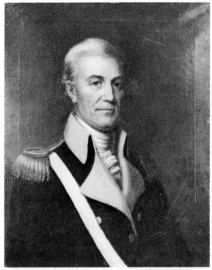

193.

196.

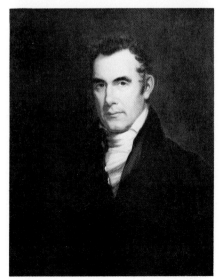

202.

196. *Mrs. Charles Henry Poor* (Mattie Lindsay Stark; 1816-1875) circa 1835
Oil on wood, 18 x 14.
Inscribed on back on paper label: Sincerely/ Your friend Thos Sully.
Owner: Charles C. Glover III, Washington, D.C.
§ The inscription on the label, which is obscured by a new backing, appears
to be in King's hand and may be humorous in intent like that on King's
self-portrait of 1856-1858 (see cat. no. 125).

197. *Pope Innocent X* after Diego Velázquez
Unlocated. Bequeathed to RL, August 2, 1862; deaccessioned after 1885.
References: GGK, #59. RL 1862 and 1885, #54.

198. *Portrait*
Unlocated.
Reference: RL 1885, #248.

199. *Portrait*
Unlocated.
Reference: RL 1885, #250.

200. *Portrait*
Unlocated.
Reference: RL 1885, #251.

201. *Portrait*
Unlocated. Exhibited at the Apollo Association, New York, in January
1839.
Reference: Cowdrey, *AAU. Record,* p. 215, #194.

202. *Portrait of a Gentleman*
30¼ x 25.
Owner: Butler Hospital, Providence, R.I.
Reference: King, "Will," codicil of January 21, 1862: "I hereby give and
bequeath unto the Butler Hospital for the Insane, located in Providence Rhode
Island, it being the same Institution to which I formerly made a donation of paint-
ings and engravings, certain paintings now in my possesion and numbered on back
or on the frame thereof as follows, to wit Nos. 17 – 101 – 102 – 103 – 68 & 69. . . ."
This portrait is undoubtedly included in the foregoing group.
§ The Butler Hospital has no record of such a donation or bequest.

203. *Portrait of a Gentleman*
Unlocated. Exhibited at the PAFA in 1817, 1825, 1830, and 1832.
References: Rutledge, *Cumulative Record of Exhibition Catalogues* (PAFA),
p. 114, #119, #133, #180, #67.

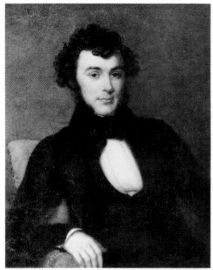

204.

205.

206.

204. *Portrait of a Gentleman*
29½ x 24.
Owner: Adams National Historic Site, Quincy, Mass.

205. *Portrait of a Girl* (Mrs. Henry Smith?) 1859
Oil on wood, 17½ x 13¾.
Unlocated. Sold by Parke Bernet on January 26, 1972.
Reference: William Campbell, National Gallery of Art, Smithsonian Institution, to author, October 13, 1972; notes that the portrait is inscribed (on back?) "Washington, January 1, 1859."

206. *Portrait of a Lady*
30 x 24.
Owner: Sheldon W. Dean, Flushing, N.Y.
References: Sheldon W. Dean to Bayard King, February 5, 1977, in possession of Bayard King; according to Dean, the portrait was inherited from his aunt, Emma Dean Washburn. CBK, "Will"; lists several bequests to CBK's Dean cousins, including Amelia, Helen, Elvira, and an unnamed married sister (probably Emma), to whom he left $100 each and paintings numbered 90, 47, 48, and 61, respectively, which are not identified in any other way.

207. *Portrait of a Lady*
Oil on wood, 17 x 13.
Owner: Mrs. William P. Catucci, Bloomfield, N.J.
References: Mrs. Catucci to author, April 6, 1977; states that Mrs. Catucci, as Sheldon W. Dean's sister, inherited this portrait through her father from Amelia Dean (see "References," cat. no. 206). The latter's sense of modesty, it is said, led her to have an artist paint the black scarf around the subject's neck.

208. *Portrait of a Lady*
Unlocated. Exhibited at the PAFA in 1825.
Reference: Rutledge, *Cumulative Record of Exhibition Catalogs* (PAFA), p. 114, #131.

209. *Portrait of a Lady* 1827
Unlocated. Exhibited at the Apollo Association, New York, in October 1838, and in 1839.
Reference: Cowdrey, *AAU. Record,* pp. 215-16, #226 and #13.

210. *Portrait of a Lady*
Unlocated. Exhibited at the Boston Athenaeum in 1854.
Reference: BA 1854, p. 11, #192; lists the owner in 1854 as Mrs. S. L. Fairfield.

211. *Portrait of a Lady*
Owner: Mrs. Benjamin Evans, Washington, D.C. Formerly in the collection of Meta Morris Evans.

212. *Portrait of a Lady of Virginia*
Unlocated. Exhibited at the Apollo Association, New York, in October 1839.
Reference: Cowdrey, *AAU. Record,* p. 216, #223: "Portrait of a Lady of Virginia. *Belongs to James Herring.*"
§ Possibly the same as catalog number 248.

207.

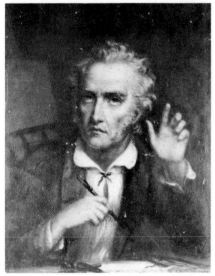

214.

213. *Portrait of an Officer of the U.S. Army*
Unlocated. Exhibited at the Apollo Association, New York, in October 1838.
Reference: Cowdrey, *AAU. Record*, p. 216, #30.

214. *Portrait of an Unknown Artist*
Oil on wood, 17½ x 13¾.
Owner: Bowdoin College Museum of Art, Brunswick, Me. Acquired in 1974 from Ross Levett, who purchased it in Washington, D.C., in 1967.
§ Notwithstanding the exaggerated expression showing an artist in the throes of inspiration, the portrait bears a resemblance to CBK's self-portrait of 1856-58 (see cat. no. 125). If, as Mr. Levett points out, there is a bird drawn on the sketch pad, perhaps the picture represents King's grandfather, the merchant artist Nathaniel Bird.

215. *Mrs. John Randall* (Deborah Knapp; 1763-1852)
36 x 28.
Owner: Mrs. Alexander Smith, Scarsdale, N.Y.
References: FARL. JHP, #1049.

216. *Mrs. Thomas Mann Randolph, Jr.* (Harriot Wilson; 1794-1822) 1814
Owner: Sarah Lacey.
Reference: Mrs. H. E. Miller to author, April 3, May 5, 1973.
§ Not seen by author.

217. *Abraham Redwood* (1709-1788) 1816
42½ x 34.
Owner: Redwood Library. Given winter of 1816-17.
References: RL 1859, #74. RL 1862 and 1885, #38. Index, #99. Mason, *Annals*, p. 121; mentions that on January 7, 1817, the library board resolved to thank CBK "for his elegant portrait of Mr. Abraham Redwood." CAP and FARL; both note that the portrait was copied from one in the Redwood family collection in 1817.

215.

217.

224.

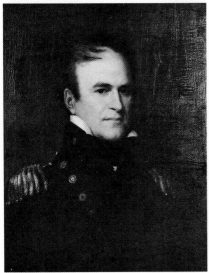

225.

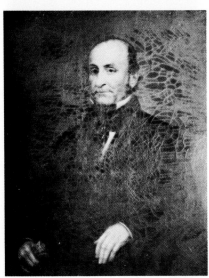

228.

218. *Reed* circa 1814
Unlocated.
Reference: Senator William Hunter, from Washington, D.C., to wife, December 24, 1814, on file in the Newport Historical Society: "Reed sits for his picture to young King."

219. *Rembrandt* after Rembrandt van Rijn
Unlocated. Given to RL before 1859; deaccessioned after 1885.
References: RL 1859, #50. RL 1862 and 1885, #61.

220. *Rembrandt's Mother* after Rembrandt van Rijn
30 x 25.
Unlocated. Given to RL, December 1861; deaccessioned after 1885.
References: GGK, November 25, December 14, 20, 1861. RL 1862 and 1885, #95. Mason, *Annals*, p. 226.

221. *Sir Joshua Reynolds* after Sir Joshua Reynolds
Unlocated. Bequeathed to RL, August 2, 1862; deaccessioned after 1885.
References: GGK, #36. RL 1862 and 1885, #158.

222. *General Rhea*
Unlocated. Exhibited at the PAFA in 1823.
References: Oliver, *J. Q. Adams*, p. 92; mentions that Adams saw this portrait at CBK's on March 24, 1819. PAFA 1823, p. 16, #330: "Gen. Rhea of Tennessee, of the House of Representatives, of the U. States, painted for Delaplaine's gallery. . . ."

223. *Elizabeth Newman Richardson* 1850
Oil on wood, 17½ x 13¾.
Signed on back: Elizabeth Newman Richardson Washington, D.C. 1850 Charles B. King.
Owner: Mrs. Prescott Huidekoper, Dedham, Mass.
§ Subject, who died in childhood of scarlet fever, was the granddaughter of CBK's cousin, Mrs. Francis Newman (see cat. no. 175).

224. *Asher Robbins* (1757-1845) circa 1825-1829
29 x 24.
Owner: Brown University, Providence, R.I. Given by CBK in 1857 through John R. Bartlett.

225. *Commodore John Rodgers* (1771-1838) 1824
Oil on wood, 28 x 23.
Owner: Redwood Library. Given before 1859.
References: RL 1859, #82; gives date as 1824. RL 1862 and 1885, #125; mistakenly give date as 1844. Index, #41.

226. *Rush*
Unlocated.
Reference: Watterston, *New Guide to Washington*, p. 102; in 1847 Watterston saw this portrait at CBK's and described it as "inimitable."

229.

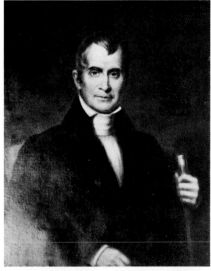

230.

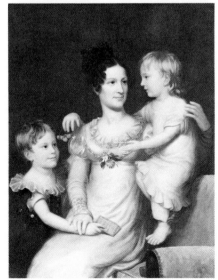

231.

227. *Miss Satterlee* circa 1838
Illustrated in figure 26.
Oil on wood, 17½ x 14½.
Inscribed on back: Portrait of a Miss Satterlee.
Owner: National Collection of Fine Arts, Washington, D.C. Gift of
Albert M. Pitcher, 1976.

228. *Alfred Vernon Scott, Sr.* (1803-1860) circa 1854
36 x 28½.
Owner: Professor and Mrs. William Owen Nixon Scott II, Athens, Ga.;
Scott is the subject's great-grandson.

229. *Mrs. Alfred Vernon Scott, Sr., and Son, William Owen Nixon Scott I*
(1813-1897; 1850-1917)
37½ x 31½.
Owner: Professor and Mrs. William Owen Nixon Scott II, Athens, Ga.

230. *General John Scott* (1773-1839)
36 x 28½.
Owner: Professor and Mrs. William Owen Nixon Scott II, Athens, Ga.

231. *Mrs. William Winston Seaton and Children* circa 1835
44½ x 34½.
Owner: Mrs. H. D. Colt, Washington, D.C. Acquired in 1975 through
Adam Weschler & Son from Belle M. Johnson, Washington, D.C.
§ Mrs. Seaton was the sister of Joseph Gales, Jr., editor and publisher of
the *National Intelligencer,* and wife of William Winston Seaton, Gales's
partner and long-time mayor of the capital. The children are Augustine and
Julia Seaton, the latter of whom holds a book inscribed "Art of Teasing
Mad[e] Easy Washing[ton] 18__."

232. *Miss Semmes*
Unlocated. Bequeathed to RL, August 2, 1862; deaccessioned after 1885.
References: GGK, #2. RL 1862 and 1885, #30. Watterston, *New Guide to
Washington,* p. 102; in 1847 this and a companion portrait at CBK's may have been
seen by Watterston, who notes: "Among the most beautiful are the . . . portraits of
the Misses S__."

233. *Letitia Tyler Semple*
Unlocated.
Reference: Letitia Tyler Semple, daughter of President Tyler, to the Rich-
mond sculptor Edward Valentine, December 3, 1902, on file in CBK file, Valentine
Museum: "He painted one of myself while I was, at the invitation of my father,
performing the duties of the Lady of the White House. That portrait is now in
Atlanta, Ga. I gave it to my Nephew Captain William G. Wallet, Editor of the
Richmond Times. On his death his wife took the portrait to her home in Atlanta."
§ Subject was the sister of Mrs. Henry L. Jones (see cat. no. 116).

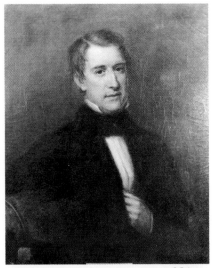

234.

235.

236.

234. *William H. Seward* (1801-1872) 1839
30 x 25.
Signed on back: Gov'r Seward N. Y./ C. B. King.
Owner: Redwood Library. Given before 1859.
References: RL 1859, #3. RL 1862 and 1885, #8. Index, #95.

235. *Gertrude Murray Shepard* (1836-1902) circa 1840
36 x 30.
Owner: William B. Shepard, Edenton, N.C., subject's great-nephew.
Reference: Inventory of American Paintings Executed before 1914, NCFA.

236. *Mrs. William Biddle Shepard* (Charlotte Buste Cazenove)
Oil on wood, 30 x 25.
Owner: Mrs. William B. Rosevear, Edenton, N.C.
Reference: Inventory of American Paintings Executed before 1914, NCFA.

237. *John Henry Sherburne* (1794-1850) circa 1825
30 x 25.
Owner: Dr. and Mrs. John A. Reidy, Boston, Mass.
References: FARL. Donations 1810-1858, p. 13, September 1825; lists
CBK's gift of Sherburne's *The Life of John Paul Jones,* recently published and
probably presented to the artist by the writer at the time his portrait was painted.

238. *Mrs. John Henry Sherburne* (Mary Ann Hall) circa 1825
30 x 25.
Owner: Dr. and Mrs. John A. Reidy, Boston, Mass.

239. *Roger Sherman* after Ralph Earle
Unlocated. Was in the collection of Senator George F. Hoar, Worcester,
Mass., in 1892.
Reference: Clarence Winthrop Bowen, *The History of the Centennial Cele-
bration of the Inauguration of George Washington as the First President of the
United States* (New York: D. Appleton and Company, 1892), p. 526.

240. *Mary Jane Glover Shriver* (1824-1919) circa 1845
Oil on wood, 23¾ x 19½.
Owner: Charles C. Glover III, Washington, D.C.
§ Subject was the sister of Matilda Ann Glover Williamson (see cat. no.
283).

241. *Colonel Richard Singleton* (1776-1851/2) circa 1826
39 x 31 (sight).
Owner: William D. Simpson, Columbia, S.C.
Reference: FARL.
§ Subject was the father-in-law of George McDuffie (see cat. no. 147).

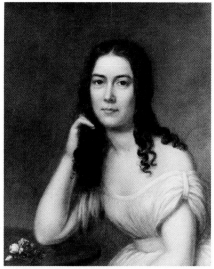

240.

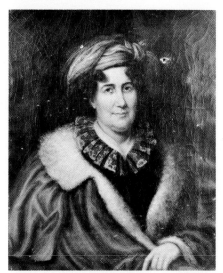

244.

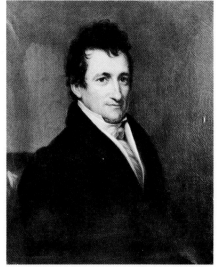

246.

242. *Samuel Harrison Smith* 1829
30 x 25.
Unlocated.
Reference: Smith, *The First Forty Years of Washington Society;* reproduces (as frontispiece and on p. 40) drawings after CBK's portraits of Mr. and Mrs. Samuel Harrison Smith, cited as in the collection of G. Henley Smith, Washington, D.C.

243. *Mrs. Samuel Harrison Smith* 1829
30 x 25.
Unlocated.
References: Same as for catalog number 242.

244. *Mrs. Samuel Harrison Smith* (Margaret Bayard; 1778-1844) 1829
30 x 25.
Signed on back: Mrs. Harrison Smith. Author of Winter in Washington Original C. B. King.
Owner: Redwood Library. Given before 1859.
References: Donations 1810-1858, p. 15, August 1829; lists a gift from CBK of Mrs. Smith's *What is Gentility,* recently published and probably presented to the artist by the writer at the time her portrait was painted. Watterston, *New Guide to Washington,* p. 102; in 1847 this portrait was seen at CBK's by Watterston, who described it as "inimitable." RL 1859, #4. RL 1862 and 1885, #213. Index, #122.

245. *Alexander Smythe, of Virginia*
Unlocated.
Reference: Oliver, *J. Q. Adams,* p. 92; mentions that Adams saw this portrait at CBK's on March 24, 1819.

246. *Samuel L. Southard* (1787-1842) 1828
30 x 25.
Owner: Redwood Library. Given before 1859, exhibited at the Boston Athenaeum in 1828.
References: BA 1828, p. 7, #211; lists this portrait as "The Secretary of the Navy," a post Southard held from 1823 to 1829. Watterston, *New Guide to Washington,* p. 102; in 1847 this portrait was seen at CBK's by Watterston, who described it as "inimitable." RL 1859, #65. RL 1862 and 1885, #121. Index, #17.
FARL.

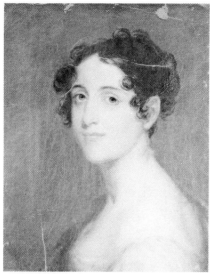

247.

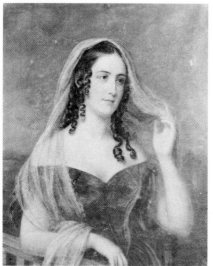

248.

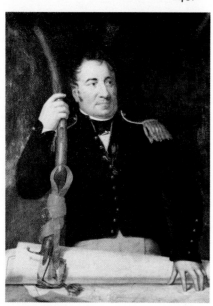

250.

247. *Mrs. Delia Stewart* after Gilbert Stuart
Oil on India silk, 18 x 14.
Owner: Redwood Library. Given before 1859.
References: RL 1859, #5. RL 1862 and 1885, #135. Index, #123.

248. *Mrs. Stockton, of Virginia*
30 x 25.
Owner: Redwood Library. Given before 1859. Possibly exhibited at the Apollo Association, New York, in October 1839.
References: Cowdrey, *AAU. Record*, p. 216, #223. RL 1859, #14. RL 1862 and 1885, #72. Index, #24.
 § Possibly the same as catalog number 212.

249. *General John Stricker* (1759-1825) 1816
Illustrated in figure 14.
44½ x 34½.
Signed on back of original canvas: General Stricker C. B. King Pinxt Baltimore 1816.
Owner: Maryland Historical Society, Baltimore. Gift of Charles P. Tiernan, 1852.
References: JHP, #3205. Rutledge, *Maryland Historical Society Magazine* 41 (March 1946): 38.

250. *General John Stricker* 1816
43¾ x 34.
Signed on back: Gen'l Stricker C. B. King. pinxt. Baltimore – 1816.
Owner: General John Stricker Junior High School, Dundalk, Md. Bequeathed by Captain Robert Slaughter, Charlottesville, Va., in 1975. Captain Slaughter was subject's great-great-grandson.
 § Probably a replica of catalog number 249.

251. *General John Stricker*
44 x 33.
Owner: Mrs. Robert F. Brent and Miss Helen Harris, Baltimore, Md.
References: FARL, JHP, #80.
 § Probably another replica of catalog number 249.

252. *Mrs. Jonathan Swift* (Mary Roberdeau; 1767-1833)
Owner: Mr. John Bigelow Patten, Rhinebeck, N.Y.
Reference: FARL.
 § Attribution doubtful.

253. *Benjamin Ogle Tayloe* (1796-1868) circa 1830
29¾ x 24.
Owner: Mr. and Mrs. H. Gwynne Tayloe II, Warsaw, Va.
References: CAP. FARL.
 § Possibly by Joseph Wood.

254. *Mrs. Benjamin Ogle Tayloe* (Julia M. Dickinson) circa 1830
30 x 25.
Inscribed on back (not by CBK): Mrs. Julia M. D. Tayloe/ wife of B. Ogle Tayloe/ Painted by C. B. King/ From a water color sketch by Saunders/ Presented by Mrs. Dix to Mrs. G. B. W[arren] June 1880.
Owner: Rensselaer County Historical Society, Troy, N.Y.

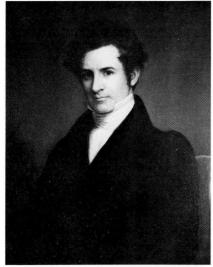

253.

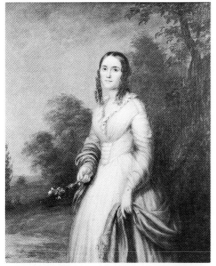

254.

255. *Colonel John Tayloe III* (1771-1828) after Gilbert Stuart
29½ x 24⅜.
Owner: Mr. and Mrs. H. Gwynne Tayloe II, Warsaw, Va.
References: CAP. Newman, "Journal of Elizabeth Hannah Newman"; indicates that King often visited the Tayloe home in Washington.

256. *Mrs. John Tayloe* (Anne Ogle; 1772-1855) after Gilbert Stuart
29½ x 24½.
Owner: Mr. and Mrs. Gwynne Tayloe II, Warsaw, Va.

257. *William Henry Tayloe* (1799-1871) circa 1839
29⅜ x 24⅛.
Owner: Mr. and Mrs. H. Gwynne Tayloe II, Warsaw, Va.
§ Possibly by Joseph Wood.

258. *Colonel Israel Peyton Thompson* (1788-1862) circa 1817
29¼ x 24.
Destroyed by fire, 1955; formerly owned by Alfred and Charles Carr, St. Louis, Mo.
References: FARL. JHP, #2143.

259. *Mrs. Israel Peyton Thompson* (Angelica Robinson; 1799-1829) circa 1817
29¼ x 24.
Owner: Alfred and Charles Carr, St. Louis, Mo.
References: FARL. JHP, #2142.
§ Subject was the granddaughter of Charles Willson Peale.

260. *Smith Thompson* (1768-1843) circa 1820
Unlocated.
References: CAP. FARL. Thompson to CBK, August 4, 1834, HSP, Dreer Collection; requests CBK to make a copy of the portrait "taken by you" for Thompson's son Gilbert, who was planning to move south.
§ Probably painted when Thompson was secretary of the navy (1818-1823).
Assuming King fulfilled the request, two versions of the portrait existed.

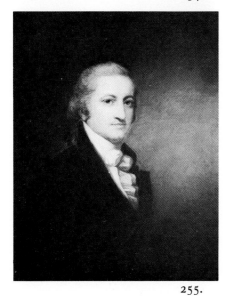

255.

256.

257.

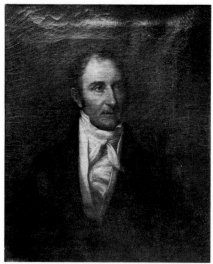

262.

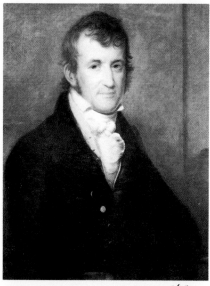

265.

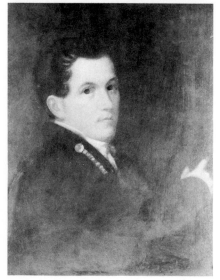

267.

261. *Smith Thompson* circa 1820 or 1834
 Unlocated. FARL records this portrait as having been given by Mrs. Laura
L. S. Nicholson to the Kansas City Museum of History and Science, Kansas
City, Mo.
 References: same as for catalog number 260.

262. *Dr. William Thornton* (1761-1828) after Gilbert Stuart circa 1828
 30 x 25.
 Owner: Redwood Library. Given before 1859.
 References: Newman, "Journal of Elizabeth Hannah Newman"; records
many visits by CBK to the home of Dr. Thornton, who made the original design for
the Capitol Building, and his wife. RL 1859, #17. RL 1862 and 1885, #120.
Index, #87.

263. *Hore Browse Trist* (1802-1856) circa 1828
 30 x 25.
 Owner: Miss Ellen Coolidge Burke, Alexandria, Va.
 Reference: FARL.
 § Attribution doubtful.

264. *Nicholas Trist*
 Unlocated.
 Reference: *American Heritage,* August 1970, p. 12.

265. *Henry St. George Tucker* (1780-1848) circa 1820
 28 x 24⅛.
 Owner: Museum of Early Southern Decorative Arts, Winston-Salem, N.C.
 References: CAP. FARL.
 § Attribution doubtful.

266. *Mrs. Joseph T. Tuley* (Mary Edelin) circa 1830
 36 x 28.
 Owner: Mrs. F. W. McM. Woodrow, Washington, D.C.
 Reference: FARL.

267. *Mann S. Valentine* (1786-1865) circa 1814
 38½ x 31.
 Owner: Valentine Museum, Richmond, Va.
 References: CAP. Edward Valentine to the Redwood Library, January 28,
1921, in CBK file, Valentine Museum: "I have one of Mr. King's pictures . . . of
my father . . . probably painted between 1807-1810 while he was an Officer in the
State-Guard."
 § The date given by Edward Valentine is incorrect; CBK was in England at
the time. However, he was in Richmond in 1814, and although the attribu-
tion of the portrait to him seems doubtful, it may be because the picture
appears to have been skinned during restoration.

268. *Marcia Van Ness*
 Unlocated.
 Reference: Alice Curtis Desmond, *Glamorous Dolly Madison* (New York,
1946, p. 78); includes a reproduction of this portrait.

269.

269. *Stephen Van Rensselaer* (1764-1839) circa 1829
30 x 25.
Owner: Redwood Library. Bequeathed on August 2, 1862.
References: GGK, #33. RL 1862 and 1885, #85. Index, #20.

270. *General Joseph Bradley Varnum* circa 1816-1817
Unlocated.
References: F. W. Coburn to the Rhode Island Historical Society, April 22, 1929, on file in the society; states that CBK's original was copied by Charles Loring Elliott, which copy was then at the Capitol.

271. *Mrs. George Augustus Waggaman* (Camille Arnoult; 1795-1876)
circa 1835
Unlocated.
References: FARL. JHP, #3599.
§Attribution doubtful.

272. *Anne Caroline Walker*
30 x 25 (sight; oval).
In private collection.

273. *George Washington* (1732-1799) after Gilbert Stuart
30 x 25.
Signed on back: Washington from Stuart by C. B. King.
Owner: Redwood Library. Given in December 1861.
References: GGK, December 14, 20, 1861. RL 1862 and 1885, #105. Mason, *Annals,* p. 226. Index, #9.

274. *George Washington* after Gilbert Stuart
29 x 23½ (oval).
Owner: Redwood Library.
Reference: Index, #68; lists portrait as a copy from Stuart and gift of CBK in 1861.

272.

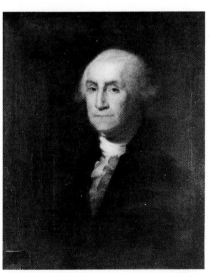

273.

274.

275.

281.

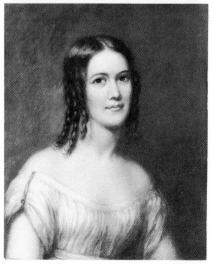

283.

275. *Henry Washington* [?] (1765-1812) circa 1815
29½ x 24½.
Owner: Virginia Historical Society, Richmond. Given by S. Henry Horace Lee Washington, Jr., 1951.
References: CAP. FARL.
§ The portrait cannot be of Henry Washington because the subject appears to have been in his twenties when the picture was painted.

276. *Andrew Way* (1775-1833) circa 1825
29 x 24.
Owner: Mrs. Paul J. Bleiler, Ontario, Calif.
References: Maryland Historical Society, *Catalogue of Paintings, Engravings, etc.* . . . , 1856, p. 5; lists a portrait by King – perhaps this one – exhibited by the subject's son, A. J. Way, whom King may have instructed. FARL. JHP, #3488.

277. *Mrs. Andrew Way* (1789-1870) circa 1825
29 x 24.
Owner: Mrs. Paul J. Bleiler, Ontario, Calif.
References: FARL. JHP, #3489.

278. *George Brevitt Way I* (1811-1868) circa 1825
29 x 24.
Owner: Miss Laura W. Cottrell, Washington, D.C.
Reference: JHP, #3487.

279. *Daniel Webster* (1782-1852) 1817
Illustrated in figure 17.
30 x 25.
Signed on back: Daniel Webster Member of Congress from Massachusetts 1817. Painted by C. B. King Washington.
Owner: Redwood Library. Given before 1859.
References: RL 1859, #91. RL 1862 and 1885, #118. Index, #85. *Diary of C. F. Adams*, 1: 48, January 17, 1824: "He was copying his portrait of Mr. Webster, which is one of his best likenesses as it appears to me. The eyebrows and the expression of the eyes is very admirably copied."

280. *Daniel Webster*
Unlocated.
References: Charles Henry Hart, "Life Portraits of Daniel Webster," *McClure's Magazine* (May 1897), pp. 619-30; refers to this version, which was formerly in the Corcoran Gallery's Ogle-Tayloe Collection.

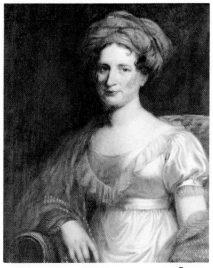

285.

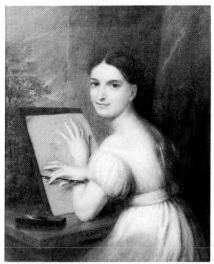

286.

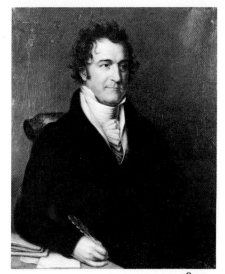

287.

281. *Mrs. Hugh Lawson White* (Mrs. Anne E. Peyton; ?-1847)
30¼ x 25¼.
Owner: The New-York Historical Society, New York. Given by Mrs.
A. Cortlandt Van Rensselaer in 1921.
Reference: The New-York Historical Society, *Catalogue of American Portraits,* 2 vols. (New Haven: Yale University Press, 1974), 2:887.

282. *Eli Whitney* 1821
36 x 28 (sight).
Owner: Eli Whitney Debevoise, New York, N.Y.
References: Jeannette Mirsky and Allan Nevins, *The World of Eli Whitney* (New York: MacMillan Company, 1952); illustrates the portrait and notes that Whitney's widow, who preferred it to Morse's better-known version of 1822, had it engraved by D. C. Hinman for Dennison Olmsted's *Memoirs of Eli Whitney* (New York, 1846); also notes that Whitney sat to King in the summer of 1821. Stauffer, #1435; mentions that the portrait was engraved by William Hoogland.

283. *Matilda Ann Glover Williamson*
23¾ x 19½.
Owner: Charles C. Glover III, Washington, D.C.
§ See catalog number 240.

284. *General Joshua Wingate* (1773-1843)
Unlocated. Was on loan to the Portland Museum of Art until 1950.
Reference: W. D. Barry to author, December 10, 1976.

285. *Mrs. Joshua Wingate* (1780-1867)
30⁷⁄₁₆ x 25½.
Owner: Maine Historical Society. Given by Miss Annie F. H. Boyd, 1970.

286. *Agnes Wirt* (1816-1831) circa 1831
29 x 24.
Owner: Mrs. Alexander B. Smith, Scarsdale, N.Y.
§ The portrait is posthumous; family tradition has it that on being asked to paint it, CBK replied: "Yes, if you will let me do it in the pose I remember best. I had come to give her a drawing lesson and as she was not quite ready, she covered her work with her hands, glanced over her shoulder, and said, 'Don't look yet, Mr. King.' "

287. *William Wirt* (1772-1834) 1820
36 x 30.
Owner: Redwood Library. Given before 1859.
References: RL 1859, #94. RL 1862 and 1885, #116. Index, #28. *Diary of C. F. Adams,* 1:47, January 17, 1824; a version of this portrait was seen at CBK's by Adams, who described it as "good."

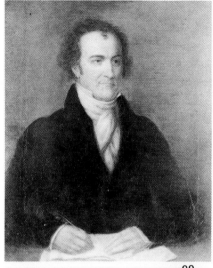

288.

289.

290.

288. *William Wirt* circa 1820
36 x 30.
Owner: Mrs. Walker Lewis, Baltimore, Md., subject's great-great-granddaughter.
References: FARL. JHP, #578.

289. *William Wirt* circa 1820
36 x 30.
Owner: Department of Justice, Washington, D.C.
Reference: FARL.

290. *William Wirt* circa 1834
30 x 25 (sight).
Owner: Mrs. Alexander B. Smith, Scarsdale, N.Y.

291. *Daniel Phineas Woodbury* (1812-?) circa 1835
29½ x 24½.
Owner: Mrs. Thomas C. Woodbury, Washington, D.C., widow of subject's son.
Reference: FARL.

292. *Mrs. Daniel Phineas Woodbury* (Catherine Rachel Childs; 1819-1896)
circa 1845
29½ x 24½.
Owner: Mrs. Thomas C. Woodbury, Washington, D.C., widow of subject's son.
§ Subject was the daughter of Mr. and Mrs. Thomas Childs (see cat. nos. 45 and 46).

293. *Levi Woodbury* (1789-1851) circa 1839
30 x 25.
Owner: Dartmouth College, Hanover, N.H. Given by the Woodbury family.
References: Sully, "Journal," p. 203, June 18, 1839: "Yesterday, called on Levy Woodbury with King." Watterston, *New Guide to Washington,* p. 102; in 1847 a portrait of "Woodbury" (perhaps Levi) was seen at CBK's by Watterston, who described it as "inimitable." CAP.

294. *Levi Woodbury* circa 1839
30⅛ x 25⅛.
Owner: Mrs. Blair Brooke, Philadelphia, Pa.
Reference: FARL.

295. *Mrs. Levi Woodbury* (Elizabeth Clapp)
30½ x 25¼.
Owner: Mrs. A. Staton, Chevy Chase, Md.
Reference: FARL.

296. *Mary E. Woodbury* (Mrs. Montgomery Blair)
Oil on wood, 17⅛ x 13¾.
Owner: Mrs. R. C. Hollyday, Bedford Hills, N.Y.
Reference: FARL.

293.

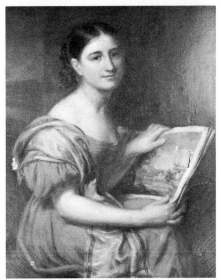

297.

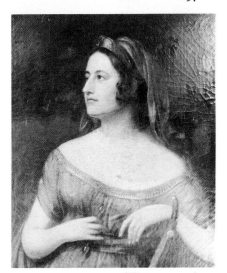

298.

297. *Josephine Causten Young*
35½ x 30.
In private collection.

298. *Josephine Causten Young*
Oil on wood, 30 x 25.
In private collection.

299. *MacClintock Young*
35½ x 30.
In private collection.

Indian Subjects

[Most of the portraits of Indians listed herein were painted by Charles Bird King for the War Department's Indian Gallery, which was almost entirely destroyed in the Smithsonian fire of 1865. These works, for the most part, were painted in oil on wood and were in gilt frames measuring 18 x 14 inches (height by width). King also painted many replicas of the portraits he made for the Indian Gallery, a number of which are still extant.]

300. *Amiskquew (The Spoon)* Menominee 1831
Destroyed by fire, 1865.
References: Rhees, #82. MH, 3: 192ff.

301. *Amiskquew* 1831
Oil on wood, 17¼ x 13½.
Signed on back: Amiskquew Menomine Warrior The Spoon Painted by C. B. King Washington 18[31].
Owner: The Warner Collection, Gulf States Paper Corporation, Tuscaloosa, Ala. Given to RL before 1859; sold by PB in 1970.
References: RL 1859, #43; lists portrait as having been painted in 1831. RL 1862 and 1885, #203. Index, #106. PB, #19.

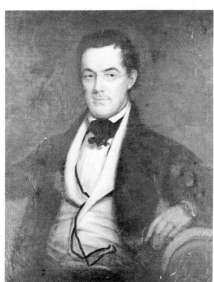

299.

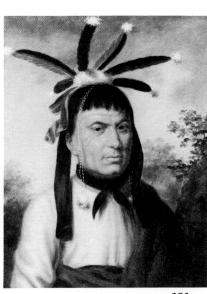

301.

302. *Amisquam (Wooden Ladle)* after James Otto Lewis Winnebago 1826
Destroyed by fire, 1865.
References: Rhees, #6. MH, 2:274ff.

303. *Ammoi (He That Comes for Something)* Yankton Sioux 1837
Destroyed by fire, 1865.
Reference: Rhees, #87.

304. *Anacamegischa (Foot Prints)* after James Otto Lewis Chippewa 1827
Destroyed by fire, 1865.
References: Rhees, #56. PM, #28.210. MH, 1:344ff.

305. *Apauly-Tustennugee* Creek 1825
30½ x 25.
Inscribed on back: Apauly-Tustennuggee Creek Chief; (not by CBK)
Apauly Testunnuggee Creek I Chief/ 387322/ By C. B. King/ Paid/.
Owner: Smithsonian Institution, Washington, D.C.

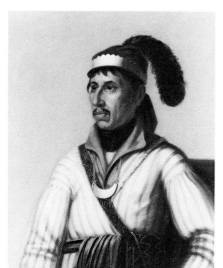

305.

306. *Artoway (Paddy Carr)* Creek 1825-1826
Destroyed by fire, 1865.
References: Rhees, #128. MH, 2:46ff.; attributed to CBK by Hodge.

307. *Asheaukou (Sunfish)* Sac 1837
Destroyed by fire, 1865.
Reference: Rhees, #95.

308. *Assinaboin Indian (Wijunjon? The Light)* circa 1832
Illustrated in figure 68.
Oil on wood, 24 x 19¾.
Signed on back: Assinaboin Indian from the most remote tribe that had ever visited Washington up to 1838. C. B. King.
Owner: The Warner Collection, Gulf States Paper Corporation, Tuscaloosa, Ala. Given to RL before 1859; sold by PB in 1970.
References: RL 1859, #63. RL 1862 and 1885, #170. Index, #102. Ewers, p. 469. PB, #18.

309. *Attecure (Young Reindeer)* after James Otto Lewis Chippewa 1827
Destroyed by fire, 1865.
Reference: Rhees, #54.

310. *Major Timpoochee Barnard* Yuchi 1825
Destroyed by fire, 1865.
References: Rhees, #135. MH, 2:50ff.

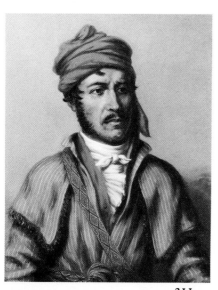

311.

311. *Major Timpoochee Barnard* 1825
Oil on wood, 17½ x 13¾.
Signed on back: Major Timpoochey Barnard Creek Chief CB King Washington 1825.
Owner: The Warner Collection, Gulf States Paper Corporation, Tuscaloosa, Ala. Given to RL before 1859; sold by PB in 1970.
References: RL 1859, #8. RL 1862 and 1885, #196. Index, #111. PB, #9.

312. *Caatousee (Creeping Out of the Water)* after James Otto Lewis Chippewa 1827
Destroyed by fire, 1865.
References: Rhees, #115. PM, #28.201. MH, 1 : 197ff.

313. *Chatonwahtooamany (Little Crow)* Mdwekanton Sioux 1824
Destroyed by fire, 1865.
References: Rhees, #125. PM, #28.196. MH, 1 : 125ff.

314. *Chenannoquot* Menominee 1835
Oil on wood, 17½ x 13¾.
Inscribed on back: [by CBK] Che-man(nan)-o(no)-quot Minomine Chief;
[not by CBK] Painted by C. B. King Washington 1835.
Owner: The Warner Collection, Gulf States Paper Corporation, Tuscaloosa, Ala. Given to RL before 1859; sold by PB in 1970.
References: RL 1859, #42. RL 1862 and 1885, #202. Index, #105. PB, #20.

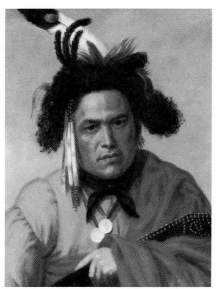

314.

315. *Chippewa Chief* after James Otto Lewis 1827
Destroyed by fire, 1865.
Reference: Rhees, #18.

316. *Chippewa Chief* after James Otto Lewis 1827
Destroyed by fire, 1865.
Reference: Rhees, #29.

317. *Chippewa Chief* after James Otto Lewis 1827
Destroyed by fire, 1865.
Reference: Rhees, #83.

318. *Chippewa Squaw and Child* after James Otto Lewis 1827
Destroyed by fire, 1865.
References: Rhees, #146. PM, #28.202. MH, 1 : 200, 248; Hodge suggests
that the original sketch is that in Thomas L. McKenney's *Sketches of a Tour to the
Lakes*, 1827, facing p. 307.

319. *Chittee Yoholo, or Holato Micco (Blue King)* Seminole 1826
Destroyed by fire, 1865.
References: Rhees, #107. PM, #28.283. MH, 2 : 201ff.

320. *Choncape (Big Kansas)* Oto 1822
Destroyed by fire, 1865.
References: Rhees, #94. PM, #28.203. Ewers, p. 470. MH, 1 : 218ff.

321. *Choncape* circa 1822
Illustrated in figure 72.
Oil on wood, 17½ x 13¾.
Inscribed on back (probably not by CBK): Ottoe half chief from River
Platte. Visited Washington in 1825 [1821-1822] and there painted by Charles B.
King. The necklace is the claws of the Grisly Bear.
Owner: Danish National Museum, Copenhagen. Purchased in 1854 with
eight other Indian portraits (cat. nos. 333, 349, 379, 412, 415, 439, 444, 483) from
the estate of Major General Peter von Sholten, governor general of the Danish
West Indies, who probably received them as a gift from President Andrew Jackson
in 1831.
Reference: B-S, pp. 6, 13.

322. *Coosa Tustennuggee* Creek 1825
Destroyed by fire, 1865.
Reference: Rhees, #51.
§ A copy of this portrait by George Cooke is at the Wilmette Historical Commission, Wilmette, Ill.

323. *Corbamappa (Wet Mouth)* after James Otto Lewis Chippewa 1827
Destroyed by fire, 1865.
Reference: Rhees, #109.

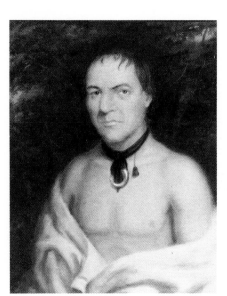

324.

324. *Cosneboin (or Esneboin)* after James Otto Lewis Chippewa 1827
Not destroyed in fire of 1865.
Oil on wood, 17¼ x 13⅞.
Signed on back: Co-sne-boin Chippeway Chief Painted by C. B. King from a Drawing by Lewis Washington 1827.
Owner: Smithsonian Institution, Washington, D.C.

325. *Eshtahumbah (Sleepy Eyes)* Sioux circa 1824
Destroyed by fire, 1865.
References: Rhees, #10. PM, #28.192. MH, 1: 104ff.
§ See catalog number 631 for original drawing.

326. *Foke Luste Hajo (Craggy Black Clay)* Seminole 1826
Destroyed by fire, 1865.
References: Rhees, #68. MH, 2: 320ff.

327. *Fox Chief* after James Otto Lewis 1826
Destroyed by fire, 1865.
Reference: Rhees, #121.

328. *Gadegewe (Spotted)* Chippewa 1835
Destroyed by fire, 1865.
Reference: Rhees, #19.

329. *Halpatter-Micco (Billy Bowlegs)* Seminole circa 1825-1826
Destroyed by fire, 1865.
Reference: MH, 2: 8ff; attributed to King by Hodge.

330. *Hawchekeongga (He Who Kills Osages)* Missouri 1837
Destroyed by fire, 1865.
Reference: Rhees, #15.

331. *Hayne Hudjihini (Eagle of Delight)* Oto 1822
Destroyed by fire, 1865.
References: Rhees, #131; mistakenly listed as "Rant-che-wai-me." MH, 1: 165ff.
§ See catalog number 632 for original drawing.

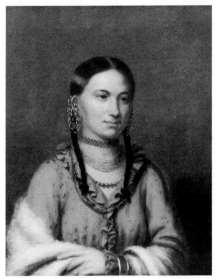

332.

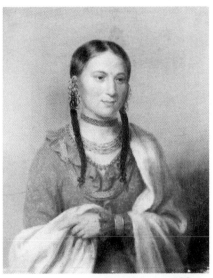

333·

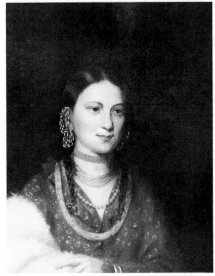

334·

332. *Hayne Hudjihini* circa 1822
Oil on wood, 17 x 13¾.
Owner: The Warner Collection, Gulf States Paper Corporation, Tuscaloosa, Ala. Exhibited for sale at the Boston Athenaeum in 1828; given to RL in April 1829; sold by PB in 1970.
References: BA 1828, p. 8. Donations 1810-1858, p. 17, September 21, 1829. RL 1859, #37. RL 1862 and 1885, #194. Index, #109. Mason, *Annals*, pp. 133-34. PB, #2.
§ The back of this portrait has an oil profile sketch.

333. *Hayne Hudjihini* circa 1822
Oil on wood, 17½ x 13¾.
Inscribed on back (probably not by CBK): Eagle of Delight being the youngest of the five wives, the Ottoe chief her husband, brought here to Washington in 1825 [1821]. Painted by C. B. King. She died immediately on the return home from measles caught on her journey home. She was pleasing and modest.
Owner: Danish National Museum, Copenhagen. For early provenance, see "Owner," catalog number 321.
Reference: B-S, p. 12.

334. *Hayne Hudjihini* circa 1822
Oil on wood, 17 x 14.
Owner: Thomas Gilcrease Institute of American History and Art, Tulsa, Okla.

335. *Hayne Hudjihini* circa 1822
Illustrated in figure 52.
Oil on wood, 17½ x 13¾.
Owner: The White House, Washington, D.C. Given in 1962 by employees of Sears Roebuck and Co., together with four other portraits (see cat. nos. 380, 416, 440, 445); purchased from Kennedy Galleries, Inc., New York; originally owned by Patrick Macaulay of Baltimore, who sent them in 1826 to a friend, Christopher Hughes, chargé d'affaires to the Netherlands.
Reference: Viola, *Indian Legacy,* p. 119.

336. *Heho Tustennuggee (Deer Warrior)* Seminole 1826
Destroyed by fire, 1865.
References: Rhees, #111. MH, 3:208ff. Ewers, p. 472.

337. *Governor Hicks* Seminole 1826
Destroyed by fire, 1865.
Reference: Rhees, #118.

338. *Hoowaunneka (Little Elk)* Winnebago 1828
Destroyed by fire, 1865.
Reference: Rhees, #58.

339. *Hoowaunneka* 1828
Illustrated in figure 43.
Oil on wood, 17½ x 13⅜.
Owner: Peabody Museum, Harvard University, Cambridge, Mass.

340. *Iaubeanu* after James Otto Lewis Chippewa 1826
Destroyed by fire, 1865.
References: Rhees, #30. PM.

341. *Jackopa (The Six)* after James Otto Lewis Chippewa 1827
Not destroyed in fire of 1865.
Oil on wood, 17⅜ x 13⅞.
Signed on back: Jack-o-pa (The Six) Chippeway Chief – Painted by CB. King from Drawing by Lewis Washington 1827.
Owner: Smithsonian Institution, Washington, D.C.
References: Rhees, #72. MH, 3: 240ff.

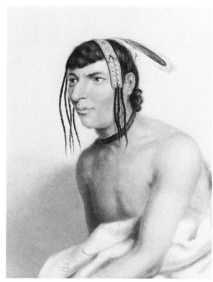

341.

342. *Kaakaahuxe (Little Crow)* after James Otto Lewis 1826
Destroyed by fire, 1865.
Reference: Rhees, #140.

343. *Kaikeekaimaih (All Fish)* Sac
Destroyed by fire, 1865.
Reference: Rhees, #123.

344. *Kaipolequa (White-Nosed Fox)* Sac circa 1824
Destroyed by fire, 1865.
References: Rhees, #44. MH, 2: 357ff.; attributed to King and dated by Hodge.
§ See catalog number 633 for original drawing.

345. *Keemeone (Rain)* Chippewa 1827
Destroyed by fire, 1865.
Reference: Rhees, #52.

346. *Keesheswa (The Sun)* Fox circa 1837
Destroyed by fire, 1865.
References: Rhees, #37. MH, 2: 154ff; dated by Hodge.
§ See catalog number 634 for original drawing.

347. *Keokuk (Watchful Fox)* Sac 1826
Unlocated.
Reference: Viola, *Indian Legacy,* p. 121; mentions that in 1826 CBK borrowed the portrait of Keokuk from the War Department because, as he wrote to McKenney, "Count Gramasy wishes to take a copy to France."

348. *Keokuk* 1827
Oil on wood, 17½ x 13¾.
Owner: The Warner Collection, Gulf States Paper Corporation, Tuscaloosa, Ala. Purchased from a descendant of the King family.
Reference: Viola, *Indian Legacy,* pp. 123, 138.
§See catalog number 635 for original drawing.

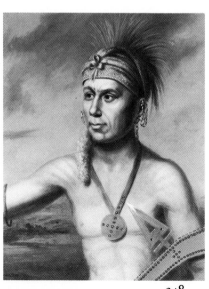

348.

349. *Keokuk* 1827
Illustrated in figure 77.
Oil on wood, 17½ x 13¾.
Inscribed on back (probably not by CBK): Kee-o-kuck, first War Chief of

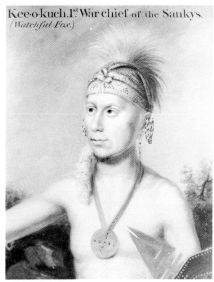

Kee-o-kuch, 1st War chief of the Sankys.
(Watchful Fox.)

the Saukies from Missouri. Visited Washington in 1827. A distinguished speaker and man of talent. Painted from nature. Charles B. King.

Owner: Danish National Museum, Copenhagen. For early provenance, see "Owner," catalog number 321.

Reference: B-S, p. 8.

350. *Keokuk* 1827
Oil on wood, 17 x 14.
Owner: Thomas Gilcrease Institute of American History and Art, Tulsa, Okla.

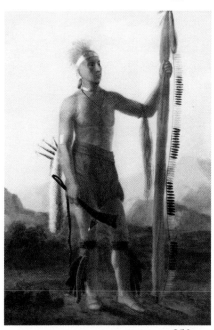

350.

351. *Keokuk* 1829
Destroyed by fire, 1865.
References: Rhees, #77. PM, 28.263.

352. *Keokuk* 1829
38½ x 26½.
Signed on back: Keokuk [illegible] with [illegible] CB King Washington.
Owner: The Warner Collection, Gulf States Paper Corporation, Tuscaloosa, Ala. Given to RL before 1859; exhibited at the Newport (R.I.) High School in January 1865; sold by PB in 1970.
References: RL 1859, #21; lists portrait as "Keokuk, a Sauk Chief, with the Standard of his Nation" and, RL 1862 and 1885, #25 adds "In Washington and in Boston, 1837." Index, #115. Mason, *Annals*, p. 247. MH, 1: liv; considered by Hodge to be a copy of a Lewis, reversed.

352.

353. *Keokuk and His Son Musewont (Longhaired Fox)* 1827
Destroyed by fire, 1865.
References: Rhees, #144; dates this portrait 1827. MH, 2: 115ff.; Hodge suggests the date 1837.

354. *Kewadin (The North Wind)* after James Otto Lewis Chippewa 1827
Destroyed by fire, 1865.
Reference: Rhees, #45.

355. *Kihegamawsheshe (Brave Chief)* Omaha 1837
Destroyed by fire, 1865.
Reference: Rhees, #137.

356. *Kishkalwa* Shawnee 1825
Unlocated.
References: PM, #28.189. MH, 1: 33ff.; dated and attributed to King by Hodge.

357. *Kitcheewaabeshas (Good Martin)* after James Otto Lewis Chippewa 1827
Oil on wood, 17⅜ x 13½.
Signed on back: Washington Painted by CB King From a Drawing by Lewis Chippeway Chief.
Owner: The Warner Collection, Gulf States Paper Corporation, Tuscaloosa, Ala. Purchased from the University of Pennsylvania Museum.
References: PM, #98. MH, 1: liv.

357.

358. *Lakeetoomerasha (Little Chief)* Pawnee 1837
Destroyed by fire, 1865.
Reference: Rhees, #12.

359. *Ledagie* Creek 1835
Destroyed by fire, 1865.
References: Rhees, #138. MH, 3: 144ff.

360. *Leshawloolalehoo (Big Chief)* Loup Pawnee 1837
Destroyed by fire, 1865.
Reference: Rhees, #74.

361. *Mahaskah (White Cloud)* Iowa 1824
Oil on wood, 17 x 14.
Owner: Thomas Gilcrease Institute of American History and Art, Tulsa, Okla.

361.

362. *Mahaskah* 1824
Unlocated.
Reference: MH, 1: 283ff.
§Possibly the same as catalog number 361, since this portrait was not in the Indian Gallery.

363. *Mahaskah (the Younger)* Iowa
Unlocated.
Reference: MH, 1: 301ff.

364. *Makataimeshekiakiah (Black Hawk)* Sac 1833
Destroyed by fire, 1865.
References: Rhees, #133. MH, 2: 58ff.

365. *Makataimeshekiakiah* circa 1833
Oil on wood, 23 x 19¾.
Owner: The Warner Collection, Gulf States Paper Corporation, Tuscaloosa, Ala. Probably bequeathed to RL on August 2, 1862; sold by PB in 1970.
References: GGK: "By an oversight I forgot to show Mr. Mason an Indian portrait (which Mr. King wished the Library to have, if they desired it). It matches with the other Indian portraits, Red Jacket, etc. . . ." Mason, *Annals,* p. 232; records that the Redwood Library board voted at its meeting on April 21, 1862, to accept the painting in exchange for *Judith Meditating the Murder of Holofernes* (see cat. no. 582). RL 1862, p. 25, #47, p. 56, #168. RL 1885, #168. PB, #13.

365.

366. *Mauchcoomaim* after James Otto Lewis Iowa 1826
Destroyed by fire, 1865.
Reference: Rhees, #136.

367. *Menawa* Creek 1826
Destroyed by fire, 1865.
References: Rhees, #23; MH, 2: 178ff.: "It is one of the most spirited of the works of that gifted artist, King, and has been often recognised by Menawa's countrymen, who on seeing it have exclaimed, 'Menawa!'"

368. *Metakoosega (Pure Tobacco)* after James Otto Lewis Chippewa
circa 1826
Unlocated.
References: MH, 1: 115ff. PM, #28.194.

369. *Micanopy* Seminole
Destroyed by fire, 1865.
References: Rhees, #63. MH, 2: 335ff.

370. *Mishshaquat (Clear Sky)* after James Otto Lewis Chippewa 1827
Destroyed by fire, 1865.
Reference: Rhees, #3.

371. *Mistipee* Creek 1825
Destroyed by fire, 1865.
References: Rhees, #24. PM, #28.213. MH, 2: 39ff.

372. *Mistipee* 1825
Illustrated in figure 13.
17¼ x 13¾.
Signed on back: Mistipe Yoholo-Mico's son Creek Indian C. B. King,
Washington, 1825.
Owner: Museum of Early Southern Decorative Arts, Winston-Salem, N.C.
Bequeathed to RL on August 2, 1862; sold by PB in 1970.
References: GGK, #43. RL 1862 and 1885, #176. Index, #104. PB, #10.

373. *Moanahonga (Great Walker)* Iowa 1824
Destroyed by fire, 1865.
References: Rhees, #88. MH, 1: 318ff.
§ See figure 64 for original drawing.

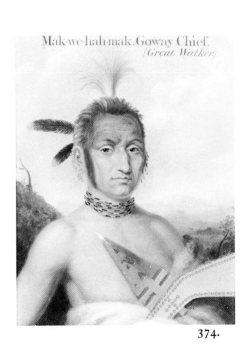

Mak-we-hah-nak, Goway Chief.
(Great Walker)

374.

374. *Moanahonga* circa 1824
Oil on wood, 17 x 14.
Owner: Thomas Gilcrease Institute of American History and Art, Tulsa,
Okla.

375. *Moanahonga* circa 1824
Illustrated in figure 65.
Oil on wood, 17½ x 13¾.
Inscribed on back: Mah-ne-hah-nak Ioway Chief Great Walker.
In private collection. Bequeathed to RL on August 2, 1862; sold by PB in
1970; resold by Kennedy Galleries, Inc.
References: GGK, #52; lists this portrait as "White Cloud." RL 1862; on
p. 26, #52, lists it as "White Cloud"; on p. 56, #165, lists it as "Moanahonga."
RL 1885, #165. Index, #108. Mason, *Annals,* p. 235, #52.

376. *Mohongo and Child* Osage 1830
Destroyed by fire, 1865.
References: Rhees, #110. MH, 1: 44ff. *National Intelligencer,* February
25, 1835, includes a letter about the portrait, written to McKenney by Andrew S.
Hughes, who accompanied Mohongo back to Indian country: "The extraordinary
harmony and fine expression on Mo-hon-go's face and the speaking expression of

her child are suspected by some to be artificial. I declare . . . that I think it is not within the power of any artist to put on canvas a likeness of any human being more perfect or more life-like than are both Mo-hon-go and her child. . . ."

377. *Mohongo and Child* circa 1830
Illustrated in figure 58.
Oil on wood, 17¼ x 14¼.
Owner: Thornton I. Boileau, Birmingham, Mich.

378. *Monchonsia (White Plume)* Kansas 1822
Destroyed by fire, 1865.
References: Rhees, #91. Ewers, p. 496; dates it 1821. MH, 3:48ff.

379. *Monchonsia* circa 1822
Oil on wood, 17½ x 13¾.
Inscribed on back (probably not by CBK): Mooghe Uaroe, White Plume, a Kansas Chief from the River Kansas. Visited Washington in 1825 [1821]. He was a real savage, and would treat a lady with no more respect than if she was a dog. Painted by C. B. King.
Owner: Danish National Museum, Copenhagen. For early provenance, see "Owner," catalog number 321.

379.

380. *Monchonsia* circa 1822
Oil on wood, 17½ x 13¾.
Owner: The White House, Washington, D.C. For early provenance, see "Owner," catalog number 335.

381. *Naagarnep (One Who Sits at the Head)* after James Otto Lewis Chippewa 1827
Destroyed by fire, 1865.
Reference: Rhees, #21.

382. *Naasheoshuck (Roaring Thunder)* Sac 1837
Destroyed by fire, 1865.
Reference: Rhees, #25.

383. *Nahetluchopie (Little Doctor)* Creek 1825
Destroyed by fire, 1865.
References: Rhees, #50. MH, 3:176ff.
§ See catalog number 637, possibly the original drawing.

384. *Nawkaw (Wood)* Winnebago 1828
Destroyed by fire, 1865.
References: Rhees, #75. MH, 1:146ff.

385. *Neamathla* Seminole 1826
Destroyed by fire, 1865.
References: Rhees, #36. MH, 2:216ff.

386. *Neomonni (Walking Rain)* Iowa 1837
Destroyed by fire, 1865.
References: Rhees, #101. MH, 2:150ff.

380.

387.

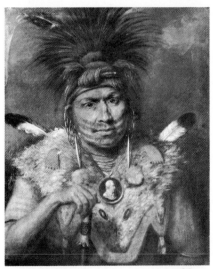

388.

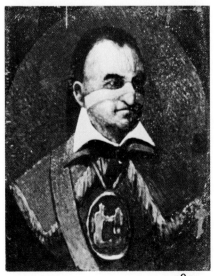

389.

387. *Nesouaquoit (Bear in the Fork of a Tree)* Fox 1837
35½ x 29½.
Unlocated. Given to RL before 1859; sold by PB in 1970.
References: RL 1859, #45. RL 1862 and 1885, #44. Index. PB, #16.

388. *Nesouaquoit* 1837
Oil on wood, 30 x 25.
Signed on back: Ne.SA.AW.Quot/Bear in the fork of the tree/By C. B.
King 1837/Washington/Chief of the band of the/Lac & Fox Indians.
Owner: Chicago Historical Society, Chicago, Ill.
Reference: MH, 1 : lv, 312ff.

389. *No Cush* Yuchi circa 1830
Oil on millboard, 2⁹⁄₁₆ x 2.
Signed on back: Chief/No-Cush/Chief No Cush/Chas. B. King.
Owner: Yale University Art Gallery, New Haven, Conn.; Leila A. and
John Hill Morgan Collection.
References: Ewers, p. 472. *Yale University Portrait Index 1701-1951* (New
Haven: Yale University Press, 1951), p. 59.

390. *Notchimine (No Heart)* Iowa 1837
Not destroyed in fire of 1865.
Illustrated in figure 75.
Oil on wood, 17⅜ x 13¼.
Inscribed on back on label (not by CBK): Nan-chi-ming-ga, No Heart,
Ioway. C. B. King, 1837.
Owner: Smithsonian Institution, Washington, D.C.
References: Rhees, #103. MH, 2 : 110ff.

391. *Notin (Wind)* Chippewa
Destroyed by fire, 1865.
References: Rhees, #129. MH, 3 : 32ff.
§ See catalog number 638 for original drawing.

392. *Nowaykesugga (He Who Strikes Two at Once)* Oto 1837
Destroyed by fire, 1865.
References: Rhees, #64. MH, 3 : 16ff.

393. *Ocangeewack* after James Otto Lewis Chippewa 1827
Destroyed by fire, 1865.
Reference: Rhees, #122.

394. *Ochefinceco (Charles Connello)* Creek 1825
Destroyed by fire, 1865.
References: Rhees, #124. MH, 3 : 112ff.

395. *Ohyawamincekee (Yellow Thunder)* after James Otto Lewis Chip-
pewa 1827
Destroyed by fire, 1865.
References: Rhees, #55. MH, 3 : 304ff.

396. *Okeemakeequid (Chief that Speaks)* after James Otto Lewis Chippewa
circa 1826
Destroyed by fire, 1865.
References: Rhees, #117. PM. MH, 1:253ff.

397. *Ongpatonga (Big Elk)* Omaha 1822
Destroyed by fire, 1865.
References: Rhees, #90. PM #28.208. MH, 1:273ff.; Hodge dates this
1821.

398. *Ongpatonga* circa 1822
Illustrated in figure 73.
Oil on wood, 17 x 14.
Owner: Thomas Gilcrease Institute of American History and Art, Tulsa,
Okla.

399. *Ongpatonga* circa 1822
Oil on wood, 17½ x 13¾.
Owner: Newberry Library, Chicago, Ill.

399.

400. *Opothe-Yoholo* Creek 1825
Destroyed by fire, 1865.
References: Rhees, #53. PM, #28.211. MH, 2:17ff.

401. *Oshawguscodaywayqua* (Mrs. John Johnston) after James Otto Lewis
1826
Oil on canvas, mounted on wood, 18 x 14.
Inscribed on back of wood: Mrs. Johnson [*sic*] Chippeway Washington
1826.
Owner: Buffalo and Erie County Historical Society, Buffalo, N.Y. Gift of
the Reverend William McMurray, 1894.

402. *Panansee (Shedding Elk)* Sac 1827
Destroyed by fire, 1865.
Reference: Rhees, #114.

403. *Pashenine (Good Marksman)* after James Otto Lewis Chippewa 1827
Destroyed by fire, 1865.
References: Rhees, #60. MH, 3:96ff.

404. *Pashepahaw (Stabber)* Sac circa 1824
Destroyed by fire, 1865.
References: Rhees, #41. MH, 1:194ff.
§ See catalog number 639 for original drawing.

405. *Paytakootha (Flying Cloud)* Shawnee
Unlocated.
References: PM, #28.199. MH, 1:172ff.

406. *Peahmuska (The Fox Wending His Course)* Fox 1824
Destroyed by fire, 1865.
References: Rhees, #104. MH, 1:231ff.
§ See catalog number 640 for original drawing.

401.

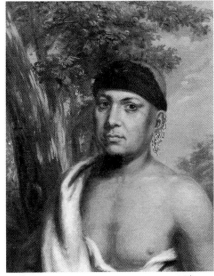

407.

407. *Peahmuska* 1831
Oil on wood, 17¼ x 13¾.
Signed on back: Pee-mas-ka (The Fox Wending his course) A Chief of the Foxes Painted by CB. King 1831.
Owner: The Warner Collection, Gulf States Paper Corporation, Tuscaloosa, Ala. Given to RL before 1859; sold by PB in 1970.
References: RL 1859, #41. RL 1862 and 1885, #169. Index, #114. PB, #12.

408. *Peajuk* after James Otto Lewis Chippewa 1827
Destroyed by fire, 1865.
Reference: Rhees, #4.

409. *Peechekir (Buffalo)* Chippewa
Destroyed by fire, 1865.
References: Rhees, #79. MH, 3:288ff.
§ See catalog number 641 for original drawing.

410. *Peskelechaco* Republican Pawnee 1822
Destroyed by fire, 1865.
References: Rhees, #89. MH, 2:303ff.

411. *Peskelechaco* circa 1822
Illustrated in figure 48.
Oil on wood, 17½ x 13¾.
Owner: William J. Williams, Cincinnati, Ohio. Bequeathed to RL on August 2, 1862; sold by PB in 1970.

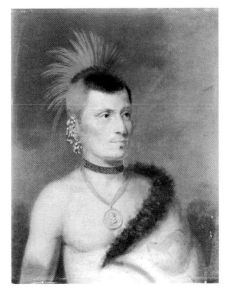

412.

412. *Peskelechaco* circa 1822
Oil on wood, 17½ x 13¾.
Inscribed on back (probably not by CBK): Ohuy Turgoh, Republican Pawnee Chief from the River Platte. Visited Washington in 1825 [1821]. Painted by C. B. King. He was so Gallant that he used to say to every Lady he was introduced to that she was the handsomest woman he had seen.
Owner: Danish National Museum, Copenhagen. For early provenance, see "Owner," catalog number 321.
Reference: B-S, p. 16.

413. *Petalesharro (Generous Chief)* Loup Pawnee 1822
Destroyed by fire, 1865.
References: Rhees, #92; lists this portrait as "Terre-ki-tan-ahu." Jedidiah Morse, *Report to the Secretary of War,* 1822; includes an engraving by Simeon Smith Jocelyn of this portrait as the frontispiece. MH, 1:202.

414. *Petalesharro* circa 1822
Illustrated in figure 46.
Oil on wood, 17½ x 13¾.
Owner: The Warner Collection, Gulf States Paper Corporation, Tuscaloosa, Ala. Purchased from a descendant of the King family.
Reference: Viola, *Indian Legacy,* pp. 123, 140.

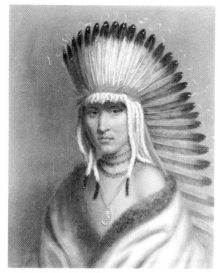

415.

415. *Petalesharro* circa 1822
Oil on wood, 17½ x 13¾.

Inscribed on back (probably not by CBK): Terre-ku-tana-hu. Chief of the Loup Pawnees. He is the son of Old Knife and was much carressed in Washington for having rescued a white woman [actually an Indian maiden] from the stake where his own nation had placed her to be burnt. He provided himself with two horses, and sud[d]enly seizing the victim placed her on one and accompanied her with the other until she was in safety. He fel[l] a victim to his visit to the whites, change of diet and the measles killed him. Painted by C. B. King 1825. Reside[s] on the Platte River.

Owner: Danish National Museum, Copenhagen. For early provenance, see "Owner," catalog number 321.

Reference: B-S, p. 15.

416. *Petalesharro* circa 1822
Oil on wood, 17½ x 13¾.
Owner: The White House, Washington, D.C. For early provenance, see "Owner," catalog number 335.

417. *Petalesharro* circa 1822
Oil on wood, 17 x 14.
Owner: Thomas Gilcrease Institute of American History and Art, Tulsa, Okla.

418. *Petalesharro* circa 1822
Oil on wood, 17½ x 13¾.
Owner: Newberry Library, Chicago, Ill.

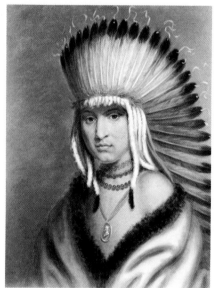

416.

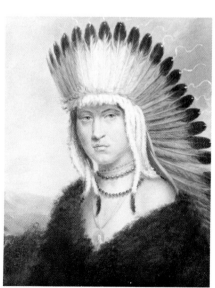

417.

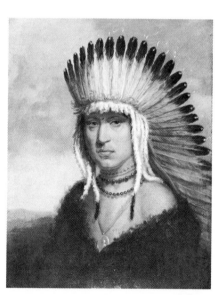

418.

419.

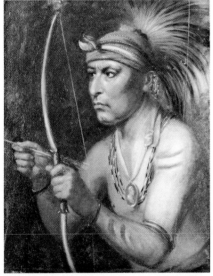

420.

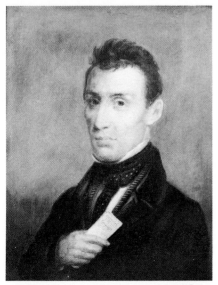

425.

419. *Joseph Porus* (or *Polis*) Penobscot 1842
Oil on wood, 17 x 14.
Owner: Thomas Gilcrease Institute of American History and Art, Tulsa,
Okla.

420. *Powasheek (To Dash the Water Off)* Fox 1837
Oil on wood, 17½ x 13¾.
Owner: The Warner Collection, Gulf States Paper Corporation, Tusca-
loosa, Ala. Bequeathed to RL in September 1862; sold by PB in 1970.
References: RL 1862 and 1885, #175. Index. PB, #14.

421. *Pushmataha* Choctaw 1824
Destroyed by fire, 1865.
References: Rhees, #22. PM, 28.188. MH, 1:62ff.

422. *Pushmataha* 1824
Destroyed by fire, 1865.
References: Rhees, #42. MH, 1:31ff. Thomas L. McKenney and James
Hall, *Catalogue of One Hundred and Fifteen Indian Portraits,* 1836, a prospectus
of the forthcoming publication of the authors' *Indian Tribes of North America;*
refers to a portrait of Pushmataha done after Joseph Wood – possibly this version
or that illustrated in catalog number 421.

423. *Pushmataha* 1824
Illustrated in figure 55.
Oil on wood, 17¼ x 13¼.
Signed on back: Push-ma-ta-ha Distinguished Chief Painted by CB. King
Washington a few weeks before his death in the Presidency of Genl Jackson.
Owner: The Warner Collection, Gulf States Paper Corporation, Tusca-
loosa, Ala. Given to RL before 1859; sold by PB in 1970.
References: RL 1859, #44. RL 1862 and 1885, #201. Index, #113. PB, #7.
§ Pushmataha died in Washington, D.C., in 1824; Andrew Jackson was
president from 1829 to 1837.

424. *Quatawapea (Colonel Lewis)* Shawnee
Unlocated.
References: PM, #28.198; lists this portrait as by CBK. MH, 1:168ff.; Hodge
believes it is not by CBK.

425. *John W. Quinney* Stockbridge 1842
Oil on wood, 17 x 14.
Owner: Thomas Gilcrease Institute of American History and Art, Tulsa,
Okla.

426. *Rantchewaime (Female Flying Pigeon)* Iowa 1824
Destroyed by fire, 1865.
References: Rhees, #97; see catalog number 331. MH, 1:296ff.; mistakenly
used Hayne Hudjihini's picture for Rantchewaime.

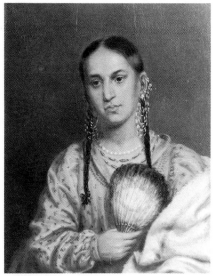

427.

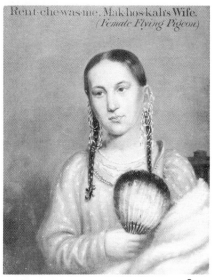

Rent-che-was-me, Makhos-kah's Wife.
(Female Flying Pigeon)

428.

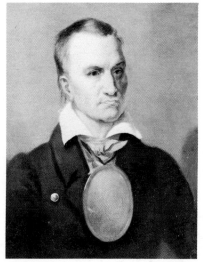

433.

427. *Rantchewaime* circa 1824
Oil on wood: 17½ x 13½.
Signed on back: Rant-the-nai-me Female Flying Pigion Maharoks [Mahas-kah's] wife Married at 17 years 14 when painted C. B. King.
Owner: The Warner Collection, Gulf States Paper Corporation, Tusca-loosa, Ala. Bequeathed to RL on August 2, 1862; sold by PB in 1970.
References: GGK, #44; incorrectly lists this portrait as "Eagle of Delight." RL 1862, p. 25, #43; also lists it as "Eagle of Delight," but lists it as "Rantche-waime" on p. 57, #177. RL 1885, #177. Index, #103. PB, #6.

428. *Rantchewaime* circa 1824
Oil on wood, 17 x 14.
Owner: Thomas Gilcrease Institute of American History and Art, Tulsa, Okla.

429. *John Ridge* Cherokee 1824
Destroyed by fire, 1865.
References: Rhees, #69. MH, 2 : 326ff.

430. *Sagoyewatha (Red Jacket)* Seneca 1828
Destroyed by fire, 1865.
References: Rhees, #98. PM, #28.187. MH, 1 : 5ff.

431. *Sagoyewatha*
Destroyed by fire, 1865.
Reference: Rhees, #143.

432. *Sagoyewatha* 1828
Illustrated in figure 56.
Oil on wood, 17½ x 13½.
Inscribed on back: Red Jacket Seneca Chief.
Owner: Albright-Knox Art Gallery, Buffalo, N.Y. Given by The Sey-mour H. Knox Foundation in 1970. Bequeathed to RL on August 2, 1862; sold by PB in 1970.
References: GGK, #48. RL 1862 and 1885, #174. Index, #29. PB, #4.

433. *Sagoyewatha*
Oil on canvas, mounted on wood, 30 x 25.
Owner: The Historical Society of Pennsylvania, Philadelphia. Purchased at the Edward D. Ingraham Collection sale in 1855.
Reference: CAP.

434. *Sagoyewatha*
Oil on wood, 17 x 14.
Owner: Yale University Art Gallery. Given by de Lancy Kountze in 1925.
Reference: *Yale University Portrait Index* (New Haven: Yale University Press, 1951), p. 59.

435. *Selocta* Creek 1825
Destroyed by fire, 1865.
References: Rhees, #70. MH, 2 : 348ff.

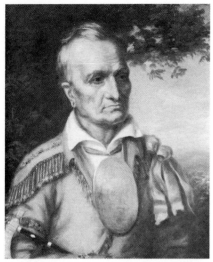

434.

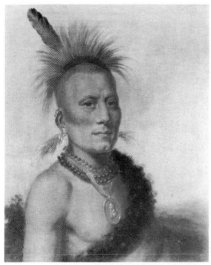

439.

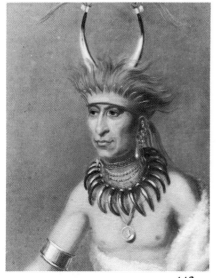

443.

436. *Sequoyah (George Guess)* Cherokee 1828
Unlocated.
Reference: MH, 1 : 130ff.

437. *Sequoyah*
27 x 18 (sight).
Owner: Geoffrey Barker Churchill.
Reference: FARL.

438. *Sharitarish (Wicked Chief)* Pawnee 1822
Destroyed by fire, 1865.
References: Rhees, #93. MH, 2 : 293ff.
§ See catalog number 642, possibly the original drawing.

439. *Sharitarish* circa 1822
Oil on wood, 17½ x 13¾.
Inscribed on back (probably not by CBK): Wicked Chief, head of the Great
Pawnees. Visited Washington in 1825 [1821], resides on the River Platte. Painted
after nature by C. B. King. The Red horse they wear in their heads is given them
by the Great Council for some exploit in war, and cannot be worn by anyone to
whom it is not given.
Owner: Danish National Museum, Copenhagen. For early provenance, see
"Owner," catalog number 321.
Reference: B-S, p. 14.

440. *Sharitarish* circa 1822
Illustrated in figure 71.
Oil on wood, 17½ x 13¾.
Owner: The White House, Washington, D.C. For early provenance, see
"Owner," catalog number 335.

441. *Shauhaunapotinia (Man Who Killed Three Sioux)* Iowa 1837
Unlocated.
References: PM, #28.209. MH, 1 : 326ff.

442. *Shaumonekusse* Oto 1822
Destroyed by fire, 1865.
References: Rhees, #130. MH, 1 : 156ff.
§ Subject was the husband of Hayne Hudjihini (see cat. nos. 331-335).

443. *Shaumonekusse* circa 1822
Oil on wood, 17½ x 13½.
Inscribed on back: Redwood Library Care of R Rogers Newport.
Owner: The Warner Collection, Gulf States Paper Corporation, Tusca-
loosa, Ala. Exhibited for sale at the Boston Athenaeum in 1828; given to RL in
April 1829; sold by PB in 1970.
References: BA 1828, p. 8, #232. Donations 1810-1858, p. 17, September 21,
1829. RL 1859, #36. RL 1862 and 1885, #195. Mason, *Annals,* pp. 133-34. Index,
#110. PB, #1.

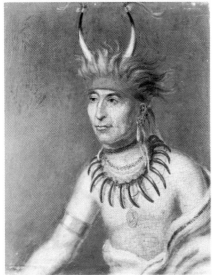

444.

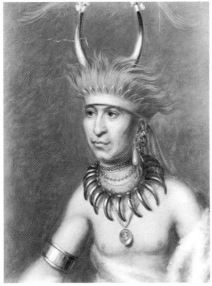

445.

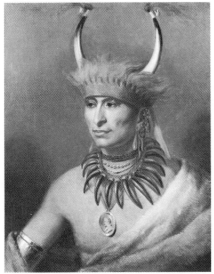

446.

444. *Shaumonekusse* circa 1822
Oil on wood, 17½ x 13¾.
Inscribed on back (probably not by CBK): Ottoe Chief, husband of Eagle of Delight. Resides on the River Platte. Visited Washington in 1825 [1821]. When he had his leave visit to the president he made him a present of his horns as a mark of respect. Painted by C. B. King.
Owner: Danish National Museum, Copenhagen. For early provenance, see "Owner," catalog number 321.
Reference: B-S, p. 11.

445. *Shaumonekusse* circa 1822
Oil on wood, 17½ x 13¾.
Owner: The White House, Washington, D.C. For early provenance, see "Owner," catalog number 335.

446. *Shaumonekusse* circa 1822
29½ x 24½.
Owner: Joslyn Art Museum, Omaha, Neb. Purchased from M. Knoedler & Co., Inc., in 1962.

447. *Shaumonekusse* circa 1822
Oil on wood, 17½ x 13¾.
Owner: Hirschl & Adler Galleries, New York, N.Y. Acquired at the Geraldine Rockefeller Dodge estate sale in 1976.

448. *Shingaba W'Ossin (Image Stone)* Chippewa
Destroyed by fire, 1865.
References: Rhees, #2. PM, #28.190. MH, 1:50ff.

449. *Colonel John Stedman (or Stidham)* 1825
Destroyed by fire, 1865.
Reference: Rhees, #35.

450. *Tagoniscoteyeh (Black Fox)* 1828
Destroyed by fire, 1865.
Reference: Rhees, #9.

451. *Tagoniscoteyeh* 1828
Oil on wood, 17½ x 13¾.
Signed on back: Ta-go-nis-co-te-yeh/Black Fox. Cherokee Chief/Painted by C. B. King/Washington 1828.
Owner: du Val Radford, Bedford, Va. Given to the owner's grandfather, R. C. W. Radford, by an Indian chief for saving the life of his son.
Reference: Richard Champlin, "Note on the Charles Bird King Indian Portraits," *Newport History* 44 (Summer 1971): 77-179.
§ The back of this portrait has two portrait sketches.

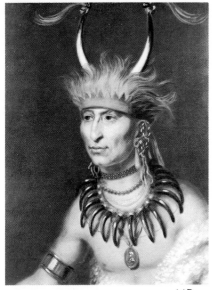

447.

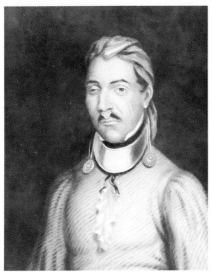

456.

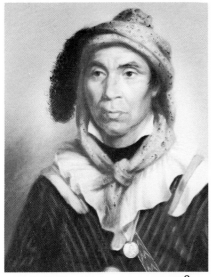

458.

452. *Tahcolaquoit* Sac
Destroyed by fire, 1865.
References: Rhees, #32. MH, 3:64ff.
§ See catalog number 643 for original drawing.

453. *Tahrohon (Plenty of Meat)* Iowa 1837
Destroyed by fire, 1865.
References: Rhees, #38. MH, 2:158ff.
§ See catalog number 644, possibly the original drawing.

454. *Taiomah (Bear Whose Scream Makes the Rock Tremble)* Fox
circa 1824
Destroyed by fire, 1865.
References: Rhees, #48. MH, 2:107ff.; attributed to King by Hodge.
§ See catalog number 645 for original drawing.

455. *Tenskwautawaw (The Prophet,* or *Open Door)* after James Otto Lewis?
Shawnee
Destroyed by fire, 1865.
References: Rhees, #99. PM, #28.192. MH, 1:75ff.

456. *Tenskwautawaw* 1829
Oil on wood, 23½ x 20½.
Owner: Thomas Gilcrease Institute of American History and Art, Tulsa,
Okla.

457. *Tshusick* Chippewa 1827
Destroyed by fire, 1865.
References: Rhees, #147. PM, #57.031. MH, 1:353ff.
§ See figure 57 for a lithograph made from Henry Inman's copy of this
portrait.

458. *Tulceemathla* Seminole 1826
Oil on wood, 16½ x 13½.
Owner: Lowe Art Museum, University of Miami, Coral Gables, Fla.
Acquired from the University of Pennsylvania Museum in 1971.
References: MH, 2:82ff. CBK file, NCFA.

459. *Tuskiehu Tustennuggee (Little Prince)* Creek 1825
Destroyed by fire, 1865.
Reference: Rhees, #71.

460. *Tustennugee Emathla (Jim Boy)* Creek circa 1825
Unlocated.
Reference: MH, 2:173ff.; Hodge mistakenly refers to this as "Rhees, #36"
(described in cat. no. 385).

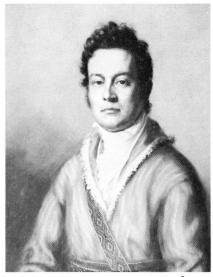

461.

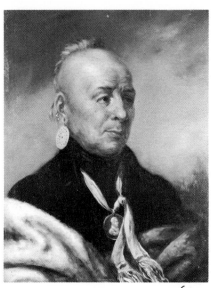

465.

461. *David Vann* 1825
Oil on wood, 17 x 14.
Owner: Thomas Gilcrease Institute of American History and Art, Tulsa, Okla.
Reference: MH, 3:216ff.
§ Vann was an ancestor of Will Rogers's.

462. *Waapashaw* after James Otto Lewis? Sioux circa 1825
Unlocated.
References: PM, #28.193. MH, 1:106ff.

463. *Waatopenot (Eagle's Bill)* after James Otto Lewis Fox 1826
Destroyed by fire, 1865.
References: Rhees, #49. MH, 3:272ff.

464. *Wabaunsee (Causer of Paleness)* Potawatomi 1835
Destroyed by fire, 1865.
References: Rhees, #105. MH, 2:194ff.

465. *Wabaunsee* 1835
Oil on wood, 17½ x 13½.
Signed on back: Wab-bawn-see, Cause of Paleness, Powerful Chief of the Potawatomies, Resides in Illinois, 80 years old. Painted by C. B. King, Washington, 1835.
In private collection. Bequeathed to RL on August 2, 1862; sold by PB to Eugene B. Adkins, Tulsa, Okla., in 1970; resold by PB in 1973.
References: GGK, #46 or #47. RL 1862, p. 25, #46 or #47, p. 56, #166. RL 1885, #166. Index. PB, #17.

466. *Waemboeshkaa* after James Otto Lewis? Chippewa circa 1826
Destroyed by fire, 1865.
References: Rhees, #132. PM, #28.207 (reversed). MH, 1:258ff.

467. *Wahekanshekai* after James Otto Lewis Winnebago 1826
Destroyed by fire, 1865.
References: Rhees, #61. Ewers, p. 472; lists this as *Wakaunhaka (Snake Skin)*.

468. *Wahkeontawkah (Big Thunder)* Mdwekanton Sioux 1837
Destroyed by fire, 1865.
Reference: Rhees, #14.

469. *Wahronesah (Surrounder)* Oto 1837
Destroyed by fire, 1865.
Reference: Rhees, #13.

470. *Wakaunhaka* circa 1837
Destroyed by fire, 1865.
References: Rhees, #127. MH, 2:298ff.; attributed to King by Hodge.

471. *Wakechai (Crouching Eagle)* Sac 1824
Destroyed by fire, 1865.
References: Rhees, #65. MH, 2 : 411ff.
§ See catalog number 646 for original drawing.

472. *Wakechai* circa 1824
Illustrated in figure 54.
Oil on wood, 17½ x 13¾.
Inscribed on back: Wai-kee-chai, Sauky Chief Crouching Eagle.
Owner: The Warner Collection, Gulf States Paper Corporation, Tuscaloosa, Ala. Bequeathed to RL on August 2, 1862; sold by PB in 1970.
References: GGK, #46 or #47. RL 1862, p. 25, #46 or #47, p. 56, #167. RL 1885, #167. Index, #112. PB, #11.

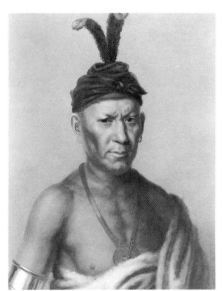

473.

473. *Wakechai* circa 1824
Oil on wood, 17½ x 13¾.
Owner: Hirschl & Adler Galleries, New York, N.Y. Acquired at the Geraldine Rockefeller Dodge estate sale, 1976.

474. *Wanata (The Charger)* after James Otto Lewis Sioux 1826
Destroyed by fire, 1865.
References: Rhees, #119. MH, 1 : 223ff. Ewers, p. 472; states portrait is after Lewis.

475. *Wanata* after James Otto Lewis 1826
Illustrated in figure 62.
38½ x 26½.
Signed on back: Indian Chief in the dress of ceremony CB King Washington.
Owner: The Warner Collection, Gulf States Paper Corporation, Tuscaloosa, Ala. Given to RL before 1859; exhibited at the Newport (R.I.) High School in January 1865; sold by PB in 1970.
References: RL 1859, #22. RL 1862 and 1885, #20. Mason, *Annals,* p. 247. Index, #116. PB, #8.

476. *Wapella (Prince)* Fox 1837
Destroyed by fire, 1865.
References: Rhees, #106. MH, 2 : 99ff.

477. *Watchemonne (Orator)* Iowa 1837
Destroyed by fire, 1865.
References: Rhees, #46. MH, 2 : 164ff.

478. *Wekrootaw (He Who Exchanges)* Oto
Destroyed by fire, 1865.
Reference: Rhees, #108.

479. *Wekrootaw* 1837
Destroyed by fire, 1865.
Reference: Rhees, #139.

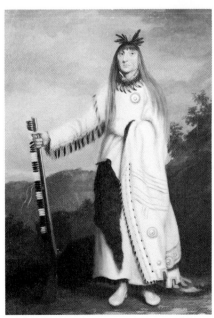

474.

480. *Weshcubb (The Sweet)* after James Otto Lewis Chippewa 1826
Destroyed by fire, 1865.
References: Rhees, #47. PM, #28.195. MH, 1:120ff.

481. *Yaha Hajo (Mad Wolf)* Creek 1825
Destroyed by fire, 1865.
References: Rhees, #67. MH, 2:393ff.

482. *Yoholo-Micco* Creek 1825
Destroyed by fire, 1865.
References: Rhees, #27. MH, 2:36ff.

483. *Young Cornplanter* Seneca 1827
Oil on wood, 17½ x 13¾.
Inscribed on back (probably not by CBK): Young Corn Planter, Senecas Indian, New York. Aid to Red Jacket. Original portrait by C. B. King 1827. He is a half breed.
Owner: Danish National Museum, Copenhagen. For early provenance, see "Owner," catalog number 321.

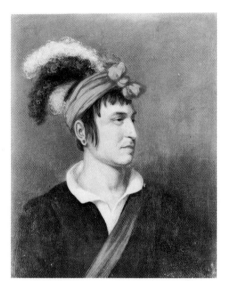

483.

484. *Young Omaha, War Eagle, Little Missouri, and Pawnees* 1822
Illustrated in figure 49.
27 x 35½.
Owner: Smithsonian Institution, Washington, D.C.
References: Cowdrey, *National Academy of Design Exhibition Record,* p. 278. CBK files, NCFA.

Subject Pictures

Still Life

485. *Apples, Pears, Plums and Grapes*
Unlocated. Given to RL in December 1861; deaccessioned after 1885.
References: *Diary of C. F. Adams,* 1:48, January 17, 1824; mentions that King had "some very sweet fruit pieces, which would adorn a summer house or even a dinner parlour very much." GGK, December 14, 20, 1861. Donations 1859-1863, December 12, 1861. RL 1862 and 1885, #162.

486. *Basket with Beef and Poultry; Fish Nearby*
Unlocated. Given or bequeathed to RL before 1862; deaccessioned after 1885.
References: RL 1862 and 1885, #163.

487. *Cherries, Strawberries, Pitcher of Cream, &c.*
Unlocated. Given or bequeathed to RL before 1862; deaccessioned after 1885.
References: RL 1862 and 1885, #161.

488. *Chilean Strawberries, Raised by J. C. Calhoun*
Unlocated. Given to RL in December 1861 ; not listed thereafter.
References : GGK, December 14, 20, 1861. Donations 1859-1863, December 12, 1861.
§ Possibly the same as catalog number 487.

489. *Fish*
30 x 25.
Unlocated. Given to RL in December 1861 ; not listed after 1862.
References : RL 1862, p. 23. Mason, *Annals*, p. 226.
§ Possibly the same as catalog number 486.

490. *Flower Piece. By Old Master.*
Unlocated. Bequeathed to RL on August 2, 1862 ; deaccessioned after 1885.
References : GGK, #74. RL 1862 and 1885, #156 or #185 (see cat. no. 491).

491. *Flower Piece (Old)*
Unlocated. Bequeathed to RL on August 2, 1862 ; deaccessioned after 1885.
References : GGK, #8. RL 1862 and 1885, #156 or #185 (see cat. no. 490).

492. *Grapes and Pears*
30 x 25.
Unlocated. Given to RL in December 1861 ; deaccessioned after 1885.
References : RL 1862 and 1885, #159. Mason, *Annals*, p. 226.

493. *Grapes, Peaches, Pears, with Decanter* circa 1815-1825
Illustrated in figure 82.
25 x 30.
Owner : John S. H. Russell, Washington, D.C., a great-grandson of Edward King, CBK's second cousin, to whom the artist gave this painting and that described in catalog number 495.

494. *Melons of Different Varieties*
Unlocated. Given to RL in December 1861 ; deaccessioned after 1885.
References : GGK, December 14, 20, 1861. Donations 1859-1863, December 12, 1861. RL 1862 and 1885, #160.

495. *Pomegranate, Grapes, Pineapples* circa 1835-1840
Illustrated in figure 83.
25 x 30.
Owner : John S. H. Russell, Washington, D.C., great-grandson of Edward King, CBK's second cousin, to whom the artist gave this painting and that described in catalog number 493.

496. *Poor Artist's Closet*
Unlocated. Bequeathed to RL on August 2, 1862 ; deaccessioned after 1885.
References : GGK, #26. RL 1862 and 1885, #214 ; list works as "Poor Artist's Closet ; or Sale of Artist's effects."
§ Possibly the same as catalog number 497.

497. *Poor Artist's Cupboard* circa 1815
Illustrated as frontispiece.
Oil on wood, 29¾ x 27¾.
Owner: Corcoran Gallery of Art, Washington, D.C. Purchased from Knoedler & Co., Inc., in 1955. Possibly the work exhibited at the Boston Athenaeum in 1828 and bequeathed in 1862 to the RL, which deaccessioned it after 1885 (see cat. no. 496). Also, possibly the work won by Albert Christie at the Apollo Association's raffle of 1839 (see cat. no. 498).
References: BA 1828, p. 5, #127; lists the picture exhibited as *The Poor Artist's Closet.*

498. *Property of a Poor Artist*
Unlocated. Exhibited for sale ($75) at the Apollo Association, New York, in 1838, 1839; purchased by the Apollo Association on December 7, 1839, for $85, and raffled off later that month to Albert Christie of New York City. Possibly the work now in the Corcoran Gallery of Art.
References: Cowdrey, *AAU. Record,* pp. 215-16. "Minutes, Committee of the Apollo Association."

499. *Shells and Coral*
Unlocated. Exhibited at the Apollo Association, New York, in 1839.
Reference: Cowdrey, *AAU. Record,* p. 216, #41.

500. *Still-Life, Game* 1806
Illustrated in figure 6.
14 X 11.
Signed lower center: CB King 1806; stamped on back with red wax seal with coat of arms and motto Cum Capit Capito.
Owner: IBM Corporation, Armonk, N.Y.

501. *The Vanity of the Artist's Dream* 1830
Illustrated in figure 79.
36 x 30.
Signed lower right: CB King 1830.
Owner: Fogg Art Museum, Harvard University, Cambridge, Mass. Given by Grenville L. Winthrop in 1942. Formerly in the collection of Muriel Matthews, to whom it had descended from Thomas R. Walker, Utica, N.Y. Possibly the work exhibited at the Boston Athenaeum in 1832.
References: BA 1832, p. 1, #39; lists the picture exhibited as *Poor Artist's Study* and as owned by "J. Fullerton," whose name appears on the face of the painting and who also owned Sully's copy of CBK's *Grandfather's Hobby.*

502. *Vegetables*
30 x 25.
Unlocated. Given to RL December 1861; deaccessioned after 1885.
References: RL 1862 and 1885, #164. Mason, *Annals,* p. 226.

Landscape

503. *Breedan's [or Bredon's] Cottage at Harper's Ferry*
Unlocated. Bequeathed to RL on December 11, 1862; deaccessioned after 1885.
References: GGK. #70. Donations 1859-1863, December 11, 1862. RL 1885, #261.

504. *Environs of Milan, Italy*
43 x 56 (approximate).
Unlocated: Given to RL in December 1861; deaccessioned after 1885.
References: Watterston, *New Guide to Washington*, p. 102; in 1847 this painting was seen at CBK's by Watterston, who described it as among the most beautiful there. GGK, November 25, 1861. Donations 1859-1863, December 1, 1861. RL 1862 and 1885, #3.
§ The titles of this work and that described in catalog number 511 were somehow combined and mistakenly applied to catalog number 514, which is still in the RL collection.

505. *Flemish Landscape*
Unlocated. Given to RL before 1859; deaccessioned after 1885.
References: RL 1859, #11; lists no artist or donor, but RL 1862 and 1885, #51, list it as by CBK.

506. *Great Falls of the Potomac, 14 Miles from Washington*
Unlocated. Bequeathed to RL on August 2, 1862; deaccessioned after 1885.
References: GGK, #72. RL 1862 and 1885, #182.

507. *Hadley's Falls, New York*
39 x 51 or 51 x 39.
Unlocated. Bequeathed to RL on August 2, 1862; deaccessioned after 1885.
References: GGK, #71. RL 1862 and 1885, #181; describe this scene as on the "Hudson River, a few miles above Glen's Falls."

508. *Harper's Ferry, Government Work Lock on the Potomac* circa 1815-1820
Illustrated in figure 99.
Oil on wood, 17¼ x 30.
Signed on back (according to JHP): C. B. King Government Work Lock on the Potomac original by C. B. King & presented by him to Edward King Nov. 1861.
Unlocated. Acquired (together with cat. no. 509) in 1952 by Victor Spark of New York and later sold.
References: JHP, #3492. Spark to author, October 19, 24, 1972, and February 12, 1973.

509. *Harper's Ferry, Looking Upstream* circa 1815-1820
Illustrated in figure 100.
Oil on wood, 17¼ x 30.
Signed on back (according to JHP): C. B. King Evening Down the Potomac, Harper's Ferry in the Distance – original by C. B. King & presented by him to Edward King Nov. 1861.
Unlocated. Acquired (together with cat. no. 508) by Victor Spark of New York and later sold.
References: JHP, #3493. Spark to author, October 19, 24, 1972, and February 12, 1973.

510. *House of Torquato Tasso, at Sorrento, near Naples* circa 1835
44½ x 34½.
Inscribed on back (probably by GGK): The House of Tasso at Sorento copy by C. B. King.
Owner: Gerald R. LePage, Mansfield, Conn. Purchased 1974. Given to RL December 1861; deaccessioned after 1885.
References: GGK, December 14, 20, 1861. Donations 1859-1863, December 12, 1861. RL 1862 and 1885, #75.

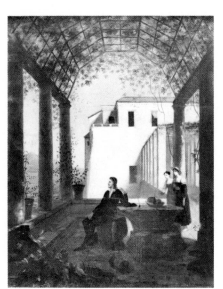

510.

511. *Italian Landscape* after Salvator Rosa
Unlocated. Given to RL before 1859; deaccessioned after 1885.
References: RL 1859, #71; lists this work only as having been given by King. RL 1862 and 1885, #21; list this work as having been given and painted by King.
§ The titles of this landscape and that in catalog number 504 were somehow combined and mistakenly applied to catalog number 514, which is still in the collection of the Redwood Library.

512. *Landscape* after Orizonte
Unlocated. Bequeathed to RL on August 2, 1862; exhibited at the Newport (R.I.) High School in January 1865; deaccessioned after 1885.
References: GGK, #53. RL 1862 and 1885, #179. Mason, *Annals*, p. 247.
§ "Orizonte" was an Italianized Fleming whose real name was Jan Frans van Bloemen.

513. *Landscape, Snow Piece* after Orizonte
Unlocated. Bequeathed to RL on August 2, 1862; deaccessioned after 1885.
References: GGK, #54. RL 1862 and 1885, #180.

514. *Landscape with Catalogue* (or *Environs of Milan, Italy*) 1828
Illustrated in figure 102.
30 x 25.
Owner: Redwood Library. Bequeathed on December 11, 1862.
References: GGK, #39; lists this picture as "Landscape with Catalogue." Donations 1859-1863, December 11, 1862; lists it as "Catalogue of C. B. King's Paintings." Mason, *Annals*, p. 325, #39; lists it as "Landscape."
§ This picture is presently entitled *Environs of Milan, Italy (Copy from Salvator Rosa?)*, having somehow been confused with catalog numbers 504 and 511, both of which were deaccessioned after 1885.

515. *Landscape with Female and Child, Near a Brook in which Swans Are Swimming*
Unlocated. Bequeathed to RL on August 2, 1862; deaccessioned after 1885.
References: GGK, #67. RL 1862 and 1885, #186.

516. *Large Landscape. From a Spanish Painting.*
Unlocated. Bequeathed to RL on August 2, 1862; deaccessioned after 1885.
References: GGK, #49. RL 1862 and 1885, #52.

517. *River Po in Italy* after Claude Lorrain
Unlocated. Given to RL in December 1861; deaccessioned after 1885.
References: GGK, December 14, 20, 1861. Donations 1859-1863, December 12, 1861. RL 1862 and 1885, #2.

518. *Ship on Fire at Night*
Unlocated. Bequeathed to RL on August 2, 1862; deaccessioned after 1885.
References: GGK, #23. RL 1862 and 1885, #71.

519. *Sunset View on the Potomac; Georgetown, D.C. in Sight*
Unlocated. Bequeathed to RL on August 2, 1862; deaccessioned after 1885.
References: GGK, #20. RL 1862 and 1885, #147.

520. *View on the Wissahicon Creek, which Enters the Schuykill River about 5 Miles above Fairmount Water-works, Philadelphia*
Unlocated. Bequeathed to RL on August 2, 1862; deaccessioned after 1885.
References: GGK, #19. RL 1862 and 1885, #146.

Genre

521. *The Adieu* circa 1839
Unlocated.
References: Biddle and Fielding, *Life and Works of Thomas Sully*, p. 335; notes that between November 21, 1839, and June 13, 1840, Sully painted a picture of this title from "a subject suggested by King."

522. *Bargaining for a Kiss*
Unlocated. Bequeathed to RL on August 2, 1862; deaccessioned after 1885.
References: GGK, #16. RL 1862 and 1885, #64.

523. *Boy Stealing Fruit from His Sister*
Unlocated.
Reference: Neal, "Observations," p. 55; in 1824 this picture was seen at the widow Bridgen's in London by Neal, who described it as "a boy stealing fruit from his sister, whom he was amusing with a soapbubble, which he was holding over the plate with one hand, while he drew away the fruit with the other."

524. *Bust of Dead Mother. Two Young Ladies and Little Boy Contemplating It.* 43 x 56 (approximate).
Unlocated. Given to RL in December 1861; consigned on November 26, 1862, to Mrs. A. W. C. Van Ness of Washington, D.C.

References: RL 1862, #9. Van Ness to Redwood Library, March 20, April 3, 19, 1862, and Mason, *Annals,* pp. 226, 238; reveal that Mrs. Van Ness claimed that CBK had promised her the painting because her daughter and sister had posed for the girls in the scene. The picture was given on condition it revert back to the library at some future time, which apparently never happened.

525. *The Chemist in Meditation* after Gabriel Metsu
Unlocated. Given to RL before 1859; deaccessioned after 1885.
References: RL 1859, #28. RL 1862 and 1885, #49.

526. *Child and Dog. From a Cast.*
Unlocated. Given to RL before 1859; deaccessioned after 1885.
References: RL 1859, #30. RL 1862 and 1885, #145.

527. *Child at Prayer*
Unlocated. Given to RL before 1859; deaccessioned after 1885.
References: RL 1859, #35. RL 1862 and 1885, #90.

528. *Children and Bubble* 1806-1812
Unlocated.
References: Dunlap, *History,* p. 29; notes that one of the paintings King brought home from London was his "girls and the cat," probably this painting. PAFA 1813, p. 16, #75; lists it as *Children and Bubble,* with the caption "Philosophers like children sometimes choose/ To chase the bubble and the substance lose." *Port Folio,* August 1813, p. 137; contains the following description of the painting: "This picture is entitled to much praise. The subject is fanciful and executed with considerable judgment; there are some parts, especially the cat on the table looking up at the bubble, that attracted our attention; we are, however, inclined to believe that the artist has laboured more on this picture than was necessary, particularly the colouring."

529. *Conscience Makes Cowards*
30 x 25.
Unlocated. Given to RL in December 1861; deaccessioned after 1885.
References: RL 1862 and 1885, #97. Mason, *Annals,* p. 220.

530. *Death*
Unlocated. Given to RL in December 1861; deaccessioned after 1885.
References: GGK, #55. RL 1862 and 1885, #206.

531. *Father's Joy and Mother's Glory*
Unlocated. Given to RL before 1859; deaccessioned after 1885.
References: RL 1859, #62. RL 1862 and 1885, #23.

532. *Girl and Cat. From an Engraving.*
Unlocated. Given to RL before 1859; exhibited at the Newport (R.I.) High School in January 1865; deaccessioned after 1885.
References: RL 1859, #59. RL 1862 and 1885, #221. Mason, *Annals,* p. 247.

533. *Girl Playing with Cat and Kitten*
Unlocated. Bequeathed to RL on August 2, 1862; deaccessioned after 1885.
References: GGK, #1. RL 1862 and 1885, #1.

534. *Girl Reading Love-letter by Lamp-light*
Unlocated. Given to RL in December 1861; deaccessioned after 1885.
References: GGK, December 14, 20, 1861. Donations 1859-1863, December 12, 1861. RL 1862 and 1885, #96.

535. *Girl Taking Food to a Prisoner*
Unlocated. Given to RL in December 1861; deaccessioned after 1885.
References: GGK, December 14, 20, 1861. Donations 1859-1863, December 12, 1861. RL 1862 and 1885, #100.

536. *Girls at the Brook. From a Cast.*
Unlocated. Given to RL before 1859; deaccessioned after 1885.
References: RL 1859, #67. RL 1862 and 1885, #152.

537. *Grandfather's Hobby* circa 1824-1830
Illustrated in figure 92.
36¼ x 28¼.
Owner: The Henry Francis du Pont Winterthur Museum, Winterthur, Del.
References: Biddle and Fielding, *Life and Works of Thomas Sully*, p. 363; notes that between December 19, 1824, and January 12, 1825, Sully copied CBK's *Juvenile Ambition,* probably the original title of this picture. S. G. Goodrich, ed. *The Token* (Boston, 1830), pp. iii, iv, ix, 233-34; contains a verse entitled "Grandfather's Hobby," which accompanies an engraving (see fig. 95) by E. Gallaudet of Sully's copy (see fig. 94), then titled the *Hobby,* which was owned by J. Fullerton. BA 1828, p. 3; lists the Sully copy owned by Fullerton, but entitled "Riding my Grandfather's Hobby." BA 1831, p. 6; lists a work by CBK, probably this one, entitled "Riding my Grandfather's Hobby" and owned by W. H. Eliot. Oliver, *J. Q. Adams,* p. 131; records that Adams saw this at the Boston Athenaeum in 1831 and described it as "King's boy reading a Newspaper." Neal, "Observations," p. 56; asserts that the idea for this picture originated with Leslie.

538. *Grandfather's Hobby* circa 1824-1838
Unlocated. Exhibited at the Apollo Association, New York, in 1838 and 1839; purchased by the association in March 1839 and raffled off in December 1839 to a Joseph J. West of New York City.
References: Cowdrey, *AAU. Record,* pp. 215-16; lists this work with the following caption: "This picture has been engraved several times in Europe and the United States." Review, *New York Mirror,* October 27, 1838, p. 142: "'Grandfather's Hobby' is pleasingly designed, well drawn, and coloured with great beauty."
§ Possibly a replica of catalog number 537.

539. *Grandfather's Hobby* 1852
Illustrated in figure 93.
45 x 35.
Signed lower left: C. B. King 1852.
Owner: College of St. Mary's, Omaha, Neb. Given by Duane Hillmer. Purchased in 1974 from Scott Lentz, who owned it from about 1952.
Reference: CBK file, NCFA.

540. *Grandfather's Hobby*
Unlocated. Given to RL in December 1861; deaccessioned after 1885.
References: GGK, December 14, 20, 1861. Donations 1859-1863, December 12, 1861. RL 1862 and 1885, #5.
§ Possibly the same as catalog number 539.

541. *Hard Lesson*
Unlocated. Bequeathed to RL on August 2, 1862; deaccessioned after 1885.
References: GGK, #11. RL 1862 and 1885, #138.

542. *I Hope I See You Well*
Unlocated. Given to RL in December 1861; deaccessioned after 1885.
References: GGK, December 14, 20, 1861. Donations 1859-1863, December 12, 1861. RL 1862 and 1885, #225.

543. *Industry and Idleness. Two Little Girls under the Shade of a Tree; One Studying, the Other Sleeping.*
Unlocated. Given to RL in December 1861; exhibited at the Newport (R.I.) High School in January 1865; deaccessioned after 1885.
References: GGK, December 14, 20, 1861. Donations 1859-1863, December 12, 1861. RL 1862 and 1885, #151. Mason, *Annals*, p. 247.

544. *Interior of a Ropewalk* circa 1845
Illustrated in figure 96.
39 x 54½.
Inscribed on back (probably by GGK): Interior of a Ropewalk Original by C. B. King
 Owner: University of Virginia Art Museum, Charlottesville, Va. Purchased in 1977 from Hirschl & Adler and Kennedy Galleries, New York; acquired from the New York State Historical Association in exchange for catalog number 545 in 1967. Given to RL in December 1861; deaccessioned after 1885.
References: RL 1862 and 1885, #17. Mason, *Annals*, p. 226. CBK file, New York State Historical Association. Caroline Keck to author, September 22, 1972.

545. *Itinerant Artist* circa 1830
Illustrated in figure 87.
44¾ x 57.
Owner: New York State Historical Association. Acquired from Hirschl & Adler in exchange for catalog number 544 in 1967; given to RL in December 1861; deaccessioned after 1885; collection of Mrs. Gunn, Newton, Mass.; acquired by Vose Galleries in 1958; sold to Nicholson Galleries in 1963; purchased by Hirschl & Adler in 1966.
References: Watterston, *New Guide to Washington*, p. 102; in 1847 this painting was seen at CBK's by Watterston, who described it as among the most beautiful there. GGK, November 25, 1861. Donations 1859-1863, December 1, 1861. RL 1862 and 1885, #15.

546. *"I Will Be a Soldier." Little Child with Sword and Gun, and Old Man with Wooden Leg.*
43 x 56 (approximate).
Unlocated. Given to RL in December 1861; exhibited at Newport (R.I.) High School in January 1865; deaccessioned after 1885.
References: RL 1862 and 1885, #12. Mason, *Annals*, pp. 226, 247.

547. *Kiss Me if You Dare*
Unlocated. Bequeathed to RL on August 2, 1862; deaccessioned after 1885.
References: GGK, #13. RL 1862 and 1885, #143.

548. *Lady Sleeping under Umbrella on the Sea Shore*
Unlocated. Bequeathed to RL on August 2, 1862; deaccessioned after 1885.
References: GGK, #68. RL 1862 and 1885, #224.

549. *"Long Wished for Come at Last." Girl with Miniature and Letter.*
Unlocated. Given to RL in December 1861; deaccessioned after 1885.
References: GGK, December 14, 20, 1861. Donations 1859-1863, December 12, 1861. RL 1862 and 1885, #148.

550. *Love Letter and Three Figures*
Unlocated. Bequeathed to RL in December 1862; deaccessioned after 1885.
References: GGK, #75. Donations 1859-1863, December 11, 1862. RL 1885, #260.

551. *Mother Praying over Her Sleeping Child*
Unlocated. Given to RL in December 1861; deaccessioned after 1885.
References: GGK, December 14, 20, 1861. Donations 1859-1863, December 12, 1861. RL 1862 and 1885, #191.

552. *Neglected Wife*
Unlocated. Bequeathed to RL on August 2, 1862; deaccessioned after 1885.
References: GGK, #41. RL 1862 and 1885, #32.

553. *"Oh! Tis so Cold!" Colored Woman Putting Little Child into the Bath.*
Unlocated. Given or bequeathed to RL before September 1862; deaccessioned after 1885.
Reference: RL 1862 and 1885, #77.

554. *Rachel Envying Her Sister. Three Little Girls.*
Unlocated. Given to RL in December 1861; deaccessioned after 1885.
References: GGK, December 14, 20, 1861. Donations 1859-1863, December 12, 1861. RL 1862 and 1885, #155.

555. *Rustic Scene* after Nicholas Berchem
Unlocated. Given or bequeathed to RL before September 1862; deaccessioned after 1885.
Reference: RL 1862 and 1885, #83.

556. *School Girl Writing Composition*
Unlocated. Bequeathed to RL on August 2, 1862; deaccessioned after 1885.
References: GGK, #35. RL 1862 and 1885, #53.

557. *Slave on Sale. Girl with a Chain on Her Wrist.*
Unlocated. Bequeathed to RL on August 2, 1862; deaccessioned after 1885.
References: GGK, #9. RL 1862 and 1885, #137.

558. *Sleeping Mother*
Unlocated. Bequeathed to RL on August 2, 1862; deaccessioned after 1885.
References: GGK, #7. RL 1862 and 1885, #140.

559. *Sleep (Sleeping Girl)*
 Unlocated. Bequeathed to RL on August 2, 1862; deaccessioned after 1885.
 References: GGK, #56. RL 1862 and 1885, #53.

560. *Smoker and Card Player* after Adrian van Ostade
 Unlocated. Given to RL before 1859; deaccessioned after 1885.
 References: RL 1859, #27. RL 1862 and 1885, #447.

561. *Snow Storm. "There's No Place like Home."*
 30 x 25.
 Unlocated. Given to RL in December 1861; deaccessioned after 1885.
 References: RL 1862 and 1885, #217. Mason, *Annals*, p. 226.

TEMPERANCE LECTURE SERIES

562. *Temperance Lecture, No. 1. First Step to Ruin.*
 Unlocated. Given to RL before 1859; deaccessioned after 1885.
 References: RL 1859, #46. RL 1862 and 1885, #209.

563. *Temperance Lecture, No 2. Second Step to Ruin, the Loafer.*
 Unlocated. Given to RL before 1859; deaccessioned after 1885.
 References: RL 1859, #47. RL 1862 and 1885, #210.

564. *Temperance Lecture, No. 3. Third Step to Ruin, the Fast Man.*
 Unlocated. Given to RL before 1859; deaccessioned after 1885.
 References: RL 1859, #48. RL 1862 and 1885, #211.

565. *Temperance Lecture, No. 4. Last Step, Meditating on Departed Spirits.*
 Unlocated. Given to RL before 1859; deaccessioned after 1885.
 References: RL 1859, #49. RL 1862 and 1885, #212.

566. *Two Young Ladies and Their Dead Bird*
 Unlocated. Bequeathed to RL on August 2, 1862; deaccessioned after 1885.
 References: GGK, #51. RL 1862 and 1885, #34.

567. *Way of the World. Girl Giving Her Companion a Soap Bubble with One
 Hand, and Stealing Her Grapes with the Other.*
 Unlocated. Given to RL in December 1861; deaccessioned after 1885.
 References: GGK, December 14, 20, 1861. Donations 1859-1863, December
12, 1861. RL 1862 and 1885, #73.

History

568. *Ceyx and Alcyone* after Richard Wilson
 43 x 56.
 Unlocated. Given to RL in December 1861; deaccessioned after 1885.
 References: GGK, November 25, 1861. Donations 1859-1863, December 1,
 1861. RL 1862 and 1885, #4.

569. *Charity*
Unlocated.
Reference: Sully, "Journal," p. 131; December 27, 1837; records Sully's having made a "design for a charity, suggested by a sketch fr. King."

570. *Christ. From an Old Master.*
Unlocated. Given to RL before 1859; deaccessioned after 1885.
References: RL 1859, #24. RL 1862 and 1885, #172.

571. *The Concert. . . . Forming part of the Painting Called the Rich Man's Feast; from Bonifaccio*
Unlocated. Bequeathed to RL on December 11, 1862; deaccessioned after 1885.
References: GGK, #73; lists this work as "Landscape (Trees)." Donations 1859-1863; lists it as "Landscape." RL 1885, #253; lists it as above, *The Concert . . .*

572. *Daniel Boone Discovering the Valley of the Mississippi*
Unlocated. Exhibited at the Maryland Historical Society in 1858.
Reference: Maryland Historical Society, *Catalogue of Paintings,* 1858, p. 11; lists the artist simply as "King" (possibly CBK), and the owner as "Judge Lee."

573. *The Daughter of Jephthah*
Unlocated. Given or bequeathed to RL; deaccessioned after 1885.
Reference: RL 1885, #257.

574. *Elymas, the Sorcerer, Struck with Blindness after Raphael*
Unlocated. Given to RL before 1859; deaccessioned after 1885.
References: RL 1859, #25. RL 1862 and 1885, #153.

575. *Eve*
Unlocated. Bequeathed to RL on August 2, 1862; deaccessioned after 1885.
References: GGK, #10. RL 1862 and 1885, #173.

576. *Eve at the Fountain (Back View)*
Unlocated. Bequeathed to RL on August 2, 1862; deaccessioned after 1885.
References: GGK, #65. RL 1862 and 1885, #149.

577. *Girl at the Grave of Fanny*
Unlocated. Bequeathed to RL on August 2, 1862; deaccessioned after 1885.
References: GGK, #31. RL 1862 and 1885, #29.

578. *Holy Water. Two Angels Holding a Vase of Water. From a Plaster Cast.*
Unlocated. Given to RL before 1859; deaccessioned after 1885.
References: RL 1859, #38. RL 1862 and 1885, #91.

579. *Infant St. John after Sir Joshua Reynolds*
Unlocated. Given to RL in December 1861; deaccessioned after 1885.
References: GGK, December 14, 20, 1861. Donations 1859-1863, December 12, 1861. RL 1862 and 1885, #154.

580. *Jeremiah* after Michelangelo
Unlocated. Given to RL before 1859; deaccessioned after 1885.
References: RL 1859, #55. RL 1862 and 1885, #48.

581. *Joseph (and Potiphar's Wife)*
Unlocated. Given to RL in December 1861; deaccessioned after 1885.
References: *Diary of C. F. Adams,* 1:48, January 17, 1824; after a visit to King's gallery, Adams noted that there were "some voluptuous pieces also, which it would not do to notice before ladies. One in particular which appeared to be Joseph and the wife of Potiphar although we could not see for a veil which John and myself attempted to raise, when we discovered the deception. It was very accurate." Donations 1859-1863, December 12, 1861. GGK, December 14, 20, 1861. RL 1862 and 1885, #226.

582. *Judith Meditating the Murder of Holofernes*
Unlocated. Bequeathed to RL but not received because it was exchanged for an Indian portrait, probably catalog number 365.
References: GGK #38. Mason, *Annals,* pp. 232, 235.

583. *Juvenile St. Cecilia. Patroness of Music and Musicians.*
Unlocated. Bequeathed to RL on August 2, 1862; deaccessioned after 1885.
References: GGK, #6. RL 1862 and 1885, #36.

584. *Laura Bianchi, Titian's Mistress*
Unlocated. Bequeathed to RL on August 2, 1862; deaccessioned after 1885.
References: GGK, #3. RL 1862 and 1885, #222.

585. *Lazy Lawrence and Jim. Miss Edgeworth's Parents' Assistant.*
Unlocated. Given to RL in December 1861; exhibited at the Newport (R.I.) High School in January 1865; deaccessioned after 1885.
References: GGK, December 14, 20, 1861. RL 1862 and 1885, #150.

586. *Lear and Cordelia* 1806-1812
Unlocated.
Reference: Neal, "Observations," p. 55; notes that in 1824 this picture was seen at the widow Bridgen's in London by Neal, who describes "one of Lear and Cordelia – judging by the old man's look, and the youthful beauty of the female. It was a very good picture, all things considered, strong and graceful, and better in idea than any thing of his [King's] I have lately seen."

587. *Lot and His Daughter. Copy from an Old Master.*
Unlocated. Bequeathed to RL on August 2, 1862; deaccessioned after 1885.
References: GGK, #30. RL 1862 and 1885, #223.

588. *Madonna della Seggiola* after Raphael
Unlocated. Given or bequeathed to RL; deaccessioned after 1885.
Reference: RL 1885, #262.

589. *The Marriage Festival of Isaac and Rebecca; or "La Molina"*
after Claude Lorrain
Unlocated. Bequeathed to RL on August 2, 1862; deaccessioned after 1885.
References: GGK, #50. RL 1862 and 1885, #70.

590. *Mary Magdalen*
Unlocated. Given or bequeathed to RL; deaccessioned after 1885.
Reference: RL 1885, #265.

591. *Mary Magdalen* after Guido Reni
30 x 25.
Unlocated. Given to RL in December 1861; deaccessioned after 1885.
References: RL 1862 and 1885, #98. Mason, *Annals,* p. 226.

592. *Medea* after Guido Reni
Unlocated. Bequeathed to RL on August 2, 1862; deaccessioned after 1885.
References: GGK, #5. RL 1862 and 1885, #216.

593. *Miss Simple, now Sister Agnes, in a Convent*
Unlocated. Given to RL before 1859; deaccessioned after 1885.
References: RL 1859, #51. RL 1862 and 1885, #22.

594. *Niobe's Daughter*
Unlocated.
Reference: Catalog of the Ogle-Tayloe Collection, Corcoran Gallery, 1920.

595. *Old King Cole*
Unlocated. Given to RL before 1859; deaccessioned after 1885.
References: RL 1859, #69. RL 1862 and 1885, #171.

596. *Paris, Son of Priam, of Troy, from a Bust*
Unlocated. Given to RL before 1859; deaccessioned after 1885.
References: RL 1859, #61. RL 1862 and 1885, #57.

597. *Pylades and Orestes* after Benjamin West 1809
Unlocated. Exhibited at the PAFA in 1814.
References: Sully, "Journal," p. 11, September 14, 1809; mentions Sully's
having returned West's original, which Sully and no doubt King had borowed
to copy at their rooms in Buckingham Place. PAFA 1814, p. 25, #259.

598. *Rip Van Winkle Returning from a Morning Lounge* circa 1825
Illustrated in figure 86.
44 x 56¼.
Inscribed on back (probably by GGK): Rip Van Winkle Returning from a
Morning Lounge Original by C. B. King.
Owner: Museum of Fine Arts, Boston, Mass. Bequeathed by Maxim
Karolik in 1952. Formerly in the collection of William C. Loring, Boston (?),
1932; given to RL in December 1861; deaccessioned after 1885.
References: Watterston, *New Guide to Washington,* p. 102; in 1847 this
painting was seen at CBK's by Watterston, who described it as among the most
beautiful there. RL 1862 and 1885, #13. Mason, *Annals,* p. 226. *Antiques,* Feb-
ruary 1932, p. 67.

599. *Sigismunda, Weeping over the Heart of Tancred* after Correggio
30 x 25.
Unlocated. Given to RL in December 1861; deaccessioned after 1885.
References: RL 1862 and 1885, #87. Mason, *Annals,* p. 226.

600. *Silenus*
Unlocated. Bequeathed to RL on August 2, 1862; deaccessioned after 1885.
References: GGK, #18. RL 1862 and 1885, #142.

601. *Telemachus and Mentor, Shipwrecked on the Isle of Calypso*
after Benjamin West 1810
43 x 56 (approximate).
Unlocated. Exhibited at the PAFA in 1813; given to RL in December 1861;
deaccessioned after 1885.
References: Sully, "Journal," p. 12, March 3, 1810; mentions Sully's having
returned West's original, which Sully and no doubt King had borrowed to copy
at their rooms in Buckingham Place. PAFA 1813, p. 13, #11. *Port Folio,* August
1813, p. 126; describes this work as a copy after West that "possesses much merit."
GGK, November 25, 1861. Donations 1859-1863, December 1, 1861. RL 1862 and
1885, #16.

602. *Venus Endeavoring to Prevent Adonis from Going to the Chase, on the Day
He Was Killed by Mars* after Titian
43 x 56 (approximate).
Unlocated. Given to RL in December 1861; deaccessioned after 1885.
References: GGK, November 25, 1861; Donations 1859-1863, December 1,
1861. RL 1862 and 1885, #18.

Fancy Pieces and Others

603. *Blind Girl Reading*
Unlocated. Bequeathed to RL on August 2, 1862; deaccessioned after 1885.
References: GGK, #32. RL 1862 and 1885, #31.
§ Possibly the same as catalog number 605.

604. *Butterfly in a Storm. Frightened Young Lady, with Bonnet Blown off,
Parasol Turned Inside out.*
Unlocated. Given to RL before 1859; deaccessioned after 1885.
References: RL 1859, #2. RL 1862 and 1885, #89.
§ See catalog number 653, possibly an original study.

605. *The Castle Builder* 1829
Illustrated in figure 98.
30 x 25.
Signed lower right: Painted by Charles B. King 1829.
In private collection.
§ Possibly the same as catalog number 603.

606. *Costume, Carolus 1st*
Unlocated. Bequeathed to RL on August 2, 1862; deaccessioned after 1885.
References: GGK, #57. RL 1862 and 1885, #66.

607. *Costume of a French Princess, A.D. 1000*
Unlocated. Bequeathed to RL on August 2, 1862; deaccessioned after 1885.
References: GGK, #62. RL 1862 and 1885, #55.

608. *Costume of Female of Quality. Carolus 2d of France.*
Unlocated. Bequeathed to RL on August 2, 1862; deaccessioned after 1885.
References: GGK, #61. RL 1862 and 1885, #144.

609. *Costume, Time of Charlemagne. Female Head and Beautiful Vase of Flowers.* circa 1838
Illustrated in figure 97.
30 x 25.
Inscribed on back (probably by GGK): Costume time of Charlemagne by C. B. King.
Owner: J. J. Bowden, Tarzana, Calif. Given to RL in December 1861; deaccessioned after 1885.
References: GGK, December 14, 20, 1861. Donations 1859-1863, December 12, 1861. RL 1862 and 1885, #94.

610. *Dying Soldier in Armor*
30 x 25.
Unlocated. Given to RL in December 1861; sold by Vose Galleries (?) in 1952.
References: RL 1862 and 1885, #207. Mason, *Annals,* p. 226. Index to Minutes of the Redwood Library Board, on file in Redwood Library.

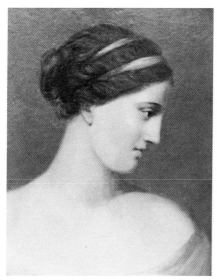

611.

611. *A Fancy Head*
Oil on wood, 17½ x 14.
Inscribed on back: A Fancy head by C. B. King and presented by him to Mrs. William Henry Tayloe of Mount Airy.
Owner: Mr. and Mrs. H. Gwynne Tayloe II, Warsaw, Va.

612. *Female Lashed to a Wreck*
Unlocated. Bequeathed to RL on August 2, 1862; deaccessioned after 1885.
References: GGK, #40. RL 1862 and 1885, #199.

613. *The Fortune Teller* after Sir Joshua Reynolds
Unlocated. Given to RL before 1859; deaccessioned after 1885.
References: RL 1859, #29. RL 1862 and 1885, #27.

614. *French Costume in 1400*
Unlocated. Given to RL before 1859; deaccessioned after 1885.
References: RL 1859, #19. RL 1862 and 1885, #81.

615. *The Gambler, with His Cards, Pistol Case, and Goblet*
30 x 25.
Unlocated. Given to RL in December 1861; deaccessioned after 1885.
References: RL 1862 and 1885, #93. Mason, *Annals,* p. 226.

616. *Girl with Water Jug*
Unlocated. Given to RL before 1885; deaccessioned thereafter.
Reference: RL 1885, #264.

617. *Gypsy Boy* after Sir Joshua Reynolds
Unlocated. Given to RL before 1859; deaccessioned after 1885.
References: RL 1859, #39. RL 1862 and 1885, #99.

618. *Head of a Drunkard*
Unlocated.
Reference: Watterston, *New Guide to Washington*, p. 102; in 1847 Watterston saw a painting at CBK's gallery that he described as "an admirable and spirited head of a Drunkard."

619. *"I am not Mad."*
Unlocated.
Reference: Watterston, *New Guide to Washington*, p. 102; in 1847 this painting was seen at CBK's by Watterston, who described it as "very fine."

620. *Indian Girl at Her Toilet* circa 1835
Illustrated in figure 59.
26½ x 21¾.
Signed on back: Presented to the Redwood Library by Charles B. King, Esq.
In private collection. Bequeathed to RL on August 2, 1862; sold by PB in 1970.
References: GGK, #64. RL 1862 and 1885, #219. Index, #117. PB, #21.

621. *Interior of a Church*
Unlocated. Bequeathed to RL on December 11, 1862; deaccessioned after 1885.
References: GGK, #69. Donations 1859-1863, December 11, 1862. RL 1862 and 1885, #259.

622. *Madness, or the Maniac*
Unlocated. Bequeathed to RL on August 2, 1862; deaccessioned after 1885.
References: GGK, #25. RL 1862 and 1885, #215.

623. *Mexican Girl*
Unlocated. Given to RL before 1859; deaccessioned after 1885.
References: RL 1859, #56. RL 1862 and 1885, #79.

624. *Old Witch by Firelight (Sarah Prince)*
Unlocated. Bequeathed to RL on August 2, 1862; deaccessioned after 1885.
References: GGK, #17. RL 1862 and 1885, #218.

625. *Peasant Girl* circa 1840
Oil on wood, 15 x 12.
In private collection.

626. *Pirate*
Unlocated. Given to RL before 1859; deaccessioned after 1885.
References: RL 1859, #23. RL 1862 and 1885, #208.

627. *Portrait of a Lady, Greek Custom [sic]*
Unlocated Exhibited at the Apollo Association, New York, in October 1839.
Reference: Cowdrey, *AAU. Record*, p. 216, #45.

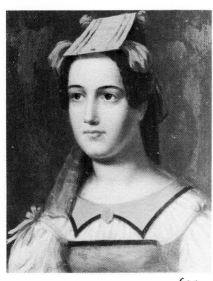

625.

628. *"The Sage"* after Johann E. Schenau
Unlocated. Bequeathed to RL on August 2, 1862; deaccessioned after 1885.
References: GGK, #27. RL 1862 and 1885, #35.
§ CBK probably copied the engraving (see fig. 81) of this painting, a print
of which he owned and which he gave to the Redwood Library.

629. *Vine Dresser of Capri, near Naples* after Titian
Unlocated. Given to RL before 1859; deaccessioned after 1885.
References: RL 1859, #9. RL 1862 and 1885, #88.

630. *The Young Dragoon*
30 x 25.
Unlocated. Given to RL in December 1861; deaccessioned after 1885.
References: GGK, December 14, 1861. RL 1862 and 1885, #92. Mason,
Annals, p. 226.

Studies

Heads of Indians

[There are sixteen known studies by King of Indian heads. All are charcoal on gray
paper, approximately 9⅞ x 6½ inches (height by width). All are identifiable (some
tentatively) with paintings by King. These studies are owned by Mr. and Mrs.
Bayard LeRoy King, Saunderstown, R.I., and were discovered among family papers
in 1974 by Mr. King, a descendant of Edward King, the artist's second cousin.]

631. *Eshtahumbah.* See catalog number 325.
632. *Hayne Hudjihini.* See catalog number 331.
633. *Kaipolequa.* See catalog number 344.

631.

632.

633.

634.

635.

637.

638.

639.

640.

634. *Keesheswa.* See catalog number 346.
635. *Keokuk.* See catalog number 348.
636. *Moanahonga.* See catalog number 373. Illustrated in figure 64.
637. *Nahetluchopie* (?). See catalog number 383.
638. *Notin.* See catalog number 391.
639. *Pashepahaw.* See catalog number 404.
640. *Peahmuska.* See catalog number 406.

641.

642.

643.

644.

645.

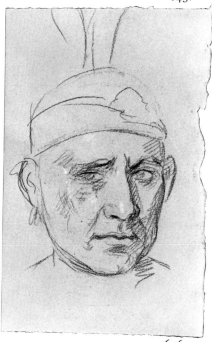

646.

641. *Peechekir*. See catalog number 409.
642. *Sharitarish* (?). See catalog number 438.
643. *Tahcolaquoit*. See catalog number 452.
644. *Tahrohon* (?). See catalog number 453.
645. *Taiomah*. See catalog number 454.
646. *Wakechai*. See catalog number 471.

Miscellaneous

647. *Female Head, from Life*
Unlocated. Given to RL before 1859; deaccessioned after 1885.
References: RL 1859, #13. RL 1862 and 1885, #41.

648. *Hand* after Benjamin West? 1806-1812
Charcoal on gray paper, 9⅞ x 6½.
Owner: George Gordon King, Washington, D.C. See the note for "Studies –
Heads of Indians."

649. *Head* after Giorgione
Unlocated. Given to RL before 1859; deaccessioned after 1885.
References: RL 1859, #64. RL 1862 and 1885, #65.

650. *Head* after Sir Anthony Van Dyck
Unlocated. Bequeathed to RL August 2, 1862; deaccessioned after 1885.
References: GGK, #14. RL 1862 and 1885, #157.

651. *Lafayette* 1825
Charcoal on gray paper, 9⅞ x 6½.
Signed on back: Original sketch of Lafayette from life C. B. King Wash-
ington 1825.
Owner: Alexandra King, Saunderstown, R.I. See the note for "Studies –
Heads of Indians."
§ See also catalog number 129, the painting for which this study was made.

652. *Study from Life (Head)*
Unlocated. Given to RL before 1859; deaccessioned after 1885.
References: RL 1859, #20 or #40. RL 1862 and 1885, #43.
§ See catalog number 653.

653. *Study from Life. Young Female with Bonnet Falling Back on the Shoulders.*
Unlocated. Given to RL before 1859; deaccessioned after 1885.
References: RL 1859, #40 or #20. RL 1862 and 1885, #39.
§ See catalog number 652. Possibly a study for catalog number 604.

Bibliography

The entries are arranged alphabetically within each division denoting type of source, unless otherwise indicated.

Unpublished Sources

Manuscripts

ARCHIVES OF AMERICAN ART, WASHINGTON, D.C.
Charles Bird King File.
Sully, Thomas. "Journal of Activities, 1792-1846." Microfilm of typewritten copy of original, New York Public Library.

CITY HALL, NEWPORT, R.I.
Land Evidence. Office of the City Clerk. Vols. 9, 12-14, 18, 37.
Probate Records. Probate Court. Vols. 2-6, 9, 12, 13, 21.

CORCORAN GALLERY OF ART, WASHINGTON, D.C.
"The Constitution and By-Laws of the Washington Art Association: Organized at the City of Washington, November 1856."

DIBBLE, MRS. T. R., PERU, VT.
"Journal of Elizabeth Hannah Newman, 1838-1846." 2 vols.

FEDERAL RECORDS CENTER, SUITLAND, MD.
Last Will and Testament of Charles Bird King, estate number 4525 O. S.

GOVERNMENT OF THE DISTRICT OF COLUMBIA, WASHINGTON, D.C.
Deed Transfers. Office of the Recorder of Deeds. Vols. J. A. S. 7, 20; N. C. T. 6, 8-10; W. B. 12, 23, 30, 32, 42, 68, 78, 116.

GREENSBORO HISTORICAL MUSEUM, GREENSBORO, N.C.
The Dolly Madison Collection.

HISTORICAL SOCIETY OF PENNSYLVANIA, PHILADELPHIA.
Letters of Washington Allston, Sir William Beechey, Joseph Delaplaine, John Flaxman, Charles Bird King, Rembrandt Peale, and Thomas Sully.

MARYLAND HISTORICAL SOCIETY, BALTIMORE.
Letters of John Gadsby Chapman.

NATIONAL ARCHIVES, WASHINGTON, D.C.
Letters of the Commissioner of Public Buildings, Record Group 42.
"Washington City Tax and Assessment Books, 1814 to date." Record Group 351. Records of the Government of the District of Columbia.

NEWPORT HISTORICAL SOCIETY, NEWPORT, R.I.
King Family Papers
"Letters of Hon. Wm. Hunter to Wife, 1813-1816."

THE NEW-YORK HISTORICAL SOCIETY, NEW YORK.
Charles Bird King File.
"Letters Received by American Art Union, April, 1838, to March, 1842."
"Minutes of the Committee of the Apollo Association to Promote the Fine Arts &c.,
 1839-1846."

REDWOOD LIBRARY AND ATHENAEUM, NEWPORT, R.I.
Charles Bird King File.
Minutes of the Board of Directors.
"Primary Record Book of Donations since June 1859 to May 1, 1863."
"Register of Donations to the Redwood Library, 1810-1858."

ROYAL ACADEMY OF ARTS, LONDON, ENGLAND.
"Royal Academy Council Minutes, 1769 to date."

VALENTINE MUSEUM, RICHMOND, VA.
Charles Bird King File.

Other

Belt, Stephanie. "The Portrait of Mrs. John Quincy Adams in the National Collection of Fine Arts." Research paper, Office of the Registrar, National Collection of Fine Arts, Smithsonian Institution, Washington, D.C., 1969. (Typewritten.)

Index of Portraits, Redwood Library, Newport, R.I. (Typewritten.)

Overby, Osmond. "32 Clarke Street: An Historical Report to the Newport Restoration Foundation," [1970] (Typewritten.)

Reiff, Daniel D. Collation of inscriptions on King's painting *Vanity of the Artist's Dream,* Archives, Fogg Art Museum, Harvard University, Cambridge, Mass. (Typewritten.)

Turner, Henry E. "Cemetery Records." Newport Historical Society, Newport, R.I., n.d. (Typewritten.)

Books and Reports

Adams, Charles Francis. *Diary of Charles Francis Adams.* Edited by Aïda DiPace Donald and David Donald. 4 vols. The Adams Papers, edited by L. H. Butterfield. Series 1: Diaries. Cambridge, Mass.: Belknap Press of Harvard University Press, 1964.

Adams, John Quincy. *Memoirs of John Quincy Adams, Comprising Portions of His Diary from 1759 to 1848.* Edited by Charles Francis Adams. Vols. 6, 7. Philadelphia: J. B. Lippincott & Co., 1875.

Annual Report of the Board of Regents of the Smithsonian Institution, Showing The Operations, Expenditures, and Condition of the Institution for the Year 1861. Washington, D.C.: Government Printing Office, 1862.

Annual Report of the Directors of the Redwood Library and Athenaeum, Newport, R.I., to the Proprietors. Submitted Wednesday, Sept. 24, 1862. Newport: James Atkinson, 1862.

Apollo Association. *Transactions of the Apollo Association for the Promotion of the Fine Arts in the United States, at the First Annual Meeting, December 16, 1839.* New York: Printed for the Association, 1839.

The Baltimore Directory for 1817-18. Containing the Names, Occupations, and Residences of the Inhabitants; with a Variety of Other Useful Matter. Corrected Up to the First of April. To be Continued Annually, in May. Baltimore: James Kennedy, 1817.

Biddle, Edward, and Mantle Fielding. *The Life and Works of Thomas Sully (1783-1872).* Philadelphia: Wickersham Press, 1921.

Birket-Smith, Kaj. *Charles B. King's Indian Portraits in the National Museum.* Translated by Clifford Richey. Copenhagen: Bianco Lunos Bogtrykkeri A/S, 1942.

Channing, George G. *Early Recollections of Newport, R.I., from the year 1793 to 1811.* Newport: A. J. Ward, Charles E. Hammett, Jr., 1868.

Cowdrey, Mary Bartlett. *American Academy of Fine Arts and American Art-Union. Exhibition Record, 1816-1852.* The John Watts DePeyster Publication Fund Series, vol. 77. New York: New-York Historical Society, 1953.

————. *American Academy of Fine Arts and American Art-Union. Introduction, 1816-1852.* The John Watts DePeyster Publication Fund Series, vol. 76. New York: New-York Historical Society, 1953.

————. *National Academy of Design Exhibition Record, 1826-1860.* The John Watts DePeyster Publication Fund Series, vols. 74, 75. New York: New-York Historical Society, 1943.

De Havilland, John von Sonntag. *A Metrical Description of a Fancy Ball Given at Washington, 9th April, 1858. Dedicated to Mrs. Senator Gwin.* Washington, D.C.: Franklin Philp, 1858.

Delano, Judah. *The Washington Directory, Showing the Name, Occupation, and Residence of Each Head of a Family and Person in Business: the Names of the Members of Congress, and Where They Board: Together with Other Useful Information.* Washington, D.C.: William Duncan, 1822.

De Mare, Marie. *G.P.A. Healy, American Artist: An Intimate Chronicle of the Nineteenth Century.* New York: David McKay Co., Inc., 1954.

Dix, John. *A Hand-Book of Newport, and Rhode Island.* Newport: C. E. Hammet, Jr., 1852.

Donaldson, Thomas. "Miscellaneous Collections: Indian Portraits, Oil Paintings, Daguerreotypes and Photographs." *Annual Report of the Board of Regents, of the Smithsonian Institution Showing the Operations, Expenditures, and Condition of the Institution to July, 1885.* Washington, D.C.: Government Printing Office, 1886, pp. 794-97.

Dunlap, William. *History of the Rise and Progress of the Arts of Design in the United States.* 1834 reprint. Edited by Alexander Wyckoff. 3 vols. New York: Benjamin Blom, 1965.

Elliot, Jonathan. *Historical Sketches of the Ten Miles Square Forming the District of Columbia; with a Picture of Washington, Describing Objects of General Interest or Curiosity at the Metropolis of the Union: Also a Description of the River Potomac....* Washington, D.C.: J. Elliot, Jr., 1830.

Faux, William. "Memorable Days in America." Vols. 11, 12 of *Early Western Travels, 1748-1846.* Edited by Reuben Gold Thwaites. 32 vols. Cleveland: Arthur H. Clark Co., 1904-07.

Goodrich, S. G., ed. *The Token; A Christmas and New Year's Present.* Boston: Publishers vary, 1828-42.

Green, Constance McLaughlin. *Washington, Village and Capitol, 1800-1878.* Princeton: Princeton University Press, 1962.

Greenough, Horatio. *Letters of Horatio Greenough to His Brother, Henry Greenough.* Edited by Francis Boott Greenough. Boston: Ticknor and Company, 1887.

Herring, James, and James B. Longacre, eds. *The National Portrait Gallery of Distinguished Americans.* 4 vols. New York: Monson Bancroft; Philadelphia: Henry Perkins; London: O. Rich, 1834-39.

Lee, Cuthbert. *Portrait Register.* [Ashville, N.C.]: Biltmore Press, 1968.

Leslie, Charles Robert. *Autobiographical Recollections.* Edited by Tom Taylor. Boston: Ticknor and Fields, 1860.

McKenney, Thomas L., and James Hall. *The Indian Tribes of North America: With Biographical Sketches and Anecdotes of the Principal Chiefs.* Edited by Frederick Webb Hodge. 3 vols. Edinburgh: John Grant, 1933-34.

Mason, George Champlin. *Annals of the Redwood Library and Athenaeum, Newport, R.I.* Newport: Redwood Library, 1891.

Morse, Samuel F. B. *Samuel F. B. Morse, His Letters and Journals.* Edited by Edward Lind Morse. 2 vols. Boston: Houghton Mifflin Company, 1914.

"Observations on American Art. Selections from the Writings of John Neal." Edited by Harold E. Dickson. Pennsylvania State College Studies no. 12. *The Pennsylvania State College Bulletin* 37 (February 4, 1943).

Oliver, Andrew. *Portraits of John and Abigail Adams.* The Adams Papers, edited by L. H. Butterfield. Series 4: Portraits. Cambridge, Mass.: Belknap Press of Harvard University Press, 1967.

―――. *Portraits of John Quincy Adams and His Wife.* The Adams Papers, edited by L. H. Butterfield. Series 4: Portraits. Cambridge, Mass.: Belknap Press of Harvard University Press, 1970.

Rhees, William Jones. *An Account of the Smithsonian Institution, Its Founder, Building, Operations, Etc., Prepared from the Reports of Prof. Henry to the Regents, and Other Authentic Sources.* Washington, D.C.: Thomas McGill, 1859.

―――, comp. and ed. *The Smithsonian Institution: Documents Relative to Its Origin and History, 1835-1899.* 2 vols. Washington, D.C.: Government Printing Office, 1901.

Rutledge, Anna Wells, ed. *Cumulative Record of Exhibition Catalogues; the Pennsylvania Academy of the Fine Arts, 1807-1870; the Society of Artists, 1800-1814; the Artists' Fund Society, 1835-1845.* Memoirs of the American Philosophical Society, vol. 38. Philadelphia: American Philosophical Society, 1955.

Smith, Mrs. Samuel Harrison. *The First Forty Years of Washington Society.* Edited by Gaillard Hunt. New York: Charles Scribner's Sons, 1906.

Stauffer, David McNeely. *American Engravers Upon Copper and Steel.* 2 vols. New York: Grolier Club of the City of New York, 1907.

Swan, Mabel Munson. *The Athenaeum Gallery, 1827-1873. The Boston Athenaeum as an Early Patron of Art.* Boston: Boston Athenaeum, 1940.

Trollope, Frances. *Domestic Manners of the Americans.* Edited by Donald Smalley. New York: Alfred A. Knopf, 1949.

Tuckerman, Henry T. *Book of the Artists. American Artist Life, Comprising Biographical and Critical Sketches of American Artists: Preceded by an Historical Account of the Rise and Progress of Art in America.* New York: G. P. Putnam & Son, 1867.

Viola, Herman J. *The Indian Legacy of Charles Bird King.* Washington, D.C.: Smithsonian Institution Press and Doubleday & Company, Inc., 1976.

Watterston, George. *New Guide to Washington: Containing a History and General Description of the Metropolis, Its Public Buildings, Institution, &c, with Seventeen Beautiful Lithographed Engravings. Accompanied by a New and Correct Map.* Washington, D.C.: Robert Farnham, 1847-48.

Catalogs

The entries are arranged in chronological order.

Pennsylvania Academy of the Fine Arts, Philadelphia. Catalogs of annual exhibitions for 1813, 1814, 1817, 1818, 1822-25, 1830-32, 1834, 1836-38, 1840, 1843. Titles and publishers vary.

Boston Athenaeum, Massachusetts. Catalogs of annual exhibitions for 1828, 1831-32, 1854. Titles and publishers vary.

Maryland Historical Society, Baltimore. *Catalogue of Paintings, Engravings, &c &c. at the Picture Gallery of the Artists' Association, and of the Maryland Historical Society.* Baltimore: John D. Toy, 1856.

Redwood Library, Newport, R.I. *Catalogue of Pictures and Busts Belonging to the Redwood Library, Newport, R.I., July 1st, 1859. With the Names of the Donors, &c.* Privately printed.

Redwood Library, Newport, R.I. *Catalogue of Pictures, Statuary, &c., Belonging to the Redwood Library, September 1, 1885.* Privately printed.

Parke Bernet Galleries, Inc., New York, N.Y. *The Important Collection of Twenty-One Portraits of North American Indians by Charles Bird King (1785-1862). Property of the Redwood Library and Athenaeum, Newport, Rhode Island. Sold by Order of the Board of Directors.* Catalog of auction at the Parke Bernet Galleries, Inc., New York, N.Y., May 21, 1970.

Newspapers

The entries are arranged in chronological order.

National Intelligencer (Washington, D.C.), December 31, 1818, February 2, 1819, May 26, 1819, November 30, 1821.

United States Telegraph (Washington, D.C.), February 6, 8, 10, 11, March 8, 1826.

New York Mirror: A Weekly Journal Devoted to Literature and the Fine Arts, October 20, 27, 1838.

Newport Mercury, January 7, 1854.

Newport Daily News, March 20, 1862.

New York Times, March 21, 1862.

Providence Journal, March 26, 1862.

Star Magazine (Washington, D.C.), December 31, 1961.

Periodicals

The entries are arranged in chronological order.

The Port Folio, a Monthly Magazine, Devoted to Useful Science, the Liberal Arts, Legitimate Criticism, and Polite Literature, July 1812; August 1813; January, February, May 1814; November 1815; January 1816.

Peale, Rembrandt. "Reminiscences." *The Crayon* 3 (March 1856): 100-102.

Clark, Allen C. "Joseph Gales, Junior, Editor and Mayor." *Records of the Columbia Historical Society, Washington, D.C.* 23 (1920): 86-146.

Elliott, Maude Howe, "Some Recollections of Newport Artists: A Paper Read Before the Society, Monday, November 15th, 1920." *Bulletin of the Newport Historical Society* 35 (January 1921): 1-32.

Mechlin, Leila. "Art Life in Washington." *Records of the Columbia Historical Society, Washington, D.C.* 24 (1922): 164-91.

Knox, Katharine McCook. "Adventuring in Early American Art." *The Daughters of the American Revolution Magazine,* July 1953, pp. 878, 885-90.

Ewers, John C. "Charles Bird King, Painter of Indian Visitors to the Nation's Capital." *Smithsonian Report for 1953* (1954): 463-82.

Chamberlain, Georgia S. " 'The Baptism of Pocahontas'; John Gadsby Chapman's Gigantic Mural in the Rotunda of the National Capitol." *The Iron Worker* 23 (Summer 1959): 15-22.

Cobb, Josephine. "The Washington Art Association: An Exhibition Record, 1856-1860." *Records of the Columbia Historical Society, Washington, D.C.* 63-65 (1963-65): 122-90.

Viola, Herman J. "Washington's First Museum: The Indian Office Collection of Thomas L. McKenney." *The Smithsonian Journal of History* 3 (Fall 1968): 1-18.

————. "Portraits, Presents, and Peace Medals: Thomas L. McKenney and Indian Visitors to Washington." *American Scene* 11 (1970).

————. "Invitation to Washington – A Bid for Peace." *The American West* 9 (January 1972): 19-31.

Other Sources

Catalog of American Portraits, National Portrait Gallery, Smithsonian Institution, Washington, D.C.

"A Collection of Engravings, Made by Charles B. King, and by Him Presented to the Redwood Library and Athenaeum." 14 vols. On file in the Redwood Library and Athenaeum, Newport, R.I.

Inventory of American Paintings Executed before 1914, National Collection of Fine Arts, Smithsonian Institution, Washington, D.C.

Mounted and annotated photographs, Frick Art Reference Library, New York, N.Y.

Pleasants, J. Hall. "Studies in Maryland Painting." Mounted and annotated photographs, Maryland Historical Society, Baltimore, Md.